P9-DED-468

ART IN OUR TIME
A CHRONICLE OF THE MUSEUM OF MODERN ART

I have been immersed in the world of art since I was a small child. One of my first memories is of my mother, Abby Aldrich Rockefeller, studying a Toulouse-Lautrec print in her gallery on the seventh floor of our home on West Fifty-fourth Street, which would later become the site of The Museum of Modern Art's sculpture garden.

Mother approached art emotionally as well as intellectually, and she wanted her children to revel in the full beauty of a painting, statue, or piece of porcelain. She taught all of us to be open to all art—to allow its colors, textures, composition, and context to speak to us, and to understand what the artist was trying to achieve and how the work might provide a challenging or reassuring glimpse of the world around us. My parents filled their homes with art from many parts of the world. Unlike Father, my mother had a broad eclectic taste. By the early 1920s, she had begun to focus on contemporary art and, guided by Edith Halpert of the Downtown Gallery, acquired works by many living American and European artists.

It was also during this time that Mother met two remarkable ladies, Lillie P. Bliss and Mary Quinn Sullivan, who shared Mother's interest in living artists. The three knew that many talented artists had little prospect of having their works exhibited by a museum during their lifetimes, so they decided to establish a "museum of modern art" where the works of contemporary artists could be shown. "The three ladies" intended much more, of course; they wanted the Museum to be a center for art research, publication, and education. Their original vision has succeeded brilliantly, due to the hard work and dedication of their colleagues and successors— both Trustees and staff—down to the present day.

My association with MoMA has been one of the richest and most rewarding of my life. In many ways I consider myself a steward of Mother's original vision for the Museum. After more than a half century as a Trustee, Chairman, Chairman Emeritus, collector, and avid museum visitor, I have come to understand and appreciate the power and beauty of art in the way she hoped I would. I am very happy the new MoMA is such a vibrant testament to her original vision.

— **DAVID ROCKEFELLER**
CHAIRMAN EMERITUS

Over the past forty years, The Museum of Modern Art has increasingly occupied my attention and at the same time captured my respect and my heart. The superb collection, the artists, the exhibitions, the talented curators, scholars, and other staff, the publications, the social events, the magnificent sculpture garden, the musical performances, and much more have enriched my enjoyment and deep interest in modern and contemporary art and culture in myriad ways.

It has been a privilege and a joy to serve the Museum as a Trustee, President, and Chairman, and to participate in its development and plans for the twenty-first century. From its new acquisitions and exhibitions to its Library and Archives, there is always excitement and insight to be gained into ways of looking, thinking, and living. On almost any given day my love of art can find nourishment in the Museum, spending time with Picasso's *Demoiselles d'Avignon* or gazing at a work by Sophie Tauber-Arp, discovering a work by Gabriel Orozco or revisiting a favorite Brice Marden, inhabiting a Janet Cardiff environment or being carried away by a film by Sofia Coppola.

MoMA has been a second home to me, very much part of my strong sense of family, and as much as I have loved our time in Queens, it feels good to be back home on Fifty-third Street in the simultaneously brilliant and familiar surroundings of Yoshio Taniguchi's new Museum building. I look forward to welcoming the MoMA staff, as well as the public, home, and will see you in the new galleries.

— **AGNES GUND**
PRESIDENT EMERITA

My relationship with The Museum of Modern Art began thirty-seven years ago, in 1967. Alfred H. Barr, Jr., retired that year, but his presence remained in every corner and corridor. I was twenty-three, and had already become a passionate collector of the drawings of Gustav Klimt and Egon Schiele. The Department of Prints and Drawings had been organized a year earlier, in 1966, and after a short time I found my way onto it. At that time, many of the founding Trustees and original curators were still there, and the spirit they imparted to the place was thrilling.

Now that the Museum is about to reopen in its wonderful new building, I am thinking back to what, for me, were the two most exciting moments at the Museum. The first was in early March of 1970, at the opening of a comprehensive exhibition of the work of Hector Guimard, one of France's most original and important Art Nouveau architects and designers. Guimard had long been famous for the system of entrances he designed for the Paris Métro in 1900, but little was known about the rest of his work until this show. Alfred Barr, who was one of the lenders, showed me his piece, as well as several others in the exhibition, with a vivid story about each. I saw the whole thing through his lively eye, and it was a day I will not soon forget.

In July of 2004, I walked through the almost completed new Museum of Modern Art—bare and without art—and had a similar feeling of extraordinary delight in Yoshio Taniguchi's elegantly simple and powerful design.

On the brink of a new era for the Museum, I think back on the many fascinating and renowned Trustees, curators, directors, and artists I have met within its walls. With all its changes and transitions, today, in its seventy-fifth year, the Museum continues to be the central and preeminent setting for modern and contemporary art.

— **RONALD S. LAUDER**
CHAIRMAN

When The Museum of Modern Art was established, in 1929, its founding Director, Alfred H. Barr, Jr., ambitiously set out to create "the greatest museum of modern art in the world." The task was daunting and the funding minuscule by today's standards. MoMA was launched with a modest gift of eight prints and one drawing, and underwritten with an initial subscription of $100,000, a little over $1 million in current dollars. Yet today we are just what Barr expected us to become.

Over the past seventy-five years, the Museum's collection has grown to include paintings, sculptures, drawings, prints, photographs, architectural models, design objects, films, electronic-media works, and illustrated books. And MoMA itself has grown from six rented rooms on Fifth Avenue and Fifty-seventh Street to a stunning 640,000-square-foot institution encompassing most of a city block.

All this can be seen by anyone who walks into the Museum. What is less obvious but equally important is the quiet culture of excellence that has been nurtured at MoMA since its earliest days. Thanks in large part to the benefaction and leadership of the Rockefeller family—Abby Aldrich Rockefeller, Nelson, Blanchette, and David today—MoMA thrives on a collaborative spirit that is as unique in the museum world as it is in the corporate one.

The Museum's curators, staff, and Trustees aren't only passionate about modern art; they are deeply involved with one another and devoted to the institution we all serve. And, more than anything else, it is that spirit of a common purpose and mutual respect that assures our greatness as an institution.

MoMA's unique and vibrant culture is invisible to visitors, but it is everywhere around them—from the bold design of the new building to the art on its walls, and to this book as well. Long may we celebrate it.

— **ROBERT B. MENSCHEL**
PRESIDENT

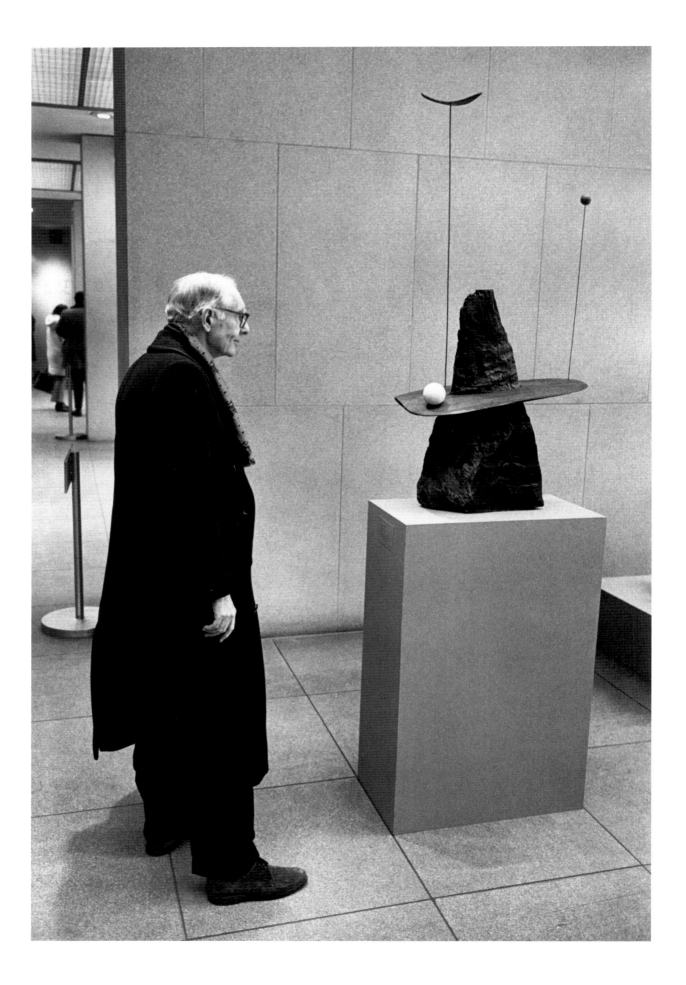

ART IN OUR TIME

A CHRONICLE OF

THE MUSEUM OF MODERN ART

EDITED BY

Harriet S. Bee and Michelle Elligott

THE MUSEUM OF MODERN ART, NEW YORK

This publication is made possible by
the Blanchette Hooker Rockefeller Fund.

Produced by the Publications Department of
The Museum of Modern Art, New York

Edited by David Frankel
Designed by Steven Schoenfelder
Production by Christina Grillo
Printed and bound by Dr. Cantz'sche Druckerei,
Ostfildern, Germany
This book is typeset in Akzidenz Grotesk, Caecilia,
and FF Din and printed on 170 gsm Luxosamt Offset.

© 2004 The Museum of Modern Art, New York
All rights reserved.
Certain illustrations are covered by claims to
copyright cited in the Photograph Credits.

Library of Congress Control Number: 2004113805
ISBN: 0-87070-001-4

Published by The Museum of Modern Art
11 West 53 Street, New York, NY 10019
www.moma.org

Distributed in the United States and Canada by
D.A.P., Distributed Art Publishers, Inc., New York

Distributed outside the United States and Canada
by Thames & Hudson Ltd., London

Printed in Germany

Front cover: Sign for the tenth-anniversary exhibi-
tion *Art in Our Time*, 1939, on the facade of The
Museum of Modern Art, New York

Back cover, clockwise from top: "Torpedo" Diagram
of Ideal Permanent Collection, drawn by Alfred H.
Barr, Jr., 1933, part of a 22-page report he pre-
pared for the Trustees; *Allegories of Modernism:
Contemporary Drawing*, installation view, 1992;
The Abby Aldrich Rockefeller Sculpture Garden,
designed by Philip Johnson, view toward the east,
1953; Alfred H. Barr, Jr., in 1967, looking at Alexan-
der Calder's 1936 construction *Gibraltar*, a gift of
the artist; Pablo Picasso, *Les Demoiselle d'Avignon*,
1907, a key work in the history of modernism ac-
quired by the Museum, viewed by Trustees and
associates, left to right, John Hay Whitney, Mrs.
William T. Emmet, Jr., A. Conger Goodyear, Nelson
A. Rockefeller, Mrs. John S. Sheppard, Edsel Ford,
and Elizabeth Bliss Parkinson (Mrs. John Parkin-
son, Jr.), 1939; View of the facade of The Museum of
Modern Art's first permanent building, designed by
Philip L. Goodwin and Edward Durell Stone, 1939.

Endpapers: Double-page spreads from The Museum
of Modern Art guest book, 1929 and 1931–35

Frontispiece: Alfred H. Barr, Jr., looks at Alexander
Calder's construction *Gibraltar*, 1936, one of a num-
ber of works given to the Museum by the artist.
Photograph by Dan Budnick

Page 10: Townhouse at 11 West 53 Street (center),
home of The Museum of Modern Art. A Calder mo-
bile hangs from the fifth floor during the exhibition
Cubism and Abstract Art, 1936. Photograph by
Soichi Sunami

CONTENTS

FOREWORD

Anniversaries are times of celebration and reflection, and as The Museum of Modern Art turns seventy-five it has much to celebrate and reflect upon. Since its founding, in 1929, it has built an unparalleled collection of modern art, engaged in an extensive exhibition and publications program, nurtured several generations of outstanding curators, educators, conservators, and administrators, developed an exceptionally dedicated and talented Board of Trustees, enlarged its space from 4,000 square feet, rented in an office building, to over 640,000 square feet in Yoshio Taniguchi's newly designed Museum, and built an endowment of over $425 million. This book chronicles the rich history of the Museum and shows many of the MoMA family who made the Museum happen—Trustees, directors, curators and other staff, and artists.

Despite its age and its considerable accomplishments, the Museum is still very much a young institution whose direction and future remain open to debate and critique. In many ways, founding Trustee Paul J. Sachs's admonition to his fellow Trustees on the occasion of the Museum's tenth anniversary—that as the Museum grows older it must contend with "the danger of timidity"—remains true today, because the danger of timidity always lurks in the shadow of success. But Sachs went on to encourage his peers to take risks, and much of the Museum's history has been about how much risk-taking—intellectual, artistic, programmatic, financial—was required in order to remain a vibrant and innovative institution while recognizing and honoring past achievements.

Throughout its existence, the Museum has understood that its single most important task was to develop its collection—through judicious acquisition and careful refinement. To do this the Trustees of the Museum also understood that it needed an outstanding curatorial staff able to conduct the necessary research to locate and secure works of art for the Museum, often after years of painstaking negotiation. Inevitably, there have been moments of greater and lesser growth as opportunities presented themselves, but there has always been intense discussion within the institution as to the nature and shape the collection should take in its dual commitment to the founding works of modern art and the art of the immediate present. The institutional tension that arises from this balancing act, across every area of the Museum's interests—painting and sculpture, architecture and design, film and media, photography, drawings, prints and illustrated books—gives definition to the Museum's mission of making modern art accessible and intelligible to its public. It has also led to extended periods of questioning the Museum's commitment to contemporary art and its willingness to take artistic and programmatic risks, especially during the turbulent 1960s and early 1970s.

In many ways the new Museum of Modern Art, the opening of which happily coincides with the Museum's seventy-fifth anniversary just as the opening of the Museum's first building coincided with its tenth anniversary, is a response to Sachs's admonition. It is by far the largest undertaking ever embarked on by the Trustees of the Museum and has involved raising over $850 million to accomplish a tripartite goal. The first part was to build a study and storage center in Long Island City (which joins the Celeste Bartos Center for Film Preservation in Hamlin, Pennsylvania, as part of the Museum's effort to provide state-of-the-art repositories for its collection) and to use it

for two and a half years as a temporary exhibition center while the new Museum was under construction; the second, to enlarge the endowment of the Museum by $111 million; and the third and most important, to remake the Museum at Fifty-third Street in Manhattan, commissioning Yoshio Taniguchi as the architect for the job, and increasing the building's size from 380,000 square feet to 640,000 square feet. The expectations of this project were, and remain, considerable: Will the new building provide the kind of space that the Museum needs in order to better present the collection, revealing more nuanced relationships between mediums and historical moments? Will the program be able to generate the kind of support required to sustain operations? And will the Museum continue to be able to raise the substantial sums of money necessary to expand the collection and present major exhibitions?

What is clear, though, is that since the late 1970s, if not before, the Trustees of The Museum of Modern Art have accepted the challenge of contemporary art. Recent initiatives have included the merger of the Museum with P.S. 1, the internationally recognized contemporary-art center in Long Island City, thus extending and enhancing exhibition possibilities for the Museum (the results of which have already included exhibitions like *Greater New York*, in 2000, and the Young Architects Program that uses P.S. 1's courtyard for an annual juried summer installation by architects early in their careers); the establishment of the Fund for the Twenty-first Century (which provides acquisition support for the purchase of contemporary art); the creation of an interdepartmental curatorial committee on contemporary art; and above all the allocation of over 15,000 square feet of space in the new Museum to the display of its extensive collection of contemporary art. These galleries, located on the second floor of Taniguchi's gallery complex, named in honor of David and Peggy Rockefeller, are designed to highlight the Museum's commitment to contemporary art by establishing it as the window through which all of the collection is to be viewed. The privileging of the present over the past is intended to define the Museum as first and foremost a place of experimentation, a place where the contemporary becomes the catalyst for an engagement with the rich history of modern art.

As the Museum looks toward the future, then, it does so based on the achievements of several generations of remarkable directors, curators, and other staff, and in the recognition of the extraordinary contributions its Trustees have made to its well-being. The Museum does so as well in the knowledge that its new home will provide yet another opportunity to explore through its collection and exhibition program the richness and complexity of modern art. It will take courage and conviction to continue this process and to avoid the satisfaction of accomplishment, which can lead all too quickly to self-congratulation and complacency. Like all great endeavors, though, the ability to carry on this task resides in the singular leadership of the Museum's Trustees, in particular the dedication, wisdom, and commitment of the Museum's Chairman, Ronald S. Lauder, its President, Robert B. Menschel, and its President Emerita, Agnes Gund; and above all its Chairman Emeritus, David Rockefeller, whose drive, energy, and belief in the Museum's future are a gift to us all.

— **GLENN D. LOWRY**
DIRECTOR

INTRODUCTION

BY HARRIET S. BEE AND MICHELLE ELLIGOTT

In 1929 the Museum was an idea. Today it is a reality of international proportions, and needs no introduction. Widely acknowledged as the foremost museum of modern and contemporary art in the world, The Museum of Modern Art is unique in several respects among the many museums that have proliferated since its founding. It possesses an unequaled, comprehensive collection of the art of our time; it is esteemed for both its collection and its vigorous program of exhibitions; it collects and exhibits in one place the principal visual arts of the modern tradition; and it is a private educational institution whose initiatives effect a lively dialogue with the public and the culture at large. The Museum was initiated as a venue for loan exhibitions of contemporary painting and drawing, and particularly to enable young American and European artists to exhibit their work during their lifetimes. Yet, the plan for a multidepartmental museum existed at the outset in the mind of its young founding Director, Alfred H. Barr, Jr., and The Museum of Modern Art became the first to recognize photography, cinema, architecture, and industrial design as departments that belonged in an art museum.

Art in Our Time chronicles the story of the Museum from its opening, ten days after the stock market crash of 1929, in a few rented rooms in a midtown Manhattan office building, up to the present day, in its new building on Fifty-third and Fifty-fourth streets. The book presents a pictorial and documentary review of each year, and each important period, in the Museum's history. This overview of highlights in the Museum's evolution looks at its events, exhibitions, collectors, works of art, artists, powerbrokers, buildings, sculpture garden, and programs over the years, including the founding of each curatorial department, major acquisitions, pivotal exhibitions, Trustees and donors, key staff, educational programming, publications, and social activities. It tells the story of how the Museum began, as a small set of art galleries inaugurated by three ladies of means who had a passion for modern art. Through a selection of photographs, official documents, letters, quotations, newspaper clippings, cartoons, and other ephemera, the complex and multilayered history of the Museum unfolds in a visual march through time, revealing the extraordinary vision of a determined group of individuals who

had the ability and courage to translate their idea into reality. It is a history made up of diverse elements that ultimately developed into one of the most illustrious cultural institutions of our time.

The title *Art in Our Time: A Chronicle of The Museum of Modern Art* suggests both the intentions of the book and its limitations. *Art in Our Time* was the title of the Museum's tenth-anniversary exhibition, the first substantial milestone in the institution's history. That exhibition included works in all the mediums the Museum collected: "painting, sculpture, architecture, graphic art, popular or folk art, industrial design, commercial art, photography and moving pictures." The exhibition and its title emphasized the Museum's interest in the arts of "today," a focus the Museum has maintained into the twenty-first century. The book's subtitle, *A Chronicle of The Museum of Modern Art,* however, acknowledges that although the volume traces the Museum's activity over seventy-five years, it should be taken as neither a definitive nor a complete history of the institution.

It would of course be impossible to record every person, activity, or occasion that created The Museum of Modern Art. Representative entries on events and individuals have been enlisted to stand in for a great many others. For instance, the Museum has organized thousands of exhibitions to date, and this volume covers only a fraction of them, in brief reports emphasizing variety as well as historical importance. As for the people represented, it has been impossible to feature all of those who have made significant contributions to the history of the Museum, among whom are artists, administrators, researchers, secretaries, receptionists, curatorial staff, archivists, librarians, educators, technicians, editors, designers, development and financial staff, press liaisons, security guards, carpenters, preparators, building custodians, and many others. Another reason for omission lies in the lack of documentation of some events or subjects. For some parts of the Museum history, appropriate documents are unusable for various reasons such as copyright restrictions or prohibitive cost. Furthermore, even if it were possible to represent all of the Museum's important events through existing documents, the constraints placed on the size of a publication such as this would preclude the inclusion of all such materials. Even given these limitations, however, it has been possible to construct a lively and interesting narrative about the institution through its own documents and photographic records, a narrative that conveys the spirit and ethos, as well as the substance, that have defined the essence of the Museum: its invitation to the public to see the best in the arts of our own time.

The book begins with a brief Prologue suggesting the dearth of activity in modern art in New York (as compared with Paris and other European cities) before the late 1920s, and underlining the need for a museum for contemporary art. Then the story of the Museum gradually unfolds in seven chronological sections that present the key people and events that made the Museum what it is today. The First Ten Years (1929–1939) presents the founding of the Museum as an educational institution, shows its first galleries and exhibitions, traces the development of its mission and the creation of the permanent collection, and marks the inauguration of new curatorial departments as well as the Museum's Goodwin–Stone Building and first sculpture garden. Road to Victory (1940–1953) highlights the Museum's involvement with the war effort, the inauguration of The Abby Aldrich Rockefeller Sculpture Garden, and the creation of new programs, such as The Junior Council and The International Program. Masters of Modern Art (1954–1964) focuses on major exhibitions devoted to Pablo Picasso and the Americans series, a fire at the Museum, and the expansion designed by Philip Johnson. Word and Image (1965–1972) deals with new and changing trends in American art in the politically turbulent 1960s, and with changes in Museum leadership. Transformations (1973–1984) covers the formation of the video program, the Picasso retrospective, and the major expansion of the Garden Hall, tower, and the West Wing designed by Cesar Pelli. Allegories of Modernism (1985–1994) showcases major photography, architecture, and painting exhibitions. And Modern Contemporary (1995–2004) chronicles the past ten years, major exhibitions such as the Jackson Pollock retrospective, *MoMA 2000*, and *Matisse Picasso*, the temporary exhibition facility MoMA QNS, and the new building in Manhattan designed by Yoshio Taniguchi.

During the course of the research for this volume, the editors came upon a page of committee minutes from 1946 recording a proposal by Mr. Barr that the Museum produce a volume on the 1913 Armory Show, an important precursor and influential inspiration for the formation of a modern art museum in the United States. Barr apparently believed that the best way to portray the spirit behind this exhibition was to utilize only primary sources from the time of the event itself. That is, he thought it would be more effective to document what the event represented at the time it occurred, what was said and how it was received, rather than to write an essay on the exhibition with the advantage of hindsight. His proposal for the publication recommends "that such a book be based on documents and memoirs with reprints of two or three first-hand accounts as an introduction, many reproductions of typical

works considered important at the time, installation photographs, photographs of the crowds, significant commentaries, wise-cracks, cartoons, caricatures, posters—all assembled as a series of documents without too much verbiage of 1946." In very much the same spirit, and not without feeling gratified to have Mr. Barr's approval of the concept for this book, the editors present here the firsthand heritage of the Museum, principally via the Museum Archives, for the reader to see and understand what the institution actually was, rather than how it has been subsequently interpreted.

The publication of this volume on the Museum's seventy-fifth anniversary also celebrates the opening of the Museum's new building between West Fifty-third and Fifty-fourth streets in Manhattan. It is intended as a multifaceted celebration of the Museum's legacy of achievement and as a tribute to the individuals whose persistent devotion to the cause of modern art led to the institution we know today as MoMA, as well as to many others who contributed to the maintenance of that legacy of excellence. It is hoped that this compilation of documents brings to life the extraordinary ideas and passions, the respect and love of art, and the dedication of talented individuals that made the Museum a reality. It is a story full of plots and subplots, of the unfolding of a singular vision of a multidepartmental museum and its realization in bold acquisitions, of boundless generosity among an extraordinary set of Trustees, of groundbreaking exhibitions, and of the inexorable phases of physical growth as the programs expanded, up to the present with the Museum's new building by the distinguished Japanese architect Yoshio Taniguchi, which provides the seventy-five-year-old Museum of Modern Art with a brilliant vision for the future. ■

ART IN OUR TIME

——PROLOGUE

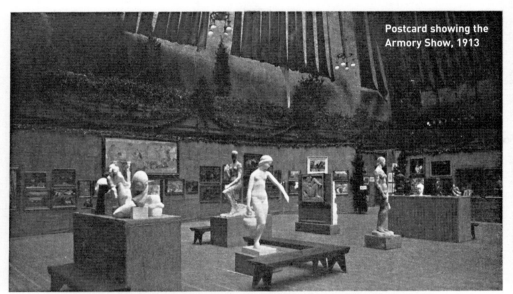

View of Foreign Exhibit; International Exhibition, New York, 1913

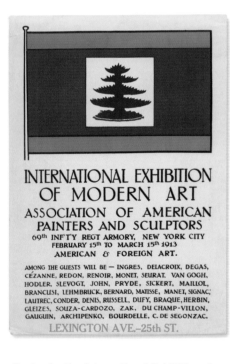

Poster for the _International Exhibition of Modern Art_, known as the Armory Show, 1913

In a sense, the epoch-making Armory Show was the real beginning of the Museum; everyone thought and hoped that the exhibition of over a thousand paintings and sculpture held in a New York Armory would be the beginning of a permanent institution. But, possibly because of the war in Europe, possibly because New York was not ready, no such institution developed. Two other forerunners of the Museum in New York were the Société Anonyme, organized by Katherine Dreier, assisted by Wassily Kandinsky, and Marcel Duchamp; (the Société actually used as its sub-title, "The Museum of Modern Art" later adding the sub-title "1920.") The Gallery of Living Art in the Washington Square branch of New York University started by Albert Gallatin, a collector, about 1925 was also valuable though quite limited. We should not forget Alfred Stieglitz's gallery, half commercial, half institutional, which showed Matisse, Cézanne, Picasso even before the Armory Show.

Alfred H. Barr, Jr., Founding Director, 1949

No 252.

To my dear friend Lilly Bliss.
& although she does not agree with me about
art. I love her still. "The modernists,
as they are called for want of a better term.
(I mean the Cubists &c) – wander after cur-
-iosities of technique, vaguely hoping
they may light on some invention which
will make them famous. They do not
belong to art, they are not artists; they
are inventors of processes of the arts"–

Louis C. Tiffany

Feb. 24ᵗʰ '16

Inscription to Lillie P. Bliss, a founder of The Museum of Modern Art in 1929, from the noted designer and academician Louis Comfort Tiffany, 1916

We are not so far apart as you seem to think in our ideas on art for I yield to no one in my love, reverence and admiration for the beautiful things which have already been created in painting, sculpture and music. . . . The truth is you older men seem intolerant and supercilious, a state of mind incomprehensible to a philosopher who looks on and enjoys watching for *and finding* the new men in music, painting and literature who have something to say worth saying and claim for themselves only the freedom to express it in their own way, a claim which you have always maintained as your inalienable right.
Lillie P. Bliss, Undated Letter to an Academician

1929–1939: THE FIRST TEN YEARS

— 1929

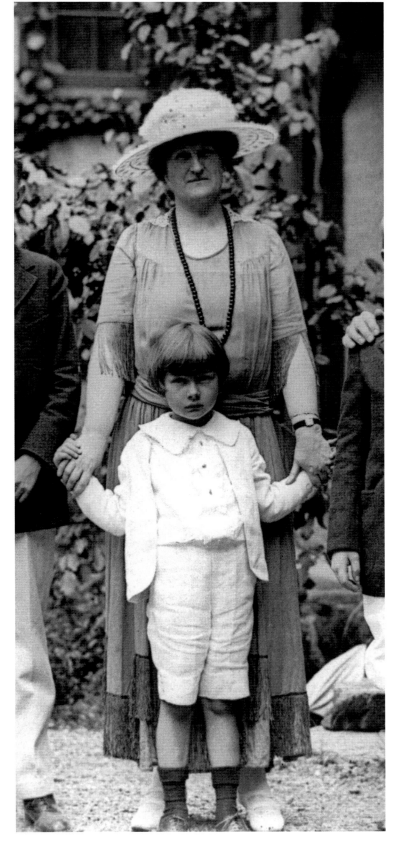

Abby Aldrich Rockefeller, a founder of the Museum, and her youngest son, David Rockefeller, now Chairman Emeritus of the Museum, 1921

Frequently at the house when I would come back from school . . . they would be there, and I would listen to conversations going on about the Museum. So I was very conscious about Mother's interest in it and the people who were identified with her. . . . I think that they felt that contemporary art was not generally appreciated, not understood. I'm sure that the Armory show *did* have an impact in that it created a great stir and controversy, but in a way there was no way that it could be followed up on because there was no museum where people could see on an ongoing basis the things that were shown in that show. So in that sense I think undoubtedly it was an important source in persuading the three ladies and others who were also involved to move forward with the Museum. They felt that artists with different points of view and trying to be creative in different ways than had been the case in the past should be given a chance.

David Rockefeller, 1991

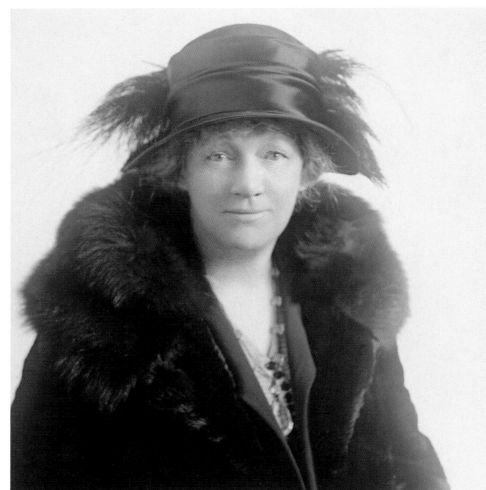

She was an advocate for modern art when it had few admirers, a patron when it had almost no market; finally through her keen intelligence, valiant championing of young artists, and her personal experience with their work, she became not only an important collector but one of the best judges of contemporary painting in this country. To gather that which has stood the test of time takes skill and taste, but to select wisely from the vast amount of unweeded material produced by contemporary artists, requires taste, courage, and insight that amount to almost a gift of prophesy.

Eleanor Robson Belmont, Actress and Opera Patron

Lillie P. Bliss, c. 1924

Miss Bliss's collection in the "music room" of her triplex apartment on Park Avenue, c. 1929

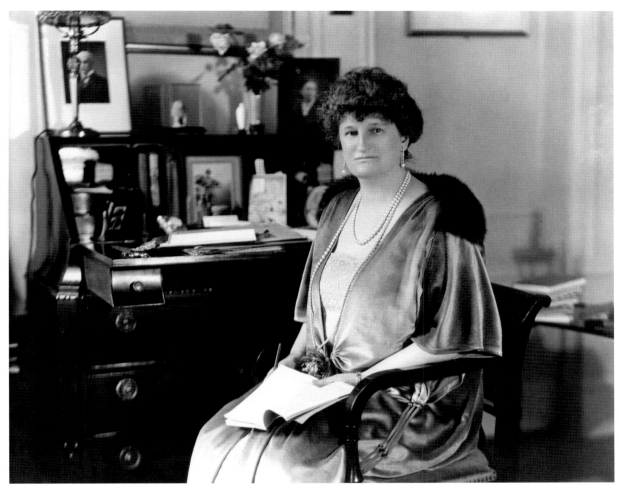

Abby Aldrich Rockefeller (Mrs. John D. Rockefeller, Jr.), 1922

During the spring a small group of New York people got together and took a first step toward a museum of modern art in New York. . . . My husband is not at all interested in modern painting so that I have to go into it myself in a very modest way. . . . I would be very glad if you would give me the names of some of the younger French painters who have not arrived yet, but who you think have great ability. In this Museum we are eager to show the pictures of the younger men.

Abby Aldrich Rockefeller

Mrs. Rockefeller's collection in her townhouse on West Fifty-fourth Street, 1936

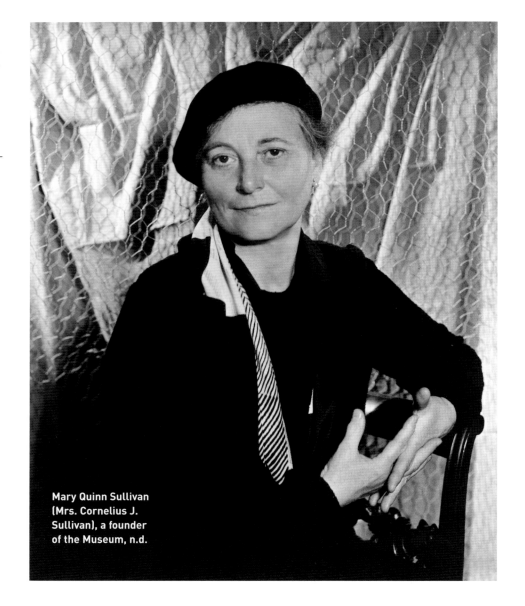

It was the perfect combination . . . [they] had the resources, the tact, and the knowledge. . . . More to the point, they had the courage to advocate the cause of the modern movement in the face of wide spread division, ignorance, and a dark suspicion that the whole business was some sort of Bolshevik plot.

Nelson A. Rockefeller

Detail of a page from the Museum guest book, 1929, showing the signatures of four founders, Mary Sullivan, Lillie Bliss, Josephine B. Crane, and Abby A. Rockefeller

Abby had met Mary Quinn Sullivan when both were interested in psychotherapy for the returning soldiers of World War I. They became friends because of their interest in art. Mary was an amateur artist, art teacher, and social dealer, married to a successful lawyer, Cornelius Sullivan, who was a collector of rare books and paintings.

Bernice Kert, Biographer, 1993

Mary Quinn Sullivan (Mrs. Cornelius J. Sullivan), a founder of the Museum, n.d.

In the latter part of May, I received an invitation to lunch with Mrs. Rockefeller. I was mystified but I accepted. On the appointed day I found Miss Bliss and Mrs. Sullivan as the only other guests. I had never met any of the three women before. There was some discussion of the possibility of organizing a modern museum, but I still did not understand what it was all about until halfway through luncheon, Mrs. Rockefeller asked the two ladies if they felt she should put to me the question they had in mind. They both answered in the affirmative, and I was told that it was proposed that I should be chairman of a committee of organization for . . . carrying out . . . the general ideas that had been outlined. . . . On accepting the chairmanship, I suggested as three other members of the committee Frank Crowninshield, Mrs. W. Murray Crane and Paul J. Sachs. They all agreed to serve.

A. Conger Goodyear, 1943

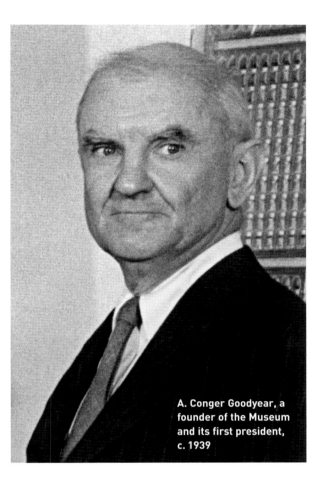

A. Conger Goodyear, a founder of the Museum and its first president, c. 1939

Frank Crowninshield, a founder of the Museum and the editor of *Vanity Fair*, n.d.

[Paul J. Sachs] was in the family of Goldman Sachs and he was a businessman and a wealthy man who had a great interest in art as well, I remember him as being somewhat abrupt, rather businesslike, but Mother liked him and respected him very much, and I think he was very helpful to Mother in giving her guidance on some of her collecting. And certainly I think nothing could have been more important for the Museum than bringing on Alfred Barr, who turned out to be the most creative force in the founding of the Museum.

David Rockefeller, 1991

Josephine Boardman Crane (Mrs. W. Murray Crane), a founder of the Museum, n.d.

Paul J. Sachs, a founder of the Museum, n.d. Asked by Mr. Goodyear to suggest a director for the new museum, Professor Sachs proposed a former student, twenty-seven-year-old Alfred H. Barr, Jr., who taught the only course in modern art in the country, at Wellesley College in Massachusetts.

THE MUSEUM OF MODERN ART
730 FIFTH AVENUE
NEW YORK

ALFRED H. BARR, Jr.
DIRECTOR

Mr. Barr's first business card as Director

Alfred H. Barr, Jr., founding Director of the Museum, 1929

Alfred Barr was not a convivial type. He was not a person who had crowds around him or chatted in symposia of an evening, over Scotch or anything else. His relationships were one-to-one. . . . The attribute that made him great [was] his awesome strength of character. There are three aspects of his character that made it what it was. The first was his unbridled passion, a torrential passion that I have never known anyone else in my lifetime to have had. The second was his stubbornness, his obdurate, bulldog tenacity. The third was his unbelievable, fierce and flaming loyalty to this institution and to his friends.

Now he had a passion that was very narrow, very clear in his own mind. It went to the learning and the diversifying and the spreading of modern art. . . . Art was his master/mistress, and . . . it was his gift of being able to mix the knowledge of what he was talking about with the enthusiasm of telling you what it was all about that made it so incredible. . . . He had a way of showing what the artist intended as nobody else could. No scholarly books you could read would help you understand that art, but Alfred was able to do the impossible—translate artists' intent into beautiful English words. . . . And with that gift, he persuaded an entire generation . . . about modern art. . . . It was all due to Alfred Barr.
Philip Johnson, Trustee, 1981

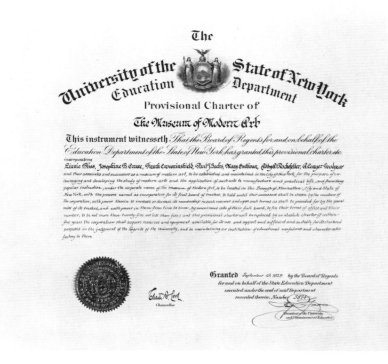

This instrument witnesseth That the Board of Regents for and on behalf of the Education Department of the State of New York has granted this provisional charter etc. incorporating Lizzie Bliss, Josephine B. Crane, Frank Crowninshield, Paul J. Sachs, Mary Sullivan, Abby A. Rockefeller, A. Conger Goodyear and their associates and successors as a museum of modern art, to be established and maintained in the City of New York for the purpose of encouraging and developing the study of modern arts and the application of such arts to manufacture and practical life, and furnishing popular instruction, under the corporate name of The Museum of Modern Art. . . .

Provisional Charter of The Museum of Modern Art, 1929

■ FIRST GALLERIES

It is perfectly located . . . in a well-known landmark and the rent is very low— a little over $2.50 a foot in comparison with $3.50 and $4 in nearby buildings.
Alfred H. Barr, Jr.

Postcard showing the Heckscher Building, now the Crown Building, at Fifth Avenue and Fifty-seventh Street, in a view from Fifth Avenue and Sixtieth Street that includes the Plaza Hotel on the right and a series of buildings in front of the Heckscher Building now occupied by the Bergdorf Goodman department store. The Museum's first galleries and offices were on the twelfth floor of the Heckscher Building.

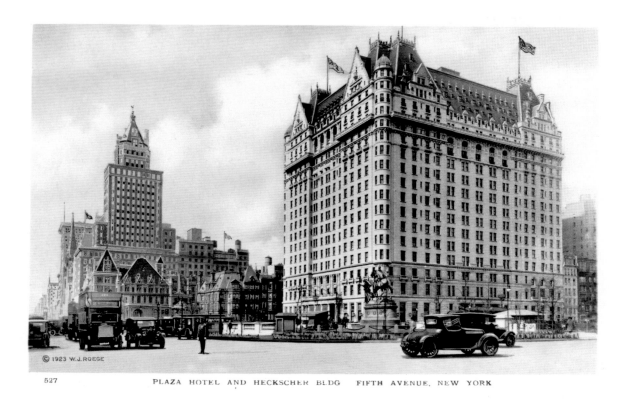

527 PLAZA HOTEL AND HECKSCHER BLDG FIFTH AVENUE, NEW YORK

THE · MUSEUM · OF · MODERN · ART
A New Institution for New York

For many years there has been a constantly recurring criticism of the great art galleries and museums of the world—they concentrate too much attention on the art of yesterday and too little on that of today. This criticism, in most instances, is based on a misapprehension of the functions of existing museums of art.

Experience has shown that the best way of giving to modern art a fair presentation is to establish a gallery frankly devoted to the works of artists who most truly reflect the taste, feeling and tendencies of the day. The Tate Gallery in London and the Luxembourg in Paris are probably the best known institutions of this specialized character.

In recent years there has been a remarkable increase of interest in modern art the world over. Nowhere has this interest been more manifest than in New York. But New York alone, among the great capitals of the world, lacks a public gallery where the works of the founders and masters of the modern schools can be seen.

It is to provide such an institution that the undersigned propose to organize, in New York, THE MUSEUM OF MODERN ART. Our immediate purpose is to hold a series of exhibitions during the next two years which shall include as complete a representation as may be possible of the great modern masters — American and European—from Cézanne to the present day. With the cooperation of artists, owners and dealers (which can safely be counted on) we believe that there can be obtained—for our exhibitions—paintings, sculptures, drawings and lithographs, of the very first order.

Our ultimate purpose is to establish a permanent public museum in this city which will acquire, from time to time, (either by gift or by purchase) collections of the best modern works of art. The possibilities of such an institution are so varied and so great that it seems unwise now to lay down too definite a program for it beyond our present one of a series of frequently recurring exhibitions during a period of at least two years.

For these two years a fund of $100,000.00 annually will be needed. To provide this we solicit the support of those who are interested in the progress of art. For the present we have established three classes of members:

1. PATRONS
—*subscribing $5,000.00 or more annually, for two years' time.*

2. CONTRIBUTING MEMBERS
—*subscribing $1,000.00 to $4,000.00 annually, for two years' time.*

3. SUSTAINING MEMBERS
—*subscribing $250.00 to $750.00 annually, for two years' time.*

We hope to receive, not only your financial support, but your cooperation in suggesting others who might be interested in such an enterprise.

One of the enclosed forms may be used for your subscription.

MISS LZIZIE BLISS
MRS. W. MURRAY CRANE
MR. FRANK CROWNINSHIELD
PROFESSOR PAUL J. SACHS
MRS. CORNELIUS J. SULLIVAN
MRS. JOHN D. ROCKEFELLER, JR. *Treasurer*
10 West 54th Street, New York City
MR. A. CONGER GOODYEAR, *Chairman*

Membership solicitation signed by the seven founding Trustees, 1929

Summer 1929

contains 2 indirect
references to "multidepart-
ment plan" — all that I

The Museum of Modern Art

could get away with at that time

THE immediate purpose of the Museum of Modern Art is to hold, in its gallery at the Heckscher Building, 730 Fifth Avenue, New York, some twenty exhibitions during the next two and a half years.

These exhibitions will include as complete a representation as possible of the great modern painters—American and European—from Cézanne to the present day, but will be devoted primarily to living artists, with occasional homage to the masters of the Nineteenth Century.

With the co-operation of artists, collectors and dealers, the Trustees of the Museum hope to obtain for these twenty exhibitions, paintings, sculptures, drawings, lithographs and etchings of the first order.

The ultimate purpose of the Museum will be to acquire, from time to time, (either by gift or by purchase) a collection of the best modern works of art. The possibilities of The Museum of Modern Art are so varied that it has seemed unwise to the organizers to lay down too definite a program for it beyond the present one of a series of frequently recurring exhibitions during a period of two and a half years.

1.

ALL over the world the increasing interest in modern movements in art has found expression, not only in private collections but also in the formation of public galleries created for the specific purpose of exhibiting permanent as well as temporary collections of modern art.

Nowhere has this tide of interest been more manifest than in New York. But New York alone, among the great capitals of the world, lacks a public gallery where the works of the founders and masters of the modern schools can today be seen. That the American metropolis has no such gallery is an extraordinary anomaly.

The municipal museums of Oslo, Halle, Halsingfors, Frankfurt, Utrecht, Lyons, Prague, Geneva, Cleveland, Chicago, Buffalo, Detroit, Providence, Worcester and a score of other cities provide students, amateurs and

This is 2nd edition and may be as late as Nov. '29. First edition is on buff paper A.H.B.

the interested public with more adequate permanent exhibits of modern art than do the similar institutions of our vast and conspicuously modern metropolis.

In these museums it is possible to gain some idea of the progressive phases of European painting and sculpture during the past fifty years. But far more important than these smaller exhibitions are the modern public collections in the great world-cities — London, Paris, Berlin, Munich, Moscow, Tokio, Amsterdam. It is to them that New York may look for suggestion, for they have each solved the problem with which New York is confronted. And this problem is as delicate as it is difficult.

IN the past few years New York's great museum—the Metropolitan—has sometimes been criticized because it did not add the works of the leading "modernists" to its collections. Nevertheless the Metropolitan's policy is reasonable and, probably, wise. The Metropolitan, as a great museum, may justly take the stand that it wishes to acquire only those works of art which seem certainly and permanently valuable. It can well afford to wait until the present shall become the past, until time, that nearly infallible critic, shall have eliminated the probability of error. But the public interested in modern art does not wish to wait. Nor can it depend upon the occasional generosity of collectors and dealers to give it more than a haphazard view of what has developed, in art, during the past fifty years.

Experience has shown that the best way of giving to modern art a fair presentation is to establish a gallery devoted frankly to the works of artists who most truly reflect the taste, feeling and tendencies of the day. The Louvre, the National Gallery of England and the Kaiser Friedrich Museum, to mention only three national museums, follow a policy similar to that of our Metropolitan. But they are comparatively free of criticism because there are in Paris, London and Berlin—in addition to and distinct from these great historical collections—museums devoted entirely to the exhibition of modern art. There can be no rivalry between these institutions because they *supplement* each other and are at times in close co-operation.

The Museum of Modern Art will in no way conflict with the Metropolitan Museum

The Museum's first brochure, with handwritten annotations by Alfred H. Barr, Jr., 1929

In preparing a draft for the brochure, the Director proposed: "In time the Museum would probably expand beyond the narrow limits of painting and sculpture in order to include departments devoted to drawings, prints, and photography, typography, the arts of design in commerce and industry, architecture (a collection of *projets* and *maquettes*), stage designing, furniture and the decorative arts. Not the least important collection might be the *filmotek,* a library of films". . . . The above ambitious prospectus was cautiously edited by the Trustees to read: "In time the Museum would expand . . . to include other phases of modern art."

Alfred H. Barr, Jr., 1967

of Art but will seek rather to supplement the older institution. The younger Museum will have many functions. First of all it will attempt ultimately to establish a very fine collection of the immediate ancestors, American and European, of the modern movement; artists whose paintings are still too controversial for universal acceptance. This collection will be formed by gifts, bequests, purchase and perhaps by semi-permanent loans.

T HE Museum galleries will display carefully chosen permanent collections of the most important *living* masters, especially those of France and the United States, though there will eventually be representative groups from England, Germany, Italy, Mexico and other countries. Through such collections American students, artists and the more general public can gain a consistent idea of what is going on in America and the rest of the world—an important step in contemporary art education. Likewise, and this is also important, visiting foreigners can be shown a collection which would fairly represent *our own* accomplishment in art. This is quite impossible at the present time.

In time the Museum will expand beyond the limits of painting and sculpture in order to include departments devoted to drawings, prints and other phases of modern art. In addition to the Museum's permanent collections, space will be set aside for great and, it is hoped, constantly recurring loan exhibitions, both national and international.

But even the beginnings of such a museum are not created overnight. A suitable building, a trained staff, as well as notable collections, will eventually be needed—and none of these can be had immediately. The present galleries will house as many as six or seven major and perhaps a dozen minor exhibitions during each year.

T HE choice of artists for the first exhibition has been no easy matter. After careful consideration it was decided to open the galleries (on November 8th, 1929) with ninety-eight works by Cézanne, Gauguin, Seurat and Van Gogh. Although these masters were all European they are, none the less, more the ancestors of modern American painting than any four American painters of the past century. They are, indeed, the strong pillars upon which are builded the painting of the early twentieth century, the world over.

Other exhibits at the Museum will include:
Paintings by distinguished contemporary American masters.

Canvases by the outstanding French painters of today.

Paintings by American masters of the past fifty years—Ryder, Winslow Homer, Eakins.

Works by American, French and German sculptors.

A retrospective exhibit of the works of Honoré Daumier.

A survey of Modern Mexican Art.

It is not unreasonable to suppose that, within ten years, New York, with its vast wealth, its already magnificent private collections and its enthusiastic but not yet organized interest in contemporary art, may achieve one of the greatest museums of modern art in the world.

For all of the Museum's exhibitions the co-operation of other museums, private collectors, and dealers is warmly invited.

The Trustees of the Museum of Modern Art are: A. Conger Goodyear, President; Miss Lizzie Bliss, Vice-President; Mrs. John D. Rockefeller, Jr., Treasurer; Frank Crowninshield, Secretary; William T. Aldrich, Frederic Clay Bartlett, Stephen C. Clark, Mrs. W. Murray Crane, Chester Dale, Samuel A. Lewisohn, Duncan Phillips, Mrs. Rainey Rogers, Paul J. Sachs, and Mrs. Cornelius J. Sullivan.

Note on Our Temporary Galleries

The floor space over all is about 4,430 square feet of which nearly 3,800 square feet are devoted to the galleries. There are about 470 linear (running) feet of wall surface for exhibition purposes divided into one large gallery, a middle sized gallery and two small galleries. A small reading room opens off the large gallery.

The partitions are built of plaster-coated gypsum block, covered with friar's cloth.

The galleries were planned from designs generously contributed by Mr. Harrie T. Lindeberg.

The youngest of New York's art museums has just made its bow to the public. The Museum of Modern Art, the creation of a group of prominent collectors and amateurs, has opened its doors in the Heckscher Building on Fifth Avenue at Fifty-seventh Street. Just as the great Armory Show of 1913 was the opening gun in the long, bitter struggle for modern art in this country, so the foundation of the new museum marks the final apotheosis of modernism and its acceptance by respectable society. . . . Thus, through private initiative, New York has taken a step that was taken long ago by other great cities of the world. . . . Even if the museum were never to acquire a single work for its permanent collection—which of course will be its most important duty—the mere act of holding loan exhibitions of masterpieces from our extraordinarily rich private collections would be sufficient justification for its existence.
Lloyd Goodrich, Art Historian

The catalogue for the Museum's first exhibition, *Cézanne, Gauguin, Seurat, van Gogh*, by Alfred H. Barr, Jr., 1929

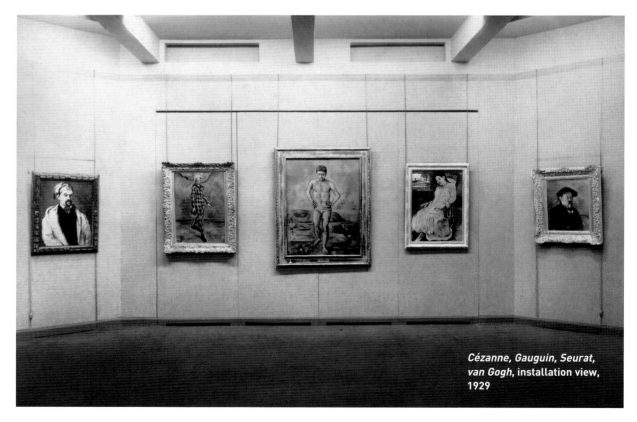

Cézanne, Gauguin, Seurat, van Gogh, installation view, 1929

≡ FIRST EXHIBITION

The walls are faced with monk's cloth of a neutral though warm beige. The pictures are hung much lower than in any museum or commercial gallery, approximately fifty inches from the floor to the center of the picture. The paintings are not hung according to the strict laws of symmetry. . . . Sometimes the pictures are hung in groupings for reasons of affinity or contrast, not unlike stamps in a stamp album. The impression of the galleries is of something new. On the floor there are pale gray rugs and a couch or two in the main gallery. Admission is free. The public comes and goes by elevator. . . . In less than two years the Heckscher Building will no longer be able to handle the traffic.

Margaret Scolari Barr (Mrs. Alfred H. Barr, Jr.), 1987

Museum attendance ledger for the first exhibition, showing a total of 47,293 visitors in one month, November 7–December 7, 1929

≡ FIRST ACQUISITIONS

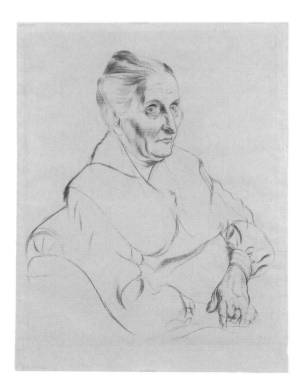

Max Pechstein, *Dialogue*, 1920. Woodcut, one of nine acquisitions given to the Museum by Paul J. Sachs in 1929

George Grosz, *Anna Peter*, 1926–27. Pencil drawing, a gift of Paul J. Sachs in 1929

◾ FIRST PAINTING ACQUIRED

1930

Dear Mr. Goodyear: I am wondering whether the Museum would care to add to its collection *The House by the Railroad Track* by Hopper . . . If so I should be glad to present . . . it. . . . My principal reason for making this offer is the feeling that it is highly desirable for the Museum to start a collection which, in the beginning at any rate, will be predominantly American.

Stephen C. Clark, Trustee

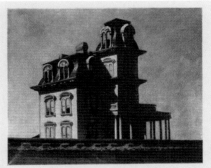

Detail of a page from *The Bulletin of The Museum of Modern Art*, showing the first major painting acquired by the Museum, Edward Hopper's *House by the Railroad*, 1925

◾ JUNIOR ADVISORY COMMITTEE

The matter of Junior Trustees—to be called an Advisory Committee—was discussed. It was suggested that the Junior Trustees should be a group of young people interested in the Museum from which possible future Trustees should be drawn.

Trustee Minutes

Three early members of the Junior Advisory Committee. Left to right: Elizabeth Bliss, Lincoln Kirstein, and Nelson A. Rockefeller

The Junior Advisory Committee, composed chiefly of young collectors, was organized. George Howe served briefly as Chairman, followed by Nelson A. Rockefeller. . . . The executive Committee [also] included Philip Johnson, Lincoln Kirstein, Mrs. Percy D. Morgan, Jr., Mrs. James B. Murphy, James Johnson Sweeney, and Edward M. M. Warburg. Among the other members were Miss Elizabeth Bliss . . . John Nicholas Brown, Miss Ethel L. Haven. Mrs. Charles S. Payson, Mrs. Charles H. Russell, Mrs. Howard J. Sachs, and John Walker III.

Alfred H. Barr, Jr., 1967

■ DEATH OF LILLIE P. BLISS

— 1931

March 12: Miss Lillie P. Bliss, Vice President and a founder, died and, with certain conditions, bequeathed to the Museum the major part of her collection. It was recognized immediately as being of the greatest importance to the Museum. In an editorial in *The Arts* . . . Forbes Watson wrote: "The bequest is a nucleus round which to build: a magnet for other collections; a continuing living reply to the doubters; a passing on of the torch; a goodly heritage. It begins the transition of the Museum from a temporary place of exhibitions to a permanent place of lasting activities and of acquisitions."

Cézannes dominated the Bliss Collection; there were eleven oils— including *The Bather, Man in a Blue Cap, Oranges, Pines and Rocks,* and *Still Life with Apples*—and eleven watercolors. Other works of exceptional value to the Museum were Gauguin's *The Moon and the Earth (Hina Te Fatou),* Matisse's *Interior with a Violin Case,* Modigliani's *Anna Zborowska,* Picasso's *Green Still Life* (1914) and *Woman in White,* Redon's *Roger and Angelica* and *Silence,* and Seurat's *Port-en-Bessin, Entrance to the Harbor* and eight drawings. Other painters represented were Daumier, Davies, Degas, Derain, Kuhn, Pissarro, Renoir, Henri Rousseau, and Segonzac.
Alfred H. Barr, Jr., 1967

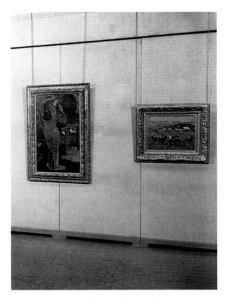

Memorial Exhibition: The Collection of the Late Lillie P. Bliss, **installation view, 1931**

Letter from Abby Aldrich Rockefeller to Cornelius N. Bliss on the death of his sister Lillie P. Bliss, 1931

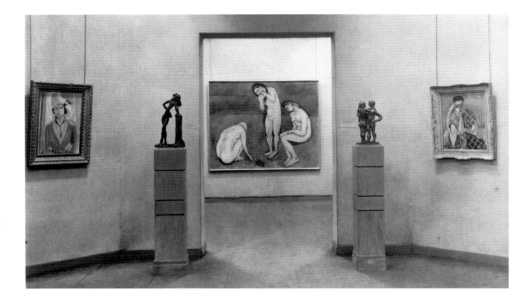

The Museum's first one-man exhibition, *Henri Matisse*, installation view, 1931

Letter to Alfred H. Barr, Jr., from Henri Matisse thanking him for his exhibition, 1931

Dear Mr. Barr: I just received the photographs of the exhibition at the Modern Museum you were kind enough to send me. They convey the idea of a perfect installation. Which is exactly what my son already wrote me. The catalogue is also very good, but I have not yet received mine though my son also said that you had sent me one. I am very touched, dear sir, dear madame, by the great care and conscientiousness that you have taken to present this exhibition in a satisfying manner; it greatly contributed to its success. I hope to have the pleasure of expressing my gratitude to you in each of your personal copies of the catalogue, either when you send them to me or when you give them to me when you come to Paris. Please accept, dear Mr. and Mrs. Barr, my warmest thanks. Yours truly, Henri Matisse.

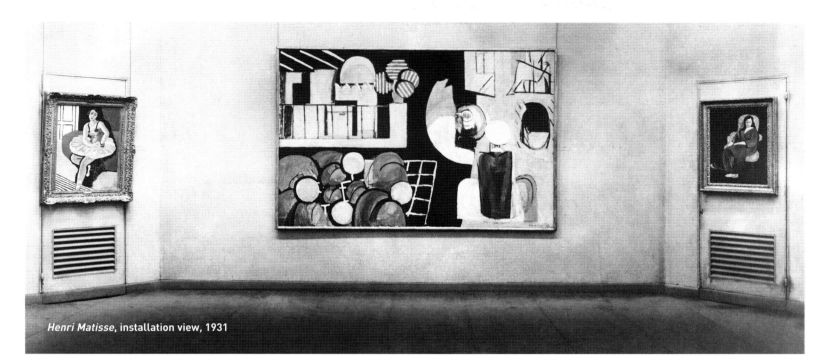

Henri Matisse, installation view, 1931

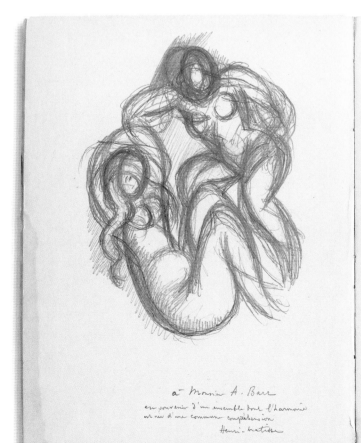

MUSEUM OF MODERN ART

HENRI·MATISSE
RETROSPECTIVE EXHIBITION

NOVEMBER 3 1931 DECEMBER 6
730 FIFTH AVENUE · NEW YORK

Copy of the catalogue *Henri Matisse Retrospective Exhibition*, by Alfred H. Barr, Jr., with a drawing and inscription to Mr. Barr by the artist, 1931

The Museum's first architecture exhibition, *Modern Architecture: International Exhibition*, installation view, 1932. A model of the Bauhaus building in Dessau of 1925–26, by Walter Gropius, is featured. This was the Museum's last exhibition in the Heckscher Building, as well as its first circulating exhibition.

1932

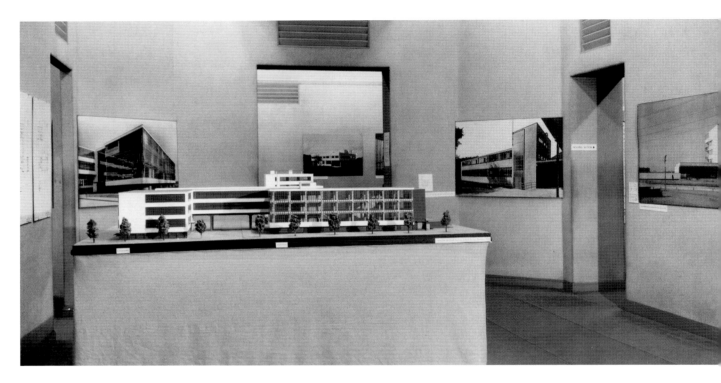

Henry-Russell Hitchcock, co-director, with Philip Johnson, of the exhibition *Modern Architecture: International Exhibition*, 1932 (photograph 1938)

In 1931 the Museum of Modern Art, an institution then only two years old and thus far devoted primarily to the presentation of the work of painters, planned its first architectural exhibition. The director, Alfred Barr, asked Philip Johnson and me to organize this event, which took place the following year. The work of Le Corbusier, Oud, Gropius, Mies van der Rohe and, by contrast, that of Wright occupied the principal place in the exhibition. But there was also work by other Americans, notably Hood, Howe & Lescaze and Neutra, and some forty architects all told, representing building of the day in fifteen countries. Concurrently with the exhibition we prepared *The International Style: Architecture since 1922.* . . . I think we can accept that the International Style was no mere superficial movement . . . for it was concerned with many, if not all, of the essentials of any architecture. . . . At least . . . the book represents an account by young and enthusiastic contemporaries of the new architecture of the twenties at the moment when it had reached its peak of achievement.

Henry-Russell Hitchcock, 1966

A[lfred] and Philip talk fervently about architecture and the design of furniture and industrial objects. It is important to find a name, a tag, for the style exemplified in the work of Le Corbusier, … etc. Finding a term for the movement is constantly at the back of their minds. A[lfred], remembering his art history, says, "Why not International Style?"—the classification under which painters such as Gentile da Fabriano . . . are grouped because they reflect influences from beyond the Alps.
Margaret Scolari Barr, 1987

Alfred H. Barr, Jr., Philip Johnson, and Margaret Scolari Barr in Cortona, Italy, 1932

■ DEPARTMENT OF ARCHITECTURE FOUNDED

The Department of Architecture was founded under the chairmanship of Mr. Philip Johnson, following the Exhibition of Modern Architecture held at the Museum in February and March 1932 and now touring the country. Previously no organization existed for the exhibition of modern architecture. . . . The Department of Architecture has organized two exhibitions. The first is the large Exhibition of Modern Architecture with models, photographs and plans, including the work of about five European and five American architects. After a conspicuously successful exhibition in New York it has been shown at the Philadelphia Museum, the Hartford Museum, and the new gallery of Sears, Roebuck in Chicago. . . . The second is a smaller and less expensive version of the first, substituting photographs for the models themselves but including all other material.
Alfred H. Barr, Jr.

■ MOVE TO TOWNHOUSE

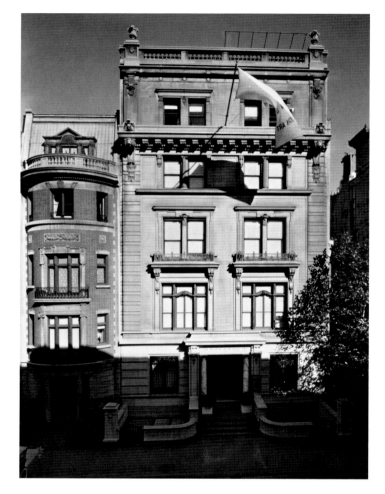

The Museum moved from its headquarters at 730 Fifth Avenue to 11 West 53d Street in May. This change marks the end of the experimental period of the Museum's history and provides facilities for expansion and development of the Museum's work.

With four floors of Exhibition space, it is now possible to keep the Museum open continuously instead of closing it between exhibitions. Opportunity is also given for the presentation of two exhibitions at the same time.
Annual Report

Townhouse at 11 West 53 Street, the second home of The Museum of Modern Art, 1932 (photograph 1937)

■ MURALS BY AMERICAN PAINTERS AND PHOTOGRAPHERS

The first exhibition to show photography as art, *Murals by American Painters and Photographers*, installation view in the townhouse at 11 West 53 Street, 1932

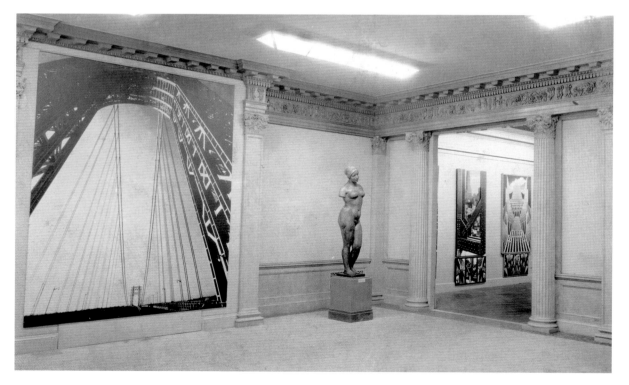

1933

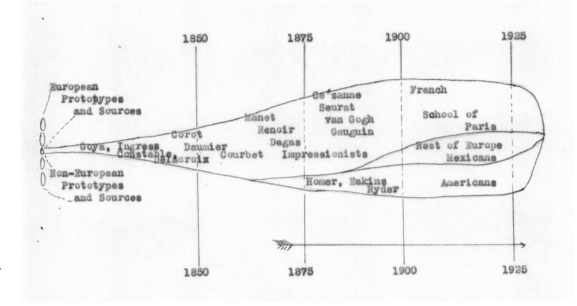

"'Torpedo' Diagram of Ideal Permanent Collection," drawn by Alfred H. Barr, Jr., in 1933, as part of a twenty-two-page report he prepared for the Trustees

Alfred H. Barr, Jr., c. 1929–30

Theory and Contents of an Ideal Permanent Collection

The Permanent Collection may be thought of graphically as a torpedo moving through time, its nose the ever advancing present, its tail the ever receding past of fifty to a hundred years ago. If painting is taken as an example, the bulk of the collection, as indicated in the diagram, will be concentrated at present in the early years of the 20th century, tapering off into the 19th with a propeller representing "Background" collections. . . . Building up a permanent collection should not be left to chance. . . . A plan of campaign, a system of strategy is necessary. This requires the full cooperation of the Trustees and Advisory Committee and much time and thought on the part of the Staff. . . .

The "Provisional Museum Collection"

The Permanent Collection is faced by lack of funds, lack of space, and competition along certain lines from two or three more richly endowed institutions. The Trustees should not be discouraged by these handicaps. An excellent temporary solution for the problem is at hand providing the Museum can depend upon its friends not so much for money but for loans of works of art. The Bliss Collection and the present Permanent Collection together already form a nucleus which if supplemented by loans from private collections would form a representative collection. . . . For at least two months during the winter as well as throughout the summer the 'Provisional Museum Collection' should be expanded to fill the whole building with a magnificent general exhibition of modern art. . . .

It is proposed to *inaugurate* and publicize *this policy* in the *opening exhibition of 1934–35, the fifth anniversary of the opening of the Museum*. . . . Coming on this anniversary such an exhibition would go far to re-establish and confirm the Museum's original purpose of forming a superb Permanent Collection. *If such a policy is not inaugurated the "Museum of Modern Art" may as well change its name to "Exhibition Gallery."*
Alfred H. Barr, Jr.

■ DEPARTMENT OF CIRCULATING EXHIBITIONS FOUNDED

The circulation of exhibitions was one of the few activities of the Museum which was not foreseen in the original plans but grew out of demand. . . . The first of the Museum's traveling shows came into being in 1931, when a circular letter was sent out inviting other institutions to participate in financing the *International Exhibition of Modern Architecture*. . . . It was also in 1931 that the Museum began to circulate through public high schools in New York City a group of 60 color reproductions, *A Brief Survey of Modern Painting*, with comments by Alfred H. Barr, Jr. . . .

Underlying this activity has been the Trustees' desire that the Museum should not be merely a metropolitan center, but that, as the major institution working exclusively in the contemporary, international field, it should have a "missionary" responsibility for promoting an understanding of what it regards as the most vital art being produced in our time.
Museum Bulletin, 1954

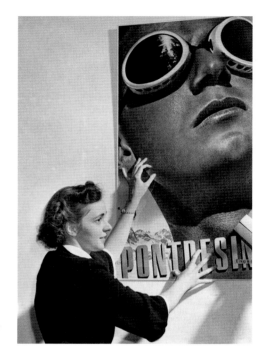

Elodie Courter, the first Director of the Department of Circulating Exhibitions, installing a poster by Herbert Matter in 1941

■ ACQUISITION OF THE LILLIE P. BLISS BEQUEST

1934

The Lillie P. Bliss Bequest is officially deeded to the Museum, March 12, 1934. Left to right: Alfred H. Barr, Jr., Director; A. Conger Goodyear, President; and Cornelius N. Bliss, brother of the late Lillie P. Bliss, 1934. The 1931 bequest had carried the condition that the Museum raise an endowment of $1 million. By 1934, $600,000 had been raised, which was deemed sufficient to meet Miss Bliss's requirement.

Philip Johnson, Chairman of the Department of Architecture, second from left, preparing the exhibition *Machine Art*, 1934

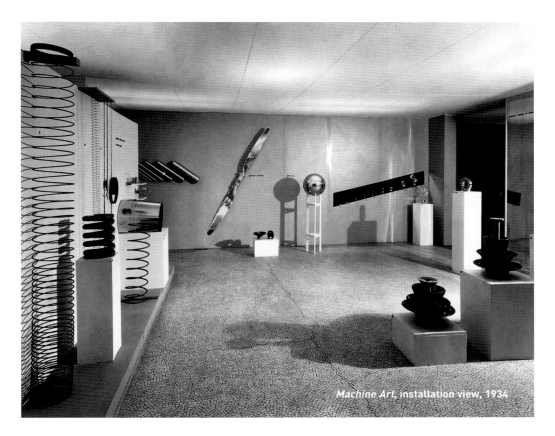

Machine Art, installation view, 1934

The catalogue for the exhibition *Machine Art*, by Philip Johnson, 1934. Cover design by Josef Albers

Johnson surprised the new Museum's audience with a three-story display of machine-made objects, from propeller blades to coils and springs, manufactured laboratory appliances and working tools, household objects, and furniture.

Set on white pedestals and platforms and against white walls, the decontextualized objects were installed with the same focus and drama that was reserved for sculpture. *Machine Art* provided a great leap forward. . . . The jolting elevation of a ball bearing to the stature of art and its acquisition into a collection of modern art had the strength and the authority of a manifesto. While the Museum's painting and sculpture collection was at first relatively conservative, the design collection had a brazen start.

Paola Antonelli, Curator of Architecture and Design, 2003

"I'm sorry, sir, but we ain't been able to turn a wheel since our differential bearing went on exhibition at the Museum of Modern Art."

Cartoon by Alan Dunn in *The New Yorker* magazine, April 7, 1934

■ DOROTHY C. MILLER

She directed many important exhibitions at the Museum, but the most influential were the six epoch-making "Americans" shows presented between 1942 and 1963. Eagerly awaited and vigorously discussed, these shows introduced major artists to their own country and then—with "The New American Painting" which toured Europe in 1958–59 and her installation at the Venice Biennale in 1962—introduced those artists to the world. Her exhibitions were notable not only for discernment in the choice of works but also for the sensitivity and care with which they were displayed and juxtaposed. They communicated to visitors the enthusiasms and sense of discovery she felt herself.

Richard E. Oldenburg, Director of the Museum (1972–1994), 2001

Dorothy C. Miller is hired as Assistant to Alfred H. Barr, Jr., 1934.

■ ROCKEFELLER GIFT AND FIRST PURCHASE FUND

Abby Aldrich Rockefeller, acting anonymously, gave $1,000 to the Director for purchases in Europe during the summer. An event of great importance to the collection, the gift constituted the Museum's first purchase fund. The Director bought three dada collages and an oil by Ernst, a collage by Schwitters, a large pastel by Masson, a gouache by Tanguy, and two suprematist oils by Malevich. . . . As a gesture of confidence, Abby Aldrich Rockefeller gave her collection of paintings to the Museum, thirty-six oils and 105 watercolors and pastels, most by Americans and almost all by living artists.

Alfred H. Barr, Jr., 1967

Letter to Abby Aldrich Rockefeller from Alfred H. Barr, Jr., 1935, thanking her for the Museum's first purchase fund, given in 1934

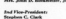

The Museum of Modern Art

11 West 53rd Street, New York, N. Y. Telephone: Circle 7-7470 Cable Address: Modernart

Trustees

President:
A. Conger Goodyear

1st Vice-President:
Mrs. John D. Rockefeller, Jr.

2nd Vice-President:
Stephen C. Clark

Secretary-Treasurer:
Samuel A. Lewisohn

William T. Aldrich
James W. Barney
Frederic C. Bartlett
Cornelius N. Bliss
Mrs. Robert Woods Bliss
Mrs. W. Murray Crane
Frank Crowninshield
The Lord Duveen of Millbank
Raymond B. Fosdick
Philip Goodwin
Mrs. Charles S. Payson
Duncan Phillips
Nelson A. Rockefeller
Paul J. Sachs
Mrs. John S. Sheppard
Edward M. M. Warburg
John Hay Whitney

Director:
Alfred H. Barr, Jr.

Executive Director:
Thomas Dabney Mabry, Jr.

July 20, 1935
c/o Chase Bank
41 r. Cambon
Paris

Dear Mrs. Rockefeller:

When you said you had bought a Dali I had no idea that it was the portrait of Gala Dali, the painter's wife. It has just been reproduced in color in <u>Minotaure</u> and Dali speaks of it as his finest painting.!

I have seen both Miss Courter and Mrs. Werthessen who are both, I think, getting the most out of their stay in Europe. They have both spent much time at the Italian exhibition and both plan to see the three other large exhibitions at Brussels, Rotterdam and Amsterdam. You have not only done them a great service in making it possible for them to come abroad for the first time in their lives, but you have also made them very happy.

I am most grateful for the $1000 to buy things with. Things are very cheap, both sculpture and painting. For instance one can get a fine terracotta a foot high by Laurens, one of the best French sculptors of the middle generation, for $35. A Picasso gouache for which Rosenberg was asking $1000 last year in New York for $350 (Mr. Goodyear is getting one. A large Masson of animals -about four feet long for $200. A Léger oil 2 x 3 ft. for $140. These are not bargains but ordinary prices.

Mr. Goodyear and I expect to settle the van Gogh - Kröller-Müller problem on the 24th at The Hague.

I hope your summer is proving restful.

Affectionately

[signature]

will write from the Hague

P.S. England is just now starting a film library!

— 1935

John Hay Whitney, Trustee and founder of the Film Library, 1935

Iris Barry, first Curator, and John E. Abbott, Director of the Film Library, c. 1935. Miss Barry had been hired in 1932 as the Museum's first Librarian.

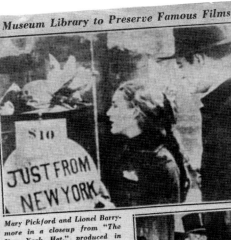

Museum Library to Preserve Famous Films

Film Library Set Up Here on $100,000 Fund

Rockefeller Foundation Gift Enables Modern Museum to Start Cinema Shelves

Moving Exhibits Planned

All U. S. to See Great Pictures, Early and New

A motion picture library dedicated to the preservation of fine or historically important films is being established at the Museum of Modern Art, it was learned yesterday. Founded though it is forty years or so after the crowds goggled at the marvelous Edison kinetoscope in a Broadway peep-show, the library will be the first thing of its kind in any public institution in the world. And thus motion picture making is to receive at last a full measure of official recognition as an art.

The library will have room in its cases for all sorts of films, from such primitives as "The Great Train Robbery" and the early Pickfords and Chaplins to the last French surrealist fancy. Nor will it be merely a collection of films, owned by a public institution but invisible to the public. The pictures will be exhibited both here and in traveling exhibitions at museums and colleges all over the country.

A Milestone for the Museum

The establishment of the motion picture library is a definite milestone along the Modern Museum's way towards complete fulfillment of the plan with which it was founded. The guilding minds of the institution at 11 West Fifty-third Street have long contemplated setting up at least a film department, if not a film library. Lack of funds prevented the carrying out of either plan. Now, however, a handsome grant from the Rockefeller Foundation, said to be in the neighborhood of $100,000, has brought both library and department well within the museum's reach.

The grant was confirmed a month or so ago, and since then preparations

Mary Pickford and Lionel Barrymore in a closeup from "The New York Hat," produced in 1912 by David Wark Griffith

Eric von Stroheim in "Blind Husbands," which he directed in 1919

Detail of newspaper article, in *The New York Herald Tribune,* June 25, 1935

This report embodies a project making possible for the first time a comprehensive study of the film as a living art. . . . *Modern art is not confined to painting and sculpture.* The Trustees and the Director of the Museum of Modern Art have planned, since . . . 1929, to develop a department of motion pictures. The art of the motion picture is the only great art peculiar to the twentieth century. It is practically unknown as such to the American public, and as such almost wholly unstudied. People who are well acquainted with modern painting and literature, the drama and architecture, are almost wholly ignorant of the work of such great directors as Pabst, Sennett, Clair, Eisenstein, Pudovkin, Griffith, Chaplin or Seastrom. Yet the films . . . have had an immeasurably great influence on the life and thought of the present generation. This new living form of expression, a vital force in our time, is such a young art that it can be studied from its beginnings: the primitives among movies are only forty years old.

John E. Abbott and Iris Barry

1936

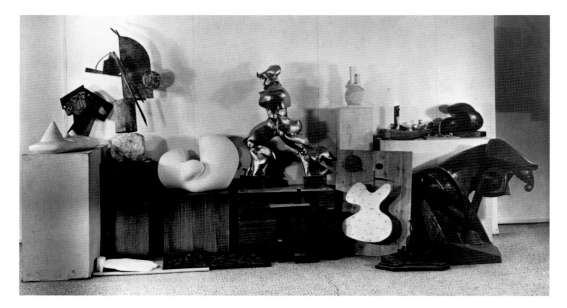

Foreign loans to the exhibition *Cubism and Abstract Art* refused admission to the United States as works of art and held under bond at 11 West 53 Street by U.S. Customs inspectors, 1936. Photograph by Beaumont Newhall

In assembling the current exhibition of cubism and abstract art the Museum of Modern Art borrowed from European collectors and museums fifty-nine paintings and nineteen sculptures. When these objects arrived in this country the Museum sought to enter them as works of art. . . . All of the abstract paintings borrowed for the exhibition were entered without difficulty . . . but the nineteen sculptures were refused. These sculptures were all original. . . . They were simply not considered to be works of art by the customs examiners. The Museum was informed that since the sculptures could not be accepted free of duty as works of art, they could be entered under whichever Tariff . . . covered the material they were made of. . . . The fundamental issue which interests the Museum and all similar institutions is whether the government shall determine by law what is art.

Thomas Dabney Mabry, Jr.,
Executive Director

Cubism and Abstract Art, installation views, 1936. Photographs by Beaumont Newhall

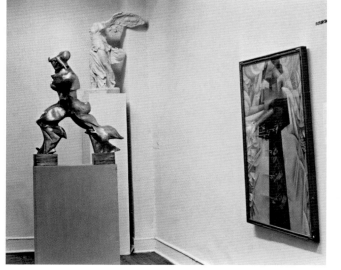

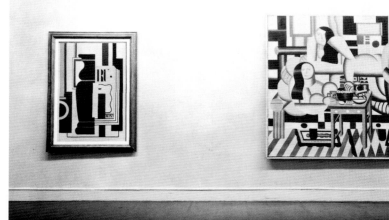

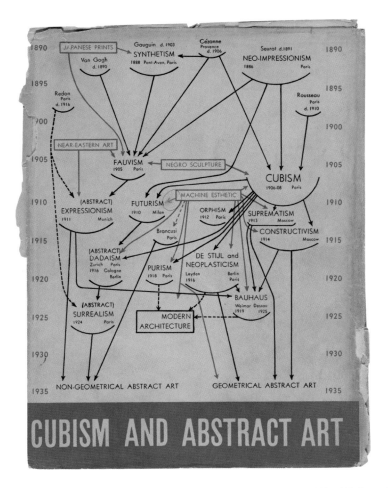

The catalogue for the exhibition *Cubism and Abstract Art*, by Alfred H. Barr. Jr., 1936. The dust jacket bears a diagram by Mr. Barr, proposing the origins and evolution of abstract art.

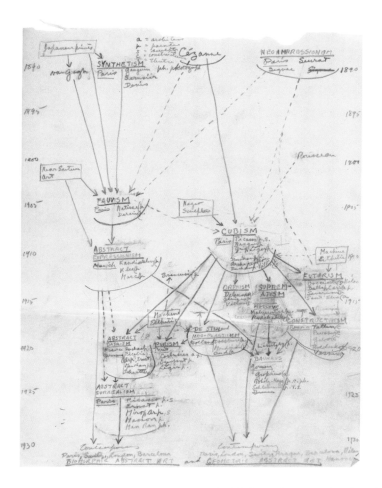

One of many hand-drawn diagrams by Alfred H. Barr, Jr., proposing the origins and evolution of abstract art, 1936

Cubism and Abstract Art, [was] for me, a budding art historian, a kind of talisman. Its wondrous chronicle of what had happened between 1875 and 1935 to bring us to the threshold of a Brave New World of art took on an authority verging on the Old Testament's. . . . As for [the] diagram [on the jacket] I still recall vividly its heraldic power; for it proclaimed, with a schema more familiar to the sciences, an evolutionary pedigree for abstract art that seemed as immutable as a chart tracing the House of Windsor or the Bourbon Dynasty. . . . The skeletal clarity and purity of this diagram were fleshed out in the text itself, which, step by step, generation by generation, movement by movement, outlined in the most pithy and impersonal way the visual mutations and the historical facts that accounted for the thrilling invention of a totally unfamiliar art belonging to our century and to no other. In doing this, Barr played the role of Christopher Columbus. He not only laid down for future his-torians and for any interested laymen the essential data for understanding the dizzying inventory of isms that erupted be-fore, during, and after the First World War, but he also forged a precise objective language that could describe, without obscure polemic and with a riveting specificity, the actual look of this new art.

Amazingly, even now . . . *Cubism and Abstract Art* maintains its fundamental authority. . . . Barr's text survives to this day in a strangely timeless and undated way, a combination of histori-cal chronicle with an unfailing ability to single out that work of art whose description will make the most salient points. . . . This level of distilled excellence is so consistent that, for the past half-century, most scholars have been refining, amplifying, or diluting Mr. Barr's initial presentation of the Gospel of mod-ern art in 1936.

Robert Rosenblum, Art Historian, 1986

Fantastic Art, Dada and Surrealism, installation view, 1936–37

Fantastic Art, Dada and Surrealism is the second of a series of exhibitions planned to present in an objective and historical manner the principal movements of modern art. The first of these, *Cubism and Abstract Art,* was held at the Museum in the spring of this year.

The divisions of the exhibition are self-explanatory. . . . The main body of the exhibition is represented by the Dada–Surrealist movement of the past twenty years together with certain of its pioneers. A number of artists who have worked along related but independent lines are brought together in a separate division. Then follow sections on comparative material and on fantastic architecture.

Alfred H. Barr, Jr.

Title page of the catalogue for the exhibition *Fantastic Art, Dada and Surrealism*, edited by Alfred H. Barr, Jr., 1936

Fantastic Art Dada Surrealism

Edited by Alfred H. Barr, Jr.

The Museum of Modern Art, New York, 1936

— 1937

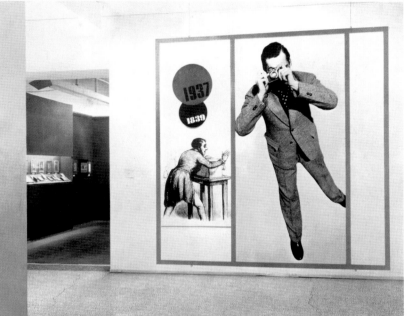

Beaumont Newhall, director of the exhibition, *Photography 1839–1937*, was the Museum's second Librarian. He was hired in 1935, when Iris Barry became the first Curator of the Film Library.

Photography 1839–1937, installation view of exhibition entry, 1937

▤ FIRST EDUCATION PROGRAM

Victor D'Amico, n.d., founder of the Museum's educational programs in 1937

Early art-appreciation course in the Young People's Gallery, the Museum's first educational program, founded in 1937

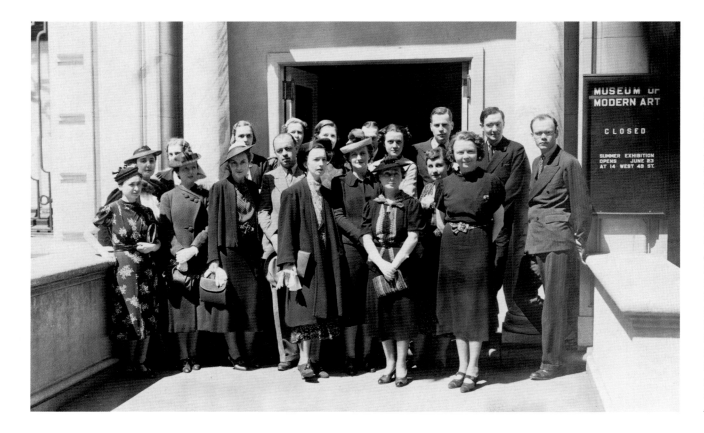

Moving Day: Museum staff members standing in front of the closed Museum of Modern Art townhouse at 11 West 53 Street before moving to temporary quarters in Rockefeller Center, 1937. Front row, left to right: Beatrice Rienfeld, Virginia Bellus, Dorothy C. Miller, John Ekstrom, Frances Collins, Carolyn Maynard, Beatrice Schwarz, Dorothy Dudley, Sarah Newmeyer; back row, left to right: Lillian Fugarini, F. Leissler, Elodie Courter, Ione Ulrich, Barbara Townsend, Ernest Tremp, Janet Henrich, Thomas Dabney Mabry, Jr., Alfred H. Barr, Jr., Beaumont Newhall

THE MUSEUM OF MODERN ART
14 WEST 49TH STREET, NEW YORK
TELEPHONE: CIRCLE 7-7470

FOR IMMEDIATE RELEASE

The Museum of Modern Art announces the removal of its offices and galleries to temporary headquarters at 14 West 49 Street. The remodeled residence building at 11 West 53 Street it has occupied since the Spring of 1932 will be torn down, with other residence buildings at 13, 15, 17, and 19 on the same street, to make way for the erection of a new Museum building.

The temporary quarters of the Museum at 14 West 49 Street are in the latest building in Rockefeller Center to be completed. It was opened for occupancy only about a month ago. The Museum has a suite of offices on the fifteenth floor; its galleries will be on the concourse level and will comprise an area almost as large as the four floors of the building just vacated by the Museum.

Detail of Museum press release announcing the removal of the Museum from the townhouse and the subsequent construction of a new building on the site, 1937

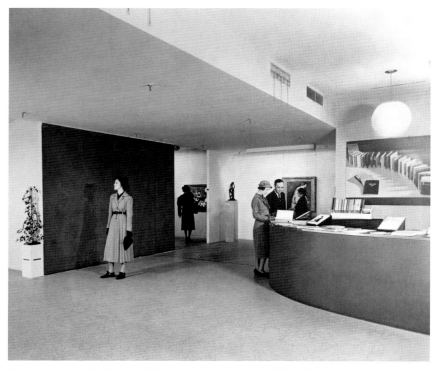

The entrance to the Museum's temporary quarters at 14 West Forty-ninth Street in the Rockefeller Center Concourse, 1937

—1938

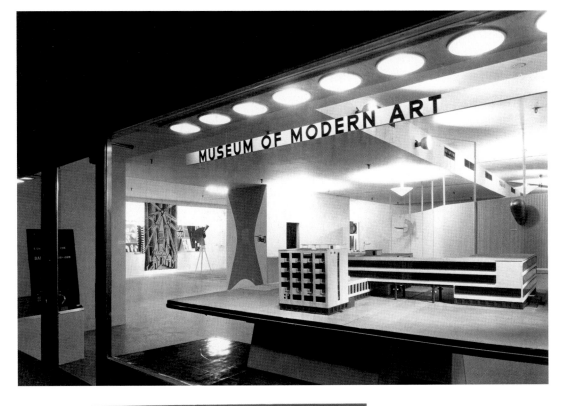

Bauhaus 1919–1928, installation view in the Rockefeller Center Concourse, 1938–39

Invitation to the exhibition Bauhaus 1919–1928

BAUHAUS WEIMAR ★ 1919 - 25 ★ DESSAU 1925 - 28

After the great Bauhaus exhibition of 1923 . . . reports reached America of a new kind of art school in Germany where famous expressionist painters such as Kandinsky were combining forces with craftsmen and industrial designers under the general direction of the architect, Gropius. A little later we began to see some of the Bauhaus books. . . . Young Americans began to turn their eyes toward the Bauhaus as the one school in the world where modern problems of design were approached realistically in a modern atmosphere. . . . During this time Bauhaus material, typography, paintings, prints, theatre art, architecture, industrial objects, had been included in American exhibitions. . . . The Bauhaus building at Dessau was architecturally the most important structure of its decade. And we can ask if in modern times there have ever been so many men of distinguished talent on the faculty of any other art school or academy.

Alfred H. Barr, Jr.

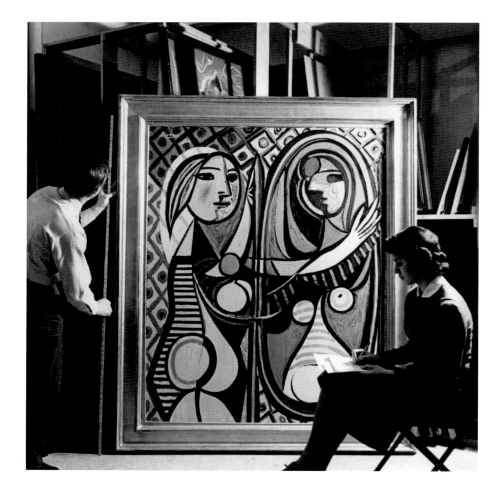

Mrs. Simon Guggenheim, who became a Trustee in 1940 (photograph 1954)

Late in 1937, Mrs. Guggenheim had without solicitation proposed buying an important painting for the Museum. The Director selected Picasso's *Girl before a Mirror*, which was bought for $10,000 early in 1938. It was the first of a series of Mrs. Guggenheim's magnificent donations.
Alfred H. Barr, Jr., 1967

Pablo Picasso's *Girl Before a Mirror*, 1932, the first of many major gifts to the Museum by Mrs. Simon Guggenheim, being examined and catalogued by Registrar staff members, 1938

■ USEFUL OBJECTS SERIES BEGINS

Useful Household Objects Under $5.00, installation view, 1938. The first in a series of design exhibitions initiated by John McAndrew, Curator of Architecture and Industrial Art

Evans's book is first of all a book of photographs and nothing but photographs; even the titles and dates are relegated to the end of each of its two parts, and Kirstein's brilliant afterword is commentary only, not an integral part of the work. The sequencing of the book may be compared to . . . Eisenstein's principle of cinematic montage, in which one shot has the capacity to alter dramatically the sense of another. Yet . . . each photograph nonetheless retains its stubborn identity as a mute record and obdurate symbol. . . . Evans's deliberate poetics of editing and sequencing in *American Photographs* helped to establish the photographer's book as an indivisible unit of artistic expression.

Peter Galassi, Chief Curator of Photography, 2000

Walker Evans: American Photographs, with an Afterword by Lincoln Kirstein, 1938

■ FIRST EXHIBITION SENT ABROAD

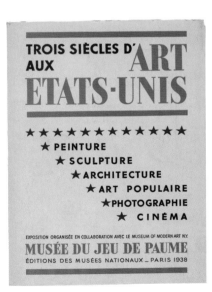

Catalogue for the first exhibition circulated abroad by the Museum, *Trois siècles d'art aux États-Unis* (Three Centuries of American Art), shown at the Musée du Jeu de Paume, Paris, 1938

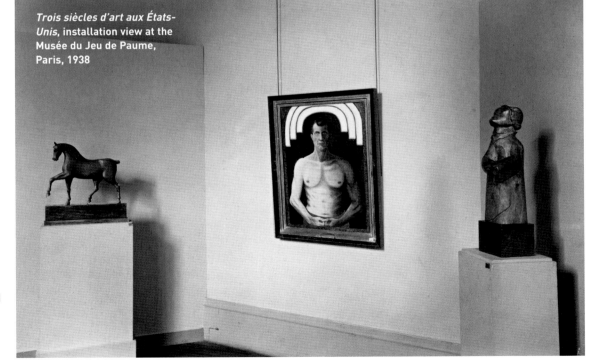

Trois siècles d'art aux États-Unis, installation view at the Musée du Jeu de Paume, Paris, 1938

1939

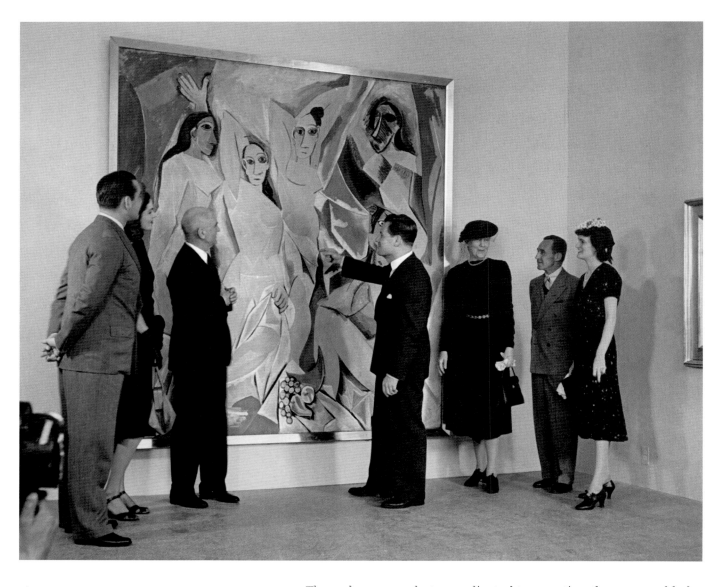

Pablo Picasso's *Les Demoiselles d'Avignon*, 1907, a key work in the history of modernism, viewed by Trustees and associates on its acquisition by the Museum. Left to right: John Hay Whitney, Mrs. William T. Emmet, Jr., A. Conger Goodyear, Nelson A. Rockefeller, Mrs. John S. Sheppard, Edsel Ford, and Elizabeth Bliss Parkinson (Mrs. John Parkinson, Jr.), 1939

Through a somewhat complicated transaction there was added to the collection early in 1938 the very large *Les Demoiselles d'Avignon*, painted about 1907, and called by Alfred Barr "one of the few pictures in the history of modern art which can be called epoch-making." The eight feet square canvas was purchased from Jacques Seligman & Company, two members of the firm . . . making substantial contributions toward its purchase price. The balance required was to be obtained from the sale of *The Race Course* by Degas, one of the pictures included in the Bliss Bequest. This was the first important sale from the permanent collection. Two years later the sale was concluded and as a consequence *Les Demoiselles* actually became the property of the Museum.

A. Conger Goodyear, 1943

The townhouse at 11 West 53 Street and adjacent structures are demolished to make way for the Museum's new building, 1938.

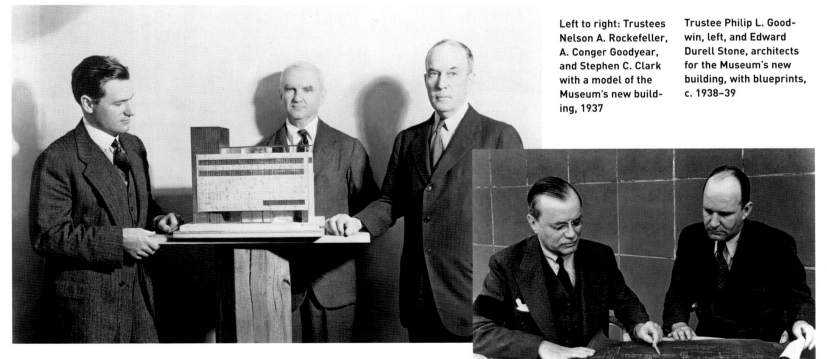

Left to right: Trustees Nelson A. Rockefeller, A. Conger Goodyear, and Stephen C. Clark with a model of the Museum's new building, 1937

Trustee Philip L. Goodwin, left, and Edward Durell Stone, architects for the Museum's new building, with blueprints, c. 1938–39

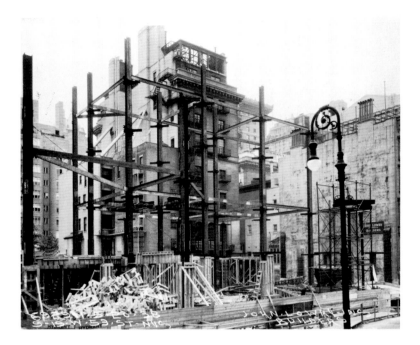

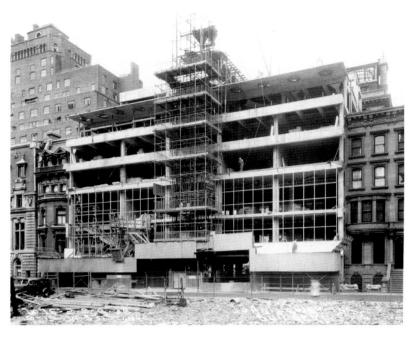

Construction photograph, c. 1938, showing initial framing for the Museum's new building. This view from West Fifty-third Street reveals the Abby Aldrich and John D. Rockefeller, Jr., family home on West Fifty-fourth Street on the site of the Museum's future sculpture garden.

The architects were Edward Durell Stone, who began his career as an ardent modernist . . . and Philip L. Goodwin, who was a member of the museum's board. Goodwin was hired because he was the only architect associated with the museum, but his own work was not at all modernist; Stone was teamed with him in what one museum curator later called a "shotgun marriage." . . . What was built elucidated superbly the "International Style" principles: tensile, sharp, crisp, it remains one of New York's great early modern monuments. The six-story structure is a box of white marble, with a glass-walled base, two gallery floors above with panels of translucent glass, two office floors above that marked by industrial-looking horizontal strip windows and a penthouse on top of that. The boxiness of the structure was striking at a time when New York's streets were full of lyrical masonry buildings. . . .The contrast between the Museum of Modern Art and the townhouses flanking it on West 53d Street was overwhelming, as was intended. How better to show the power of the new than to juxtapose it sharply with the old.
Paul Goldberger, Architecture Critic, 1996

Construction photograph, September 12, 1938, showing further progress on the Museum's new building

THE GOODWIN–STONE BUILDING

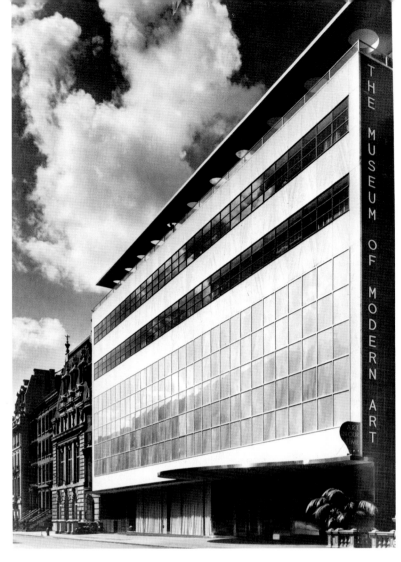

Facade of The Museum of Modern Art's first permanent building, designed by Philip L. Goodwin and Edward Durell Stone, 1939

View from the Museum's new building from the Penthouse Restaurant balcony, through one of its rooftop apertures, south toward Rockefeller Center, 1939

Aerial view of the Museum's new building, 1939

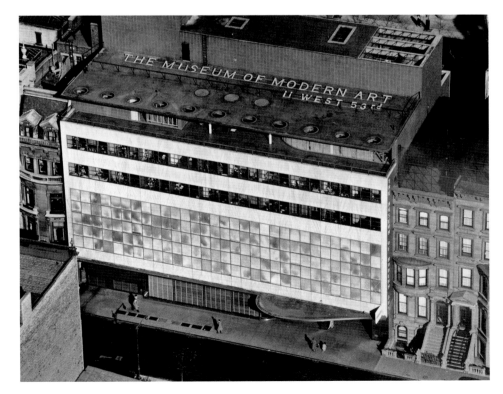

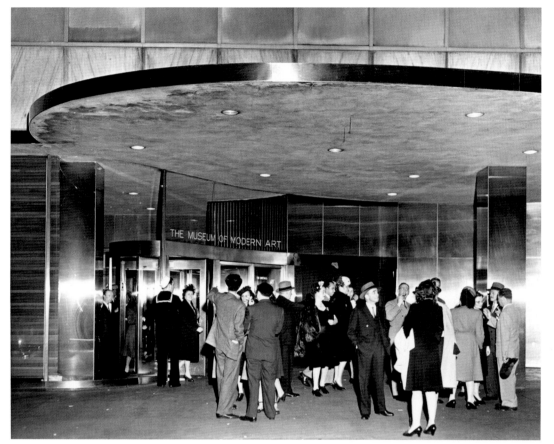

Visitors under the entry canopy of the Museum's new building (photograph 1944)

Lobby and sales desk in the Museum's new building, 1939

Interior staircase, 1939

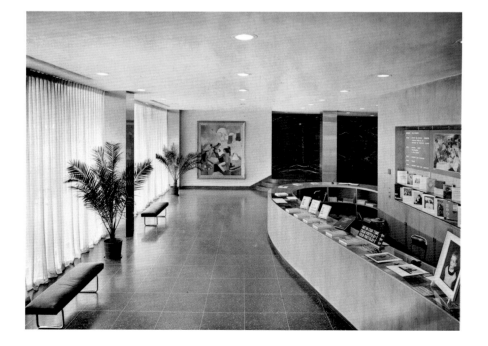

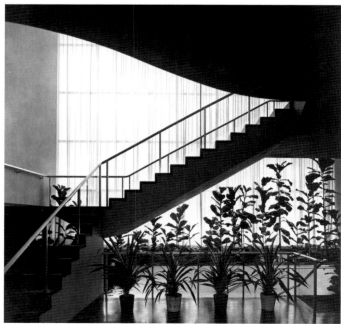

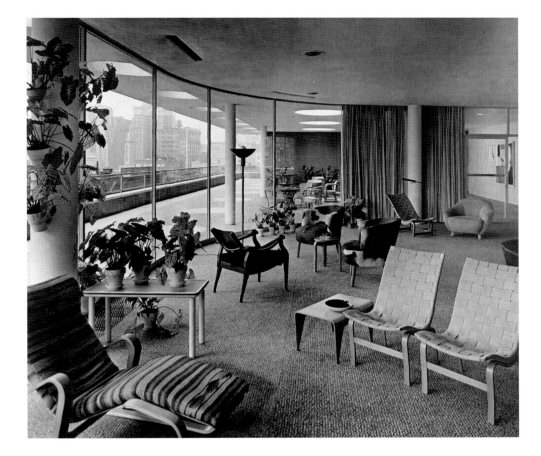

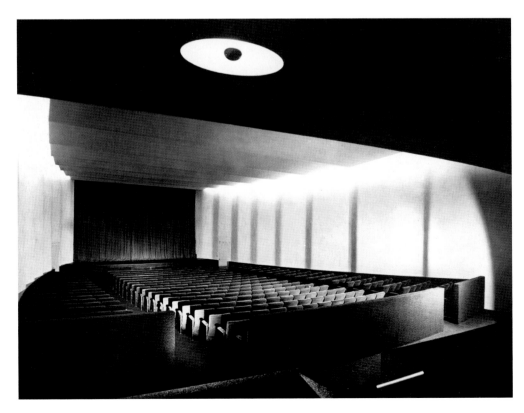

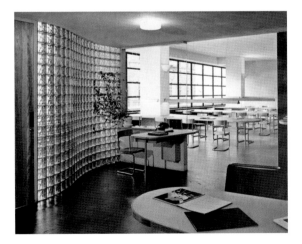

Members Penthouse Lounge, on the sixth floor of the new building, 1939

A typical staff office, 1939

Auditorium in the basement of the new building, 1939

View into the library reading room, 1939

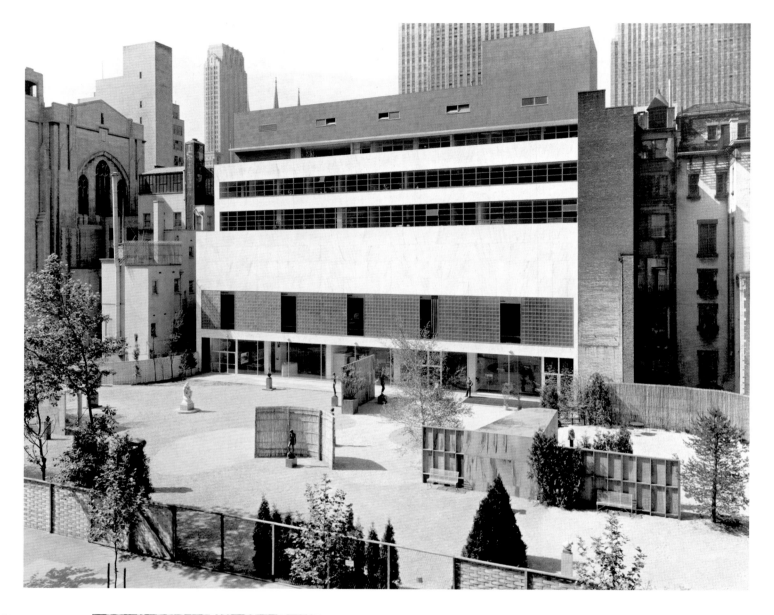

View of the Museum's first sculpture garden from West Fifty-fourth Street, 1939

John McAndrew, Curator of Architecture and Industrial Art. McAndrew and Director Alfred H. Barr, Jr., designed the Museum's first sculpture garden, in 1939.

The first garden was the happy improvisation of John McAndrew, then Curator of Architecture, and Alfred Barr. . . . It was only a week or two before the gala opening that McAndrew and Barr were told that the garden could cover all the empty Rockefeller-owned land behind the new building. . . . With a minimum of time and money, this huge, rubbly tract had to be transformed into a favorable sculpture setting by two young scholar-critics who between them knew a great deal about sculpture . . . and architecture, but nothing about the making of gardens. . . . That very night . . . they developed a scheme by working directly with rough models on a five-foot panel of masonite. Barr had everyone including himself make scale

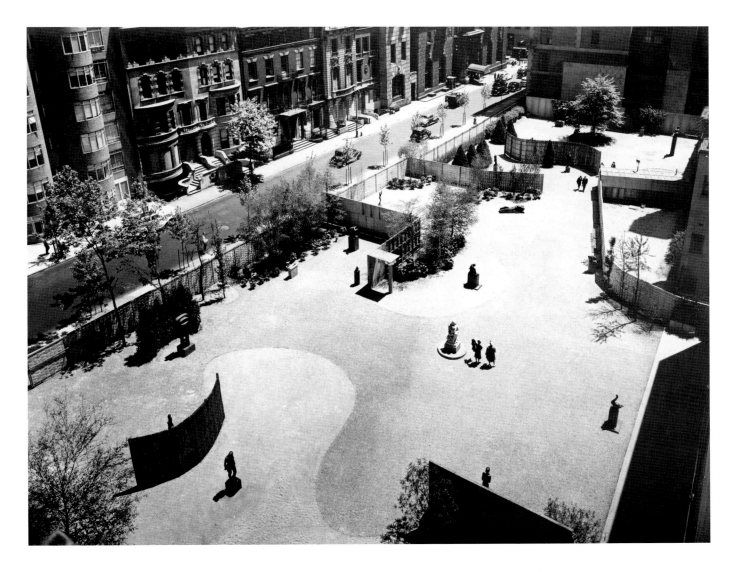

Aerial views of the sculpture garden looking toward West Fifty-fourth Street, 1939

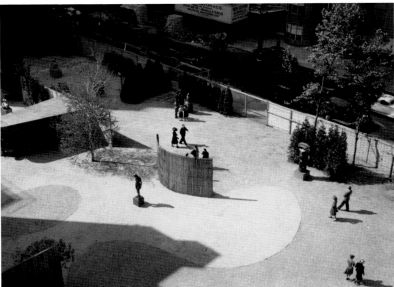

reminders of the sculpture he wished to show, then figured out how each might best be displayed. . . . Each had to have its own space, and McAndrew's problem was how to coax all this into one coherent design and to decide on the materials that would effectively and inexpensively serve the purpose. . . . Fortified by sandwiches and beer, they pushed the tiny effigies about. . . . What they settled on was a loose organization of more or less intimate spaces, comfortable for people as well as for sculpture and defined for the most part by free-standing screens.

Elizabeth Kassler, Landscape Architecture Historian, 1975

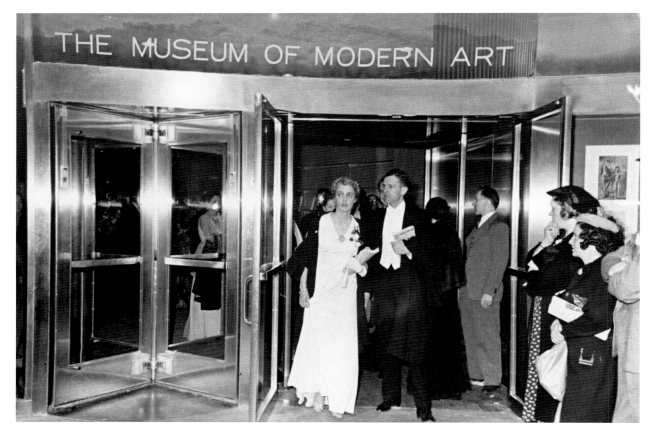

Guests at the opening of the Museum leaving the new building, 1939

In the tenth year of its existence the Museum of Modern Art comes of age, a precocious accomplishment. Reaching maturity it finds itself for the first time in a home of its own, designed for its special purposes with all of the advantages that the ingenuity of today and the experience of yesterday can devise. The exhibition galleries provide three times the space available heretofore. In the offices the Museum staff for the first time has space to carry on its work properly and all of the Museum's activities are now housed under one roof. The library emerges from its state of crowded confusion and is at last equipped for public use. An auditorium makes possible lectures, moving pictures and other developments. A final touch of completion is to be found in the garden which provides an outdoor display space as well as a setting for the building. . . . We still remain primarily an educational institution. We adhere to the policy of holding temporary exhibitions illustrating the art of today and its derivations. We are acquiring a collection which will be permanent as a stream is permanent—with a changing content. The circulation of traveling exhibitions continues. . . . New departments have been established—a Department of Architecture in 1932, to which was added Industrial Art in 1933, the Film Library in 1935. The foundations have been laid for enlarged activities in photography. . . . With the facilities of the new building must come increasing service to the public, the more definite establishment of the Museum as a national institution devoted to increasing the esthetic content of our national life.
A. Conger Goodyear

THE MUSEUM OF MODERN ART

39436 12

11 WEST 53RD STREET, NEW YORK

TELEPHONE: CIRCLE 7-7470

FOR RELEASE THURSDAY AFTERNOON
OR FRIDAY MORNING, APRIL 27 OR
APRIL 28, 1939

PRESIDENT ROOSEVELT SPEAKS ON PROGRAM

INAUGURATING NEW BUILDING OF MUSEUM OF MODERN ART

WEDNESDAY NIGHT, MAY 10

Franklin D. Roosevelt, President of the United States, will open the new Museum of Modern Art with a special address to be broadcast from the White House on Wednesday, May 10. The President's fifteen-minute talk from 10:45 - 11:00 P.M. E.D.S.T. will come as the climax of the ceremonies celebrating the opening of the new glass-walled, two-million-dollar museum building at 11 West 53 Street, and will emphasize not only the cultural significance of the Museum's work but also the national scope of its activities. The theme of the opening program will be cultural freedom.

Detail of a Museum press release announcing President Franklin Delano Roosevelt's radio speech inaugurating the opening of the Museum's new building, 1939

The mission of this museum is plain. We are dedicating this building to the cause of peace and to the pursuits of peace. The arts that ennoble and refine life flourish only in the atmosphere of peace. And in this hour of dedication we are glad again to bear witness before all the world to our faith in the sanctity of free institutions. For we know that only where men are free can the arts flourish and the civilization of national culture reach full flower. . . . The conditions for democracy and for art are one and the same. What we call liberty in politics results in freedom in the arts. There can be no vitality in the works gathered in a museum unless there exists the right of spontaneous life in the society in which the arts are nourished. . . . Crush individuality in society and you crush art as well. Nourish the conditions of a free life and you nourish arts, too. In encouraging the creation and enjoyment of beautiful things we are furthering democracy itself. That is why this museum is a citadel of civilization. As the Museum of Modern Art is a living museum . . . it can, therefore, become an integral part of our democratic institutions—it can be woven into the very warp and woof of our democracy. Because it has been conceived as a national institution, the museum can enrich and invigorate our cultural life by bringing the best of modern art to all of the American people. This, I am gratified to learn, will be done through the traveling exhibitions of the museum. . . . Thus, a nation-wide public will receive a demonstration of the force and scope of all these branches of the visual arts. . . . The opportunity before the Museum of Modern Art is as broad as the whole United States. I trust that the fine example which this institution is affording will be widely copied and that the good work will continue until the influence of the best and the noblest in the fine arts permeates every community in the land.
Franklin Delano Roosevelt

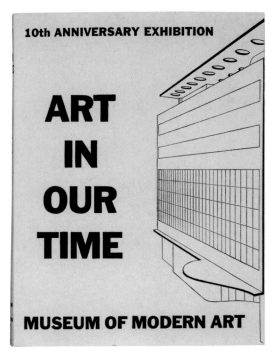

"Art in Our Time" is the first exhibition in the Museum's new building; it celebrates the Tenth Anniversary of the Museum's foundation; and it is planned especially for the visitors to the New York World's Fair. "Art in Our Time" presents achievements of living artists together with the work of certain important masters of yesterday. It differs from the special exhibitions of modern art in other New York museums at the time of the Fair by its inclusion of foreign work as well as American, and by its concern not only with painting, sculpture and the graphic arts but also with architecture, furniture, photography and moving pictures. . . . "Art in Our Time" . . . is planned along the general lines of the Museum's organization and is in fact intended to give some idea of the different kinds of art with which the Museum is concerned and some of the various ways of exhibiting them. . . . The Museum of Modern Art is a laboratory: in its experiments the public is invited to participate.
Alfred H. Barr, Jr.

Cover of the paper-bound edition of the catalogue for the exhibition *Art in Our Time,* **1939**

Art in Our Time, **installation view, 1939**

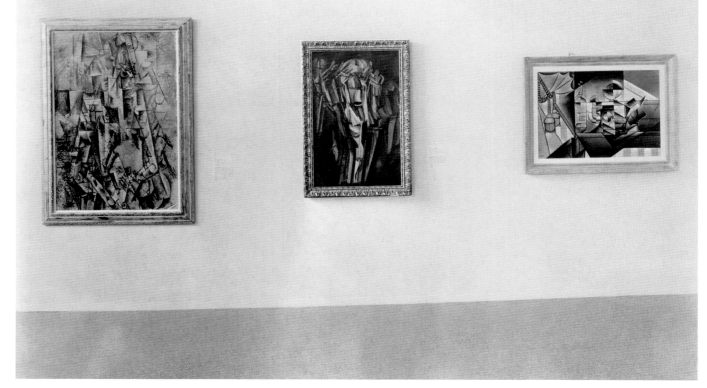

■ ART IN OUR TIME

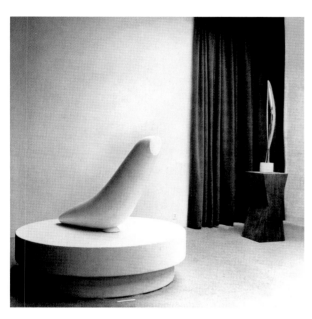

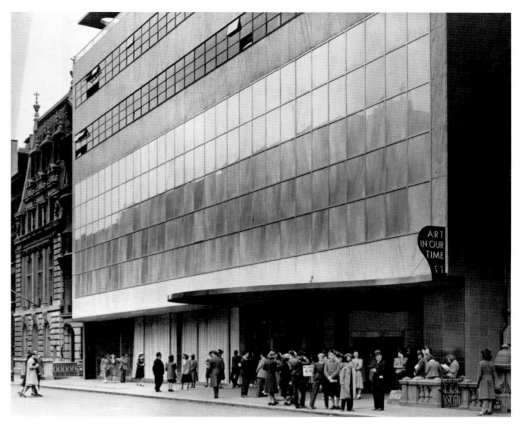

Crowds outside the Museum waiting to
see the exhibition *Art in Our Time*, 1939

Art in Our Time, installation view, 1939

■ LOBSTER TRAP AND FISH TAIL

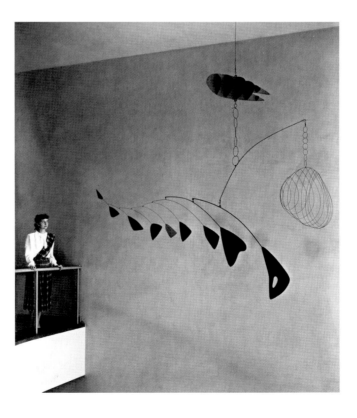

Alexander Calder's *Lobster Trap and Fish
Tail*, 1939, a hanging mobile commissioned
by the Advisory Committee for the stairwell
of the Museum's new building (photograph
November 1949)

■ CHANGE IN LEADERSHIP

Upon the resignation of A. Conger Good-year as the President of the Museum, Nelson A. Rockefeller, left, is named the President, and Stephen C. Clark the first Chairman of the Board of Trustees, 1939.

Nelson Rockefeller was one of the most complex, mercurial and changeable of men. . . . He was an Aldrich more than a Rocke-feller—he looked like his mother; he was more cheerful than his brothers. In most ways he was al-most professionally perceptive and qualitative. . . . Everything seemed to him possible, and almost everything was.

Monroe Wheeler, 1979

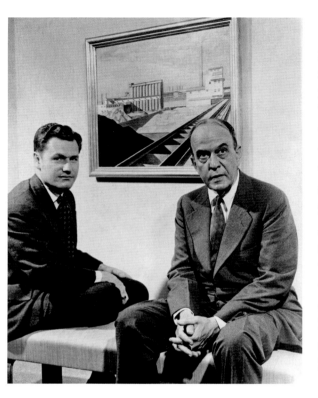

Stephen Clark . . . was a man of the ut-most distinction, passionate about paint-ings and baseball, admired by everyone but mystifying in some ways. Part of this was shyness and part of it was obstina-tion. . . . He met his match in Alfred Barr, who had another kind of obscurity, an-other kind of stubbornness, almost in antithesis. Day after day, after seeing Alfred, he would say to me: "I cannot un-derstand that man." This did not express the full force of his feeling. Underneath these mild complaints surged an extraor-dinary resentment. The museum might have lost them both had not René d'Harnoncourt. . . intervened.

Monroe Wheeler, 1979

■ MUSEUM PUBLICATIONS

Brochure offering books published by the Museum, 1939

Museum publications are an important extension of Museum activities as they provide a permanent record of an ex-hibition which frequently has involved months of research and a great deal of time and money to assemble. An exhibi-tion on view at the Museum for two months is seen by 80,000 people: a book on the same subject in university libraries will be read by thousands of students and will be sold in book stores here and abroad to additional thousands long after the ex-hibition is dismantled. . . . The meticulous attention accorded to the aesthetic value of Museum books, in addition to that given their content, has undoubtedly influenced book publishing in this country. Many Mu-seum publications have received special

Monroe Wheeler, Director of Membership since 1938, is named Director of Publications.

prizes and awards for their design and typography, and a Museum of Modern Art book is now expected to be partic-ularly attractive.

P. K. Thomajan, Editor and Poet

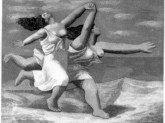

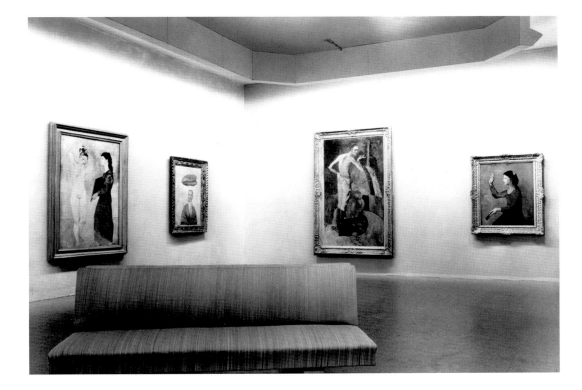

Poster for the Museum's first Picasso exhibition, *Picasso: Forty Years of His Art,* 1939–40

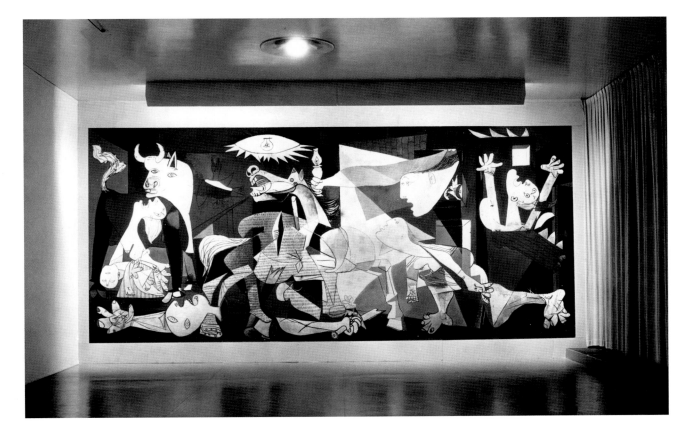

Picasso: Forty Years of His Art, installation views, 1939–40. This exhibition marked the first showing of Picasso's large canvas *Guernica,* of 1937, at the Museum. At the request of the artist, it remained in the Museum from 1939 to 1981, until the fascist Franco regime had ended, and was then transferred to Spain.

1940–1953: ROAD TO VICTORY

AVERAGE DAY AT THE MUSEUM

—1940

"Average Day in the Museum," a schematic cross-section showing the various activities that take place in the Museum's new building, 1940

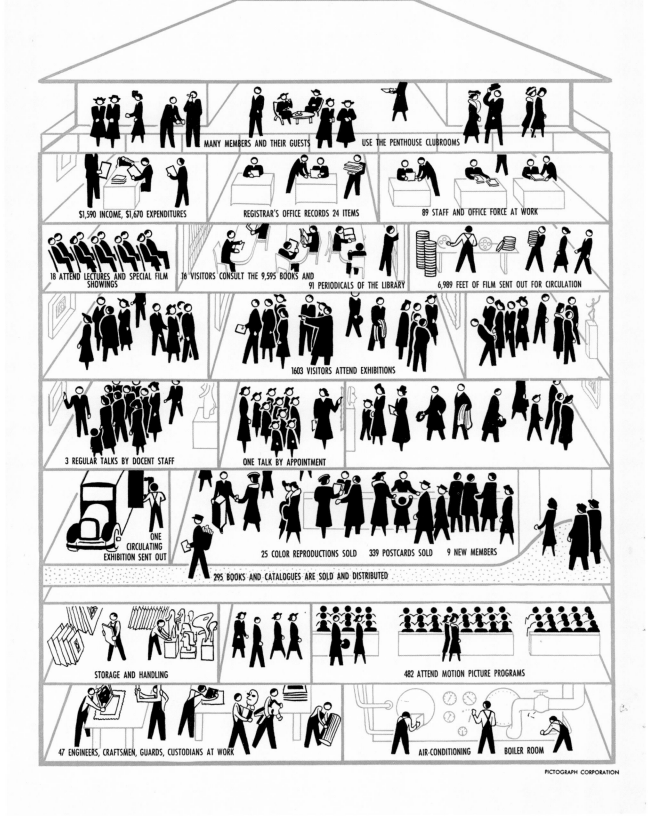

MANY MEMBERS AND THEIR GUESTS USE THE PENTHOUSE CLUBROOMS

$1,590 INCOME, $1,670 EXPENDITURES

REGISTRAR'S OFFICE RECORDS 24 ITEMS

89 STAFF AND OFFICE FORCE AT WORK

18 ATTEND LECTURES AND SPECIAL FILM SHOWINGS

16 VISITORS CONSULT THE 9,595 BOOKS AND 91 PERIODICALS OF THE LIBRARY

6,989 FEET OF FILM SENT OUT FOR CIRCULATION

1603 VISITORS ATTEND EXHIBITIONS

3 REGULAR TALKS BY DOCENT STAFF

ONE TALK BY APPOINTMENT

ONE CIRCULATING EXHIBITION SENT OUT

25 COLOR REPRODUCTIONS SOLD 339 POSTCARDS SOLD 9 NEW MEMBERS

295 BOOKS AND CATALOGUES ARE SOLD AND DISTRIBUTED

STORAGE AND HANDLING

482 ATTEND MOTION PICTURE PROGRAMS

47 ENGINEERS, CRAFTSMEN, GUARDS, CUSTODIANS AT WORK

AIR-CONDITIONING BOILER ROOM

PICTOGRAPH CORPORATION

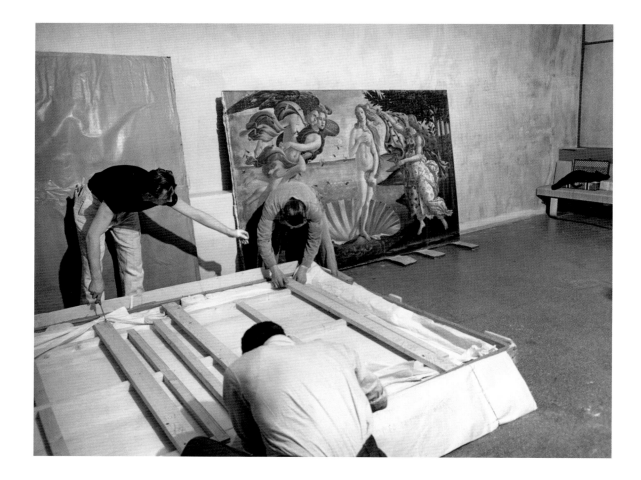

Registrar staff members unpacking artworks for the exhibition *Italian Masters*, 1940. Leaning against the wall is Botticelli's painting *Birth of Venus*, c. 1485.

Crowds waiting outside the Museum to see the exhibition *Italian Masters*, 1940

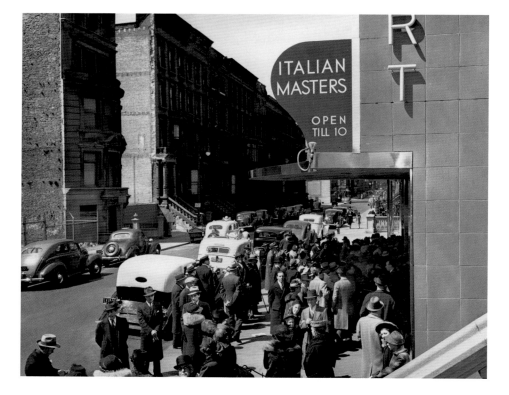

Botticelli's *Birth of Venus*, Titian's *Paul III*, a Michelangelo marble (the first ever exhibited in New York), Raphael's *Madonna of the Chair*, Verrocchio's *David*, Bernini's *Costanza Buonarelli*, Masaccio's *Crucifixion:* that these should be brought together in a single exhibition is a memorable event, but that this exhibition should be in New York is an unexpected miracle. What art museum would not be glad to assist in this miracle? For these world famous masterpieces can and should claim the hospitality even of a museum devoted to the art of our day.
Alfred H. Barr, Jr.

▬ DEPARTMENT OF PHOTOGRAPHY FOUNDED

THE NEW DEPARTMENT OF
PHOTOGRAPHY

The Bulletin of
THE MUSEUM OF MODERN ART
2 · VOLUME VIII · DEC.-JAN. 1940-41

Living photographs are, in the fullest meaning of the term, works of art. They give us a new vision of the world, they interpret reality, they help us to evaluate the past and the present. . . . The newly founded Department of Photography is a center where this type of photography can be seen and studied [and] will function as a focal center where the esthetic problems of photography can be evaluated, where the artist who has chosen the camera as his medium can find guidance by example and encouragement and where the vast amateur public can study both the classics and the most recent and significant developments of photography.

Beaumont Newhall

An issue of *The Bulletin of The Museum of Modern Art* in which the inauguration of the Department of Photography is announced, with Beaumont Newhall as its Curator, 1940–41

▬ CIRCULATING FILM LIBRARY FOUNDED

▬ DEPARTMENT OF INDUSTRIAL DESIGN FOUNDED

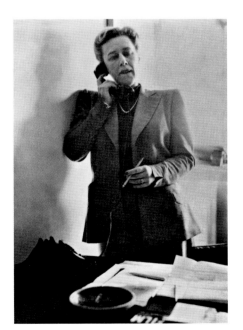

Margareta Akermark is named first Director of the Circulating Film Library (photograph 1948).

Eliot Noyes is named first Director of Industrial Design (photograph c. 1941).

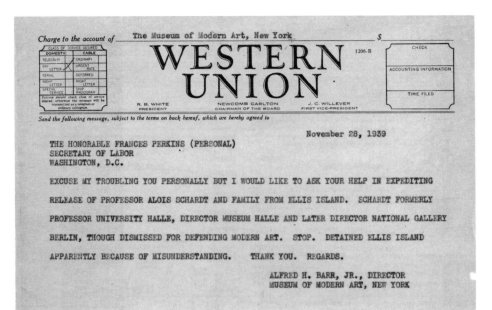

Telegram to Frances Perkins, U.S. Secretary of Labor, from Alfred H. Barr, Jr., requesting help in expediting the release of refugee Alois Schardt and family from Ellis Island, 1939. Professor Schardt had been a German art historian working in Berlin.

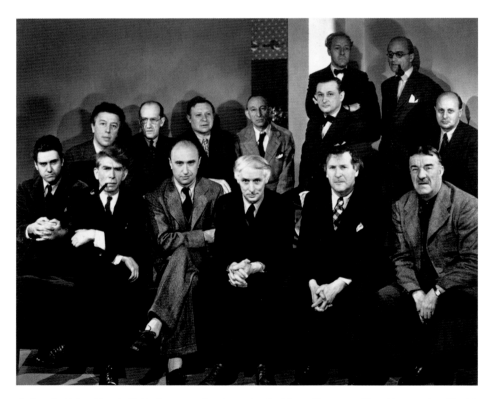

Artists in Exile, March 1942. A group of artists who fled from Europe to New York during World War II. Front row, left to right: Matta Echaurren, Ossip Zadkine, Yves Tanguy, Max Ernst, Marc Chagall, Fernand Léger; second row: André Breton, Piet Mondrian, André Masson, Amédée Ozenfant, Jacques Lipchitz, Pavel Tchelitchew, Kurt Seligmann, Eugene Berman. A number of these artists were aided by the Museum.

Shortly after the fall of Paris in June 1940, my husband, Alfred H. Barr, Jr., the Director of the Museum of Modern Art, New York, began to receive letters from artists who wanted to escape to the United States. . . . As time went by more and more urgent requests piled up on Alfred Barr's desk and the work of rescue was slow, persistent and laborious. Each individual artist required a sponsor who would financially guarantee that the artist would not become a burden on the United States government. In addition his papers had to be cleared by the State Department, a formidable hurdle because it was essential to prove that the artist was neither a communist nor even a leftist. . . . Finally, $400. had to be found to pay for passage. . . . Alfred and I were constantly anxious about the fate of the artists, most of whom we knew personally, some of them trapped in the occupied zone, others wandering from place to place in unoccupied France or, with luck, in Spain and Portugal, often with no firm address. . . . I learned, after months of frustrating work, that we had an ally in France, Varian Fry. Alfred had known him at Harvard in the mid-twenties. . . . How he got to unoccupied France in the middle of World War II I do not know [but] he was in a chateau in or near Marseilles with André Breton, his wife Jacqueline, Max Ernst and others. While he supervised the constantly shifting problems of the legal papers and passages with the Joint Rescue Committee or with me directly, his wards debated how to get out when the time came . . . for the Atlantic was riddled with submarines.

Margaret Scolari Barr, 1980

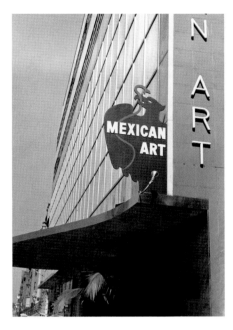

Sign outside the Museum for the exhibition *Twenty Centuries of Mexican Art*, 1940

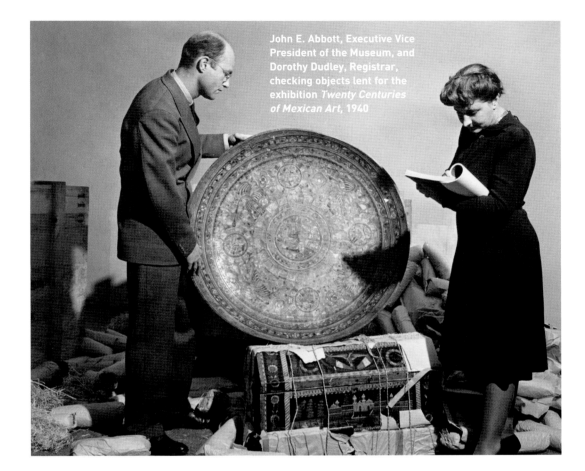

John E. Abbott, Executive Vice President of the Museum, and Dorothy Dudley, Registrar, checking objects lent for the exhibition *Twenty Centuries of Mexican Art*, 1940

The Mexican artist José Clemente Orozco painted his six-part fresco *Dive Bomber and Tank*, 1940, during the course of the exhibition *Twenty Centuries of Mexican Art*.

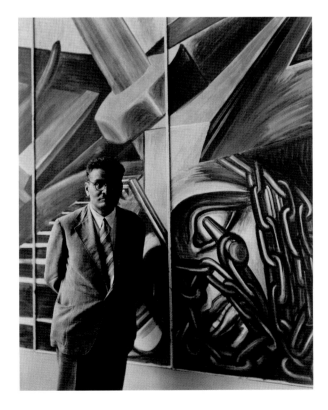

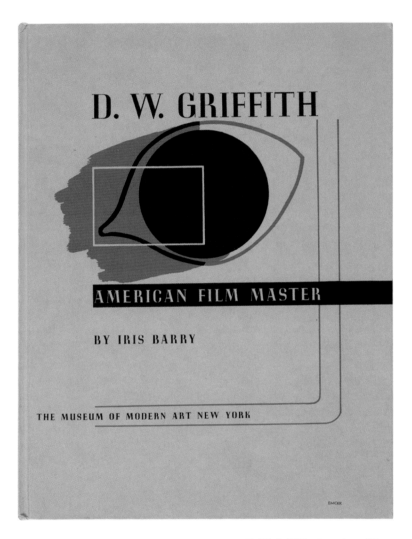

D. W. Griffith: American Film Master, by Iris Barry, 1940

Poster for a pair of exhibitions, *Two Great Americans*, on the architect Frank Lloyd Wright and the filmmaker D. W. Griffith, 1940–41

As first curator of The Museum of Modern Art Film Library, Iris Barry was also the first to rediscover and reexamine the primitive films of the late nineteenth and early twentieth centuries, especially the series of short films made for the American Mutoscope and Biograph Company by D. W. Griffith between 1908 and 1913. How Miss Barry found them, salvaged them and restored a considerable number of them to the screen is a story which has been told elsewhere. What is perhaps not on record . . . is this pioneering curator's growing excitement as she found from personal experience that Griffith had in four short years . . . laid down *all* the basic principles of the multiform twentieth-century medium . . . the art of the moving image. It was a triumph for The Museum of Modern Art to uncover this fact. The origins of the older arts are lost in prehistory, their creators unknown or barely guessed at. Here was almost the complete record of the birth of an art—and its leading artist, though he had been inactive for a decade, was still alive! . . . The Museum, in keeping with its general outlook and policy, immediately set out to communicate this discovery. In 1940, a large exhibition of the Griffith films then available and the artifacts connected with them was held in the new Museum building.

Richard Griffith, Curator, Film Library (1950–66), 1960

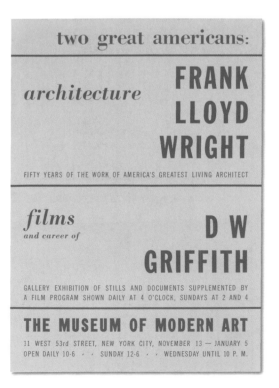

two great americans:

architecture **FRANK LLOYD WRIGHT**

FIFTY YEARS OF THE WORK OF AMERICA'S GREATEST LIVING ARCHITECT

films and career of **D W GRIFFITH**

GALLERY EXHIBITION OF STILLS AND DOCUMENTS SUPPLEMENTED BY A FILM PROGRAM SHOWN DAILY AT 4 O'CLOCK, SUNDAYS AT 2 AND 4

THE MUSEUM OF MODERN ART

11 WEST 53rd STREET, NEW YORK CITY, NOVEMBER 13 — JANUARY 5
OPEN DAILY 10-6 · · SUNDAY 12-6 · · WEDNESDAY UNTIL 10 P. M.

1941

Vincent van Gogh: The Starry Night, 1889. Oil, 29" x 36¼". Acquired through the Lillie P. Bliss Bequest, this is the first canvas by van Gogh to enter the collection of a New York Museum.

Two pages in *The Bulletin of The Museum of Modern Art*, 1941, showing the Museum's new acquisition, through the Lillie P. Bliss Bequest, of Vincent van Gogh's *The Starry Night*, 1889

Copyright 1941, Museum of Modern Art, 11 West 53 Street, New York City.

2

Van Gogh's "Starry Night"

"A star spangled sky . . . that's a thing I would like to try to do." So wrote van Gogh to his friend Emile Bernard in the spring of 1888. For months afterwards the problem obsessed him until, finally, in June 1889 he painted *The Starry Night* recently acquired by the Museum.

The Starry Night is not only one of van Gogh's most moving and beautiful pictures. It has also a particular interest, for it was painted during a critical turning point in his art and in his life.

In May 1889 van Gogh, who had suffered two attacks of what we today would probably call manic depression, was sent to the sanatorium of St. Rémy, near Arles, by his devoted brother Theo. *The Starry Night* was among the first half dozen canvases completed in these new and disquieting surroundings. But its style is the result not so much of psychological crisis as of a long delayed emergence of the artist's ability to express his strongest and deepest emotions through painting.

For over a year van Gogh's art had been a battleground between fact and feeling, between objective realism and imaginative vision, between Impressionism and what was later to be called Expressionism. Van Gogh had been a devout Impressionist under the tutelage of Pissarro and Seurat, but in 1888 he began to respond to the liberating influence of his friends Gauguin and Bernard who upheld the right of the artist to paint from his imagination without regard to realism. This influence was countered by Theo van Gogh who was loyal to Impressionism and wanted his brother to stick to facts. Theo did not like *The Starry Night* or other paintings in the St. Rémy style.

But it is in the paintings of St. Rémy with their flamboyant cypresses and heaving mountains that van Gogh's art culminates, and of this culmination *The Starry Night* is possibly the purest and most complete expression. For more than any other van Gogh it is not so much a transformation of reality as fundamentally an imaginative invention. The swirling sky, the sun-bright moon, the milky way turned to comets, the exploding stars—these reveal the unique and overwhelming vision of a mystic, a man in ecstatic communion with heavenly forces.

In this sense *The Starry Night* may well take its place among the few great religious paintings of the past hundred years. Van Gogh might have denied this for the passionate evangelical Christianity of his youth had turned to bitter disillusionment (leaving intact only the figure of Christ himself whom he called "the greatest artist"). But to the subject of *The Starry Night*, which he wrote had "haunted" him always, van Gogh attached a special significance. In a letter to Theo after discussing the problem of painting a street scene in the spirit of the realistic novelists, Flaubert and Zola, he writes, "that does not prevent me having a terrible need of—shall I say the word—religion. Then I go out to paint the stars . . ."

B.

3

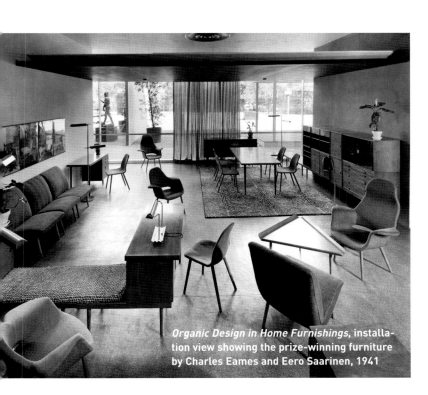

Organic Design in Home Furnishings, installation view showing the prize-winning furniture by Charles Eames and Eero Saarinen, 1941

Jury members for the Industrial Design Competition sponsored by the Museum in 1940, selecting works to be included in the exhibition *Organic Design in Home Furnishings*. Seated, left to right: Frank Parrish, Alfred H. Barr, Jr., Catherine K. Bauer, Edward Durell Stone; standing: Edgar Kaufmann, Jr., Eliot Noyes, Marcel Breuer (photograph 1941)

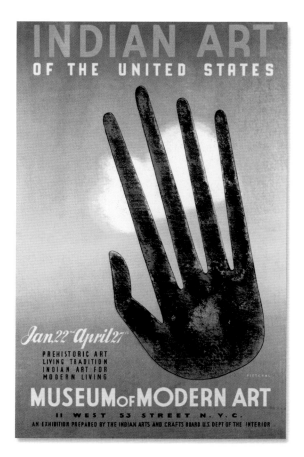

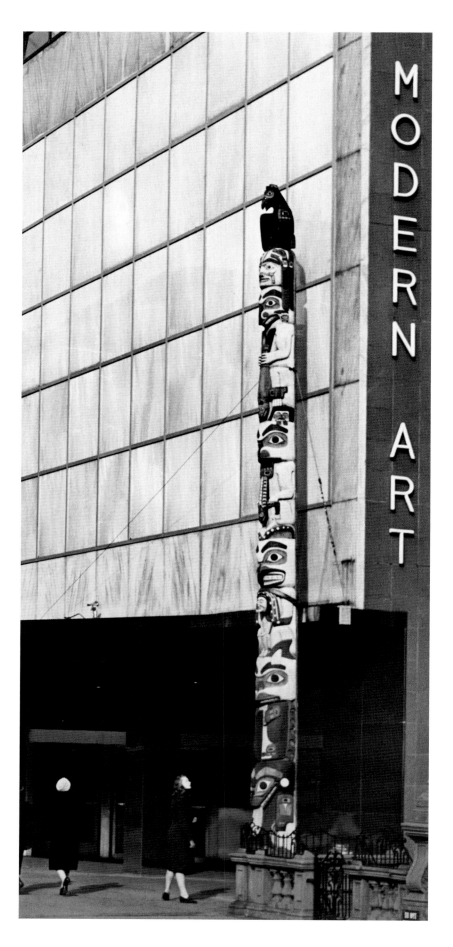

Poster for the exhibition *Indian Art of the United States*, 1941

Totem pole in front of the Museum during the exhibition *Indian Art of the United States*, 1941

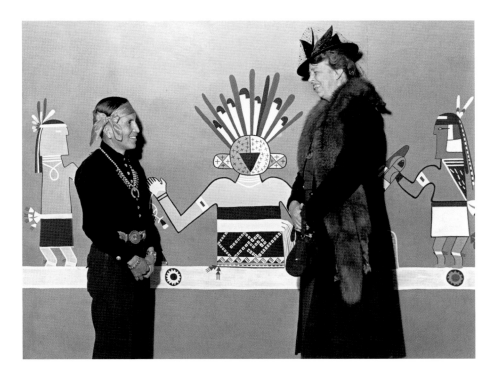

The Hopi painter Fred Kabotie and the First Lady Eleanor Roosevelt at the opening of the exhibition *Indian Art of the United States*, 1941

Navaho artists working on a sand painting during the exhibition *Indian Art of the United States*, 1941. The exhibition was directed by René d'Harnoncourt, then General Manager of the Indian Arts and Crafts Board, a division of the Department of the Interior in Washington; he joined the Museum staff in 1944 and in 1949 became its Director.

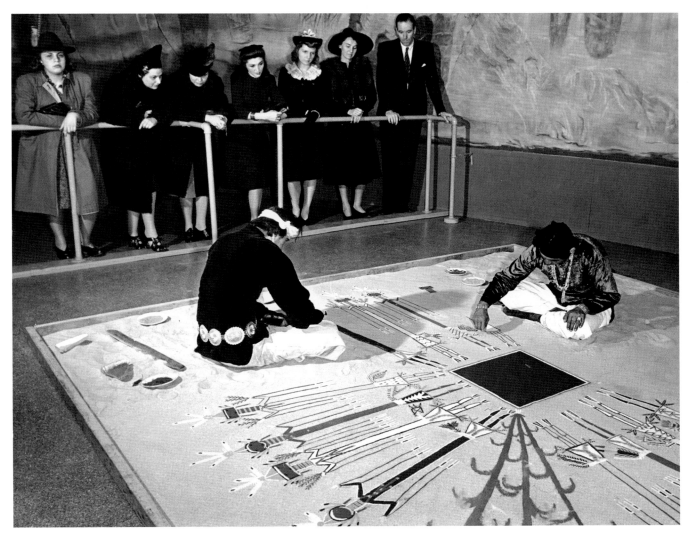

— 1942

the

MUSEUM

and the

WAR

The Bulletin of
THE MUSEUM OF MODERN ART
1 VOLUME X OCTOBER-NOVEMBER, 1942

Cover of an issue of *The Bulletin of The Museum of Modern Art* devoted to the Museum's wartime activities, 1942

Poster advertising the Museum's War Veterans' Art Center, an art school for veterans and servicemen directed by Victor D'Amico, 1942

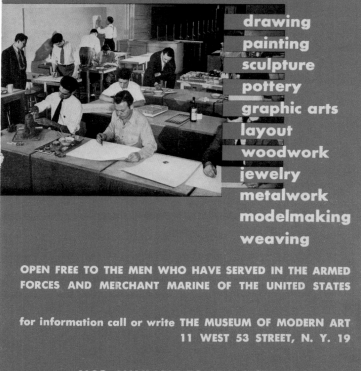

WAR VETERANS' ART CENTER

recreational and prevocational classes in

drawing
painting
sculpture
pottery
graphic arts
layout
woodwork
jewelry
metalwork
modelmaking
weaving

OPEN FREE TO THE MEN WHO HAVE SERVED IN THE ARMED FORCES AND MERCHANT MARINE OF THE UNITED STATES

for information call or write THE MUSEUM OF MODERN ART
11 WEST 53 STREET, N. Y. 19

ALSO AVAILABLE TO MEN NOW IN SERVICE

During the war years, the Museum's program was drastically modified. The Museum executed thirty-eight contracts for various governmental agencies, including the Office of War Information, the Library of Congress, and the Office of the Coordinator of Inter-American Affairs; nineteen exhibitions were sent abroad and twenty-nine were shown in the Museum, all related to the war. The Museum's Film Department analyzed enemy propaganda films. An Armed Services Program was established under the guidance of James Thrall Soby, a collector and critic who was later to join the Museum staff; the program included sending materials and exhibitions to the Armed Services and providing therapy programs for disabled veterans. In the Museum's garden a canteen for servicemen was installed and became a favorite recreation and entertainment center.

Waldo Rasmussen, Director, International Program, 1978

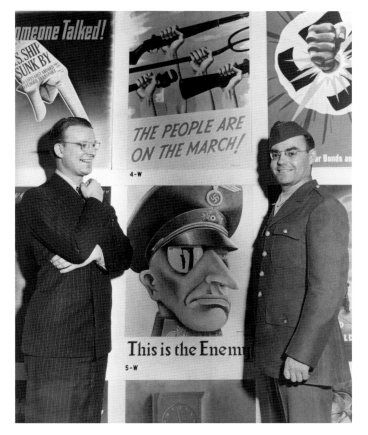

Karl Koehler and Private Victor Ancona, prize-winners in National
War Poster Competition shown at the Museum, 1942–43

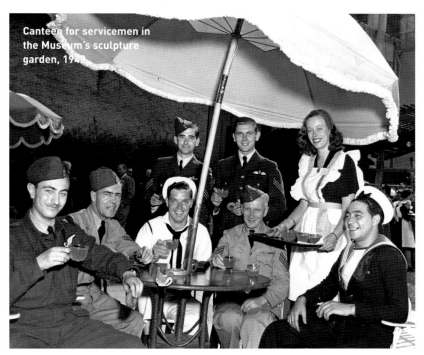

Canteen for servicemen in the Museum's sculpture garden, 1942

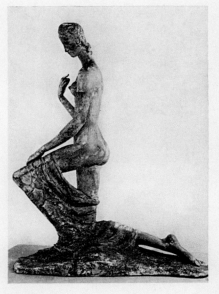

Lehmbruck's *Kneeling Woman*, the masterpiece of the greatest modern German sculptor, was *thrown out* of the Berlin National Gallery on Hitler's order. With many other pieces now in the Museum Collection, it stands for the *free art of Europe* much of it now in hiding or in exile.

Though it does not so obviously bear upon the War

THE MUSEUM COLLECTION

is a **symbol** of one of the four freedoms for which we are fighting — **the freedom of expression.**

Composed of
 painting
 sculpture
 architecture
 photography
 films
 industrial design

from 25 countries it is

art that Hitler hates

because it is **modern,** progressive, challenging

 (Hitler insists upon magazine cover realism or prettiness)

because it is **international,** leading to understanding and tolerance among nations

 (Hitler despises the culture of all countries but his own)

because it is **free,** the free expression of free men (Hitler insists upon the subjugation of art).

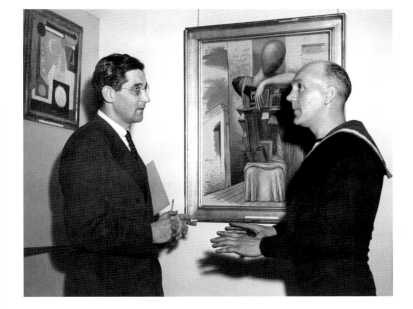

Detail of a page from *The Bulletin of The Museum of Modern Art* on wartime activities, stating the Museum's policy on freedom of expression as it relates to World War II, 1942

James Thrall Soby, Director of the Museum's Armed Services Program, meets with a representative of the U.S. Navy, 1943.

▪ ROAD TO VICTORY

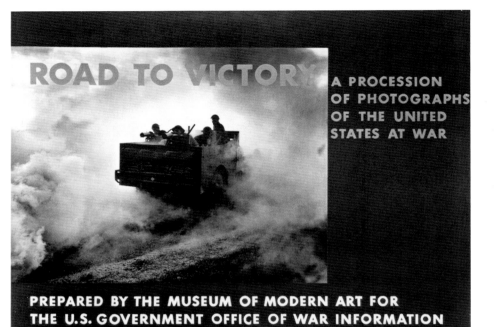

Publicity photograph for the exhibition *Road to Victory*, 1942, directed by the photographer Edward Steichen, who would become Director of Photography at the Museum five years later

▪ AMERICANS SERIES BEGINS

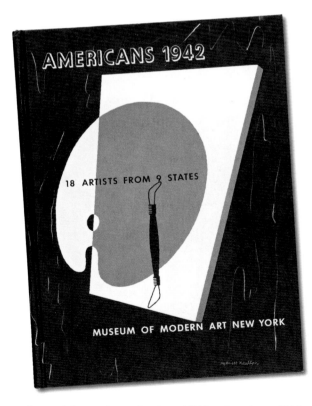

Cover of the catalogue for the exhibition *Americans 1942*, the first in a groundbreaking series of six exhibitions of American artists directed by Dorothy C. Miller

▪ LATIN-AMERICAN ART

In 1942 the Inter-American Fund was established by Nelson A. Rockefeller to support the acquisition of artworks from Latin America. Oswaldo Guayasamin, an Ecuadorian painter and guest of the State Department, is shown at the entrance to the exhibition *Latin-American Art in the Collection of The Museum of Modern Art*, May 1943.

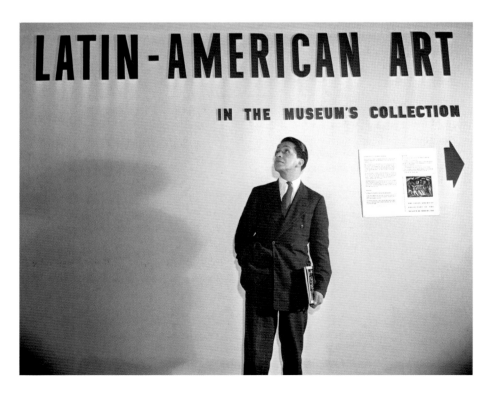

▪ BAUHAUS STAIRWAY ACQUIRED

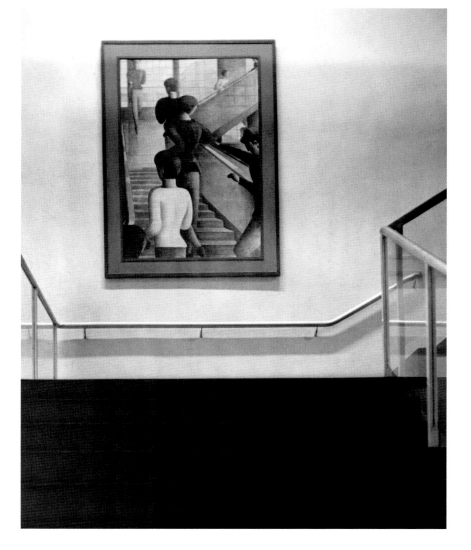

March [1933:] A[lfred] and M[arga] go to the Kunstverein exhibition of the work of Oskar Schlemmer. Two weeks later they go again; all the Schlemmers are gone. The show was not supposed to close this soon. "Where are the Schlemmers?" A[lfred] asks in surprise. Silently he is shown the way to the back room where all the Schlemmers are stacked. The far wall is dominated by the . . . *Bauhaus Stairway.* For A[lfred] and M[arga] this is the first symptom of the far-reaching consequences of National Socialist power. . . . Painting must be realistic and architecture conventional. . . . In the progressive Staatsgalerie the labels of modern pictures are covered with yellow and black paper streamers that proclaim, "for this trash 80,000 marks were paid". . . . Philip Johnson comes to Stuttgart . . . for a short visit. He thinks that the . . . "National Resurgence" . . . will be the salvation of Germany. A[lfred] tells him about the Schlemmer *Bauhaus Stairway;* and he buys it and [later] gives it to the museum.
Margaret Scolari Barr, 1987

Oskar Schlemmer's *Bauhaus Stairway*, 1932, acquired by the Museum as the gift of Philip Johnson in 1942, installed in the Museum's stairway, 1945–46

▪ JOE MILONE'S SHOESHINE STAND

Joe Milone with his *Shoeshine Stand,* a work of folk art that was exhibited in the Museum's Lobby by Alfred H. Barr, Jr., during the Christmas season, 1942–43

1943

Space had been allocated for a Photography Center in two adjoining mansions at 9 and 11 West Fifty-fourth Street, which the Museum had leased as an annex from Philip Goodwin, a trustee, and his brother. The second floors of both buildings were joined together by a connecting doorway and turned over to the department. The largest room contained the photographic collection, a library of books on photography, and an "experimental" gallery. The other rooms served as offices and a darkroom.

Beaumont Newhall, 1993

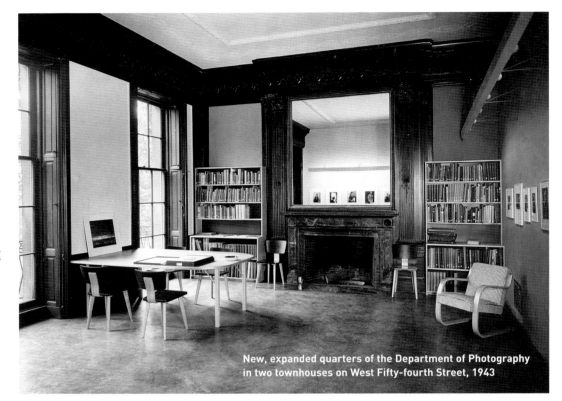

New, expanded quarters of the Department of Photography in two townhouses on West Fifty-fourth Street, 1943

Cover of the first edition of *What Is Modern Painting?* by Alfred H. Barr, Jr., a book written to demystify modern and abstract art for the public, 1943

■ WHAT IS MODERN PAINTING?

This booklet is written for people who have had little experience in looking at paintings, particularly those modern paintings which are sometimes considered puzzling, difficult, incompetent or crazy. It is intended to undermine prejudice, disturb indifference and awaken interest so that some greater understanding and love of the more adventurous paintings of our day may follow. WHAT IS MODERN PAINTING? It is not easy to answer this question in writing, for writing is done with words while paintings are made of shapes and colors. The best words can do is to give you some information, point out a few things you might overlook, and if, to begin with, you feel that you don't like modern painting anyway, words may possibly help you to change your mind. But in the end you must look at these works of art with your own eyes and heart and head. This may not be easy, but most people who make the effort find their lives enriched.

Alfred H. Barr, Jr.

His brief survey . . . is a great challenge because he so intensely wants to make modern art accessible.

Margaret Scolari Barr, 1987

Dear Alfred: For some time past a number of our more active Trustees have been greatly concerned about your position in the Museum. Their concern has arisen from the fact that so much of your time has been spent on administrative routine and so little on the kind of work you are particularly qualified to do. . . . Instead of devoting your energies to writing, you spent a large part of your time checking and rechecking with meticulous care the work of other people or engaged in endless discussions of matters of minor importance. The amount of time you are able to devote to unimportant matters and to philosophical discussion in the course of a presumably busy day has been a constant source of wonderment to me. . . . Your only original literary contribution has been "What is Modern Painting"—a work of 38 pages, which engaged your attention for nearly five months. . . . In these difficult times the relatively unimportant work you are doing does not justify a salary of $12,000 a year. Because of that fact, we have regretfully reached the conclusion that in the best interests of the Museum you should retire from the office of Director and assume the position of Advisory Director, at a salary of $6,000. a year. As Advisory Director you would not have any administrative or executive duties or the obligation to maintain an office in the Museum. . . . It may interest you to know that after your retirement we intend to abolish the position of Director of the Museum. We shall appoint a Director of Painting and Sculpture to take over part of your present duties and we shall rely upon a small and efficient Executive Committee to coordinate the various departments and maintain the cultural standards of the Museum. . . . Very sincerely yours.

Stephen C. Clark, October 15, 1943

Letter to Alfred H. Barr, Jr., from Nancy Newhall, Acting Curator of the Department of Photography during World War II, when her husband, Beaumont Newhall, was in the Service, 1943

Dear Alfo and Marga, Lincoln [Kirstein] told me all the latest news. . . . What beats me is why the MMA people don't see that you *are* the institution to most people . . . it is your great spirit that pervades the place. It is your choice of pictures, it is your choice of personnel and policy and your detailed work of editing and supervising everybody else that makes the place possible.

Philip Johnson

▪ JAMES THRALL SOBY

James Thrall Soby loved the museum more serenely and more contentedly than anyone else and everyone in and out of it loved him. It seemed perfectly natural for him to give his life to it. He was the ideal rescuer and peacemaker, directing or codirecting curatorial exhibitions and ardent ally of Barr, Johnson, Miller and associate curator Alicia Legg. He was also a fine writer in an easy, spoken style and helped to support the high reputation of our books established by Barr and John Rewald. . . . He wrote the great book on de Chirico for us. During the war he directed our Art for Armed Services Program, with our master educator, Victor D'Amico.
Monroe Wheeler, 1979

Upon the resignation of Alfred H. Barr, Jr., as Director of the Museum in 1943, James Thrall Soby is named Director of the Department of Painting and Sculpture (photograph 1954).

▪ BROADWAY BOOGIE WOOGIE ACQUIRED

Piet Mondrian's *Broadway Boogie Woogie*, 1942–43, is acquired by the Museum, and discussed in *The Bulletin of The Museum of Modern Art*, 1944

An Interview with Mondrian

by James Johnson Sweeney

"The first aim in a painting should be universal expression. What is needed in a picture to realize this is an equivalent of vertical and horizontal expressions. This I feel today I did not accomplish in such early works as my 1911 'Tree' paintings. In those the vertical emphasis predominated. A 'gothic' expression was the result.

"The second aim should be concrete, universal expression. In my work of 1919 and 1920 (where the surface of the canvas was covered by adjoining rectangles) there was an equivalence of horizontal and vertical expression. Thus the whole was more universal than those in which verticals predominated. But this expression was vague. The verticals and horizontals cancelled each other, the result was confused, the structure was lost.

"In my paintings after 1922 I feel that I approached the concrete structure I regard as necessary. And in my latest pictures such as *Broadway Boogie-Woogie* and *Victory Boogie-Woogie* the structure and means of expression are both concrete and in mutual equivalence . . .

"In my 'cubist' paintings such as *Tree* the color was vague. Some of my 1919 rectangular compositions and even many of my earlier works were painted in black and white. This was too far from reality. But in my canvases after 1922 the colors have been primary—concrete.

"It is important to discern two sorts of equilibrium in art: 1. static balance; 2. dynamic equilibrium. And it is understandable that some advocate equilibrium, others oppose it.

"The great struggle for artists is the annihilation of static equilibrium in their paintings through continuous oppositions (contrasts) among the means of expression. It is always natural for human beings to seek static balance. This balance of course is necessary to existence in time. But vitality in the continual succession of time always destroys this balance. Abstract art is a concrete expression of such a vitality.

"Many appreciate in my former work just what I did not want to express, but which was produced by an incapacity to express what I wanted to express—dynamic movement in equilibrium. But a continuous struggle for this statement brought me nearer. This is what I am attempting in *Victory Boogie-Woogie*.

"Doesburg, in his late work, tried to destroy static expression by a diagonal arrangement of the lines of his compositions. But through such an emphasis the feeling of physical equilibrium which is necessary for the enjoyment of a work of art is lost. The relationship with architecture and its vertical and horizontal dominants is broken.

"If a square picture, however, is hung diagonally, as I have frequently planned my pictures to be hung, this effect does not result. Only the borders of the canvas are on 45° angles, not the picture. The advantage of such a procedure is that longer horizontal and vertical lines may be employed in the composition.

"So far as I know, I was the first to bring the painting forward from the frame, rather than set it within the frame. I had noted that a picture without a frame works better than a framed one and that the framing causes sensations of three dimensions. It gives an illusion of depth, so I took a frame of plain wood and mounted my picture on it. In this way I brought it to a more real existence.

Broadway Boogie-Woogie. 1942-43. Oil, 50 x 50". The Museum of Modern Art, given anonymously.
14

15

—1944

The Museum's Purpose: A Suggested Restatement: The primary purpose of the Museum is to help people enjoy, understand, and use the visual arts of our time. By *enjoyment* I mean the pleasure and recreation offered by the direct experience of works of art. By *helping to understand* I mean answering the questions raised by works of art such as: why? how? who? when? where? what for?—but not so much to add to the questioner's store of information as to increase his comprehension.

By *helping to use* I mean showing how the arts may take a more important place in everyday life, both spiritual and practical. Obviously, these three activities—enjoying, understanding, using—should be thought of as interdependent. Each confirms, enriches and supports the others. Together they indicate the Museum's primary function, which is educational in the broadest, least academic sense.
Alfred H. Barr, Jr.

■ JAMES JOHNSON SWEENEY

—1945

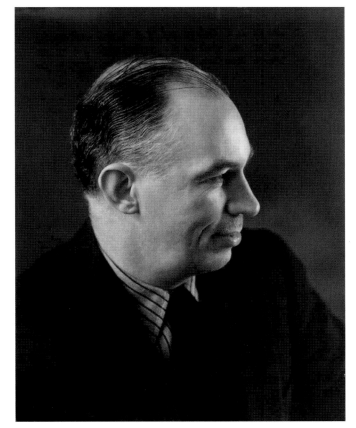

James Johnson Sweeney is named Director of Painting and Sculpture, 1945.

1946

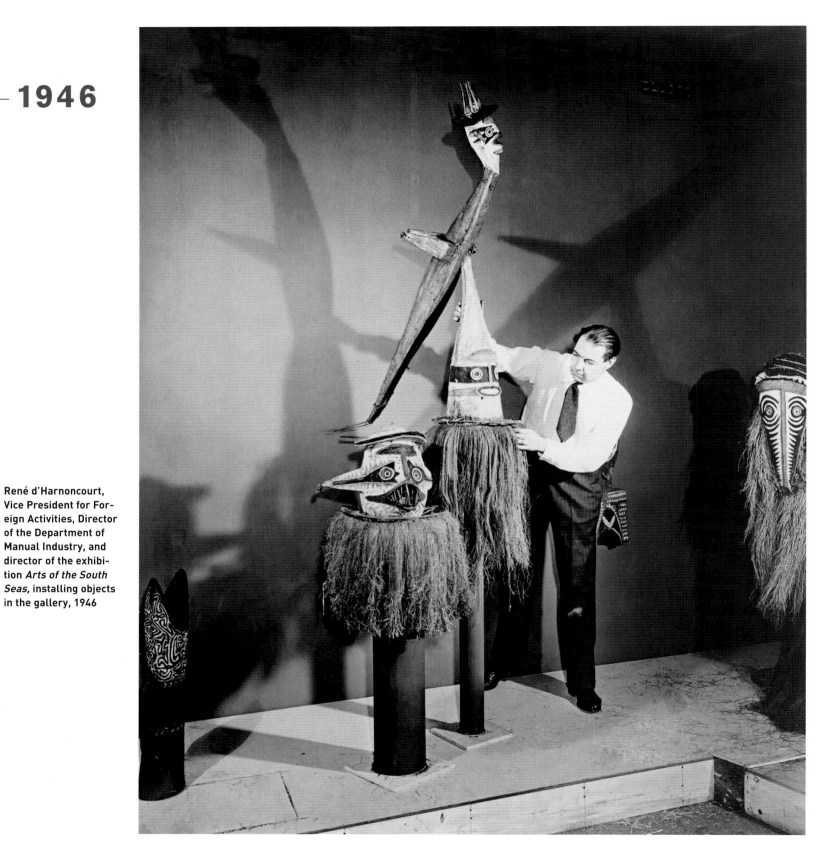

René d'Harnoncourt, Vice President for Foreign Activities, Director of the Department of Manual Industry, and director of the exhibition *Arts of the South Seas,* installing objects in the gallery, 1946

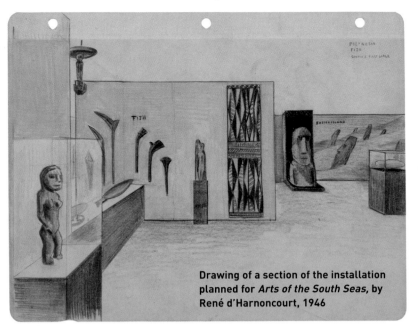

Drawing of a section of the installation planned for *Arts of the South Seas*, by René d'Harnoncourt, 1946

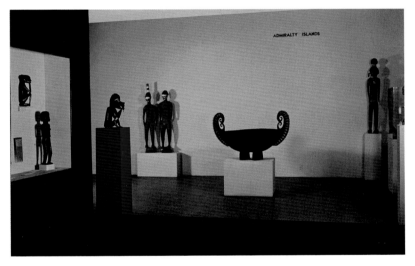

Drawing of the circulation plan for the exhibition *Arts of the South Seas*, by René d'Harnoncourt, 1946

Arts of the South Seas, installation views, 1946

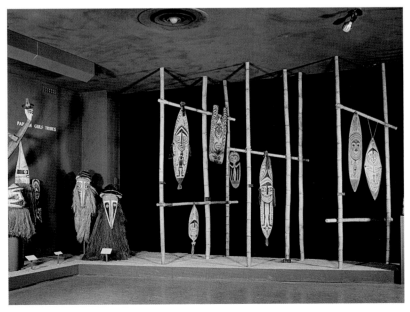

John Hay Whitney, Trustee and founder of the Film Library, is named Chairman of the Board in 1946.

Nelson A. Rockefeller begins a second term as President in 1946 (photograph 1950).

■ SECOND BOOK ON PICASSO

Cover of Alfred H. Barr, Jr.'s second book on Pablo Picasso, *Picasso: Fifty Years of His Art*, 1946

The first page of *Picasso: Fifty Years of His Art*, 1946, signed and embellished in 1952 with a drawing by Pablo Picasso and dedicated to Alfred H. Barr, Jr.

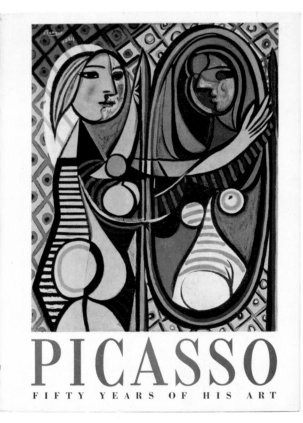

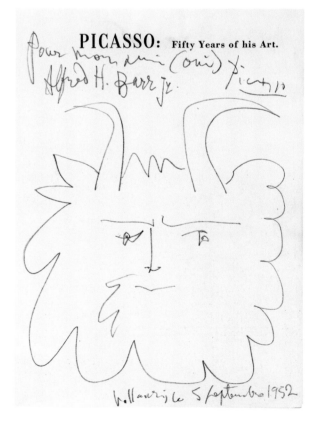

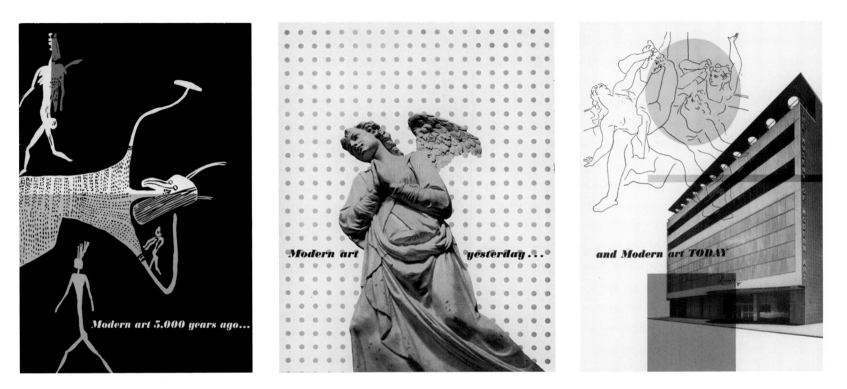

Fundraising brochure for a planned expansion of the Museum, 1946

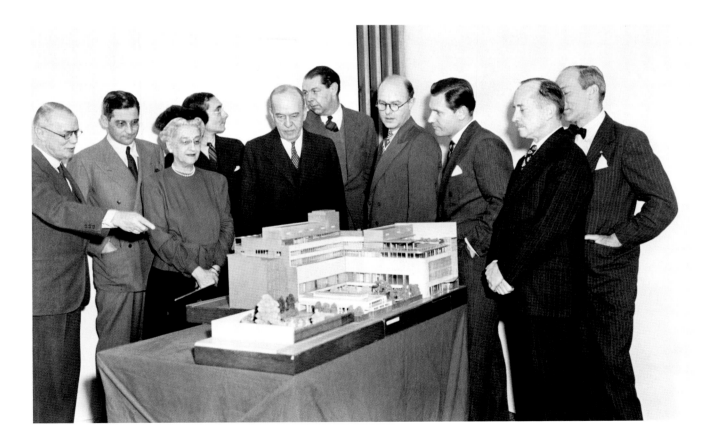

Expansion Committee with a model of the proposed addition to the Museum, 1946. Left to right: Philip L. Goodwin, James Thrall Soby, Mrs. Simon Guggenheim, Alfred H. Barr, Jr., Stephen C. Clark, René d'Harnoncourt, John E. Abbott, Nelson A. Rockefeller, Ranald H. Macdonald, Allen Porter. This proposed expansion was not executed.

— 1947

I think René is one of the great people. . . . I brought him to the Museum to pull the whole thing together at a time when it lacked a leader. That is the function he has brilliantly provided. He is not competitive with anyone else, which is quite an interesting thing in the art world. He has an extraordinary combination of the sophistication of the Old World and the drive and enthusiasm associated with the New World. He's one of those really cosmopolitan people whose range is without limit.
Nelson A. Rockefeller, 1960

René d'Harnoncourt is named Chairman of the Coordinating Committee and Director of the Curatorial Departments in 1947.

■ DEPARTMENT OF MUSEUM COLLECTIONS FOUNDED

René . . . loved and recognized genius, and . . . in spite of their endless and hopeless battles, nourished and helped Alfred Barr. He told me . . . "My duty at this museum is to preserve and nourish the genius of Alfred Barr." Alfred Barr became chief of the collection. The rest is history. The job of a museum is to have great pictures. And to the end of his working life, he helped make this museum what it is all over the world today.
Philip Johnson, 1981

Alfred H. Barr, Jr., left, named Director of a new Department of Museum Collections, with Curator Dorothy C. Miller and James Thrall Soby, Chairman of Painting and Sculpture, n.d.

■ EDWARD STEICHEN

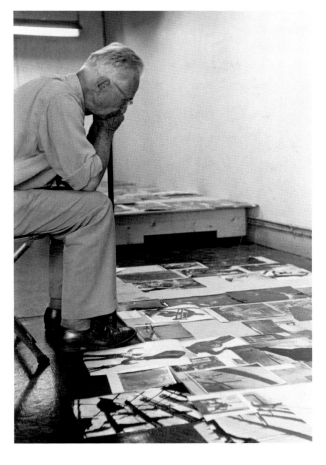

Nelson A. Rockefeller, President of the Museum of Modern Art, announces the appointment of Edward Steichen as Director of the Museum's Department of Photography. In announcing the appointment, Mr. Rockefeller said: . . . "Steichen . . . joins with the Museum of Modern Art to bring to as wide a public as possible the best work being done in photography throughout the world, and to employ it creatively as a means of interpretation in major Museum exhibitions where photography is not the theme but the medium through which great achievements and great moments are graphically presented."

Museum Press Release

Edward Steichen is named Director of Photography, 1947.

■ BERNARD KARPEL

Bernard Karpel is named Librarian of the Museum, 1947 (photograph 1942).

**FOR RELEASE MONDAY
SEPTEMBER 22, 1947**

In a joint statement Roland L. Redmond, President of The Metropolitan Museum of Art, John Hay Whitney, Chairman of the Board of The Museum of Modern Art, and Mrs. G. Macculloch Miller, President of the Whitney Museum of American Art, announced the execution of an agreement designed to coordinate the activities of the three museums in the interest of broader service to the public.

The agreement recognizes the primary interest of the Whitney Museum in American art, of the Museum of Modern Art in both American and foreign modern art, and of the Metropolitan Museum in older art which, for convenience, is referred to as "classic art". The three museums agree to consult together and to cooperate in presenting the most complete and informative exhibitions in their respective fields and to lend freely to each other objects of art which might be useful in showing the development of current trends or the relationship of modern to classic art. Other arts, such as architecture, the motion picture, photography and industrial design, are not involved in the present agreement.

Under the agreement the Metropolitan Museum will apply part of its purchase funds to the acquisition of certain of the earlier pictures and sculptures by artists represented in the collections of the Museum of Modern Art. Payment will be made over a period of years and the Museum of Modern Art will retain these objects of art as long as they remain significant in the modern movement in art or until the expiration of the agreement which is fixed at ten years, subject to renewal for longer periods. Included in this part of the agreement are important works by the following late 19th Century artists and 20th Century artists of the older generation: Cezanne, Despiau, Kolbe, Maillol, Matisse, Picasso, Redon, Rouault, Seurat and Signac and a number of unusual objects of American folk art given to the Museum of Modern Art by Mrs. John D. Rockefeller, Jr. The Museum of Modern Art is retaining for the present all of its important collection of modern American paintings.

With the funds thus received the Museum of Modern Art will be able to buy to a greater extent than heretofore the works of distinguished American and foreign artists and of younger artists whose reputations are not yet established. It will be recalled that during the last four years the Metropolitan Museum, under an arrangement with the Whitney Museum, has applied substantial sums out of the Hearn Fund to the purchase of American art. This arrangement is confirmed and the Whitney Museum will continue to develop its activities in the field of American art. Therefore, to a certain extent, the Museum of Modern Art and the Whitney Museum will be competing in buying contemporary American art, but this competition should prove beneficial to American artists and reduce the chance that new and promising talent will be overlooked.

In line with the policy of cooperation, the Museum of Modern Art will in the near future transfer to the Metropolitan Museum the painting by Daumier, *The Laundress,* left to the Museum of Modern Art by the late Lizzie P. Bliss. The Metropolitan Museum will reciprocate by depositing with the Museum of Modern Art certain modern works such as the large Maillol bronze *Chained Action* and Picasso's *Portrait of Gertrude Stein.*

While the parties expect the agreement will provide a permanent pattern for their mutual activities, they recognize that it is unwise to bind institutions indefinitely to a particular course of conduct and have, therefore, arranged that the agreement will terminate in ten years. It is anticipated that a new agreement of similar character will be made when this agreement or any renewal thereof terminates.

By this agreement the City of New York will be assured of an integrated art program. The Whitney Museum will remain solely a center for American art in the field of painting, drawing, prints and sculpture. The Museum of Modern Art will undertake the exhibition and collection of modern art of all kinds, both American and foreign, and as its collections become classic will transfer them to the Metropolitan Museum. The Metropolitan Museum will have great collections of modern art made available to it when they become appropriate for exhibition in a classic museum. Finally, collectors of modern art who wish to make their collections available to the public will be assured of fitting homes for them, first in the Museum of Modern Art and later in the Metropolitan Museum.

Press release announcing the Inter-Museum Agreement among The Museum of Modern Art, the Whitney Museum of American Art, and The Metropolitan Museum of Art, 1947, intended to allow the Metropolitan Museum to acquire a number of older works of painting and sculpture from the collections of the two modern museums, freeing them to concentrate on more contemporary acquisitions. This agreement, by which such works as Picasso's *Woman in White,* formerly in the Bliss Collection, entered the collection of the Metropolitan Museum, was terminated in 1953.

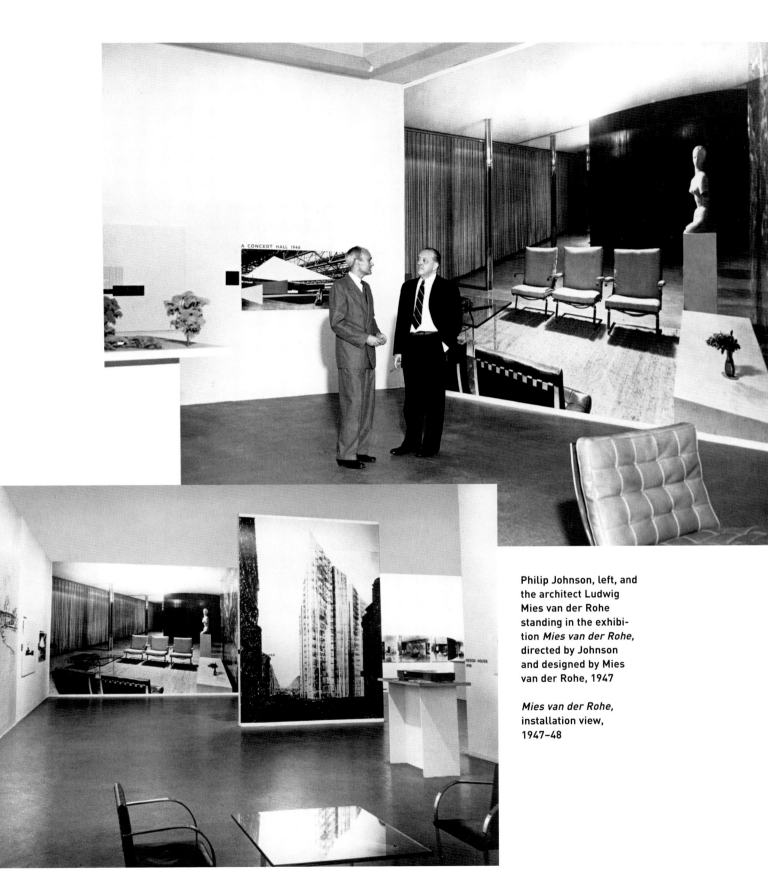

Philip Johnson, left, and
the architect Ludwig
Mies van der Rohe
standing in the exhibi-
tion *Mies van der Rohe*,
directed by Johnson
and designed by Mies
van der Rohe, 1947

Mies van der Rohe,
installation view,
1947–48

1948

THE MUSEUM OF MODERN ART

Date___APRIL 29, 1948___

To: THE STAFF Re:_____

From: SECRETARY'S OFFICE _____

The following is a resolution presented on behalf of the staff of the Museum of Modern Art by Mr. d'Harnoncourt at the Trustees meeting of April 8, 1948 to honor the death of Mrs. John D. Rockefeller, Jr.

Deeply moved by the death of Mrs. John D. Rockefeller, Jr., the staff of the Museum of Modern Art wishes to join its Trustees in paying tribute to a beloved benefactor and devoted friend.

Ever since the inception of the Museum, Mrs. Rockefeller, as one of its founders and most generous patron, has given us guidance and constant encouragement in our task. Hers was the gentle strength of faith and the true graciousness that comes from the heart. Mrs. Rockefeller loved art and wanted her fellow men to share her enjoyment of beautiful things. She was passionately interested in American painting of the past and present, and it was due to her efforts that the living values of American folk art were rediscovered. She encouraged young painters and helped us to do so. She recognized the constant need for progress and rejuvenation in the arts and encouraged us to seek out new talent and new ideas even beyond the limits of her own predilections.

Mrs. Rockefeller deeply believed in art as a means to enrich our lives and gave her support to any activity aimed at its humanitarian use. She was largely instrumental in the formulation of the Armed Services Program and the Veterans' Art Center.

In Mrs. Rockefeller the world has lost one of the truly great patrons of art of all time. Yet her generosity and devotion to the cause was so selfless that even we who were privileged to work with her will never realize the full extent of her contribution.

Tribute to Abby Aldrich Rockefeller on her death, sent to the Museum staff by René d'Harnoncourt on behalf of the Trustees, 1948

Dear Nelson . . . During the first years of the Museum . . . I used to see your mother constantly. I think the Museum interested her more than anything else; except her family. She thought about it continually and worried about it and planned for it even though she kept herself modestly in the background. . . . There are two qualities your mother had I like especially to remember, beside her generosity and kindness—these were her courage and a very special virtue which one might call statesmanship if that were not too pretentious-sounding a term. In her position, the outside world took for granted that she could do almost anything her wealth and power would permit. This being so, few realize what positive acts of courage her interest in modern art required. Not only is modern art artistically radical but it is often assumed to be radical morally and politically, and sometimes indeed it is. But these factors which might have given pause to a more circumspect or conventional spirit did not deter your mother, although on a few occasions they caused her anxiety, as they did us all. She had courage, too, and enthusiasm and imagination in carrying through the plan for the Museum. For instance, it was to her I used to turn for support in keeping the idea of a great collection alive in the minds of the Trustees; and when the businessmen on the board were reluctant and discouraging about the Film Library it was she who called the meeting to launch that flourishing department. . . . She showed her statesmanship in the way she kept the Museum together. She was the heart of the Museum, its center of gravity—and the museum while it is a great magnet is also strongly centrifugal: ideas and people tend to slip away from its spinning center and be flung off its edge. The Museum has attracted many people who were by turns generous and mean, enthusiastic and capricious. Your mother . . . helped people to forget their pettiness and recapture their vision of the museum's high goal. This she could do not only because of her position in the world but even more because she had grand vision herself. She could take the long view, the high view— and induce others to see what she saw.

Alfred H. Barr, Jr.

— 1949

Master Prints from the Museum Collection, installation view of an exhibition inaugurating The Abby Aldrich Rockefeller Print Room, named in honor of its benefactor, 1949. Mrs. Rockefeller had donated her collection of 1,600 prints to the Museum in 1940.

■ RENÉ D'HARNONCOURT NAMED DIRECTOR

René had inexhaustible patience. He was able to direct a complicated institution without seeming to do very much. He waited, and while he was waiting he prepared for the moment when people would discover for themselves the ideas he had long since fixed upon as appropriate, and inevitable, to the future of this Museum. . . . René sparkled with so much enthusiasm for this Museum that everyone in his presence felt it a privilege to be involved.
Arthur Drexler, Director of Architecture and Design (1956–1986), 1968

René d'Harnoncourt is named Director of the Museum, 1949 (photograph 1950s).

■ THE HOUSE IN THE MUSEUM GARDEN

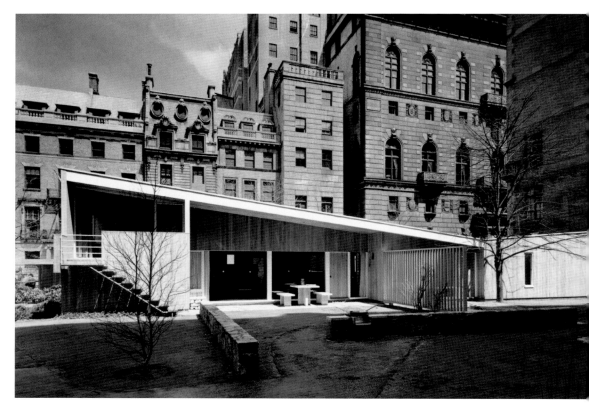

The House in the Museum Garden under construction, 1949

Marcel Breuer's House in the Museum Garden, a small house constructed on the eastern end of the Museum sculpture garden, 1949

■ ANDREW CARNDUFF RITCHIE

Andrew Carnduff Ritchie is named Director of Painting and Sculpture, 1949 (photograph 1954).

The Junior Council was formed in 1949. There are various stories of why it came into being, and one was that Alfred Barr wanted a way of getting all these Young Turks sort of contained and out of his hair . . . on the other hand, he knew that some would be trustees, so he made a structure for them to participate in the life of the Museum. . . . You had to be introduced by a member, and then you had to go through a couple of interviews. . . . Then you did an apprenticeship, always in the Art Lending Service [begun in 1951]. . . . In those days, we really functioned as the education department. There was no education department at the Modern, aside from Victor D'Amico's school, which was a different kettle of fish altogether. If there was a lecture series at the Museum, it was the Junior Council who did it. . . . There were some incredibly distinguished programs. . . . We were the ones who started publishing Christmas cards and objects, and the Junior Council published the Calendar.

Barbara Jakobson, Trustee, 1997

The Junior Council of the Museum of Modern Art held its first meeting on Tuesday, February 8, 1949, at the home of Mrs. John D. Rockefeller, III.

Present were: Mrs. Rockefeller, Chairman; Mr. Allwood, Mr. Bach, Mr. Braden, Mrs. Clark, Mrs. Erskine, Mr. Goldman, Miss Hochschild, Mr. Ireland, Mr. Knittel, Mrs. Lockwood, Mrs. Meyer, Mrs. Noyes, Miss Resor, Mrs. Rumbough, Mrs. Smith, Mrs. Straus, Mr. Swope, Mr. Warren.
Museum Trustees: Mr. Clark, Mr. Nelson Rockefeller, Mr. Soby, Mr. Wheeler.

Mrs. Rockefeller welcomed the members of the Junior Council and the Museum Trustees who were present.

The purpose of the Council, she explained, is to bring together a group of younger people who have a common interest in the arts and a desire to see them fostered soundly and liberally in this country.

Specifically, the group will study the broad range of activities undertaken in various fields by the Museum of Modern Art, will help to further these activities, and will apply its knowledge and understanding of them toward the constructive criticism of the Museum's work and the friendly interpretation of that work to the public and the art world.

She asked the members present to consider themselves a permanent organization, although she pointed out that she thought it would be well eventually to set an upper age limit to membership in order to keep the group young, and she asked the members to be on the lookout for younger people with promise and intellectual attainment.

She explained that the members of the Council will be appointed technically by the President of the Museum, and that, later on, various of the members may be asked to serve in rotation on other committees within the Museum.

The Chairman suggested that the group meet on Tuesdays once every three weeks, and the group agreed that 5:00 would be the most convenient hour.

Mrs. Rockefeller then said that she had planned an agenda for the rest of this year on the assumption that the members would want to acquaint themselves thoroughly with the Museum's history and accomplishments before undertaking a program of their own. She suggested that the next meeting

Minutes of the first meeting of the Junior Council of The Museum of Modern Art, 1949

Artworks are borrowed by Members through the Art Lending Service of the Junior Council, one of its many activities.

1950

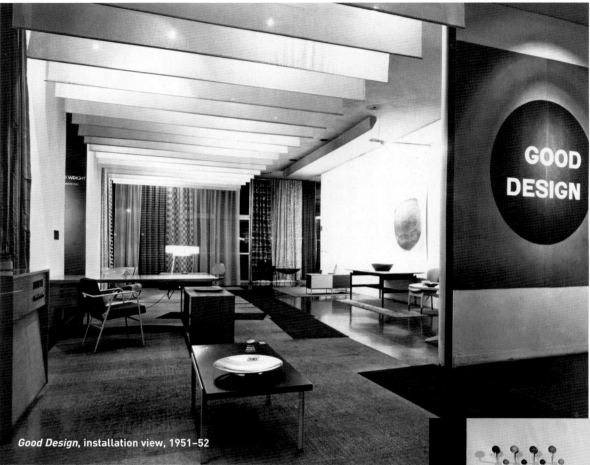

Good Design was an
annual series of exhibi-
tions jointly sponsored
by the Museum and The
Merchandise Mart in
Chicago, and shown in
both cities. The series
ended in 1955.

Good Design, installation view, 1951–52

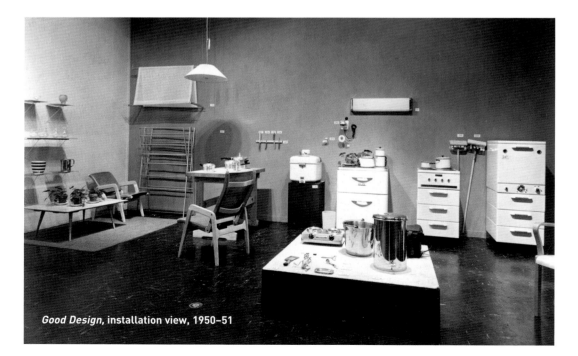

Good Design, installation view, 1950–51

Edgar Kaufmann, Jr.,
Director of the Good
Design Project at the
Museum, and architect
Alexander Girard in-
stalling the exhibition
Good Design, 1953

1951

Trustees of the Grace
Rainey Rogers Fund.
Left to right: Mattias
Plum, Richard W. Reese,
and Harrison Tweed,
presenting a check to
René d'Harnoncourt,
Director, and John Hay
Whitney, Chairman of
the Board, for the Grace
Rainey Rogers Memorial
Building to be erected
at 21 West 53 Street,
c. 1949

Although the Museum had cancelled its . . . plan to construct a new wing by Goodwin, the need for additional space remained. Two years later, plans were underway for a more modest addition: the Grace Rainey Rogers Annex at 21 West Fifty-third Street, immediately west of the Goodwin–Stone building. . . . A sliver of a building roughly twenty feet wide, it was sandwiched between the Museum and an adjoining townhouse; its rear wall abutted the new Whitney Museum of American Art building at 22 West Fifty-fourth Street, the design of which was contemporaneous with the annex. The glass facade was defined by a Miesian grid of thin, decorative iron mullions expressive of the underlying steel skeleton and displayed in a clarity and discipline typical of Mies's Chicago projects of the same period. . . . The quiet rhythm of the facade and vertical emphasis formed a stark contrast to neighboring buildings: a French Renaissance townhouse to the west, and the marble- and Thermolux-sheathed Museum to the east, whose strict horizontality, underscored by ribbon windows and the sixth-floor balcony, was terminated by the vertical lines of the annex.

Peter Reed, Curator of Architecture
and Design, 1998

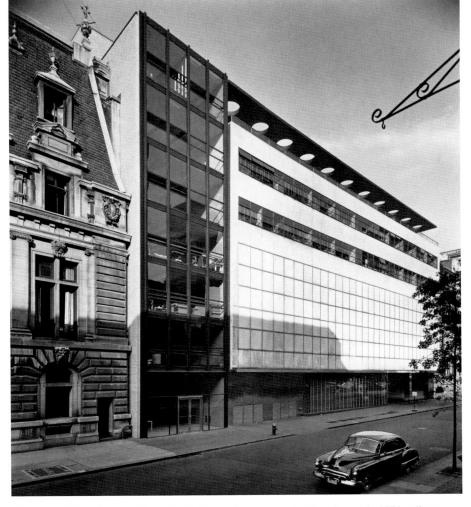

The Grace Rainey Rogers Memorial Building, designed by Philip Johnson in 1951, adjacent to the Goodwin–Stone Building. Mr. Johnson's steel-and-glass structure was known as the 21 Building (photograph 1953).

▤ MATISSE: HIS ART AND HIS PUBLIC

Matisse: His Art and His Public, by Alfred H. Barr, Jr., 1951. Cover design by Henri Matisse

Matisse: His Art and His Public, the recently published monograph by Alfred H. Barr, Jr., is based on a plan wisely laid down a long time ago by a man who knows what he is talking about. The author was fitted for this task by every possible endowment: loving and understanding painting, he has always sponsored and spread knowledge of it. His book, at once varied and exact, may be said to constitute a summation of all the comments furnished by the critics, the artist himself, his friends and his collectors. And it is as an art historian that Mr. Barr has followed, year by year, the development of an exceptionally rich career—Matisse's sixty years of eight hours' daily work. Mr. Barr's study is written with such economy of detail that it never evokes the slightest weariness on the part of the reader, who at every period of the artist's life is always eager to keep on reading further. . . . Everything is recounted with precision and integrity. This is a book that lacks nothing.

René Gaffé, Belgian Art Collector, 1952

▤ FIRST AUTOMOBILE EXHIBITION

Arthur Drexler, left, hired as Curator of Architecture in 1951, with Philip Johnson (photograph 1956)

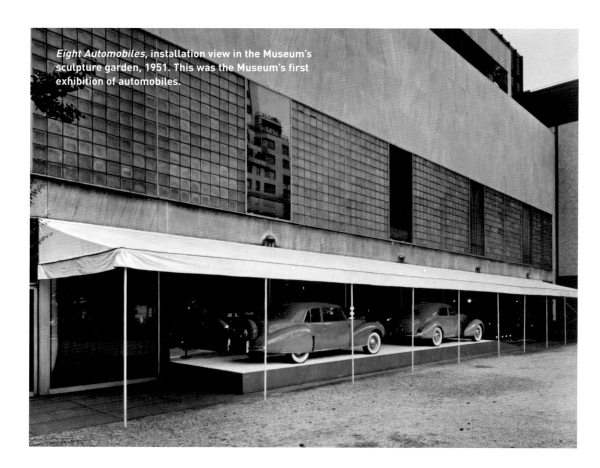

Eight Automobiles, installation view in the Museum's sculpture garden, 1951. This was the Museum's first exhibition of automobiles.

Automobiles are hollow, rolling sculpture. They have interior spaces corresponding to an outer form, like buildings, but the designer's esthetic purpose is to enclose the functioning parts of an automobile, as well as its passengers, in a package suggesting directed movement along the ground.

Arthur Drexler

1952

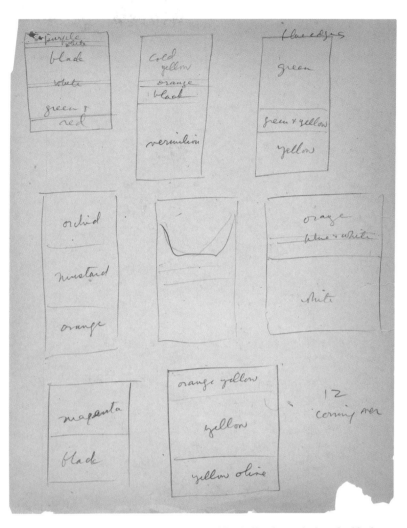

Letter to Dorothy C. Miller, director of the exhibition 15 Americans, from Jackson Pollock thanking her for his representation in the show, dated April 14, 1952

Handwritten notes by Dorothy C. Miller, 1951, indicating paintings by Mark Rothko for 15 Americans

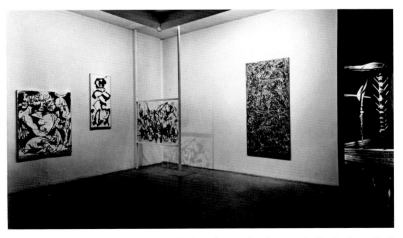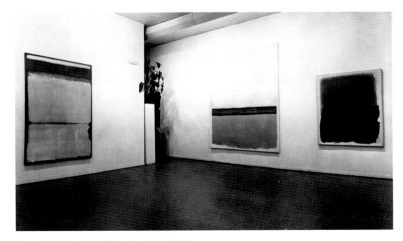

The exhibition 15 Americans, installation views, showing works by Jackson Pollock at left and by Mark Rothko at right, 1952

Porter McCray, named Director of the Museum's International Program, departing for Bonn, West Germany, for an international conference, 1952

Map illustrating the extent of the Museum's International Program by 1959. This didactic display was shown in conjunction with the New York showing of the exhibition *The New American Painting.*

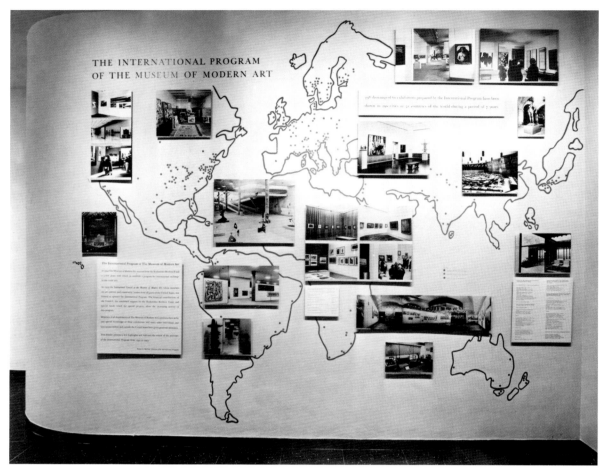

René d'Harnoncourt, second from right, with crates containing works of art to be shipped to the Musée du Louvre, Paris, for the exhibition *Seurat Paintings and Drawings*, 1958

U.S. Pavilion at the XXVII Venice Biennale, 1954. The American representation at Venice was organized by Andrew Carnduff Ritchie, Director of Painting and Sculpture (1949–57), and Trustee James Thrall Soby, under the auspices of The International Program.

1953

There were very few paintings by Americans in museums in Europe when the International Council began. The Europeans thought that America was nothing but bubble gum and Cadillacs.
Elizabeth Bliss Parkinson

Mrs. John D. Rockefeller 3rd, left, the first President of The International Council (1953–57), and Elizabeth Bliss Parkinson, right, the second President (1957–66), in 1957

Ambassador and Mrs. John Kenneth Galbraith with a painting by the American artist Grace Hartigan in the American Embassy Residence, New Delhi, India, 1963. The work was lent to the Residence as part of the Art in Embassies Program of The International Council.

The trustees of the Museum propose to form an International Council which will bring together leading members of communities throughout the United States and abroad. . . . in furthering the cause of modern art in contemporary society. The new Council's program would provide for the interchange of ideas and the exchange of cultural materials which would lead to greater understanding and mutual respect among nations. Many national governments have recognized this need and supplied official means for this exchange. Our own government generally has left this responsibility to individual enterprise. . . . The Museum of Modern Art has initiated a large-scale program providing for the sending abroad and the circulation within the United States of exhibitions dealing with most of the aspects of modern art. . . . If this job is to be done right, it must have the counsel and assistance of community leaders who strongly believe in its aims.
Blanchette Hooker Rockefeller (Mrs. John D. Rockefeller 3rd)

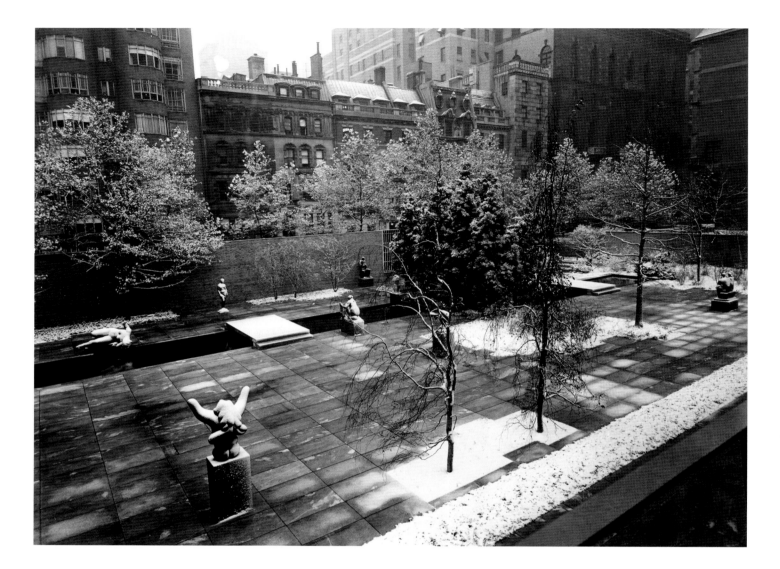

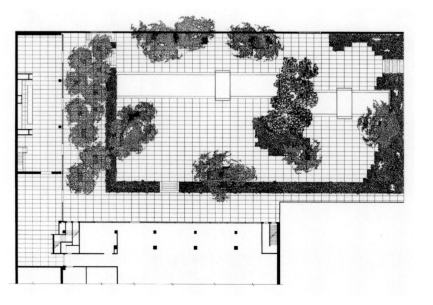

The Abby Aldrich Rockefeller Sculpture Garden, designed by Philip Johnson. View toward West Fifty-fourth Street, 1953

Plan of The Abby Aldrich Rockefeller Sculpture Garden, 1953

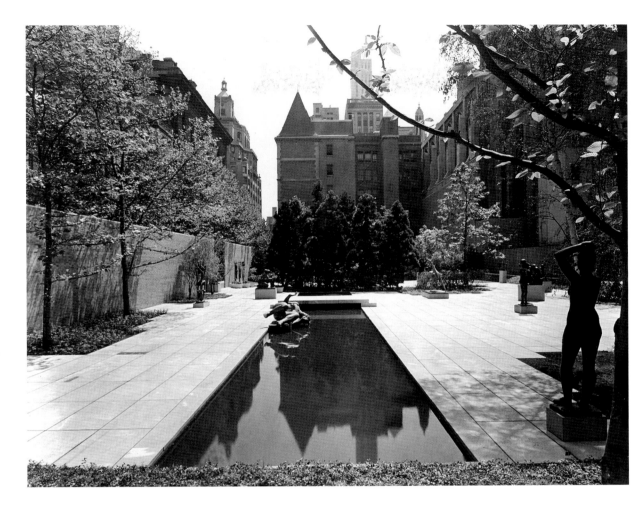

The Abby Aldrich Rockefeller Sculpture Garden. View toward the east, 1953

The Abby Aldrich Rockefeller Sculpture Garden. View south toward the rear facade of the Museum, 1953

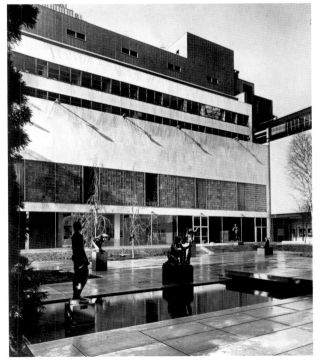

When the Trustees decided to build a wholly new sculpture garden in memory of Mrs. John D. Rockefeller, Jr. . . . they turned to Philip Johnson. . . . A roofless room is what he has always called his Museum garden—a room with sky above, high walls around, and two distinct floor levels. The upper is an L-shaped terrace which carries the floor planes of the Museum and the restaurant out beyond the glass to join inside with outside and so expand the sense of space and freedom within the buildings. Two feet below this entrance-and-dining terrace is the main sculpture garden, defined on the north by a high brick wall. . . . "What I did," Johnson says, "was to make a processional, using canals to block circulation and preserve vision, greenery to block circulation and block vision too, and bridges to establish the route. Always the sense of turning to see something. The garden became a place to wander, but not on a rigidly defined path."
Elizabeth Kassler, 1975

1954–1964: MASTERS OF MODERN ART

—1954

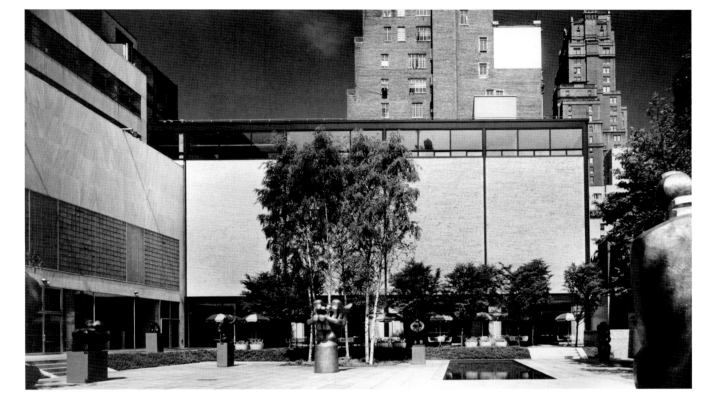

The Whitney Museum of American Art, designed by Philip Johnson, adjacent to The Museum of Modern Art on the west side of The Abby Aldrich Rockefeller Sculpture Garden, 1954

■ NEW GARDEN RESTAURANT

The Museum's Garden Restaurant, designed by Philip Johnson, 1954, on the ground floor of the Whitney Museum building

"The World of Modern Art: Twenty-fifth Anniversary, The Museum of Modern Art."
Poster by Leo Lionni, 1954

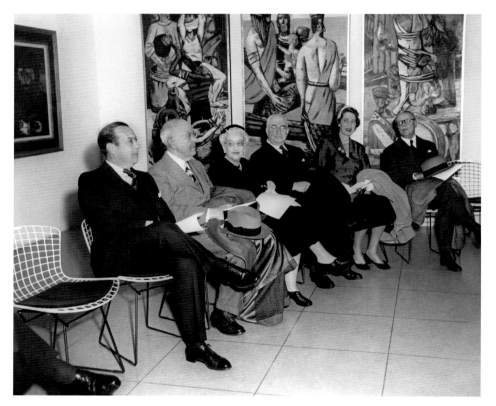

Opening ceremony for *XXVth Anniversary Exhibitions: Paintings from the Museum Collection*, 1954–55. Left to right: Mayor Robert F. Wagner and Trustees Stephen C. Clark, Mrs. Simon Guggenheim, Paul J. Sachs, Mrs. John D. Rockefeller 3rd, and Philip L. Goodwin, October 19, 1954

The public response to the Anniversary Program as reflected in the record attendance, the all-time high of membership, the increased gifts to the Museum and the extensive coverage of its activities by newspapers, magazines, radio and television both in the United States and abroad, was highly gratifying. . . . In almost every case, writers or commentators paid tribute to the fact that in only a quarter century . . . the Museum has established itself as an institution of national and international importance. Like all milestones, the Twenty-Fifth Anniversary provided an opportunity for a review of the past and, even more important, for a look at the Museum's future in the light of its achievement to date. The formation of a great collection entails responsibility for its best use; a notable record of exhibitions and publications is an incentive to do more than merely maintain the standards of the past, by constantly seeking imaginative new solutions to meet changing needs. As we move into our second quarter century, we feel the obligation to make wise and effective use of the resources and experience that we have acquired in growing to maturity, while still retaining the ideals and the broad vision of our founders, and the venturesome spirit of our formative years.

René d'Harnoncourt, 1956

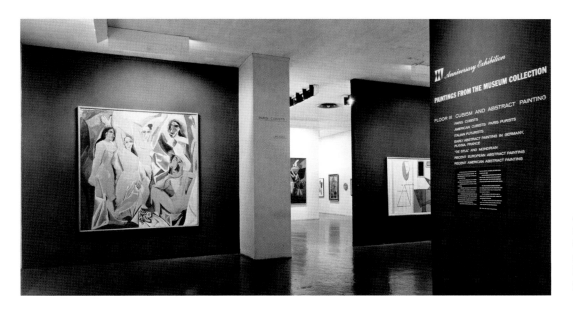

XXVth Anniversary Exhibitions: Paintings from the Museum Collection, 1954–55, installation views of first and third floors

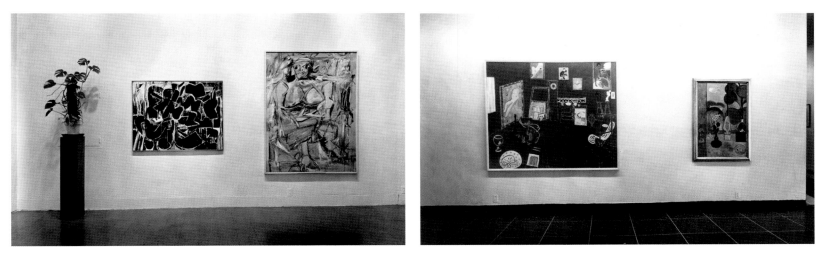

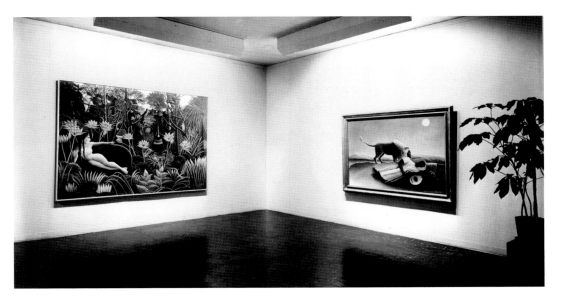

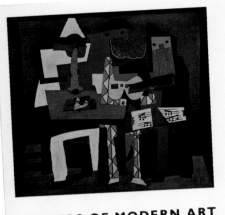

Masters of Modern Art, **edited by Alfred H. Barr, Jr., 1954. Published for the Museum's twenty-fifth anniversary, this book features a representative selection of the best works in all the curatorial departments in the collection.**

In the autumn of 1929, even before it opened its doors to the public, the Museum of Modern Art began to form its collection. Today in its manifold departments, the collection numbers many thousands of works of art. A few of the best or most characteristic are reproduced here, more to give pleasure than for any systematic exposition or record. Even more, this picture-book is an invitation to see the originals! . . . The Museum collects works radically different in purpose, medium, school and generation. . . . Even granting that the Museum should collect works of many kinds, there is still the problem of choosing the best of each. Quality, of course, should be and has been the first criterion. . . .

The Museum's Trustees, Committees and Staff are responsible for acquisitions to the collection. Ordinarily the heads of the curatorial departments after consultation with the director of the collections make recommendations to the Committee on Museum Collections, composed largely of Trustees. The Committee chairman then reports to the Board of Trustees. Anyone, however, may propose an acquisition for the collection, either as a gift or a purchase. The Museum Collection has been a loyal collaboration.

Alfred H. Barr, Jr.

▤ COMMITTEE ON MUSEUM COLLECTIONS

A meeting of the Committee on Museum Collections in the mid-1960s. Those present include William S. Lieberman and Alicia Legg (far left), Wilder Green and Elizabeth Shaw (center rear), Walter Bareiss, Mrs. John D. Rockefeller 3rd, and Mildred Constantine (center foreground), and Elizabeth Bliss Parkinson and Dorothy C. Miller (far right).

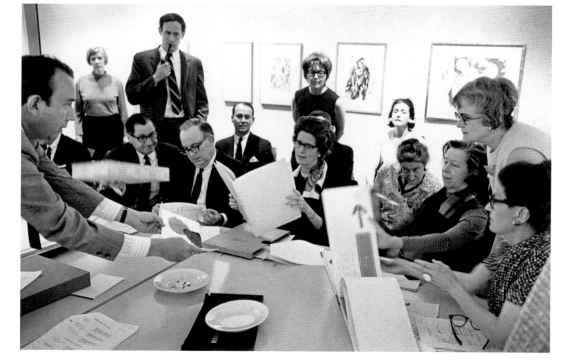

■ JAPANESE EXHIBITION HOUSE

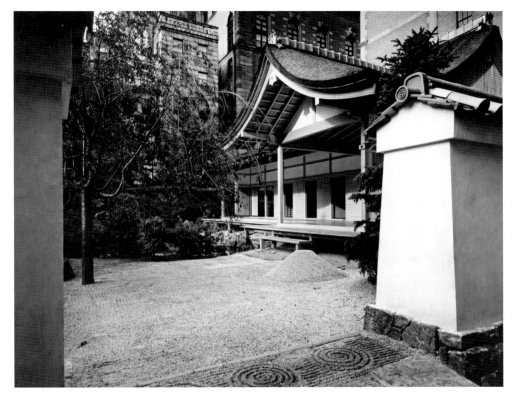

Japanese Exhibition House, exterior view at the east end of the Museum garden, installed in the summers of 1954 and 1955

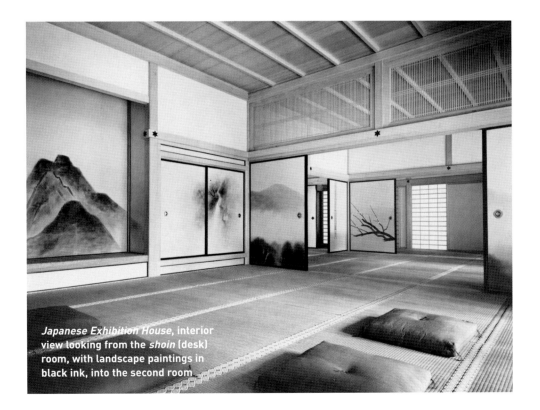

Japanese Exhibition House, interior view looking from the *shoin* (desk) room, with landscape paintings in black ink, into the second room

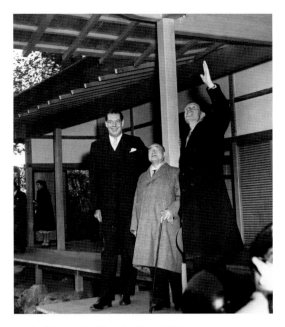

Left to right: Director René d'Harnoncourt, Japanese Prime Minister Shigeru Yoshida, and John D. Rockefeller 3rd, standing at the entrance to the *Japanese Exhibition House,* November 7, 1954

The Museum's Japanese Exhibition House was made in Nagoya in 1953. Together with all accessories it was shipped to the United States in 700 crates. Among the items included were prefabricated panels of *hinoki* (cypress) bark shingles for the roof, lanterns, fences, furnishings, and kitchen utensils, stones of all sizes and coarse white sand for the gardens. The entire building was reassembled in the Museum's garden under the supervision of the architect, Junzo Yoshimura, with the assistance of four craftsmen trained for this project in Japan. . . . A Japanese building was chosen by the Museum . . . because traditional Japanese design has a unique relevance to modern Western architecture. The characteristics that give it this relevance are post and lintel skeleton frame construction; flexibility of plan; close relation of indoor and outdoor areas; and the decorative use of structural elements.
Arthur Drexler

■ MONUMENT TO BALZAC ACQUIRED

1955

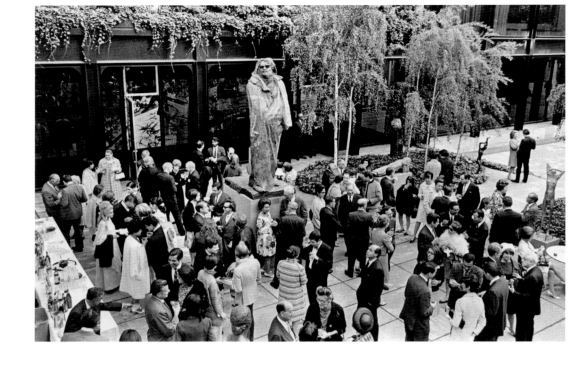

Auguste Rodin's *Monument to Balzac*, 1897–98 (cast 1954), a gift to the Museum in memory of Curt Valentin by his friends in 1955, dominates a party held in The Abby Aldrich Rockefeller Sculpture Garden in the mid-1960s.

■ THE FAMILY OF MAN

The Family of Man, edited by Edward Steichen with texts by Carl Sandburg, published in 1955 to accompany the exhibition. Cover design by Leo Lionni. This book, issued in many subsequent editions, has sold more than 2 million copies.

The Family of Man, installation view, 1955. Five copies of the exhibition were seen at eighty-eight venues in thirty-seven countries; the tour was sponsored by the U.S. Information Agency, which estimated that a total of 7.5 million people had seen it on its travels.

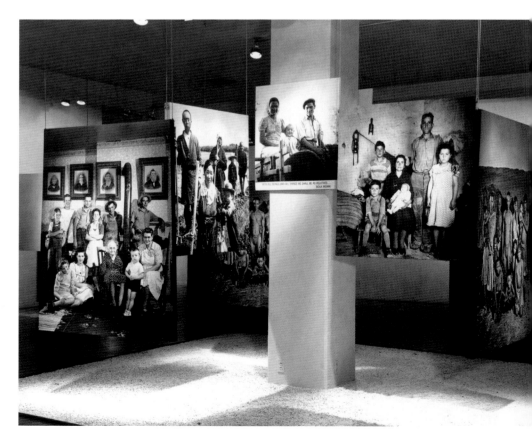

ARTHUR DREXLER

1956

Arthur Drexler, Curator of Architecture, is named Director of the Department of Architecture and Design, 1956 (photograph 1960s).

TEXTILES U.S.A.

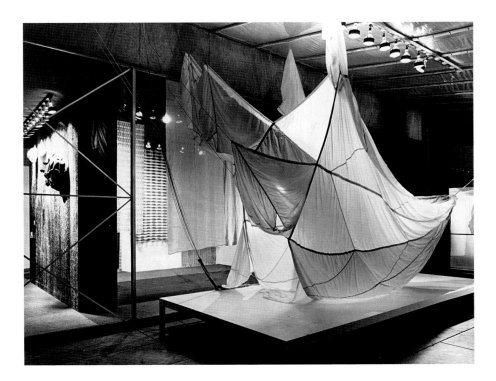

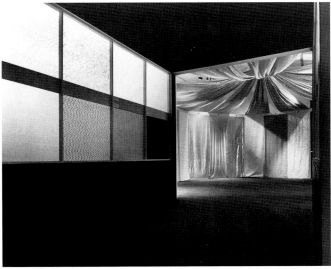

Textiles U.S.A., installation views, 1956

1957

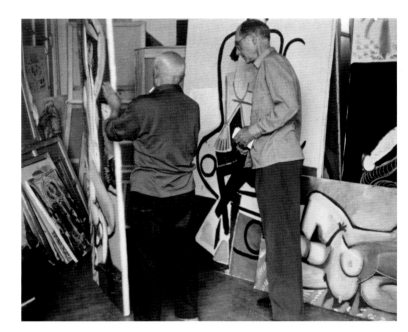

Pablo Picasso, left, and Alfred H. Barr, Jr., at La Californie, the painter's home in Cannes, France, July 1956, reviewing paintings for inclusion in the exhibition *Picasso: 75th Anniversary*

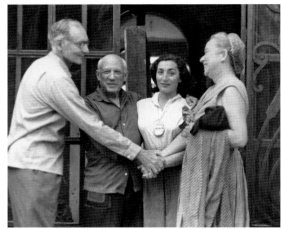

Left to right: Alfred H. Barr, Jr., Pablo Picasso, Jacqueline Roque, and Margaret Scolari Barr at La Californie, July 1956

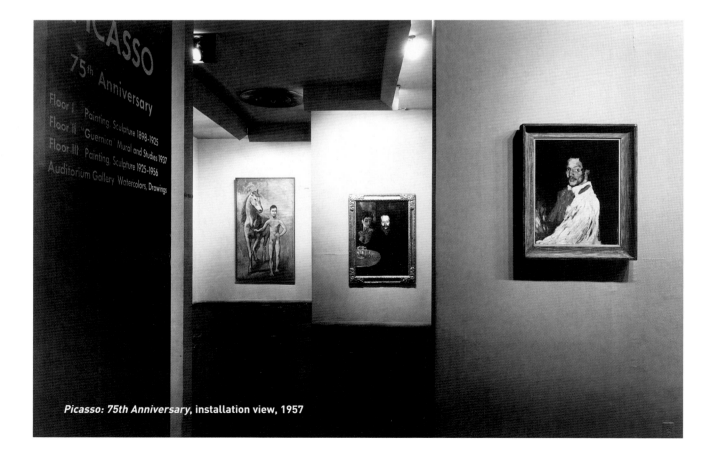

Picasso: 75th Anniversary, installation view, 1957

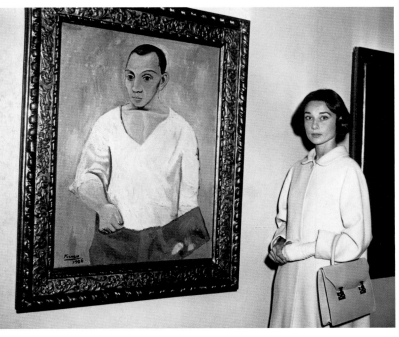

The actress Audrey Hepburn, a visitor to the exhibition *Picasso: 75th Anniversary*, standing next to a 1906 self-portrait by Pablo Picasso, 1957

Silkscreened silk tie sent to Alfred H. Barr, Jr., in a hand-decorated envelope by Pablo Picasso, 1957

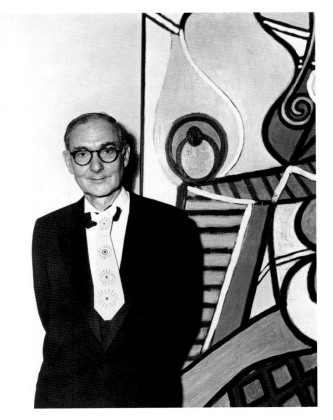

Alfred H. Barr, Jr., wearing a hand-decorated paper version of Picasso's tie at the opening of the exhibition *Picasso: 75th Anniversary*, 1957

1958

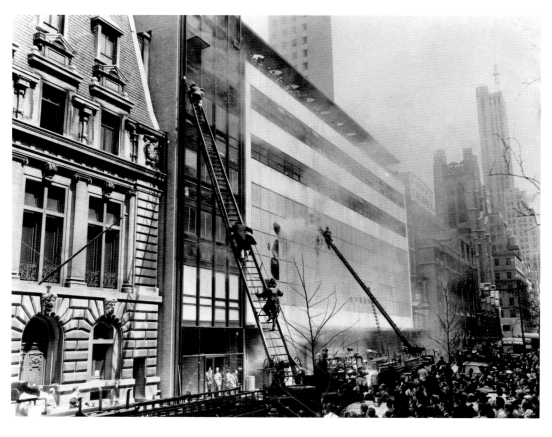

Newspaper photograph of firemen at work at the Museum on April 15, 1958. The original caption reads: "Dense smoke pours from The Museum of Modern Art, New York City, as firemen carry persons down ladder to safety from adjacent structure where they had been trapped by smoke. The blaze broke out in a second floor gallery of the Museum during the noon hour. An unknown number of men and women were trapped inside the adjacent structure which is attached to the ultra-modern Museum."

Cartoon by Alan Dunn in *The New Yorker* magazine, November 1, 1958

Just before one p.m. on April 15, 1958, I was sitting at my desk. I smelled smoke and then saw it rolling along the floor, having risen up the stairwell from the second floor, which had been closed for the installation of air conditioning. The superintendent told me *the fire* wasn't serious and that everything was under control. I descended to the ground floor, where our registrar, Dorothy Dudley, was already removing paintings by Juan Gris. On the third floor I found René [d'Harnoncourt] supervising the rescue of our sublime Seurat exhibition and its removal to the then adjacent Whitney Museum. There I met Nelson [Rockefeller]. The firemen would not let us in unless we put on their safety helmets; Nelson happily wore his. . . .

A memory which still touches me is that the crowd of on-lookers behind a police barrier on the south side of 53d Street, looking up into the smoke with the strangest expressions on their faces—curiosity, excitement, fear and love of the museum. One or two at a time some of them crossed the street to the office entrance and silently laid a dollar or five or ten on the desk of the receptionist and went away.

Monroe Wheeler, 1979

"They can't blame that on the fire."

■ PETER H. SELZ AND WILLIAM C. SEITZ

After the resignation of Andrew Carnduff Ritchie as Director of Painting and Sculpture in 1957, William C. Seitz, left, and Peter H. Selz shared curatorial responsibilities in the Department of Painting and Sculpture Exhibitions from 1958/60 to 1965.

■ ROCKEFELLER GUEST HOUSE

Exterior view of the Rockefeller Guest House, designed by Philip Johnson for Mrs. John D. Rockefeller 3rd in 1948–50 on East Fifty-second Street and donated to the Museum in 1958

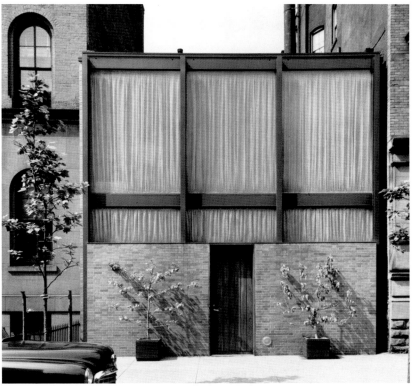

Interior view of the Rockefeller Guest House

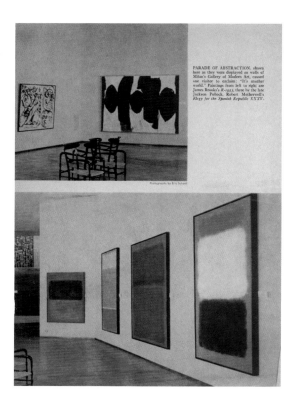

Page from "Parade of Abstraction," an article on the touring exhibition *The New American Painting* in *Time* magazine, August 4, 1958

Working its way through Europe this summer is one of the most explosive and controversial art shows in decades. Called "The New American Painting" and financed by the International Council at Manhattan's Museum of Modern Art, the exhibition is the first long, mass look Europeans have had at the leaders of the abstract expressionist movement. Billed by its partisans as the first home-grown art movement to rate international recognition, "The New American Painting" is getting cheers from most younger painters, cries of outrage from many critics, nibbles from some collectors and a monumental amount of bafflement from the general public.
Time Magazine

The [International] Council was barely five years old when it supported two controversial exhibitions that provided Europe with its first full-scale look at American Abstract Expressionism. *The New American Painting* was flawlessly directed by Dorothy C. Miller, Curator of Museum Collections, with the help of the poet Frank O'Hara, then on the Program's staff. This exhibition, which traveled to eight European cities in 1958–59, would become a benchmark in the development of Abstract Expressionist painting in Europe. *Jackson Pollock 1912–1956* was organized by Mr. O'Hara in 1957 for the São Paulo Bienal, and its subsequent European tour served as a tribute to Pollock after the artist's death.
International Council Report, 1993

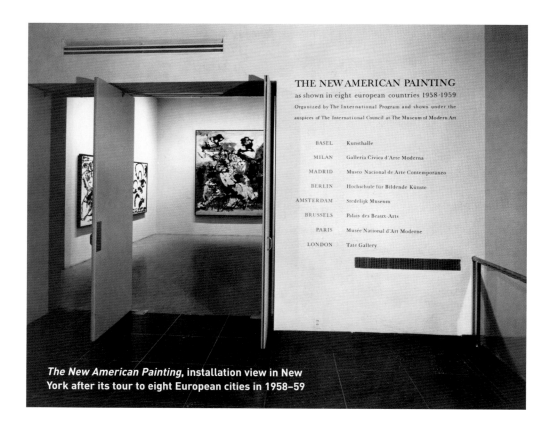

The New American Painting, installation view in New York after its tour to eight European cities in 1958–59

WATER LILIES TRIPTYCH ACQUIRED

1959

Claude Monet's *Water Lilies*, c. 1920, a triptych acquired by the Museum in 1959 through the Mrs. Simon Guggenheim Fund, being installed in the galleries by Rudolph Simacek, Master Carpenter, Jean Volkmer, Conservator, and Donald Dean, Production Manager

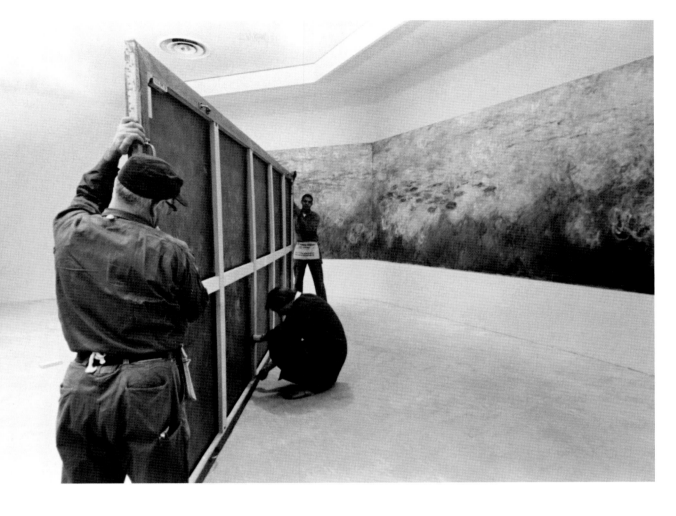

CHANGE IN LEADERSHIP

Mrs. John D. Rockefeller 3rd, named President of the Museum in 1959, with outgoing President William A. M. Burden (photograph 1962)

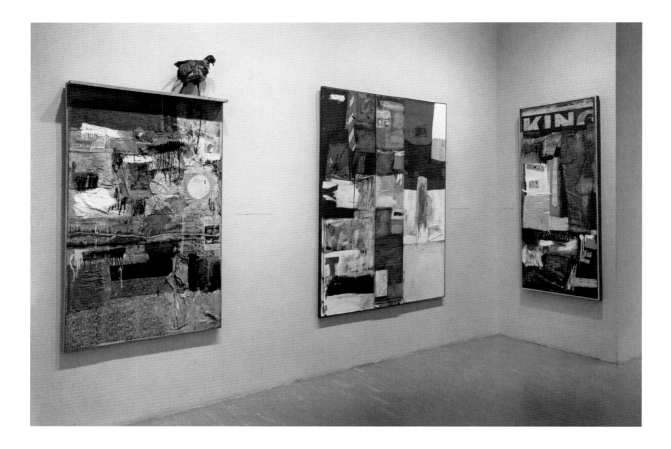

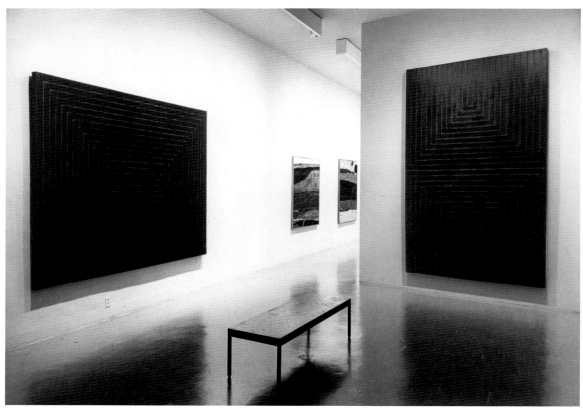

Sixteen Americans, installation views, 1959–60. This historic exhibition showed work by artists of the post–Abstract Expressionist generation for the first time at the Museum, among them, this page: Robert Rauschenberg and Frank Stella, and opposite: Jasper Johns and Ellsworth Kelly.

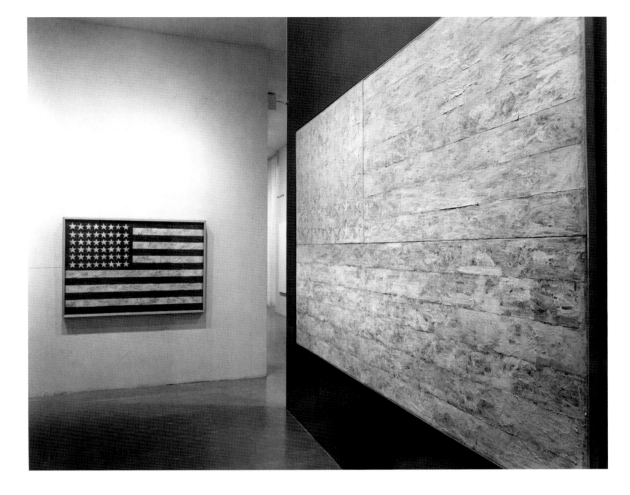

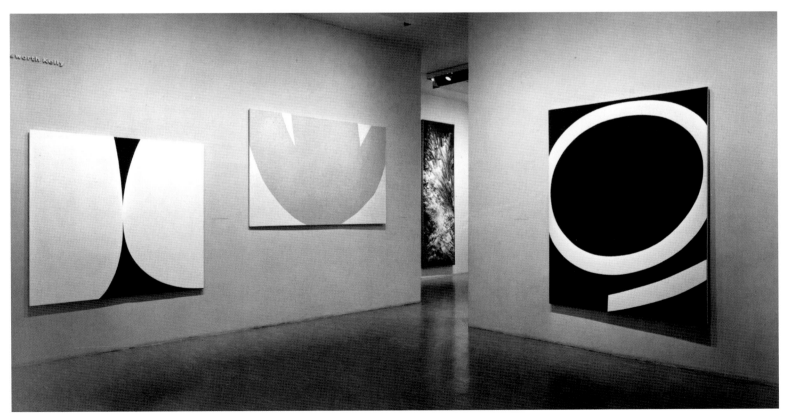

▪ JOAN MIRÓ

Cover of catalogue for the exhibition *Joan Miró*, by James Thrall Soby, 1959. Design by Joan Miró

Joan Miró with his catalogue and James Thrall Soby, 1959

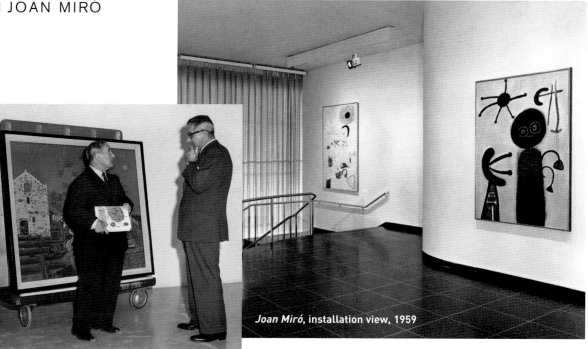

Joan Miró, installation view, 1959

There is a decided quality of trance in many of Miró's works, an impetuous spontaneity and innocence which make him one of the freshest and most beguiling painters of our time. Miró is the most instinctively talented artist of his generation, his poetic invention unflagging.

James Thrall Soby

▪ THREE STRUCTURES BY BUCKMINSTER FULLER

Buckminster Fuller is a philosopher, mathematician and engineer whose work is based on an analysis of the principles of structure as found in nature. His ideas . . . are aspects of what Fuller calls *comprehensive design* [whose] function . . . is to isolate . . . local patterns that can be turned to man's advantage in order to increase all possible advantages for all men—everywhere.

Arthur Drexler

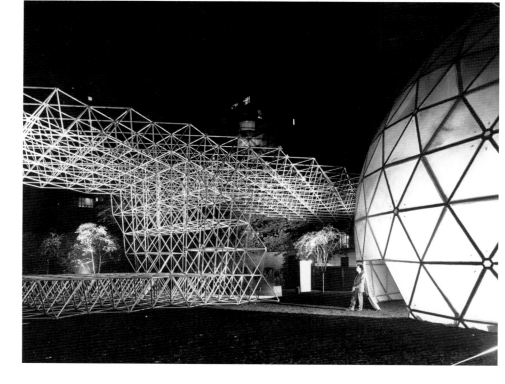

Three Structures by Buckminster Fuller, installation view in The Abby Aldrich Rockefeller Sculpture Garden, 1959.

■ CONSERVATION DEPARTMENT

1960

Conservators Jean Volkmer, right, and Tosca Zagni at work in the Museum's conservation facilities, 1960. The Conservation department had begun in 1958, under the direction of Jean Volkmer, after the Museum fire in which three paintings were destroyed and others damaged. The Museum's first conservation laboratory was founded in 1960.

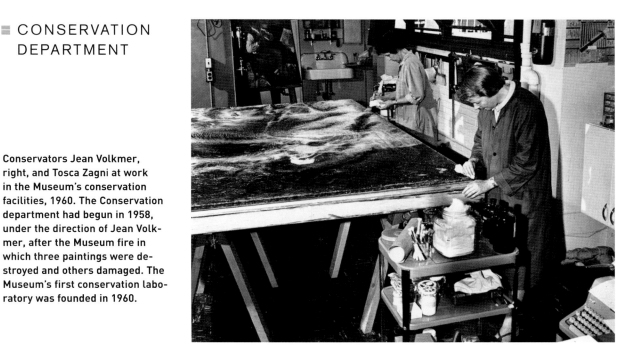

■ HOMAGE TO NEW YORK

On a dank evening in March 1960, Tinguely's "self-constructing and self-destroying work of art," *Homage to New York* (white and stately five minutes before its maiden performance, and compounded of a mélange of materials ranging from bicycle wheels and dishpans to an upright piano), vibrated and gyrated, painted pictures, played music, and magnificently but inefficiently sawed, shook, and burned itself to rubble and extinction in the sculpture garden of the Museum of Modern Art.
William C. Seitz

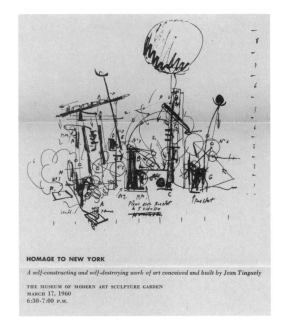

Jean Tinguely, *Homage to New York*, 1960, drawing printed on the brochure for "A Self-Constructing and Self-Destroying Work of Art," his event in The Abby Aldrich Rockefeller Sculpture Garden

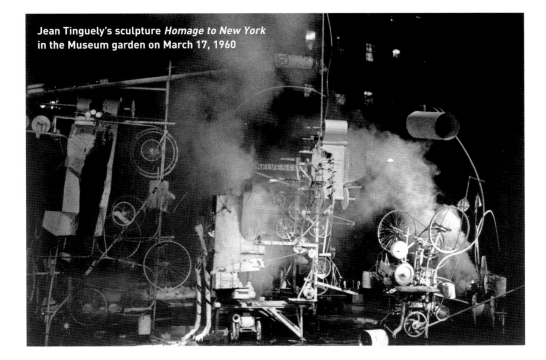

Jean Tinguely's sculpture *Homage to New York* in the Museum garden on March 17, 1960

■ JAZZ IN THE GARDEN SERIES BEGINS

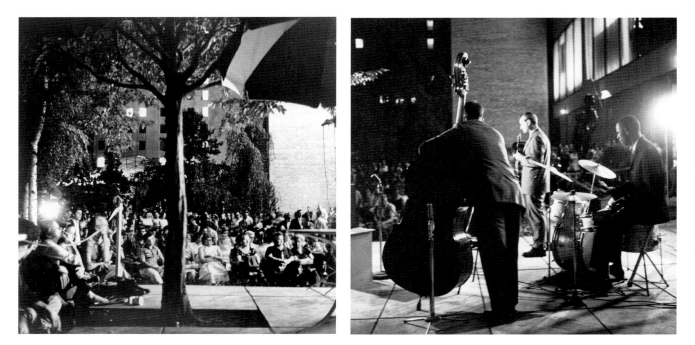

Jazz concert in The Abby Aldrich Rockefeller Sculpture Garden: the Jimmy Giuffre Quartet, with Jimmy Giuffre, clarinet and tenor saxophone; Jim Hall, guitar; Buell Neidlinger, bass; and Billy Osborne, drums, July 21, 1960

■ MUSEUM OF MODERN ART PUBLICATIONS

Monroe Wheeler, Director of Publications and Exhibitions, and director of the exhibition *Museum of Modern Art Publications: Retrospective Exhibition*, 1960

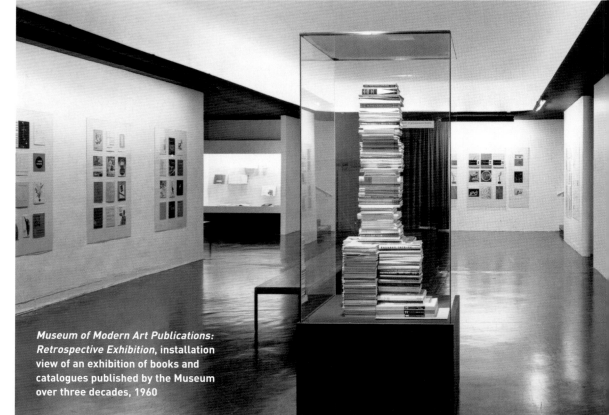

Museum of Modern Art Publications: Retrospective Exhibition, installation view of an exhibition of books and catalogues published by the Museum over three decades, 1960

— 1961

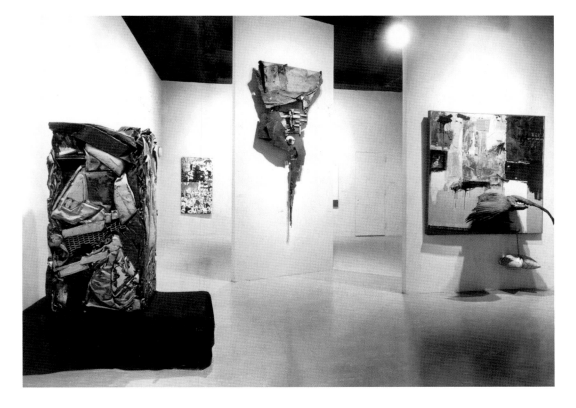

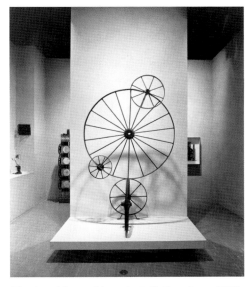

The Art of Assemblage, installation views, 1961

Assemblage is a new medium. It is to be expected, therefore, that it should be the carrier of developing viewpoints for which orthodox techniques are less appropriate. . . . The current wave of assemblage owes at least as much to abstract expressionism (with its dada and surrealist components) as it does to dada directly, but it is nevertheless quite differently oriented: it marks a change from a subjective, fluidly abstract art toward a revised association with environment. The method of juxtaposition is an appropriate vehicle for feelings of disenchantment. . . . Assemblage has become, temporarily at least, the language for impatient, hypercritical, and anarchistic young artists. *William C. Seitz*

■ WALDO RASMUSSEN

Upon the resignation of Porter A. McCray as Director of the International Program, in 1961, Waldo Rasmussen, a member of the circulating exhibitions staff since 1954, took over his responsibilities as Executive Director of Circulating Exhibitions for The International Council.

■ JOHN SZARKOWSKI

1962

My concern . . . is not with the immense, many-limbed body of photography, but only with its heart: only with work which achieves that expansion of meaning and intensity of expression that identify a work of art. . . . There are some signs that photography may be ready for re-definition of values. A decade and more ago our concepts of content, design and quality were radically changed by the amazing new freedom and mobility that came with high speed lenses, films, and developers. The transitory sensation, the unique moment, the fugitive and unlikely transposition, became the chief subject matter of the new creative photographer. . . . Now we are meeting a new generation of photographer It is possible that young photographers are turning again, with fresh eyes, to that which exists.
John Szarkowski

Edward Steichen, left, the retiring Director of the Department of Photography, with his successor, the photographer John Szarkowski, 1962. Photograph by Paul Huf

■ CHANGE IN LEADERSHIP

David Rockefeller, right, named Chairman of the Board of the Museum in 1962, in The Abby Aldrich Rockefeller Sculpture Garden with Trustee John Hay Whitney in 1961

▤ MATISSE DANCE ACQUIRED

1963

Henri Matisse's *Dance (First Version)*, 1909, the gift of Nelson A. Rockefeller in honor of Alfred H. Barr, Jr. Photograph by Henri Cartier-Bresson, 1964

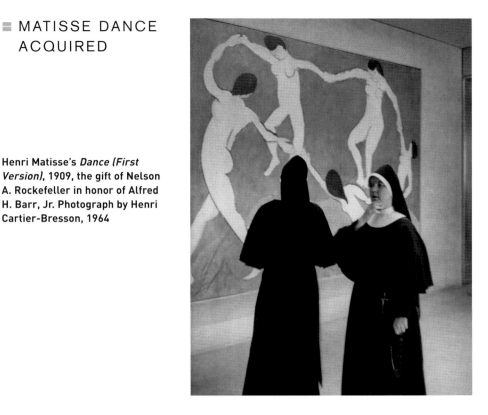

Letter and drawing to Dorothy C. Miller from the artist Ad Reinhardt with comments on the installation of his black paintings in the exhibition *Americans 1963*, the final install-ment in the Americans series. James Rosenquist was also among the artists included in this exhibition.

▤ AMERICANS 1963

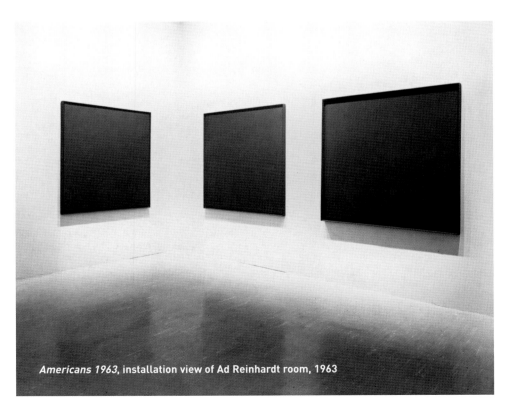

Americans 1963, installation view of Ad Reinhardt room, 1963

THE MUSEUM OF MODERN ART
11 WEST 53 STREET, NEW YORK 19, N. Y.
TELEPHONE: CIRCLE 5-8900

February 23, 1962

Indira Gandhi and Jacqueline Bouvier Kennedy (First Lady Mrs. John F. Kennedy) on March 14, 1962. Mrs. Kennedy was presenting The Children's Art Carnival in New Delhi, India.

Museum press release announcing the presentation of the Children's Art Carnival to India, 1962

The Children's Art Carnival is being presented under the auspices of Mrs. John F. Kennedy to the National Children's Museum of India by The Asia Society and by The International Council of The Museum of Modern Art, New York, of which Mrs. Kennedy is an Honorary Member. It is intended not only to give pleasure to the children of India but to function as a teaching device and serve as a training center for art teachers in the educational program of the National Children's Museum recently established in New Delhi under the leadership of Mrs. Indira Gandhi.

Mrs. Kennedy will give Mrs. Gandhi in the name of The International Council and The Asia Society an illustrated presentation portfolio which describes the Carnival's purpose and program. The Carnival itself is expected to open in India in 1963.

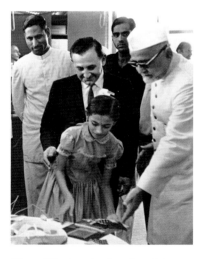

Victor D'Amico, the founder of the Children's Art Carnival and of the People's Art Center, an art school for children and adults at the Museum, with students at the National Children's Museum in New Delhi, October 1963

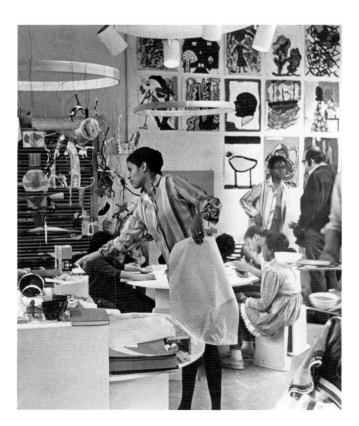

Victor D'Amico, Director of the Department of Education at the Museum of Modern Art, flew to India . . . to open the Children's Art Carnival in New Delhi and train teachers in the methods of art education. . . .

An annual event at the Museum of Modern Art in New York for more than twenty years, the Carnival has also been sent to Brussels, Italy, and Spain for limited periods. . . . In India the Carnival will tour five other major cities and then return to New Delhi and become a permanent part of the National Children's Museum.
Museum Press Release

Betty Blayton Taylor, Director of the Children's Art Carnival in Harlem, created and sponsored by The Museum of Modern Art, 1960s.

1964

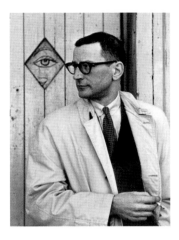

John Szarkowski, 1964. Photograph by André Kertész

Book based on the 1964 exhibition *The Photographer's Eye*, by John Szarkowski, 1966

This book is an investigation of what photographs look like and why they look that way. It is concerned with photographic style and with photographic tradition: with the sense of possibilities that a photographer today takes to his work. . . .

The history of photography has been less a journey than a growth. Its movement has not been linear and consecutive, but centrifugal. Photography, and our understanding of it, has spread from a center; it has, by infusion, penetrated our consciousness. Like an organism, photography was born whole. It is in our progressive discovery of it that its history lies.

John Szarkowski

■ MUSEUM EXPANSION

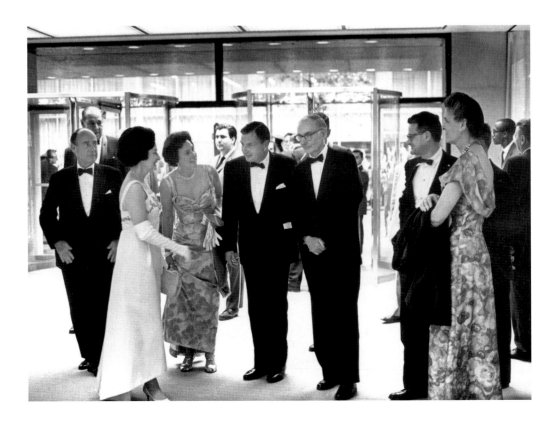

Reopening of The Museum of Modern Art, May 1964. Inside the new entrance and Lobby, designed by Philip Johnson, are, left to right, Ambassador Adlai Stevenson, Director René d'Harnoncourt (behind Stevenson), Lady Bird Johnson (First Lady Mrs. Lyndon B. Johnson), Peggy Rockefeller (Mrs. David Rockefeller), Chairman David Rockefeller, Director of Museum Collections Alfred H. Barr, Jr., Director of Administration Richard Koch, and Sarah d'Harnoncourt (Mrs. René d'Harnoncourt).

The East Wing facade was treated more-or-less uniformly from top to bottom in black steel and glass . . . forming a contrast to the white facade of the original Goodwin–Stone Building. Taking its cue from the [Grace Rainey Rogers] annex, the Miesian geometry was softened by curving the large floor-to-ceiling window frames. . . . The black-steel curtain wall took on a lacier appearance, with deep mullions hinting at the elaborate tracery in the Gothic windows of St. Thomas' Church next door.

Peter Reed, 1998

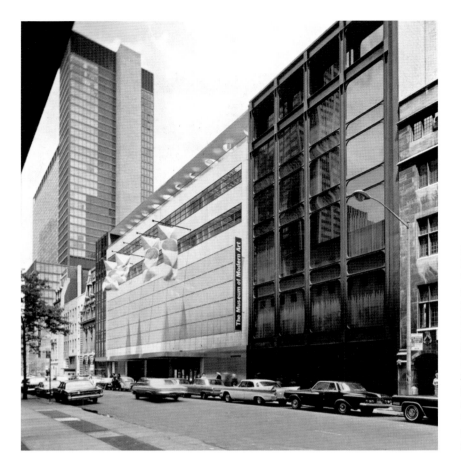

Expanded facade of The Museum of Modern Art, 1964. The building to the right of the Goodwin–Stone Building of 1939 (with flags) is the new East Wing, designed by Philip Johnson. The Grace Rainey Rogers Annex (also known as the 21 Building), designed by Johnson in 1951, can be seen adjacent to the far side of the Museum.

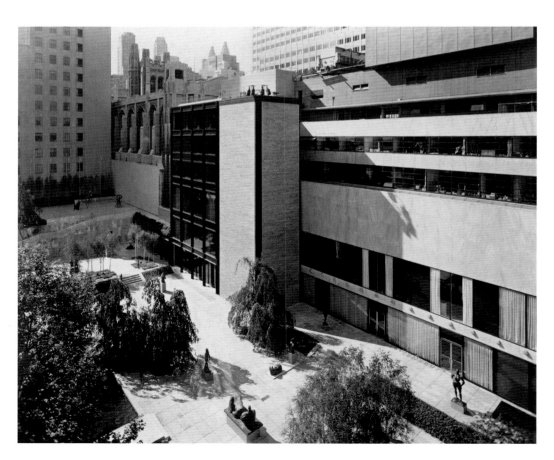

Except for certain changes in the planting . . . the intrusion of a new fire stair, and the raising of the north wall, the 1953 garden was undisturbed by the 1964 additions. The plot to the east of the 1953 garden, a site previously used for temporary exhibition structures, was now elevated From this new intermediate terrace a grand stairway doubles back from north to south in its majestic ascent to a new upper terrace—a roof garden crowning a new low wing of the Museum.

Elizabeth Kassler, 1975

Aerial view of Garden Wing and Terrace, garden facade of East Wing, and Fire Stair tower, designed by Philip Johnson, 1964

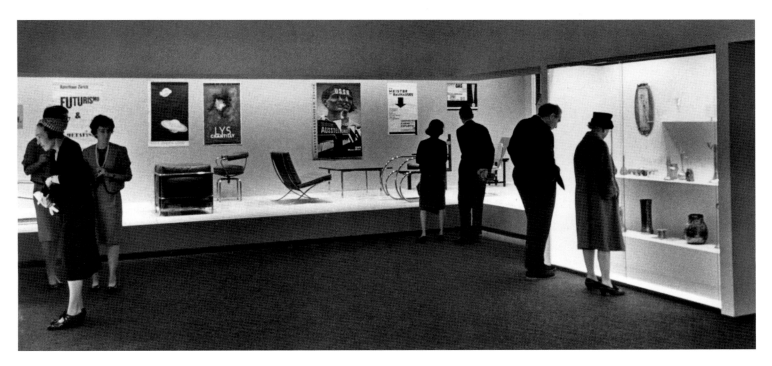

The Philip L. Goodwin Architecture and Design Galleries, the first permanent galleries devoted to displaying the architecture and design collection, 1964 (photograph 1967)

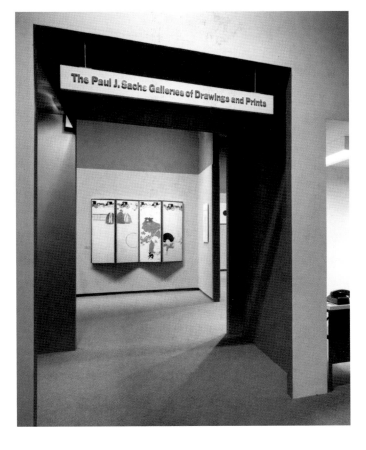

The Paul J. Sachs Galleries of Drawings and Prints, the first permanent galleries devoted to displaying the collections of drawings and prints, 1964

The Edward Steichen Photography Study Center, 1964 (photograph 1967)

1965–1972: WORD AND IMAGE

—1965

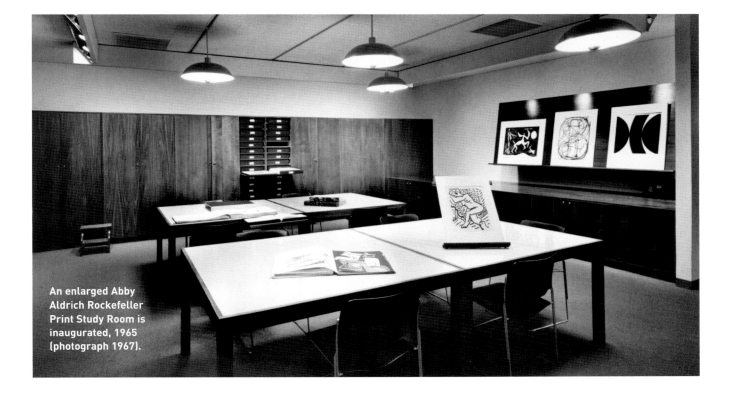

An enlarged Abby
Aldrich Rockefeller
Print Study Room is
inaugurated, 1965
(photograph 1967).

■ CHANGE IN LEADERSHIP

Elizabeth Bliss Parkinson,
named President of the
Museum, with Trustee
Philip Johnson, n.d.

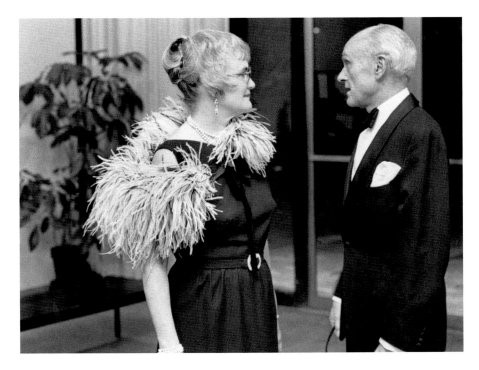

≡ JUNIOR COUNCIL CHRISTMAS CARDS

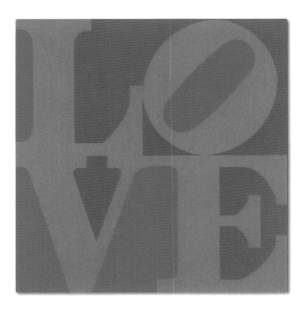

We [The Junior Council] had committees that would meet, and seriously research the collection, and also think of outside artists who could be commissioned to do cards. The famous instance is Robert Indiana: *Love* was done as a Christmas card for The Museum of Modern Art.

Barbara Jakobson, 1997

Robert Indiana's *LOVE*, 1965, one of many holiday cards commissioned by The Junior Council of the Museum. The image subsequently became well-known in various other contexts.

≡ THE RESPONSIVE EYE

The Responsive Eye, an exhibition of more than 120 paintings and constructions by 99 artists from some 15 countries, document[s] a widespread and powerful new direction in contemporary art. . . . As Mr. Seitz points out in the accompanying catalog, these works exist less as objects to be examined than as generators of perceptual responses in the eye and mind of the viewer. Using only lines, bands and patterns, flat areas of color, white, gray or black or cleanly cut wood, glass, metal and plastic, perceptual artists establish a new relationship between the observer and a work of art. These new kinds of subjective experiences, which result from the simultaneous contrast of colors, after-images, illusions and other optical devices, are entirely real to the eye even though they do not exist physically in the work itself. Each observer sees and responds somewhat differently.

Museum Press Release

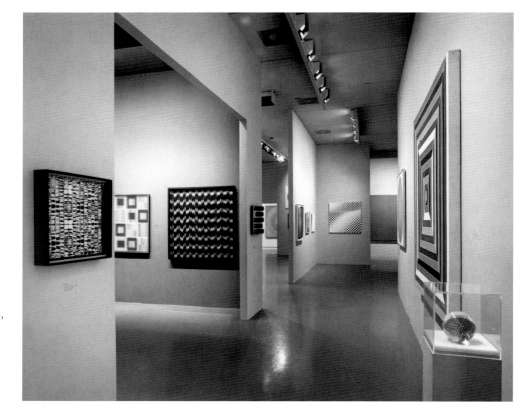

The Responsive Eye, **installation view of Op art exhibition, 1965**

"To render what the eye really sees is impossible," Giacometti repeated one evening while we were seated at dinner in the inn at Stampa. He explained that he could really not see me as I sat next to him—I was a conglomeration of vague and disconnected details—but that each member of the family sitting across the room was clearly visible, though diminutive, thin, surrounded by enormous slices of space. Everyone before him in the whole history of art, he continued, had always represented the figure as it is; his task now was to break down tradition and come to grips with the optical phenomenon of reality. What is the relationship of the figure to the enveloping space, of man to the void, even of being to nothingness? The philosophical and emotional implications of the problem he poses do not overly concern him. . . . He strives to discover the visual appearance and render it with precision—not the reflections of light which occupied the Impressionists, nor the distorted view of the camera which fails to register distance, but the object as it is contained in space, as seen by the human eye, the artist's eye.
Peter H. Selz

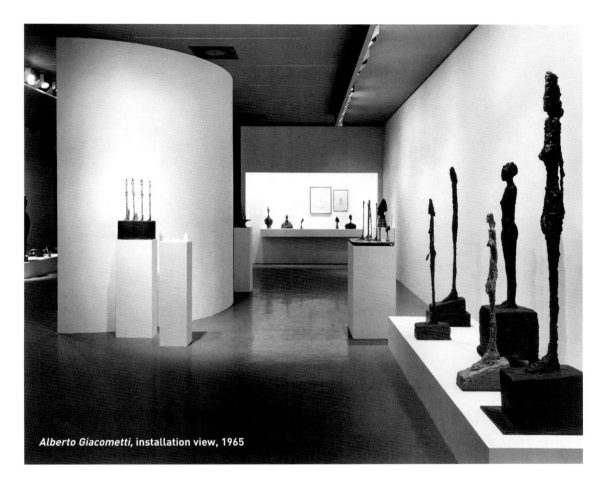

Alberto Giacometti, installation view, 1965

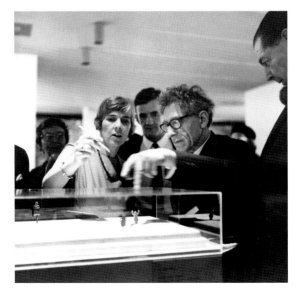

Left to right: Alicia Legg, Associate Curator of Painting and Sculpture; James Lord, author of *A Giacometti Portrait,* published by the Museum; the artist Alberto Giacometti; and Director René d'Harnoncourt, 1965

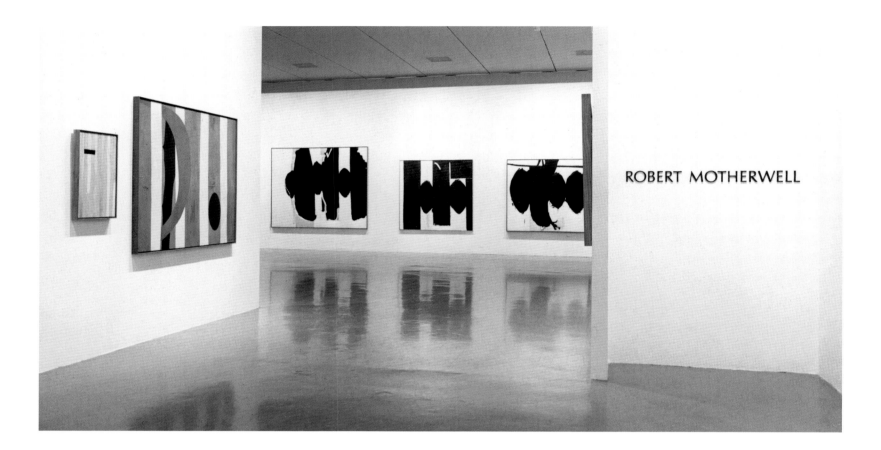

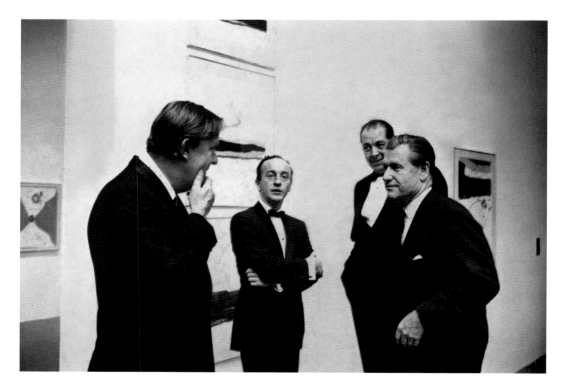

Robert Motherwell,
installation view, 1965

Left to right: The artist
Robert Motherwell;
Frank O'Hara, poet,
curator, and director of
the exhibition; Director
René d'Harnoncourt;
and Trustee Nelson A.
Rockefeller at the
opening of the exhibi-
tion *Robert Mother-
well,* 1965

1966

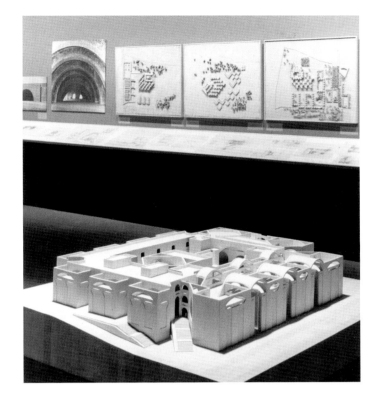

Kahn's effort to make architectural form coincide with real and symbolic functions has profoundly impressed students and influenced his peers— more perhaps than any other architectural philosophy since Mies' work in the forties.

Arthur Drexler

The Architecture of Louis I. Kahn, installation view, 1966

▦ DEPARTMENT OF FILM

▦ DEPARTMENT OF DRAWINGS AND PRINTS FOUNDED

The documentary filmmaker Willard van Dyke is named Director of the Film Library in 1965 and renames it Department of Film, 1966.

The Department of Drawings and Prints is founded as an entity independent of the Department of Painting and Sculpture, with William S. Lieberman as its Director, 1966 (photograph 1962).

Alexander Calder wrote a letter to Mr. Barr, as follows: "I have long felt that whatever my success has been, [it was] greatly as a result of the show I had at MOMA in 1943, and now, as I seem to have quite a number of I think important objects 'left over' I would like to make a gift of several of them to the Museum—if you would be interested." . . . The response to Calder's letter of 1966 was immediate. Mr. Barr and Dorothy Miller went to Roxbury, Connecticut, to see Calder's two studios and the meadow full of large sculptures. Although uncertain of what Calder would concede from their list of thirteen selections, large and small, they were told: "Oh, you can have them all."

Alfred H. Barr. Jr., 1967

Handwritten notes by Alexander Calder on works of art he donated to the Museum, December 23, 1966

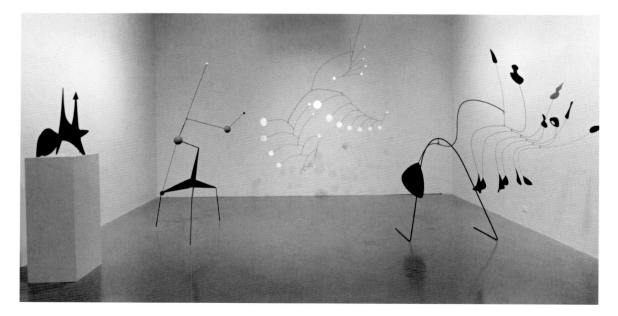

Recent Acquisitions: 19 Gifts from the Artist, **installation view, 1967**

1967

Alfred H. Barr, Jr., retires as Director of Museum Collections in 1967. A Trustee since 1940, he is named Counselor to the Trustees.

Letter to Alfred H. Barr, Jr., from Trustee John de Menil, dated May 22, 1967

III EAST SEVENTY-THIRD STREET
NEW YORK 21, N.Y.

May 22, 1967

Mr. Alfred Barr
New York

Dear Alfred,

 If ever there was a man who could retire with peace and pride, it is you. The museum you have created is capital. It has a life of its own. It will grow.

 From your retreat you will watch it with love like a father who sees his son develop his own career: a combination of amazement and pride. And you will keep contributing to it by your writings which I await with great expectation.

Yours devotedly,

John de Menil

Dear Marga and Alfred—
[At your retirement party] as I looked around the dining-room, I was suddenly overcome with the threads which reached out in so many directions like an infinite web—with you at the center. Alfred's speech was so touching . . . but I felt no one was saying that the whole force of the *idea* of the Museum which sprang full-blown from Alfred and which has grown to such gargantuan proportions was due to the extraordinary intelligence, sensitivity and generosity of spirit which is Alfred. Can you possibly conceive for a moment the number of lives you have changed by your vision? It is an overwhelming thought. Your inherent modesty probably could not acknowledge this fact. So—I shall simply say to you that I, for one, would be poor indeed without the richness of experience the years at the Museum gave to me and I feel privileged to have known you both.
Elodie Courter

■ MONROE WHEELER RETIRES

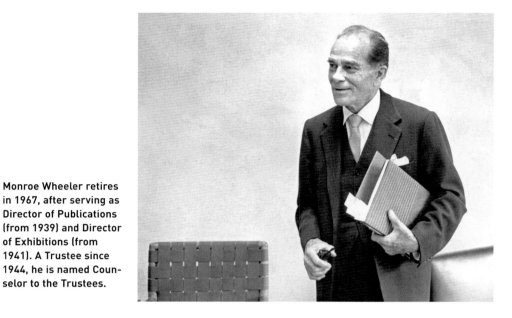

Monroe Wheeler retires in 1967, after serving as Director of Publications (from 1939) and Director of Exhibitions (from 1941). A Trustee since 1944, he is named Counselor to the Trustees.

Monroe Wheeler contributed to the quality, vitality and luster of the Museum of Modern Art. Monroe was a scholar, an editor, a publisher, a curator and so many other things as well. . . . Monroe had consummate taste and discrimination in recognizing excellence where he found it whether in literature, music, architecture or in painting and sculpture. He expressed himself eloquently and with elegance. He believed in what MoMA stands for and dedicated the better part of his life to helping make it the best institution of its kind in the world.
David Rockefeller, 1988

■ NEW DOCUMENTS: ARBUS, FRIEDLANDER, WINOGRAND

In the past decade a new generation of photographers has directed the documentary approach toward more personal ends. Their aim has been not to reform life, but to know it. Their work betrays a sympathy—almost an affection—for the imperfections and the frailties of society. They like the real world, in spite of its terrors, as the source of all wonder and fascination and value, and find it no less precious for being irrational. This exhibition shows a handful of pictures by three photographers of that generation. What unites them is not style or sensibility: each has a distinct and personal sense of the uses of photography and the meanings of the world. What they hold in common is the belief that the commonplace is really worth looking at, and the courage to look at it with a minimum of theorizing.
John Szarkowski

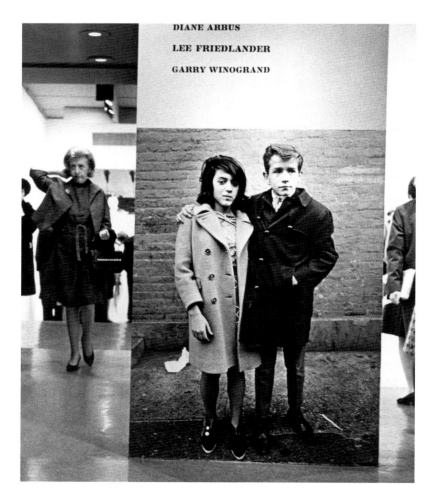

New Documents: Diane Arbus, Lee Friedlander, Garry Winogrand, view of entry to the exhibition, 1967

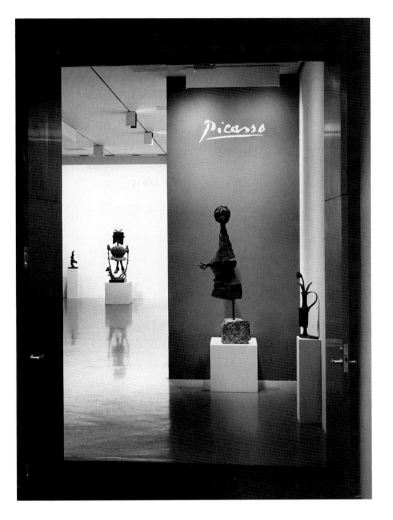

Sketch by René d'Harnoncourt for the installation of
The Sculpture of Picasso, 1967

The Sculpture of Picasso, installation view, 1967–68

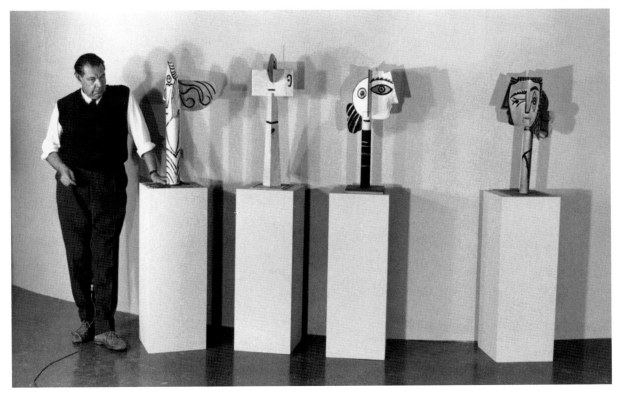

René d'Harnoncourt
installing the exhibi-
tion *The Sculpture of
Picasso*, 1967

1968

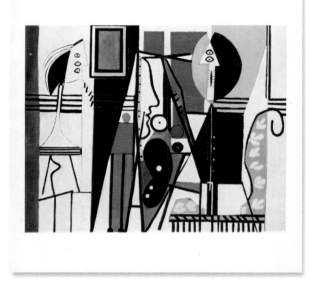

Brochure for the exhibition *The Sidney and Harriet Janis Collection,* **1968**

Formal announcement was made [on June 17, 1967] of Sidney Janis's gift of 103 works from his collection to the Museum. Carefully selected over the years, these works represented several generations of artists, exponents of cubism and futurism, hard-edge abstraction, dada and surrealism, abstract expressionism and pop art. The acquisition enriched, complemented, and refreshed the Museum Collection. Janis wrote of the gift: "That the Janis collection should find a home at a great museum has long been my hope, and happily the museum of my first love, The Museum of Modern Art, has graciously accepted it." . . .

Sidney Janis had been interested in the Museum since its opening in 1929. . . . His collection, however, remained a thing apart; it was his private garden and naturally he was preoccupied about its final disposition. As a result of a conversation with his friend William Rubin, the newly appointed Curator of Painting and Sculpture, Sidney Janis donated it to the Museum. *Alfred H. Barr, Jr., 1967*

■ JACKSON POLLOCK ONE (NUMBER 31, 1950) ACQUIRED

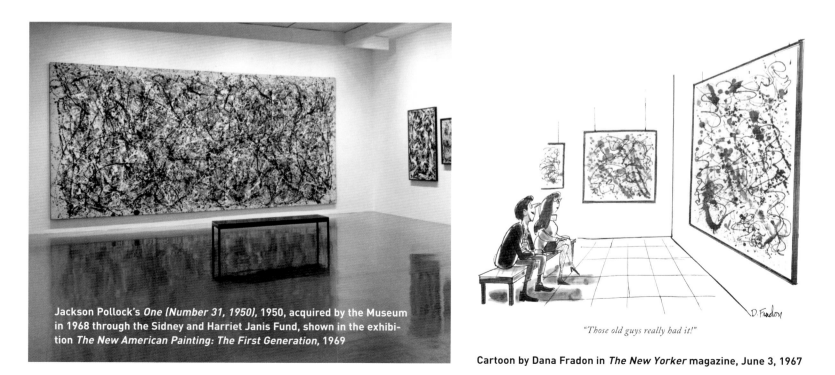

Jackson Pollock's *One (Number 31, 1950),* **1950, acquired by the Museum in 1968 through the Sidney and Harriet Janis Fund, shown in the exhibition** *The New American Painting: The First Generation,* **1969**

"Those old guys really had it!"

Cartoon by Dana Fradon in *The New Yorker* **magazine, June 3, 1967**

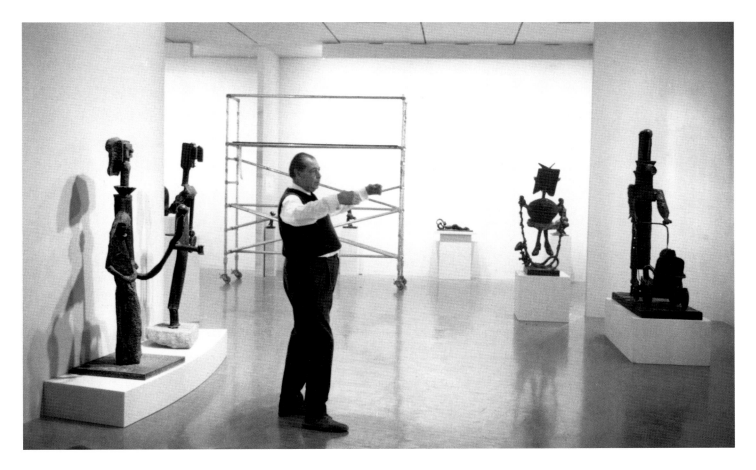

René d'Harnoncourt retires as Director of the Museum, 1968 (photograph 1967).

These nineteen years as Director have been the richest in my entire life. They have given me wonderful friendships. You have no idea of what this means to me. When I was made Director, Governor Rockefeller who was President [of the Museum] at that time, said you will find out very soon that this institution is much bigger than any one of us. I have found that out. The Museum is an extraordinary place. The energy, the faith, the devotion, the ingenuity of the people, on both the Board and the staff, are constantly pouring new blood, new energy and personality into the institution. When you get involved in the Museum of Modern Art it gives to you from its incredible richness. If I have been able to be useful, it was because I was able to accept the rich gifts that come from the Museum and give them back in a small way. Thank you very much.
René d'Harnoncourt

René d'Harnoncourt was not a scholar; he was a humanist. He was a champion and he had style. Endowed with a huge physical presence—he was six and a half feet high and weighed 230 pounds—René was sartorially splendid, untidy, and elegant, all at the same time. His expressive gestures and mobile features, like his humor, were graced by a gallant manner Throughout his life René inspired others to create. He loved people and preferred to see them singly rather than in groups. He was sympathetic and understanding. To anyone with whom he ever worked he was a friend, to many their best. Casual acquaintances instinctively sensed that they could seek his advice, that they needed his warmth. He responded and enriched their lives. He had no enemies; he was respected by everyone. . . . René was humble. He was also extraordinarily gentle, never irritable and always kind. . . . He had no peer.
William S. Lieberman

▪ BATES LOWRY NAMED DIRECTOR

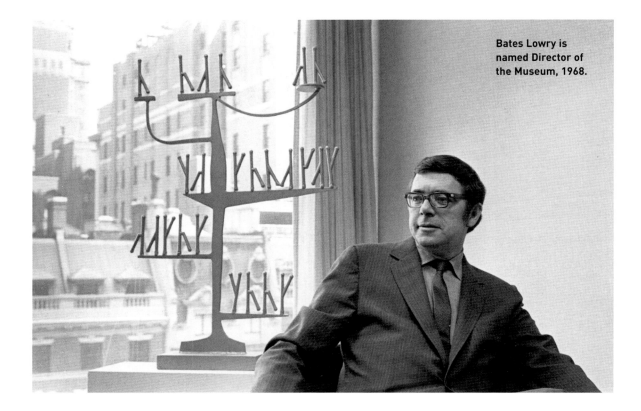

Bates Lowry is named Director of the Museum, 1968.

▪ THE LILLIE P. BLISS INTERNATIONAL STUDY CENTER

The Center makes available to the interested public, scholars, students, and artists a unique combination of resources concerned with all the visual arts: more than 25,000 original works of art in the Museum collection . . . and a remarkable body of related documentary material. . . . An unusual aspect of the Center is the new kind of open exhibition-type storage space that is much more flexible than the usual kind of storage for works of art. . . . In the new facilities, all the paintings not on exhibition in the Museum galleries are hung on specially designed sliding aluminum panels which can be easily moved into adjacent viewing rooms and seen under gallery conditions. *Museum Press Release*

Demonstration of sliding storage walls in The Lillie P. Bliss Study Center, 1968

▓ CHANGE IN LEADERSHIP

William S. Paley is
named President
of the Museum, 1968.

▓ MIES VAN DER ROHE ARCHIVE

Ludwig Glaeser, the first
Curator of the Mies van der
Rohe Archive, 1968

Page from *Ludwig Mies van
der Rohe: Furniture and
Furniture Drawings from the
Design Collection and the
Mies van der Rohe Archive*,
by Ludwig Glaeser, 1977

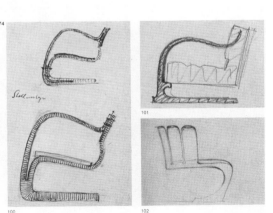

The Mies van der Rohe Archive . . . established in
1968. . . was the logical outcome of a long and cordial
relationship between Mies and the Museum. . . . In
1947 Philip Johnson organized a retrospective exhibi-
tion of Mies's work, for which he assembled forty-five
architectural drawings [which] remained at the Mu-
seum on extended loan for sixteen years. . . . At my
request, Alfred Barr, as Director of Museum Collec-
tions, then wrote to Mies asking that the drawings be
donated to the Museum. Mies replied promptly, in a
letter of July 19, 1963, giving the drawings to the Archi-
tecture and Design Collection and adding: "If in the
future there is some interesting material you wish to
have, please let me know. I will be delighted to give it
to the Museum." . . . Ludwig Glaeser . . . was appointed
[the Archive's] Curator in 1968, and held that post
until 1980. Under his direction the Archive began the
monumental task of research and the cataloguing of
more than 20,000 items.
Arthur Drexler

Invitation to the exhibition *Dada, Surrealism, and Their Heritage*, 1968

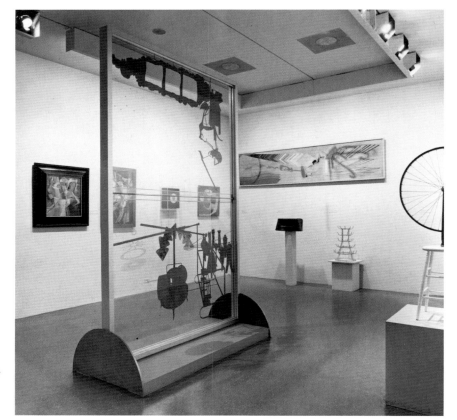

Dada, Surrealism, and Their Heritage, installation views, 1968

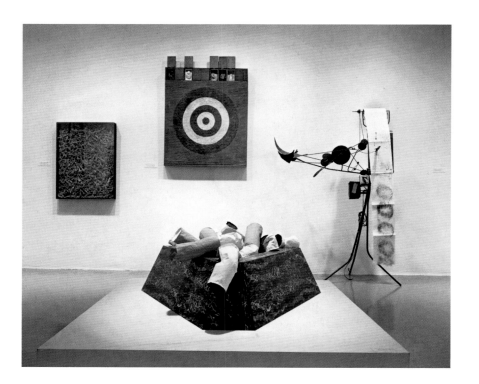

Dada, Surrealism, and Their Heritage, directed by William S. Rubin, Curator of Painting and Sculpture at The Museum of Modern Art, is the first comprehensive exhibition anywhere of these movements since . . . 1936–37, a generation ago. . . . The Heritage section of the exhibition presents a limited selection of two groups: the surrealizing works of the 1940's which constitute the early phases of the careers of some great Abstract Expressionists including Pollock, Ferber, Gottlieb and Rothko; and the works of the later 1950's and 60's . . . which are founded on a revival metamorphosis of certain essential ideas in Dadaism, as seen in recent work by Niki de Saint Phalle, Lucas Samaras, Christo, Jasper Johns, Kienholz, Claes Oldenburg and Jean Tinguely.
Museum Press Release

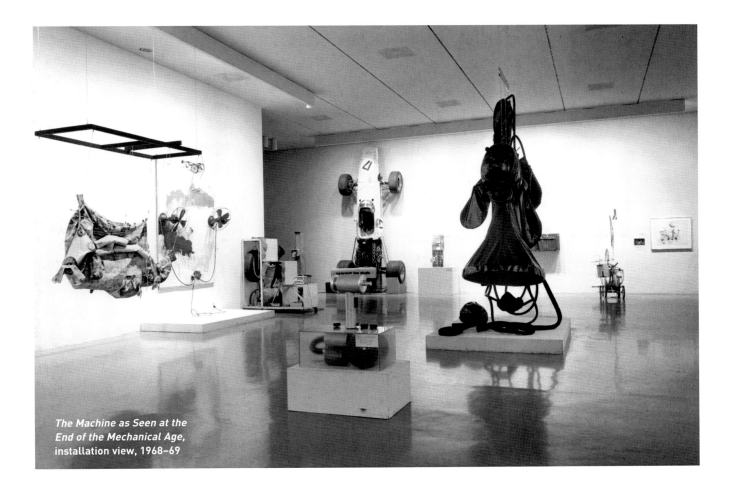

The Machine as Seen at the End of the Mechanical Age, installation view, 1968–69

Technology today is undergoing a critical transition. We are surrounded by outward manifestations of the culmination of the mechanical age. Nevertheless, the mechanical machine—which can most easily be defined as an imitation of our muscles—is losing its dominating position among the tools of mankind. Its reign is being threatened by the growing importance of electronic and chemical devices—which imitate the processes of the brain and nervous system.

This exhibition is not intended to provide an illustrated history of the machine throughout the ages but to present a selection of works that represent artists' comments on aspects of the mechanical world. . . . Leading artists of our time have held attitudes toward machines ranging from idolatry to deep pessimism. They have used machines as metaphors through which to comment upon society, or have welcomed them as providing new technical means of expression. . . . It is obvious that the decisions that will shape our society in the future will be arrived at and carried out through technology. Hopefully, these decisions will be based on the same criteria of respect for individual human capacities, freedom, and responsibility that prevail in art.

K. G. Pontus Hultén

Embossed metal cover of the catalogue for the exhibition *The Machine as Seen at the End of the Mechanical Age,* by K. G. Pontus Hultén, guest curator of the exhibition, 1968

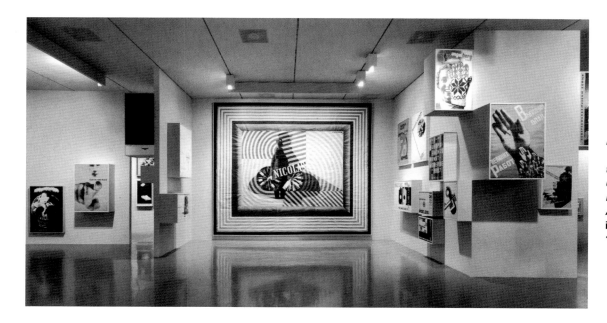

*Word and Image:
Posters and
Typography from
the Graphic Design
Collection of The
Museum of Modern
Art, 1878–1967,
installation view,
1968*

— 1969 ■ BATES LOWRY RESIGNS

Bates Lowry, who had since January served as Director of Painting and Sculpture under René d'Harnoncourt, succeeded him as Director of the Museum on July 1 and held both positions until he resigned on May 15, 1969. The Museum is indebted to him for the initiative with which he guided the institution during his brief tenure. . . . An Operating Committee, consisting of Walter Bareiss as Chairman, Wilder Green, Director of the Exhibition Program, and Richard H. Koch, Director of Administration, was appointed to administer the Museum during the selection of a new Director.

The Museum of Modern Art Biennial Report 1967–69

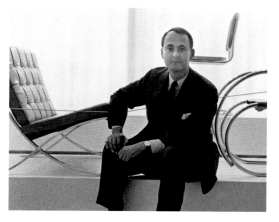

Wilder Green, Director of the Exhibition Program, n.d.

Richard H. Koch, Director of Administration, n.d.

Walter Bareiss, Trustee and Chairman of the Operating Committee, 1968 (photograph 1969)

■ DEPARTMENT OF PRINTS AND ILLUSTRATED BOOKS FOUNDED

Department of Prints and Illustrated Books is founded with Riva Castleman as its Curator, 1969 (photograph 1979).

■ DOROTHY C. MILLER RETIRES

Dorothy C. Miller retires as Senior Curator of Painting and Sculpture, 1969.

Miss Miller's friend and colleague at MOMA, Alfred Barr, is often quoted as saying, apropos acquisition policy of new artists, that to have made the right choice one out of ten times would be fortunate indeed, but Miss Miller's batting average is far better than that.... Most of her judgments, in fact, now appear ... bull's-eye accurate.... Miss Miller, in short, played a brilliant role in tracing, at the right time and in the right place, two astonishing decades of American art. She wrote a major history of those incredible years [1942 to 1963] not through the printed word that later generations could read in libraries, but through a series of living, visual events that steered spectators, both sophisticated and naïve, through the most uncharted and thrilling seas the New York art world has ever known.
Robert Rosenblum, 1985

≡ KUSAMA NUDE-IN

Newspaper photograph of artist Yayoi Kusama's "Grand Orgy to Awaken the Dead at MoMA," an unannounced event in the Museum Sculpture Garden, August 25, 1969. Security supervisor Roy Williams tries to persuade the participants to end the event; Kusama is seen walking from the pool at right.

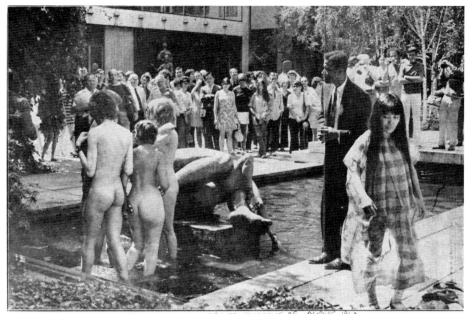

But Is It Art? Security officer Roy Williams pleads with nude young men and women to leave Museum of Modern Art fountain, where Maillol's sculpture, Girl Washing Her Hair, reclines. Impromptu nude-in was conception of Japanese artist Yayoi Kusama (right). Crowd takes it in stride. (Some took strides to get closer). —*Story on page 4*

1970 ≡ JOHN B. HIGHTOWER NAMED DIRECTOR

John B. Hightower, named Director of the Museum, with Museum President William S. Paley, 1970 (photograph 1971)

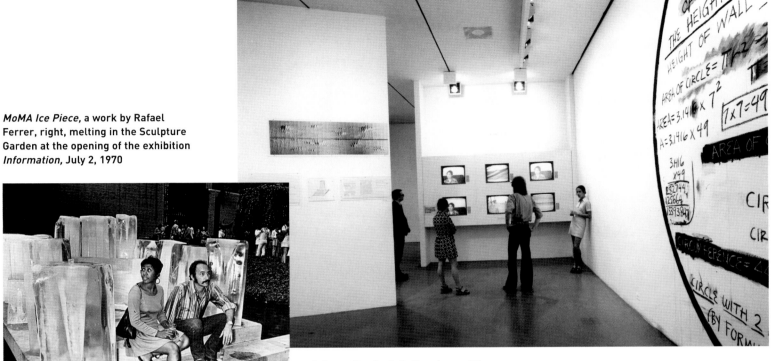

MoMA Ice Piece, a work by Rafael Ferrer, right, melting in the Sculpture Garden at the opening of the exhibition **Information**, July 2, 1970

Information, installation views of the Museum's first exhibition of Conceptual art, 1970

"Information" is primarily concerned with the strongest international art movement or "style" of the moment which is "conceptual art," "arte Povera," "earthworks," "systems," "process art," etc. in its broadest definition. The exhibition will demonstrate the non-object quality of this work and the fact that it transcends the traditional categories of painting, sculpture, photography, film, drawing, prints, etc.

Kynaston McShine, Associate Curator of Painting and Sculpture

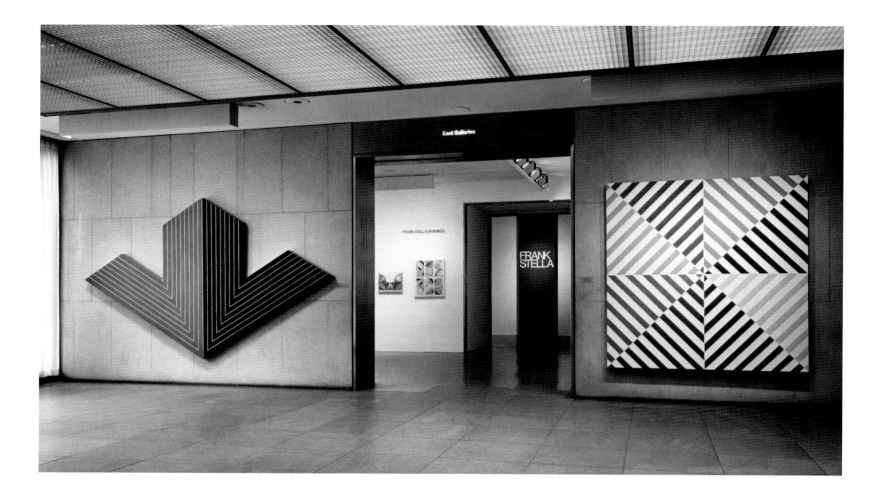

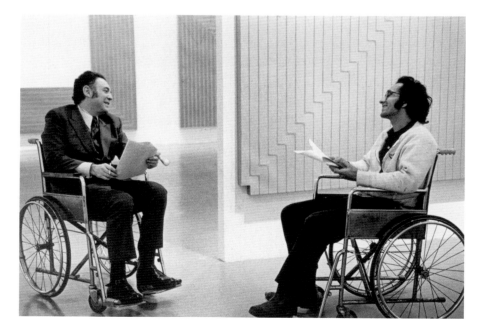

Frank Stella: Paintings, installation view, 1970

William S. Rubin, Chief Curator of Painting and Sculpture and director of the exhibition *Frank Stella: Paintings*, left, with the artist Frank Stella, 1970

1971

A Treasury of Modern Drawing, by William S. Lieberman, a catalogue of the Joan and Lester Avnet Collection, which formed the basis for the Museum's drawings collection, was published in 1978.

The Joan and Lester Avnet Collection of drawings was formed with The Museum of Modern Art specifically in mind. The collection consists of 180 sheets which range in date from 1901 through 1969. Some 40 of these were given to the Museum during the 1960s; most of the remaining drawings have been on deposit at the Museum since 1970, the year of Mr. Avnet's death. . . . Sadly, he could not witness the inauguration of the Museum's separate Department of Drawings with its own curatorial Committee in 1971. He had, however, often urged the establishment of such a department devoted to works on paper, which share similar problems of curatorship, conservation, and display. . . . The Joan and Lester Avnet collection of twentieth-century drawings . . . is the largest gift of drawings ever received by the Museum.

William S. Lieberman

The Department of Drawings is founded, with William S. Lieberman, Director of Painting and Sculpture (1969–1971), as its Director, 1971.

■ THE ARTIST AS ADVERSARY

The Artist as Adversary . . . selected by Betsy Jones, Associate Curator of Painting and Sculpture . . . brings together from the Museum's own collections a large body of work in which the state of the world, political and military institutions and events, social injustices, constitute the subject matter. . . . "Whether by means of allegory, metaphor or symbol, irony, satire both humorous and bitter, cold realism or expressive emotionalism, polemics or propaganda," the works in the exhibition are explicit in their attitudes of dissent, protest or attack. "Some of the artists have been motivated by a deep-seated, consistent desire to reform. Others, under the stimulus of critical times, have produced isolated works as acts of conscience. . . . None are noncommittal," Miss Jones writes.

Museum Press Release

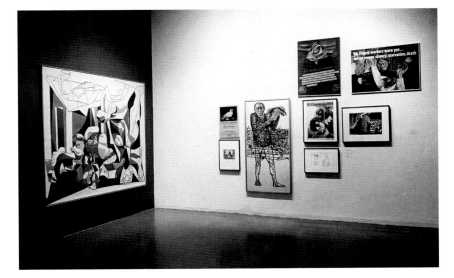

The Artist as Adversary, installation view, 1971

PICASSO GUITAR ACQUIRED

Pablo Picasso, left, donates his metal-and-wire *Guitar,* 1912, to the Museum; William S. Rubin, Chief Curator of Painting and Sculpture, is pictured on the right, 1971.

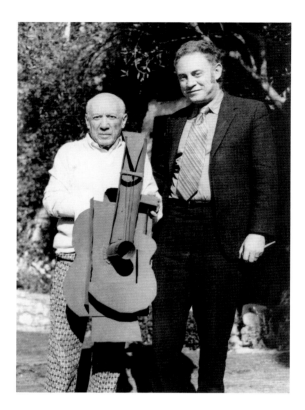

PROJECTS SERIES BEGINS

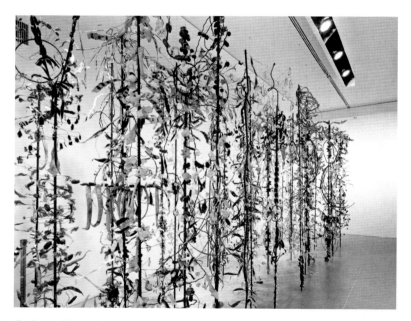

Projects: Nancy Graves, installation view, 1971–72

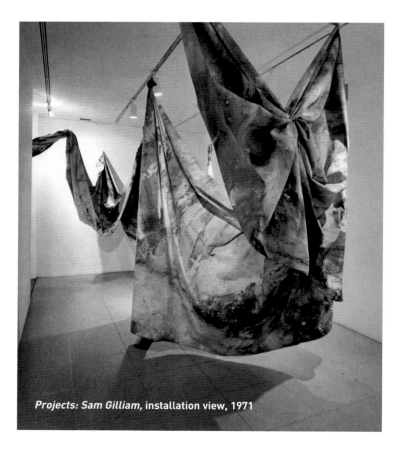

Projects: Sam Gilliam, installation view, 1971

In May 1971, The Museum of Modern Art initiated *Projects,* a continuing series of small exhibitions designed to keep the public abreast of recent developments in the visual arts. *Projects* provides artists who work in nontraditional forms and who often create situational works with the opportunity to show their art under relatively informal conditions in the Museum.
Museum Press Release

■ THE WORK OF FREI OTTO

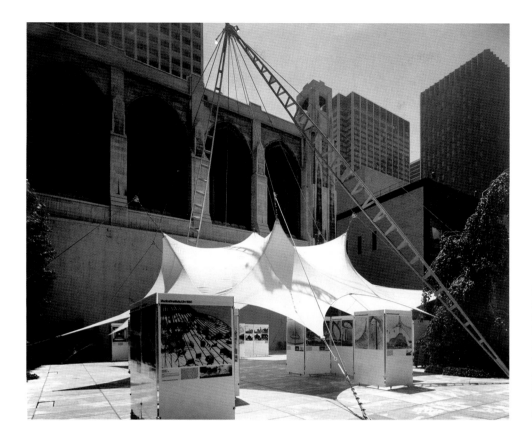

The Work of Frei Otto, installation view of the German architect Frei Otto's Exhibition Structure, a tensile system initially designed as a retractable roof and specially developed for the exhibition, on the upper terrace of the Sculpture Garden, 1971

■ SUMMERGARDEN SERIES BEGINS

Invitation to Summergarden, an annual series of events and entertainments in the Sculpture Garden of the Museum, begun in 1971

Dancers perform at Summergarden, n.d.

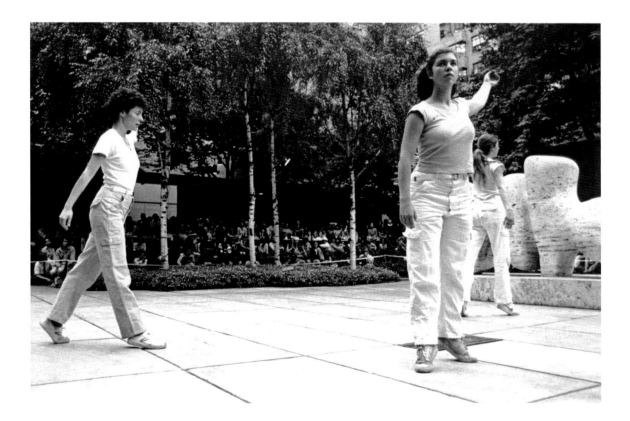

◼ RICHARD E. OLDENBURG NAMED DIRECTOR

1972

Upon the resignation of John B. Hightower, Richard E. Oldenburg, Director of Publications since 1969, is named Director of the Museum, 1972 (photograph 1984). At the same time, William S. Paley, President, is named Chairman of the Board, and Mrs. John D. Rockefeller 3rd becomes President of the Museum for the second time.

◼ FIRST AUTOMOBILE ACQUIRED

Visitor to the exhibition *A Classic Car: Cisitalia GT, 1946,* 1972–73, examining the Museum's new acquisition

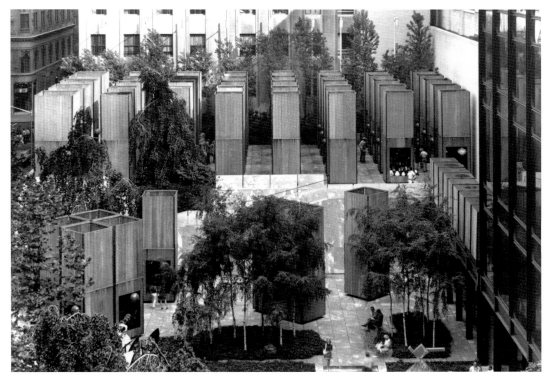

Italy: The New Domestic Landscape, installation views of exhibition kiosks for design objects in the Sculpture Garden and terrace, 1972

The emergence of Italy during the last decade as the dominant force in consumer-product design has influenced the work of every other European country and is now having its effect on the United States. . . . Italy has become a micromodel in which a wide range of the possibilities, limitations, and critical issues of contemporary design are brought into sharp focus. Many of the concerns of contemporary designers throughout the world are fairly represented by the diverse and frequently opposite approaches being developed in Italy. The purpose of this exhibition, therefore, is not only to report on current developments in Italian design, but to use these as a concrete frame of reference for a number of issues of concern to designers all over the world.

Emilio Ambasz

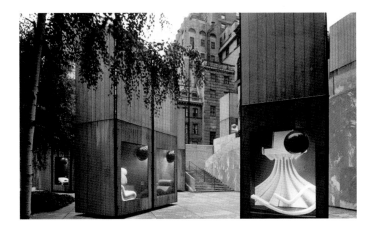

Emilio Ambasz, Associate Curator of Architecture and Design and director of the exhibition, c. 1972

Italy: The New Domestic Landscape, installation view of innovative domestic environments in the Museum galleries, 1972

1973–1984: TRANSFORMATIONS

—1973

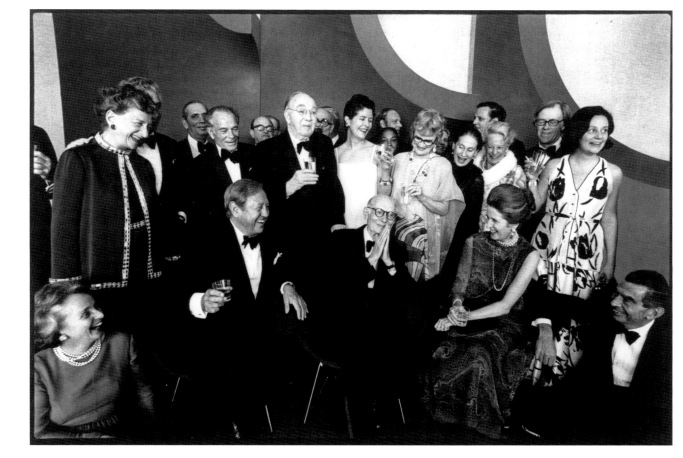

Alfred H. Barr, Jr., is honored by the Trustees of the Museum in 1973. First row, left to right: Mrs. Donald B. Straus, William S. Paley, Mr. Barr, Mrs. John D. Rockefeller 3rd, John L. Loeb; second row: Louise Reinhardt Smith, Monroe Wheeler, Henry Allen Moe, Lily Auchincloss, Elizabeth Bliss Parkinson, Celeste Bartos, Mrs. Walter Hochschild, Gifford Phillips, Mrs. Alfred M. Stern; third row: Gianluigi Gabetti (behind Mrs. Smith), Gustave L. Levy, Edward M. M. Warburg, John Hay Whitney (behind Mr. Warburg), Philip Johnson, Marie Phipps Clark, Richard E. Oldenburg, Mrs. Frank Y. Larkin, and Ivan Chermayeff. Photograph by Harry Benson

■ WILLIAM S. RUBIN

William S. Rubin, Chief Curator of Painting and Sculpture, is named Director of the Department of Painting and Sculpture in 1973 (photograph 1975).

▦ SEVEN-WEEK STRIKE

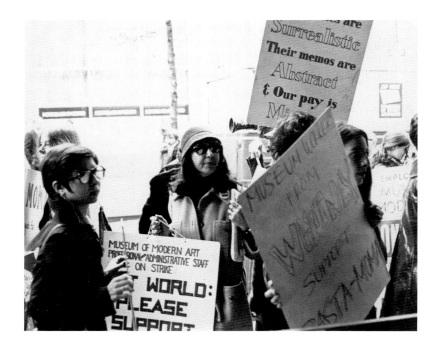

A seven-week strike against the Museum of Modern Art ended yesterday when its professional and administrative workers voted to accept a new 29-month contract. After a heated three-and-a-half-hour meeting, the striking members of Local 1, Museum Division of the Distributive Workers of America, ratified the contract, 51 to 24, and agreed to return to work this morning. . . . In a brief statement issued after the ratification vote, the museum's director, Richard E. Oldenburg, expressed gratitude "for the patience and understanding shown by the museum's members and general public during these past difficult weeks."
Robert Hanley, The New York Times

Picket line outside the Museum during the seven-week staff strike, 1973

▦ LOOKING AT PHOTOGRAPHS

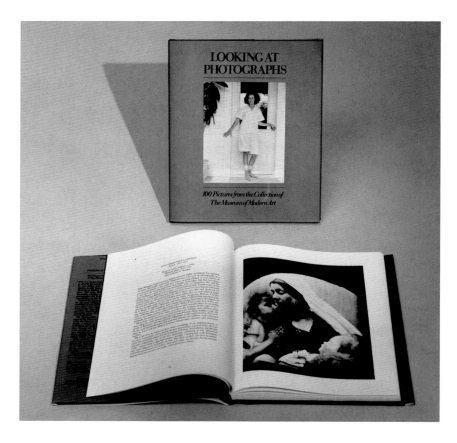

Looking at Photographs: 100 Pictures from the Collection of The Museum of Modern Art, by John Szarkowski, a volume of selections from the Museum's photography collection, 1973

The Museum of Modern Art

11 West 53 Street, New York, N.Y. 10019 Tel. 956-6100 Cable: Modernart

NO. 18
FOR IMMEDIATE RELEASE

MINI-FESTIVAL OF NEW DIRECTORS/NEW FILMS
CO-SPONSORED BY FILM SOCIETY OF LINCOLN CENTER AND MUSEUM

"New Directors/New Films," the 2nd annual international showcase for talented cineastes co-sponsored by the Film Society of Lincoln Center and The Museum of Modern Art, begins March 30 and includes 11 films from nine countries. The films, all made by directors not yet widely exposed in this country, come from India, Senegal, France, Japan, Bulgaria, England, Switzerland, Mexico and Czechoslovakia.

Last year when the "New Directors/New Films" program was initiated Vincent Canby, critic of The New York Times, noted that "the show is providing some talented young filmmakers with the kind of unhurried presentation not possible at a more or less conventional festival." Roger Greenspun referred to the series in the Times as "the lovliest body of cinema work that I have seen in some years."

The films chosen this year, catholic in scope, include among others an anarchic comedy from France, a contemporary Japanese political documentary, a Bulgarian film based on a 17th-century folk-tale, and a drama of the Mexican Revolution as seen through the writings of the American journalist John Reed.

"John Reed (Insurgent Mexico)" reconstructs the turbulent years leading up to the Mexican Revolution of 1913. Based on the experiences of the then unknown American Reed, this first narrative film by 30-year-old Mexican Paul Leduc, formerly a documentary filmmaker, depicts not only the events of the revolution itself but also the transformation of John Reed from passive observer to committed participant. Reed was later to gain fame for his coverage of the Russian Revolution and his classic book "Ten Days That Shook the World."

Well-known sculptor Niki de St. Phalle has teamed with English documentary ' maker Peter Whitehead to make "Daddy" (1972), an unusual feature about a woman ' humiliates her once tyrannical, seductive father, and then indulges with her m sexual obsessions. The first film to express women's sex fantasies, it is no

Museum press release announcing the second year of the program *New Directors/New Films*, sponsored jointly by the Museum and the Film Society of Lincoln Center, 1973

Program brochure and ticket-order form for *New Directors/New Films*

1974

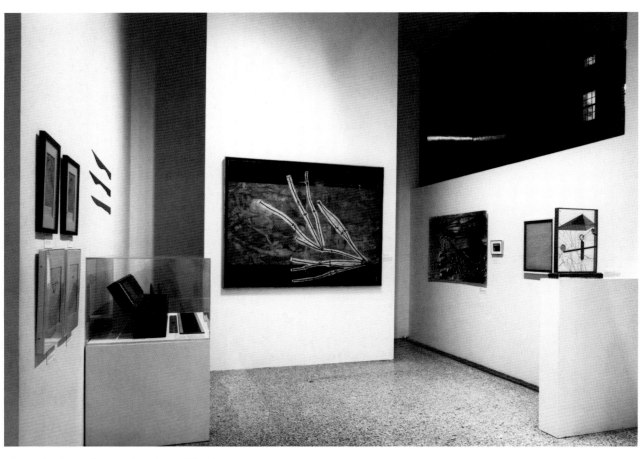

Marcel Duchamp, installation view, 1973–74

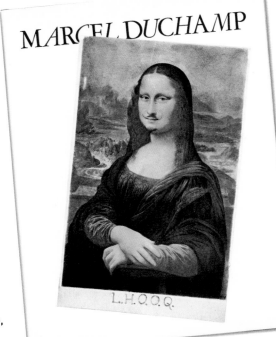

Catalogue for the exhibition *Marcel Duchamp*, edited by Anne d'Harnoncourt and Kynaston McShine, 1973

—1975

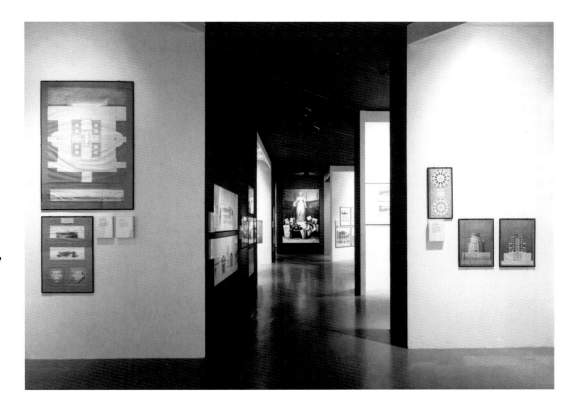

The Architecture of the École des Beaux-Arts, installation view, 1975–76

Copy of newspaper article, by Ada Louise Huxtable, in *The New York Times Magazine,* October 26, 1975

Design

The New York Times Magazine

OCTOBER 26, 1975/SECTION 6

In 1867, student Emile Bénard won the Prix de Rome with this design for a Palace for an Exhibition of Fine Arts. The drawing, part of his work at the Ecole des Beaux Arts in Paris, will hang in a show, "The Architecture of the Ecole des Beaux Arts," opening to the public Wednesday at the Museum of Modern Art.

Beaux Arts-the latest avant-garde

A 19th-century Beaux Arts student carries his competition drawing from studio to school in a cart, or charrette. The phrase en charrette is still used to mean working against a deadline.

By Ada Louise Huxtable

Nineteenth-century Paris. *Vie de Bohème.* Artists in garrets. The Beaux Arts ball. The architecture students of the Ecole des Beaux Arts in M. Gaudet's famous atelier on the Left Bank, smocks stained with *encre de Chine,* working on palatial projects for the Prix de Rome. They run careful washes behind meticulously rendered public monuments or ink in painstaking reconstructions of ancient Greek temples. A few *nouveaux* clean brushes for *les anciens.* The drawings are enormous, skillful representations of classical grandeur. Stoves at either end of the large, cluttered room barely heat the chill air. Along one wall, untidy bookshelves hold dusty copies of Vitruvius and Palladio and the prizewinning designs of students who have gone on to fame. The Ecole des Beaux Arts is more than a school. It is *la source,* the fountainhead of official architecture for Old and New Worlds.

No more. Over the past 50 years, Beaux Arts has become a bad word. For this is the large slice of architectural history (and a large part of the civilized world) which the modern movement exorcised. It is, in fact, what modern architecture rebelled against.

Now, in one of those increasingly popular, paradoxical reversals of art and taste, the discarded academic past is becoming the intriguing avant-garde. The Beaux Arts will be the subject of a large and enlightening and undoubtedly controversial exhibition starting Wednesday at that bastion of the modern movement, the Museum of Modern Art. The Academy is dead. Long live the Academy.

"The Architecture of the Ecole des Beaux Arts" is the museum's major fall show and, in the opinion of many, one of its most important contributions to tastemaking and art scholarship since "The International Style" formally introduced modern architecture to this country in 1932. It comes under the heading of that growing historical exercise called "radical revisionism," a questioning of the conventional wisdom in which reputations and movements are re-examined and reclaimed.

In truth, so arcane, so unfashionable, so discarded as proper intellectual and esthetic baggage is the world of the Beaux Arts, that this may be the first invitation to a museum opening (tomorrow night) that includes an explanation of what the show is all about. "The exhibition examines the dominant ideas of 19th-century French academic architecture," the invitation sates. "Many of the more than 200 drawings in watercolor and ink, some as large as 18 feet wide and extraordinary in their opulent and varied detail, have not been unrolled since they were submitted by students to their professors at the Ecole des Beaux Arts 150 years ago."

The unrolling has been done by Arthur Drexler, director of the museum's Department of Architecture and Design, over the last eight years, in the attic of the Ecole des Beaux Arts in Paris, where he, and they, were covered with a century and a half of soot.

But a little soot has failed to dim their essential *gloire.* As drawings, they are breathtaking. The techniques of ink and wash are handled superbly; the subjects are a galaxy of monumental structures increasingly overwhelming in size and complexity as the century moved on. The subjects are unvaryingly grand and their treatment elegant, elaborate and ornate. They deal in all the taboo words and practices—elitism, ornament, overt extravagance—of modern architectural usage.

It is a never-never world of palaces of kings, palaces of justice and palaces for the arts, of cathedrals, conservatories, stock exchanges, state banks and thermal baths, emperors' pavilions, ambassadors' compounds and mansions for rich bankers. (The last was considered a controversially ordinary subject in 1866; if a student could design a great state edifice, it was argued, he could toss off an establishment for a banker.)

More pragmatic themes were public granaries and markets, barracks for the military and, later in the century, railroad stations. But there was nothing small or humble. Among Prix de Rome competition subjects were an imperial residence at Nice (1860), a palace for the governor of Algeria (1862) and a casino on the sea (1889), scattered among more or less routine orangeries, *hôtels de ville* and royal residences. It is a world that today seems far less accessible than the moon.

The first impact of these impressive renderings is that they represent a dead society and lost skills. As drawings, they are enjoyable as beautiful drawings and illuminating as indicators of style and standards that go beyond art to reveal the social structure and cultural norms of a closed chapter in history. In this sense, they are provocative and informative documents to a very high degree.

The point that the museum is hammering home, however, in a rather hermetic, scholarly way, by overt demonstration and massive innuendo (18-foot drawings are not exactly understatement), is that this work is not irrelevant at all. According to Arthur Drexler, whose modernist credentials are impeccable, it offers the kind of satisfaction of the spirit and the eye which has always been an essential component of the art of architecture, and which is now largely lost to the modern movement through an insistently narrow and false polemic (functionalism, purity of form, abolition of ornament).

In fact, he goes right down the line to the basic definition of architecture. The Beaux Arts defined it as the public building. Modernists define it as the total built environment. Drexler thinks that a lot of values were lost in the trip from the monument to the environment. That the world of the Beaux Arts depends on an exclusionary and aristocratic concept of architecture does not bother him at all. The clear suggestion is that the emperor, today, is wearing no clothes, and it may be that we need the emperor after all.

continue

copyright THE NEW YORK TIMES MAGAZINE
Sunday October 26, 1975

**Copy of a newspaper article by Glenn Fowler,
The New York Times, September 17, 1976**

1976

In the fall of 1975, after long study and analysis, the Museum announced a highly innovative proposal to deal with the seemingly intractable problems of its financial situation and need for additional space. In essence, the plan proposed the creation through State legislation of a Trust for Cultural Resources which would be empowered to arrange for the development of the Museum's valuable air rights by constructing a condominium apartment tower. The tower would be built over a new Museum wing to the west of the existing building; this wing would approximately double the Museum's present gallery space and provide other new facilities. The Trust would be empowered to receive the equivalent of real estate taxes on the condominium and convey these payments to the Museum, providing substantial new revenues for the Museum's support.

Richard E. Oldenburg

THE NEW YORK TIMES, September 17, 1976

L B3

City Approves Trust for Building Museum of Modern Art Complex

By GLENN FOWLER

The Museum of Modern Art cleared its final governmental obstacle yesterday in its effort to build a condominium apartment tower above an expansion of its galleries on 53d Street.

The City Board of Estimate voted unanimously, after hearing arguments for more than two hours, to approve a controversial trust arrangement that would permit diversion from the city to the museum of about $1 million a year in real estate taxes on the condominium units.

Earlier this summer, the State Legislature passed enabling laws, heeding the museum's plea that its future would be endangered unless it was permitted to expand and to finance the project with what otherwise would be property taxes payable to the city.

Beame's Backing

Mayor Beame made one of his rare appearances in the Board of Estimate chamber at City Hall yesterday to muster support for ratification of the state act that created a Trust for Cultural Resources. The trust is to serve as the conduit for payments in lieu of taxes that will go to the museum instead of the city. It is an essential device because the nonprofit museum cannot legally enter the development business.

"The Museum of Modern Art is a unique and valuable cultural resource for our city," Mr. Beame said as he cast his four votes for the proposal. "It's one of the very few cultural institutions that has never received a subsidy from the city, so it certainly deserves our help in its survival."

Before the vote, opponents of the trust argued that it would amount to a giveaway of future city tax revenues at a time of extreme municipal fiscal stringency.

"We're building a palace of gold when we can't complete half-finished schools," said G. Oliver Koppell, Assemblyman from the Bronx, who led the opposition to the state Legislation. "The wealthy patrons of the museum mounted a tremendous lobbying effort. If they sincerely want to expand the galleries, they might shift their energies to raising funds for the project instead of pleading for special tax treatment from the city."

The Community Service Society also opposed the measure, urging that the city support the museum by making annual appropriations, as it does for other cultural institutions, instead of committing potential tax revenue for many future years.

Spokesmen for Lincoln Center for the Performing Arts, the Brooklyn Museum and other cultural organizations contended that the trust was appropriate. Martin E. Segal, the city's Commissioner of Cultural Affairs, noted that the Museum of Modern Art actively promoted educational activities, including free admission to art students and to elementary school pupils.

Assurances Received

The museum says it needs $17 million for its gallery expansion and $23 million for the apartment tower. Although Richard E. Oldenburg, the museum's director, said he could not reveal specific details, it is understood that Arlen Properties, which recently completed another luxury condominium, the Olympic Tower on Fifth Avenue, is the prospective developer.

Before voting in favor of the trust arrangement, Board of Estimate members received assurances from Charles M. Bleiberg, counsel to City Comptroller Harrison J. Goldin, that the city would not be liable in the event that bonds sold by the trust to finance the project were to default.

■ RIVA CASTLEMAN

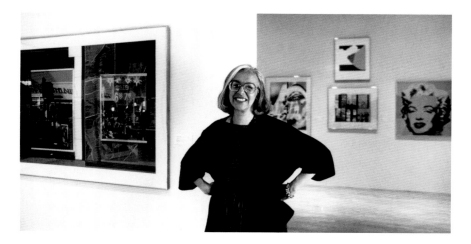

Riva Castleman, Curator of Prints and Illustrated Books, is named Director of the Department of Prints and Illustrated Books, 1976.

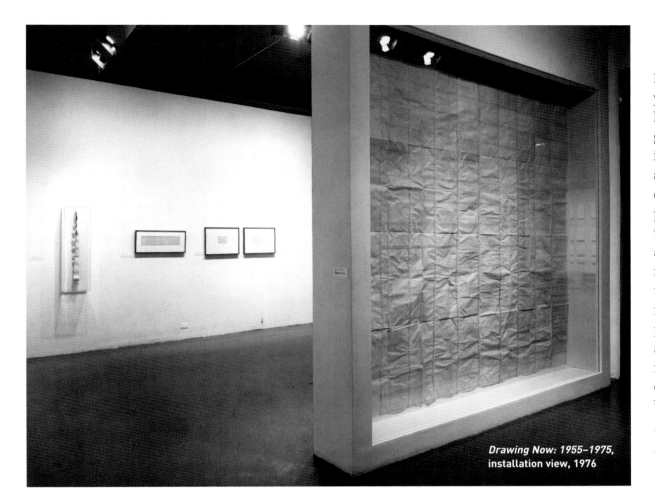

During the past twenty years a number of artists have . . . seriously investigated the nature of drawing, investing major energies in a fundamental reevaluation of the medium, its disciplines, and its uses. With this process of reevaluation and renewal, drawing has moved from one context, that of a "minor" support medium, an adjunct to painting and sculpture, to another, that of a major and independent medium with distinctive expressive possibilities altogether its own.
Bernice Rose, Curator of Drawings

Drawing Now: 1955–1975, installation view, 1976

▪ THE "WILD BEASTS": FAUVISM AND ITS AFFINITIES

Catalogue for the exhibition *The "Wild Beasts": Fauvism and Its Affinities*, by John Elderfield, 1976

▤ WILLIAM EGGLESTON

Catalogue for the exhibition *William Eggleston* by John Szarkowski, 1976

These pictures are fascinating partly because they contradict our expectations. We have been told so often of the bland, synthetic smoothness of exemplary American life, of its comfortable, vacant insentience, its extruded, stamped, and molded sameness, in a word its irredeemable dullness, that we have come half to believe it, and thus are startled and perhaps exhilarated to see these pictures of prototypically normal types on their familiar ground. . . .

As pictures . . . these seem to me perfect: irreducible surrogates for the experience they pretend to record, visual analogues for the quality of one life, collectively a paradigm of a private view, a view one would have thought ineffable, described here with clarity, fullness, and elegance.

John Szarkowski

▤ THE TAXI PROJECT

Taxicabs have already proven their worth. But, as any taxi-rider knows, there is considerable area for improvement. . . . The working taxi prototypes [commissioned by the Museum for the exhibition] evidence that a small but enlightened sector of the automobile industry has begun to recognize the market potential of a special taxi vehicle, and is also acknowledging its responsibility in contributing solutions to the traffic problems of our cities.

Emilio Ambasz

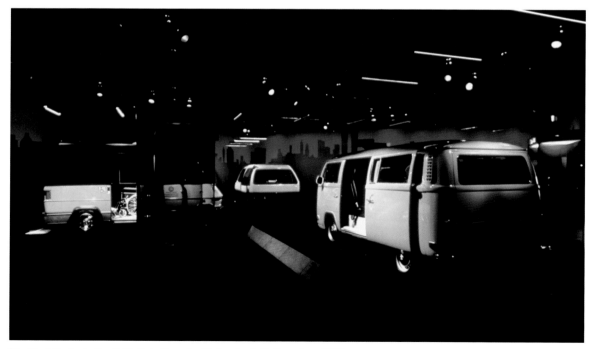

The Taxi Project: Realistic Solutions for Today, installation view, 1976

—1977

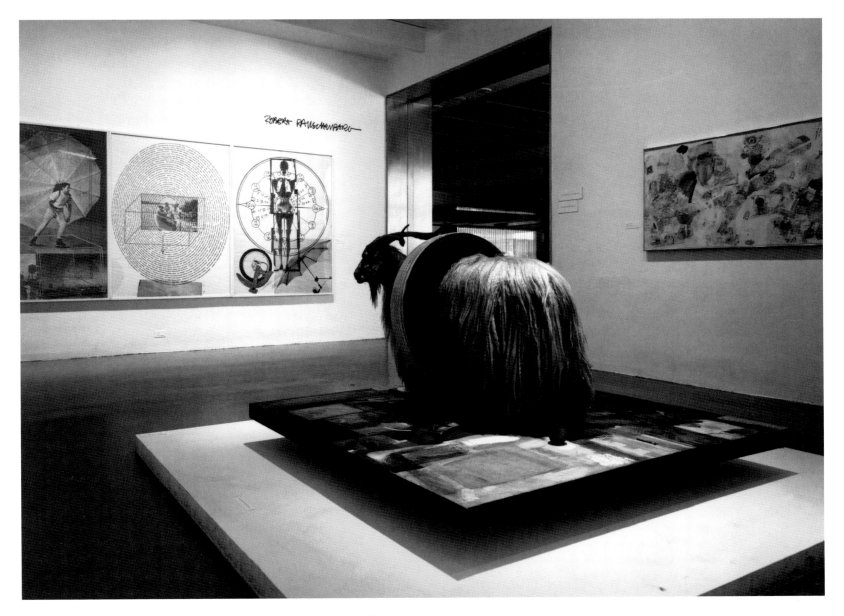

Robert Rauschenberg, installation view, 1977

▦ IMPRESARIO: AMBROISE VOLLARD

Ambroise Vollard was an extraordinary merchant of art. . . . Publishing illustrated books, however, was Vollard's uppermost ambition, and from 1900 on he energetically pursued the complexities of this creative form, matching artists and authors, type and papers. . . . Time has irrevocably linked him with the foremost artists of his day, and his determination to encourage them to make multiple art works in the form of books, prints, and bronzes has spread their genius—and his—throughout the world.
Riva Castleman

Brochure for the exhibition
Impresario: Ambroise Vollard, **1977**

▦ CÉZANNE: THE LATE WORK

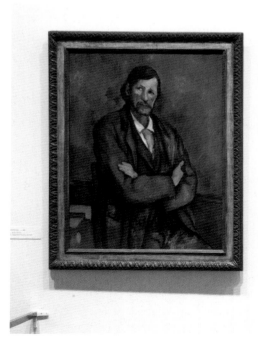 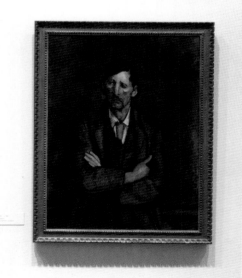

Cézanne: The Late Work, **installation view, 1977–78**

—1978

Everything was done just as it should be, and that doesn't always happen in large institutions. But everything was really done very well. I did what I wanted, I had no interference, and they actually bought a large piece from the show. . . . Alicia [Legg] was wonderful. She was very precise and very understanding and very knowledgeable. She was very good to work with. Everything got done. The catalogue got done. . . . It doesn't always happen. One thing about this Museum is that at every level it's always very professional. After working with museums all over the Western world, really, they're still the best.

Sol LeWitt, 1994

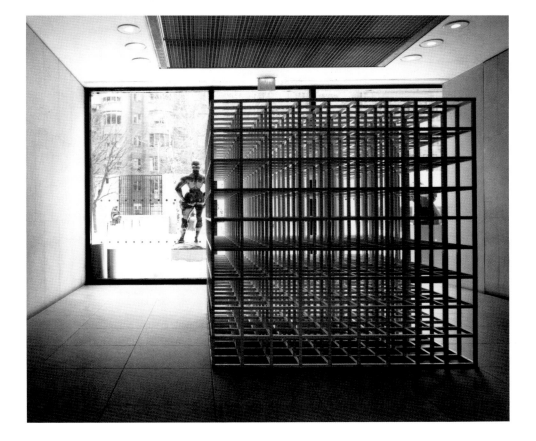

Sol LeWitt, **installation views, 1978**

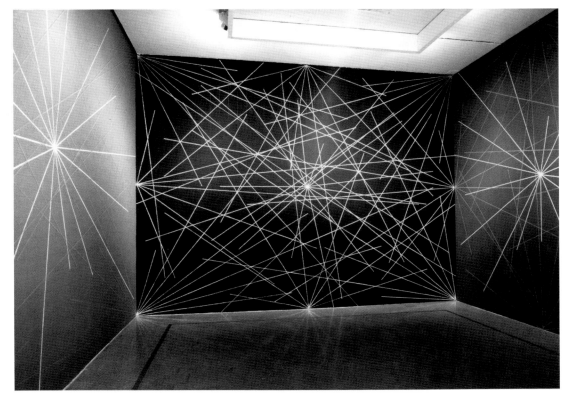

▪ VIDEO VIEWPOINTS SERIES BEGINS

Program for *Video Viewpoints*, 1978

Video Viewpoints

Five independent videomakers talk about and show their work
Monday Evenings, 7:30 p.m. Founders Room, sixth floor
The Museum of Modern Art, 11 West 53 Street, New York, N.Y. 10019
Tickets are free and are available at the Lobby Information Desk

March 13

Steina Vasulka

The Craft of Electronic Imagery

March 27

Vito Acconci

FACE/FIGHT/FLASH (Video as a Ground for Non-Video)

April 24

Bill Viola

Subjective Elements in Videotape Recordings

May 8

Beryl Korot

Video and the Loom: An Explanation of Ancient and Modern
Technologies (Illustrated by Two Multi-Channel Works)

May 22

Jon Alpert

The Work of the Downtown Community Television Center

▪ NEW EDUCATION DEPARTMENT FORMED

The Staff

Richard E. Oldenburg

July 31, 1978

Department of Education

In 1972, with the generous assistance of a grant from the Edward John
Noble Foundation, the Museum established its present Education Office,
headed by William Burback as the Director's Special Assistant for
Education.

In the past six years, the Office has done an excellent job of coordinat-
ing the Museum's education activities, improving and expanding existing
services and developing new programs to serve a larger and more diverse
public.

Recognizing these accomplishments and paralleling the organization of
corresponding functions at most other museums, it now seems appropriate
to redesignate the Education Office as the Museum's Department of Education,
headed by Bill Burback as its Director. I am happy further to announce
the appointment of Myrna Martin as Assistant Director.

Let me take the occasion of this retitling to thank the entire Education
staff for its dedicated and greatly appreciated work on behalf of the
Museum.

Memo to the staff from Director Richard E. Oldenburg
about the new Department of Education, 1978

Children's panel chaired by Philip Yenawine, Director of
Education from 1984 to 1992

1979

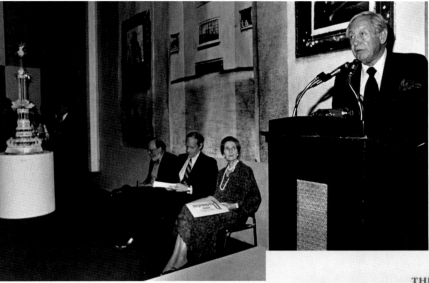

William S. Paley, Chairman of the Board, speaking at the Museum's fiftieth-anniversary party, November 1979. Seated to the left are New York City Cultural Affairs Commissioner Henry Geldzahler, Director Richard E. Oldenburg, and President Mrs. John D. Rockefeller 3rd.

The Museum of Modern Art

50th Anniversary

THE MUSEUM OF MODERN ART
CELEBRATES ITS 50TH ANNIVERSARY YEAR

The Museum of Modern Art, New York, is this year celebrating the 50th Anniversary of its founding in 1929. Acknowledged worldwide as the single most important collection of 20th-century art--painting, sculpture, drawings, prints, photography, architecture and design, and film--the Museum has been instrumental in introducing the art of our time into the mainstream of modern cultural life.

More than one million visitors per year come to the Museum to see the Collection as well as to attend temporary exhibitions, film programs, and special events. A still larger public is served by the Museum's active publishing program, its library and educational activities, and its exhibitions circulated nationally and internationally.

Detail of a Museum press release announcing the fiftieth-anniversary celebration, 1979

THE WHITE HOUSE
WASHINGTON

November 1, 1979

The fiftieth anniversary of the Museum of Modern Art is a proud milestone in our nation's cultural history. Rosalynn and I extend our warmest congratulations to its officers, trustees, staff and friends.

The Museum'a advocacy of modern art and the contemporary artist; its superb collections, pioneering exhibitions and informative publications; its early recognition of film, photography, architecture and design as important art forms have all greatly enhanced the artistic vitality of our nation. By its influence and example, the Museum has stimulated the development throughout our country of other major institutions concerned with modern art; and its traveling exhibitions abroad have furthered international understanding as well as art appreciation.

Rosalynn and I are confident that in decades to come the Museum of Modern Art will continue to broaden our cultural horizons and enrich our way of life.

Jimmy Carter

Letter from the White House congratulating the Museum on its fiftieth anniversary, signed by President Jimmy Carter and dated November 1, 1979

◼ NELSON A. ROCKEFELLER BEQUEST

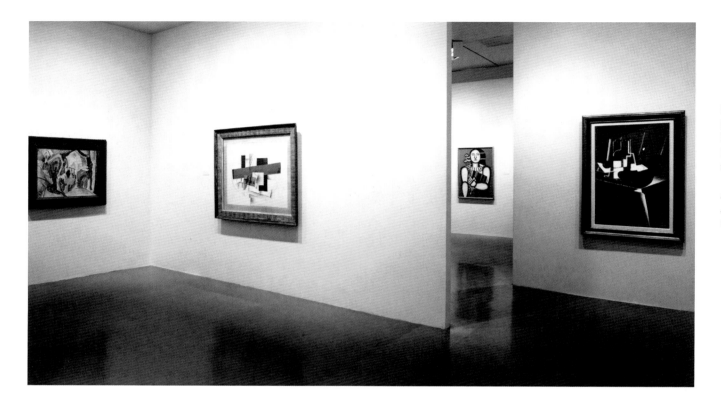

Paintings included in the 1979 Nelson A. Rockefeller Bequest. Installation view of the 1969 exhibition *Twentieth-Century Art from the Nelson Aldrich Rockefeller Collection*

◼ JAMES THRALL SOBY BEQUEST

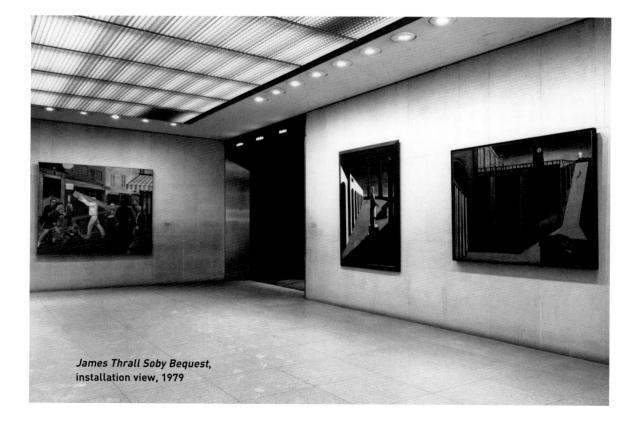

James Thrall Soby Bequest, installation view, 1979

MOMA's Boy Lauds Oscar

By Stephen Harvey

I think my favorite Oscar acceptance speech ever was Ingrid Bergman's on the occasion of her third win, for *Murder on the Orient Express.* Ever gracious, the imperturbable Swede murmured that it was "always nice to win one of these."

Well. With all due respect, those of us who toil in the Museum of Modern Art's film department can't afford to be quite so blasé. After all, we only get one of these about once every 40 years. And, scholarly sobriety aside, the day we heard the news, the giddy hysteria in the MOMA hallways would have made even Miss Rona blanch.

The best part about the academy's acknowledgment of our work is that it confirms that we've been right since 1935. Surviving chroniclers of the old days tell of a rather different climate, in which some dismissed film as guilty

pleasure for the masses, while the Hollywood powers-that-were thought us crazy for exhuming forgotten triumphs from their vaults.

The MOMA film collection grew under somewhat peculiar circumstances. The works of D. W. Griffith—a cornerstone of the archives —were acquired only because that neglected master could no longer pay the fees to store his own films elsewhere. Under founding curator Iris Barry, the job of establishing cinema as art made for strange bedfellows. Decades before he annotated the goings-on of Emma Bovary and the Bellamys, Alistair Cooke was at MOMA extolling the virtues of the likes of Douglas Fairbanks, and Luis Buñuel found a wartime haven here poring over reels of Nazi-propaganda footage.

Garbo has been wont to sneak in to view her own movie legacy from time to time, and Woody Allen, Martin Scorsese, Stanley Kubrick, and Peter Bogdanovich spent their youths learning Everything They Always Wanted to Know About Movies right in the MOMA auditorium.

The film department has grown with its audiences. Eileen Bowser has expanded the archives to span from Edwin S. Porter to Robert Altman, while Adrienne Mancia's programs go from Africa to Zagreb and the mythical kingdom of RKO-Radio. The "Looking at Film" lectures I organize bring to our public many distinguished film scholars and critics, as well as the performers and filmmakers who inspire that erudition.

In a way, I feel kind of sorry for Scorsese, Woody, and all those other guys. Like them, I played hooky to see *Intolerance* here for the first time. But they had to leave to do whatever it is that they're up to these days. I got to stay here with MOMA.

Illustrated by Randall Enos

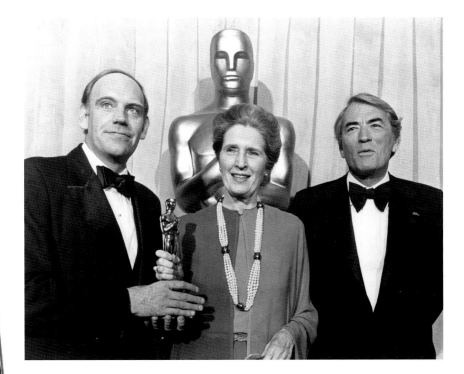

Article by Stephen Harvey, *New York Magazine,* April 25, 1979. Mr. Harvey was a curator in the Department of Film from 1972 to 1993.

The Film Department of The Museum of Modern Art receives an Oscar. Director Richard E. Oldenburg and President Mrs. John D. Rockefeller 3rd accept an honorary Oscar from the actor Gregory Peck at the Academy of Motion Picture Arts and Sciences 51st Annual Awards Ceremony, April 1979.

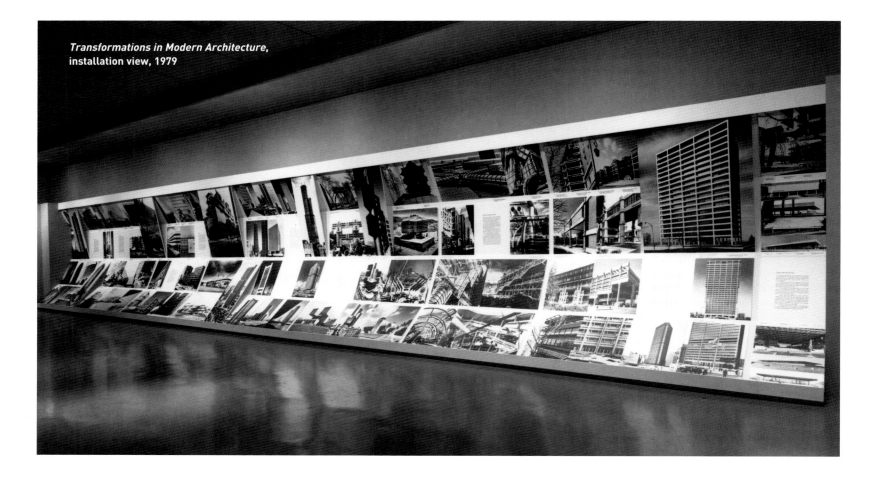

Transformations in Modern Architecture,
installation view, 1979

■ JOHN ELDERFIELD

Upon the resignation of William S. Lieberman as Director of Drawings in 1979, John Elderfield is named to succeed him, retaining the title of Curator in the Department of Painting and Sculpture that he has held since 1974.

▪ PRINTED ART: A VIEW OF TWO DECADES

—1980

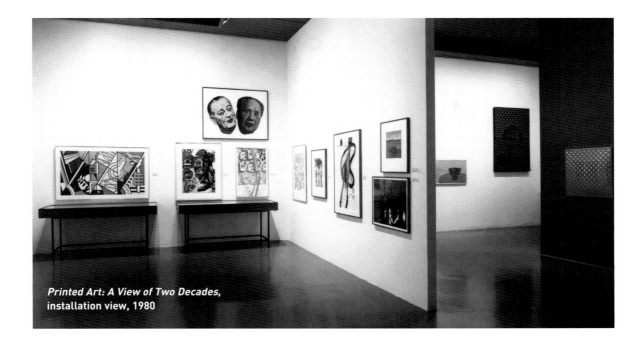

Printed Art: A View of Two Decades,
installation view, 1980

The past twenty years have been unprecedented in the production of fine prints and other printed matter by leading artists. The printed image seems ubiquitous in contemporary art and, indeed, the very definition of art today often appears to derive from the communicative possibilities inherent in print mediums. *Printed Art: A View of Two Decades,* a major 50th Anniversary exhibition of The Museum of Modern Art, surveys this renaissance in printmaking: from Pop and Minimal Art to the ephemeral booklets and periodicals of the Conceptualists; from established masters to emerging talents. . . . "Printmaking became a major component in artistic expression of the sixties and seventies because artists could find in the various media, and their work in them, the solutions to problems of form, color, meaning, and all the elements that make up the composite of subject and style that is art," notes Ms. [Riva] Castleman.
Museum Press Release

▪ MARY LEA BANDY

**Mary Lea Bandy, Administrator
of Film, is named Director of the
Department of Film, 1980 (photo-
graph 1984).**

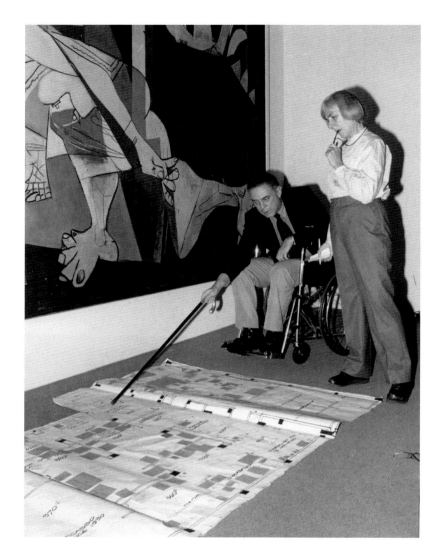

The idea for the present exhibition emerged from my visits with Picasso during the last years of his life. I had the good fortune not only to observe how Picasso lived but to see many works he kept near him. Some I had seen in exhibitions; most I knew only through photographs, and still others were entirely new to me. Studying them all in Picasso's own surroundings altered my image of the man and his work even as it expanded it. My desire to share that experience and perception was the genesis of this exhibition. . . .Because Picasso's oeuvre, in its multiplicity of styles, variety, and inventiveness, epitomizes twentieth-century art as a whole, this appeared to me a fitting exhibition to celebrate the Museum's first fifty years.

William Rubin

William S. Rubin, Director of Painting and Sculpture, and Alicia Legg, Curator of Painting and Sculpture, preparing the exhibition *Pablo Picasso: A Retrospective*, **1980**

Director Richard E. Oldenburg, First Lady Rosalynn Smith Carter, Amy Carter, and President Jimmy Carter looking at the catalogue for *Pablo Picasso: A Retrospective*, **1980**

■ PABLO PICASSO: A RETROSPECTIVE

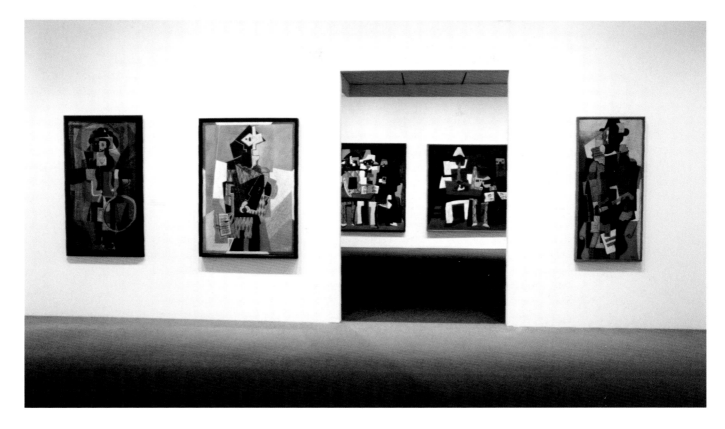

Pablo Picasso: A Retrospective, installation views, 1980

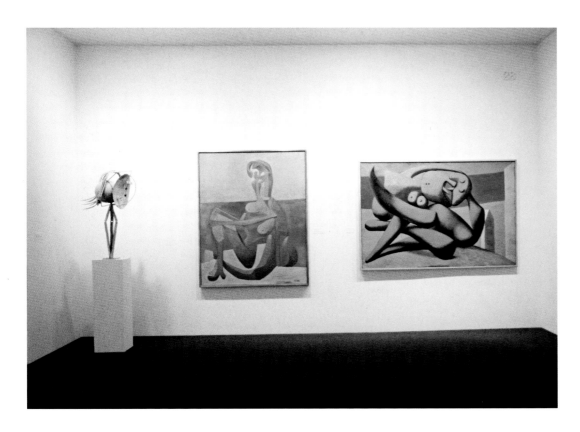

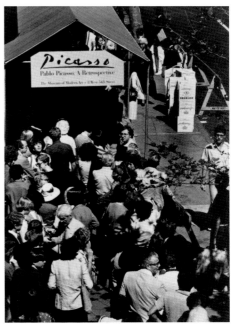

Visitors waiting in line on West Fifty-fourth Street for admission to the popular exhibition *Pablo Picasso: A Retrospective*, installed throughout the Museum's galleries. An estimated 1,021,400 people viewed the exhibition.

■ JOSEPH CORNELL

Cornell is best known for his small-scale box constructions, in which he juxtaposed familiar but unrelated objects, pasted papers and reproductions, to portray his private visions of tangible and imaginary worlds. . . . Enclosed by glass, Cornell's boxes contain sometimes free-moving, sometimes anchored trinkets. . . . "Everything can be used," Cornell once said, "but one doesn't know it at the time. How does one know what a certain object will tell another?"
Museum Press Release

Catalogue for the exhibition *Joseph Cornell*, edited by Kynaston McShine, 1980

Joseph Cornell, installation view, 1980–81

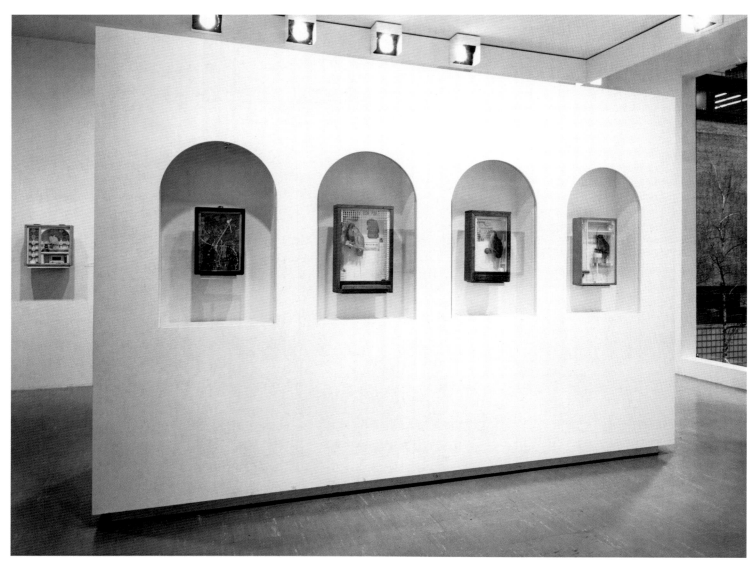

—1981

It is a rare occasion when a director can announce an acquisition that is unsurpassed in the history of his department . . . the definitive collection of the great French master Eugène Atget. . . . Working in almost total obscurity, [he] photographed Paris for thirty years until his death in 1927. In the years since, his work has become a touchstone for those who have developed the modern documentary aesthetic. After his death his work was rescued by the American photographer Berenice Abbott, who preserved and interpreted it. The collection was purchased [in 1968 by the Museum] from Miss Abbott and co-owner Julien Levy The collection . . . numbers several thousand original prints and approximately 1,000 glass negatives.
John Szarkowski, 1969

The Work of Atget, by John Szarkowski and Maria Morris Hambourg. Four volumes were published between 1981 and 1985 to accompany a series of exhibitions drawn exclusively from the Museum's Abbott-Levy collection of Atget's photographs.

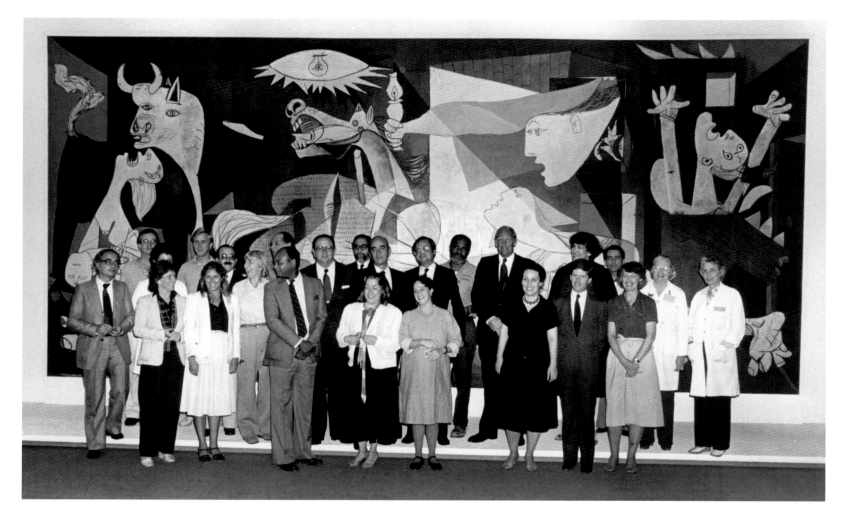

Museum staff and Spanish officials in front of Pablo Picasso's *Guernica* before it is packed and sent to Spain, September 8, 1981. Front row, left to right: a member of the Spanish team, Curator Carolyn Lanchner, Assistant Curator Laura Rosenstock, Curator Alicia Legg, Senior Curator Kynaston McShine, Executive Assistant to the Director Ethel Shein, Associate Director of Public Information Sharon Zane, Assistant Curator Cora Rosevear, General Counsel John B. Koegel, Registrar Eloise Ricciardelli. Back row: Preparator John Mincks, Conservator Anny Aviram (behind Ms. Lanchner), Conservator Terence Mahon, member of Spanish team, Preparator Albert Steventon, four members of Spanish team, Installation Preparator Gilbert Robinson, Director Richard E. Oldenburg, Director of Public Information Luisa Kreisberg, member of Spanish team, Chief Conservator Jean Volkmer, and Associate Chief Conservator Tosca Zagni

We knew it was going . . . because it wasn't even in the plans for the new wing, and they didn't want anyone to know when. . . . I chose the packers in New York but didn't tell them what it was. I did the measurements [myself]. . . . There was no work ever mentioned. . . . Once I knew the size of the door of the aircraft, I told Danny Clarke [the head carpenter] the maximum-size case. Then he built the drum that the *Guernica* had to be rolled on that would float in the box the maximum size he could build it. . . . Frankly, it was the most moving thing when they started to roll it. I just got goose pimples. When Jean [Volkmer] and her crew had unstapled it from its stretcher and the glassine was layered onto the surface and it started to roll on the drum, I just couldn't believe it. . . . It was really a big event for the staff that worked with it. The next day, of course, it had to leave. . . .

I went over to Spain [for] the opening of the *Guernica*. . . . When [people] got into the gallery and saw it they just stood there. It was as if they were in a cathedral. It was so touching. . . . It was behind this terrible . . . bulletproof glass. . . . and people were so patient. I remember [Josep Luis] Sert coming up to me, grabbing me, because he knew I was from the Museum, kissing me on two cheeks, "Oh, you saved this painting and kept it." It had nothing to do with me, you know; I was a symbol.

Eloise Ricciardelli, Registrar (1978–1991), 1994

▪ GUERNICA LEAVES THE MUSEUM

Memo to the staff from Director Richard E. Oldenburg regarding the transfer of *Guernica* from the Museum to the Prado in Madrid, Spain, September 9, 1981

The Museum of Modern Art

To The Staff

From Richard E. Oldenburg *REO*

Date September 9, 1981

Re <u>Guernica</u>

For reasons of strict security and by agreement with the Spanish authorities, I have not been able before this afternoon to share with all of you our arrangements to transfer <u>Guernica</u> to Spain in accordance with Picasso's wishes.

<u>Guernica</u> was taken down from the third floor gallery yesterday evening and packed for shipment. The efficiency, care and calm with which this was accomplished by members of our Conservation, Registrar and Carpenter staffs, supported by other departments such as Security and Public Information, evidenced superbly the skill and professionalism of everyone concerned. They all deserve our great admiration as well as our appreciation for long hours of special planning and execution.

The Museum was entrusted with this work in 1939 with the understanding that Picasso wished it ultimately to be placed permanently in the Prado Museum in Spain. The decision that the time is now appropriate for this move reflects among other considerations the conclusion of Picasso's designated attorney that the necessary conditions have been fulfilled. It also has the concurrence of Picasso's heirs.

The final step in arrangements which have been evolving over the past several months was a small ceremony in the Trustees Room this afternoon. The Minister of Culture of Spain, Inigo Cavero, and the Museum's Chairman, William S. Paley, and President, Mrs. John D. Rockefeller 3rd, signed a brief agreement formally transferring responsibility for the work from the Museum to the Spanish Government. Soon thereafter, <u>Guernica</u> and its related studies left the Museum to be flown to Madrid. They will there be installed in a newly renovated annex to the Prado in time for the celebration of the Centenary of Picasso's birth, October 25, 1981.

Obviously we all feel some sadness in seeing <u>Guernica</u> depart from this museum. It has been a very great privilege and a tribute to this institution to have had this work entrusted to us for so many years and through such changing times. However, we can take comfort and further pride in parting with it with good grace, with all possible concern for Picasso's wishes and with due recognition of the special significance which <u>Guernica</u> has for the people of Spain.

REO/tf

Guernica is taken down from the wall, unstretched, placed on layers of Mylar, and rolled up to fit into a specially made container for its transfer to Spain. Left to right: Tosca Zagni, Anny Aviram, crate-makers Sam and Vinnie, Terrence Mahon, John Mincks, Daniel Clarke, Lead Preparator Peter McIntyre, and Albert Steventon

Rolling the canvas between sheets of Mylar. Left to right: Al Steventon, Jean Volkmer, Peter McIntyre, Anny Aviram, and John Mincks. Standing in the rear is Master Carpenter Daniel Clarke, who designed and built the shipping container for the painting.

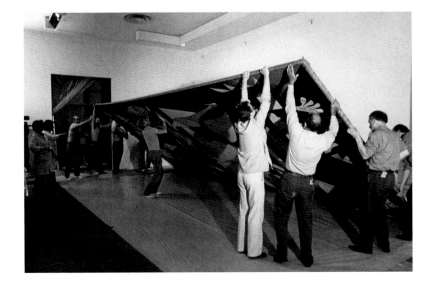

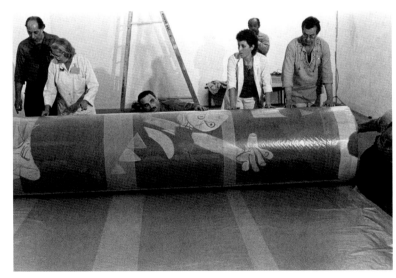

■ FOUR KANDINSKYS REUNITED

—1982

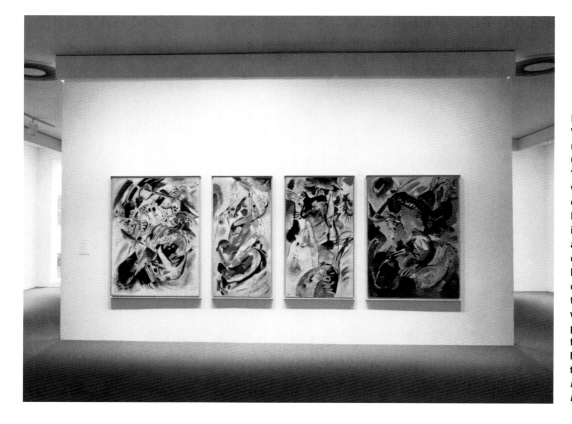

Four works on canvas by Vasily Kandinsky, commissioned by Edwin R. Campbell for his New York apartment in 1914, were reunited by an exchange with the Solomon R. Guggenheim Museum in 1982. The Museum acquired the two panels owned by the Guggenheim, adding them to its own two and completing the set. The numbered works, sometimes interpreted as suggesting the four seasons, are seen here in the 1993 exhibition *Selections from the Permanent Collection of Painting and Sculpture.*

—1983

■ THREE NEW SKYSCAPERS

Skyscrapers are machines for making money. They exploit land values to the point of making cities uninhabitable, but that is no reason to stop building them: in a free society capitalism gives us what we want. . . . Since we want and love skyscrapers, and spend so much time in them, their design ought to involve other issues besides external styling. . . . The three buildings in this exhibition illustrate with singular force the interaction of these related factors: innovation in structural design; in spatial arrangement; in the scale of abstract form; and in the manipulation of architecture as urban scenography. . . . Questions of technology, scale, and eclecticism are dealt with by all of them in ways important enough to modify the terms of the argument.

Arthur Drexler

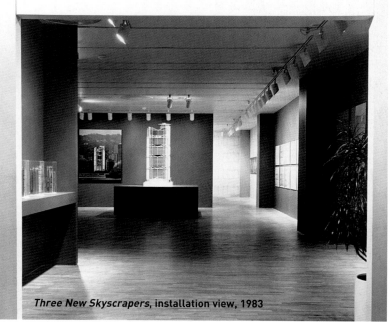

Three New Skyscrapers, installation view, 1983

1984

Director Richard E. Oldenburg and architect Cesar Pelli in front of the model for the 1984 expansion, 1983

Representatives of the Expansion Committee with the Mayor and Comptroller of the City of New York in the Sculpture Garden. Included are President Mrs. John D. Rockefeller 3rd, Chairman William S. Paley, Vice President Donald B. Marron, Mayor Edward I. Koch, Director Richard E. Oldenburg, and Comptroller Harrison Goldin, 1984.

Garden Hall, interior view, 1984

Model showing front facade of the 1984 expansion to the left

Garden Hall as seen from the garden at night, 1984

Cartoon by Charles Saxon in *The New Yorker* magazine, June 18, 1984

"Why don't we take a look? It's twice as big, but you can leave when you've had enough."

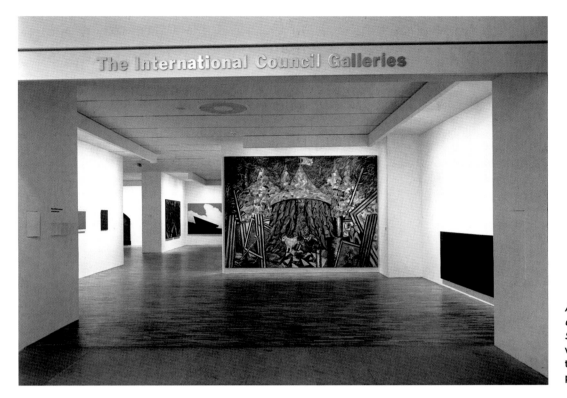

An International Survey of Recent Painting and Sculpture, installation view, 1984. This exhibition opened the expanded Museum.

"PRIMITIVISM" IN 20TH CENTURY ART

Few if any external influences on the work of modern painters and sculptors have been more critical than that of the tribal arts of Africa, Oceania and North America. Since the turn of the century when Gauguin, Picasso, Matisse, and others first acquainted themselves with masks and sculptures from these areas, modern artists have continued to display strong interest in the art and culture of tribal societies. The term "primitivism" is used to describe the Western response to tribal cultures as revealed in the work and thought of modern artists.

Museum Press Release

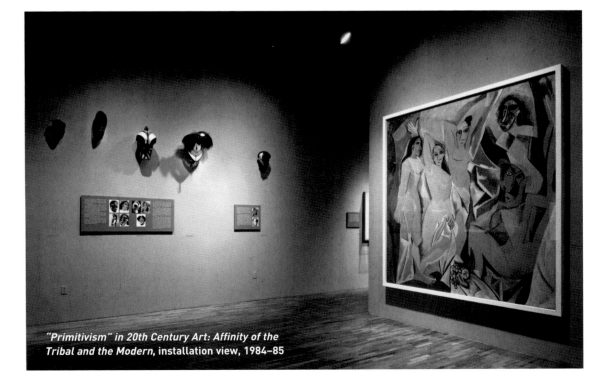

"Primitivism" in 20th Century Art: Affinity of the Tribal and the Modern, installation view, 1984–85

1985–1994: ALLEGORIES OF MODERNISM

■ CHANGE IN LEADERSHIP

—1985

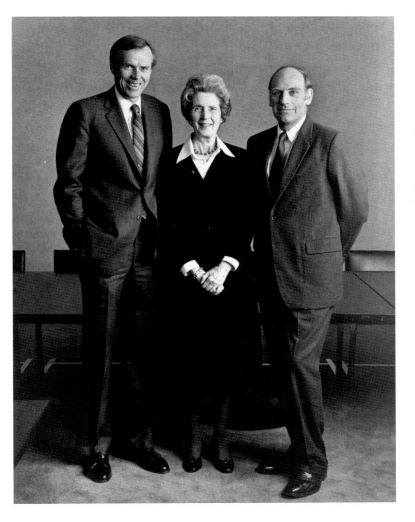

Donald B. Marron, the new President of the Museum, and Mrs. John D. Rockefeller 3rd, who becomes Chairman of the Board, with Director Richard E. Oldenburg (photograph 1984)

■ ERNA AND VICTOR HASSELBLAD PHOTOGRAPHY STUDY CENTER

The presence of King Carl XVI Gustaf of Sweden at the dedication of the Erna and Victor Hasselblad Photography Study Center in October 1985 underlined the international significance of the Center's activities. The Erna and Victor Hasselblad Foundation's unprecedented gift allows the Department of Photography to sustain and expand its capacity for sharing rare resources and research materials with photographers, students, and scholars in the worldwide photographic community. *Donald B. Marron and Richard E. Oldenburg*

John Szarkowski, Director of Photography, and King Carl XVI Gustaf of Sweden at the dedication of the Erna and Victor Hasselblad Photography Study Center, October 21, 1985. In the same year, the New Photography series was inaugurated.

1986

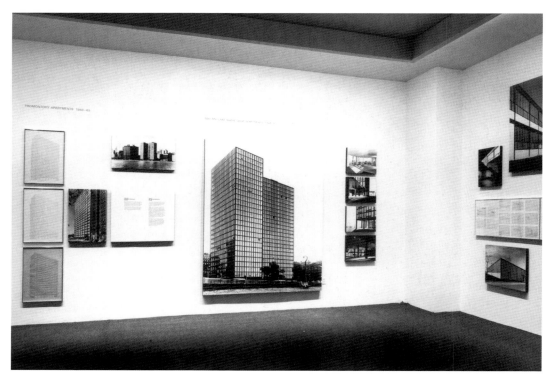

Mies van der Rohe Centennial Exhibition, installation view, 1986

▪ ARTHUR DREXLER RETIRES

His exhibitions, publications, and acquisitions for the collection over a span of three decades have greatly furthered the recognition of architecture and design as modern arts which significantly shape as well as reflect contemporary society. To all these activities he has brought an expert eye, a dedication to the highest standards of quality and a courageous independence of judgment which have earned him international respect as a particularly perceptive interpreter and critic of our environment.

Richard E. Oldenburg, 1987

Arthur Drexler retires as Director of the Department of Architecture and Design at the Museum, 1986 (photograph 1985).

Vienna 1900: Art, Architecture, and Design, installation views, 1986

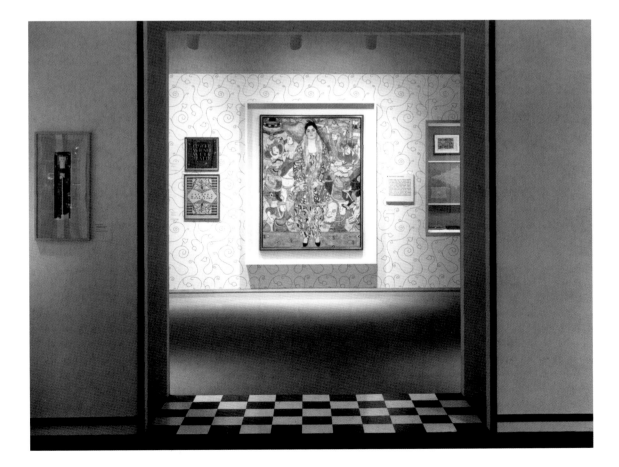

—1987

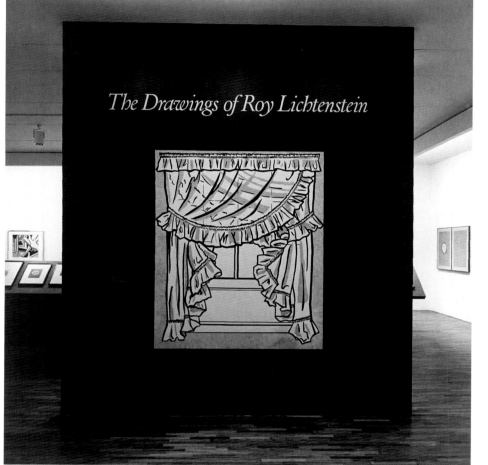

The Drawings of Roy Lichtenstein, installation view, 1987

■ THE EDWARD JOHN NOBLE EDUCATION CENTER

Newly renovated quarters of The Edward John Noble Education Center, 1987

▬ WILLIAM S. RUBIN RETIRES

— 1988

William S. Rubin retires as Director of the Department of Painting and Sculpture and is named Director Emeritus, 1988.

[William S. Rubin's] role as curator and art historian is recognized internationally as one of the most influential and impressive of our time. His eye, his acumen, his persuasiveness, and his tenacity have enriched the Museum's collection with many works now considered "icons" of modern art. Bill has also worked tirelessly and brilliantly to accomplish dynamic and challenging exhibitions that have helped to shape our vision of modernism.

Museum Press Release

▬ KIRK VARNEDOE

Richard E. Oldenburg . . . announced today the appointment of Kirk Varnedoe as Director of the Department of Painting and Sculpture, effective August 1988. William S. Rubin . . . will be retiring early. He will remain at the Museum to focus exclusively on exhibition projects, research, and writing. . . . Mr. Oldenburg stated, "We are very pleased that Kirk Varnedoe, who has been associated with the Museum since 1984, has accepted the Directorship of the Painting and Sculpture Department. In this role, he will oversee the painting and sculpture collection, its installation and acquisitions, and the painting and sculpture exhibition and loan programs, in addition to assuming all administrative responsibilities for the Department."

Museum Press Release

Kirk Varnedoe, Adjunct Curator of Painting and Sculpture since 1985, succeeds Mr. Rubin as Director of the Department of Painting and Sculpture, 1988 (photograph 1990).

▤ GARRY WINOGRAND

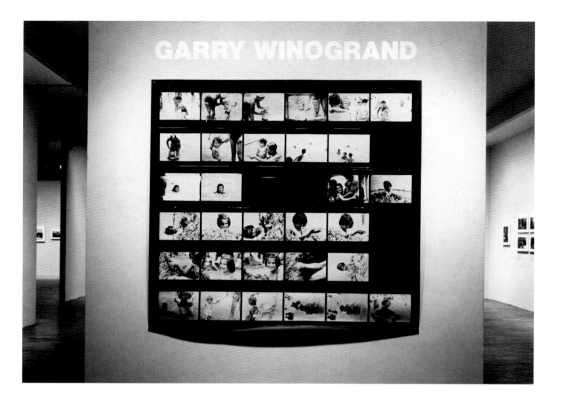

Winogrand is, in my view, the central photographer of his generation. Winogrand's pictures realize a conception of photography that is richer, more complex, and more problematic than any other since the Second World War. They also provide a picture of America during those years—of the flavor and texture of our life since Truman—that seems to me so true, clear, and tangible that it almost persuades me that I stood where he stood.
John Szarkowski

Garry Winogrand, installation view, 1988

▤ THE MODERN POSTER

The Modern Poster, installation view, 1988. Shown on the cover of *The Museum of Modern Art New York Annual Report 1987–88*

Opening of the exhibition *The Modern Poster*, May 31, 1988. Left to right: Vice President Ronald S. Lauder, Leonard A. Lauder, Evelyn Hausner Lauder, Chairman David Rockefeller, Estée Lauder, and Director Richard E. Oldenburg

Stuart Wrede, right, Curator of Architecture and Design, who succeeds Arthur Drexler as Director of Architecture and Design in 1988, with Trustee Philip Johnson (photograph 1986)

▪ RAUSCHENBERG BED ACQUIRED

1989

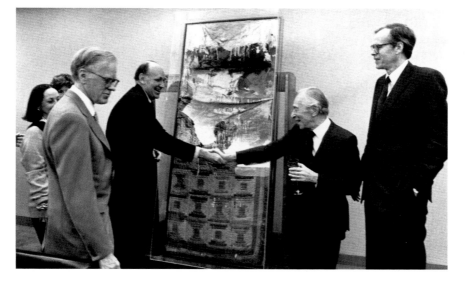

Presentation of the gift of Robert Rauschenberg's Combine painting *Bed*, 1955, to the Museum by art dealer Leo Castelli, May 19, 1989. Left to right: Trustee Barbara Jakobson, Vice President Agnes Gund, Trustee Gifford Phillips, Director Richard E. Oldenburg, Mr. Castelli, and President Donald B. Marron

▪ ARTIST'S CHOICE SERIES BEGINS

The selections and juxtapositions in these shows will shed special light on the creative intelligence of the contemporary artists who conceive them, and will allow us to see key moments in the history of modern art from a fresh viewpoint. The series will also highlight how the Museum's collection functions, not just as a fixed, didactic procession of thoroughly "understood" monuments, but also—and crucially—as a seedbed both for ongoing creativity, and for constant reassessments of the past.

Kirk Varnedoe

Artist's Choice: Chuck Close (Head-On/The Modern Portrait), installation view, 1991. The first exhibition in this series was *Artist's Choice: Burton on Brancusi*, 1989.

Andy Warhol: A Retrospective, installation views, 1989

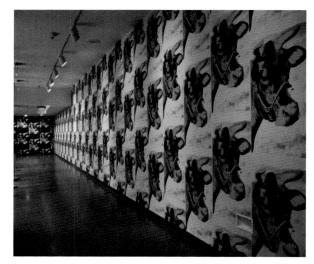

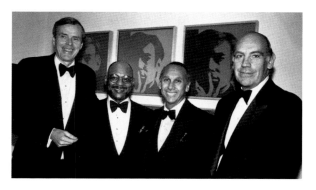

Opening of the exhibition *Andy Warhol: A Retrospective*, February 16, 1989. Left to right: President Donald B. Marron; Kynaston McShine, Senior Curator of Painting and Sculpture and director of the exhibition; Trustee Marshall S. Cogan; and Director Richard E. Oldenburg

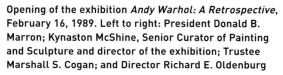

MUSEUM ARCHIVES FOUNDED

Objects and documents in the Museum Archives (photograph 2004)

— 1990

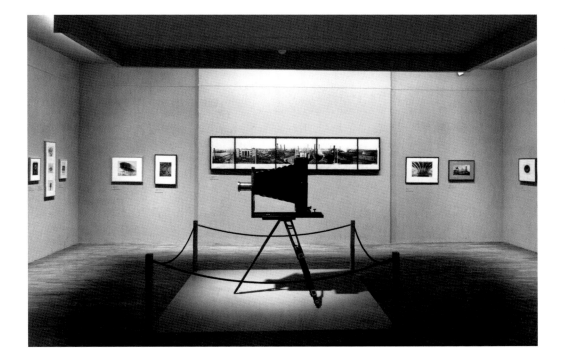

The Museum of Modern Art
Photography Until Now
February 18–May 29, 1990

A major exhibition celebrating 150 years of the
art and craft of photography.

Supported by Springs Industries, Inc.

Brochure for the exhibition
Photography Until Now,
1990

Photography Until Now,
installation view, 1990

■ AN EVENING WITH GREGORY PECK

An Evening with Gregory Peck,
a benefit for the Film Preserva-
tion Fund, November 12, 1990.
Left to right: Mary Lea Bandy,
Director of the Department of
Film, Gregory Peck, Veronique
Peck, and Cecilia Peck

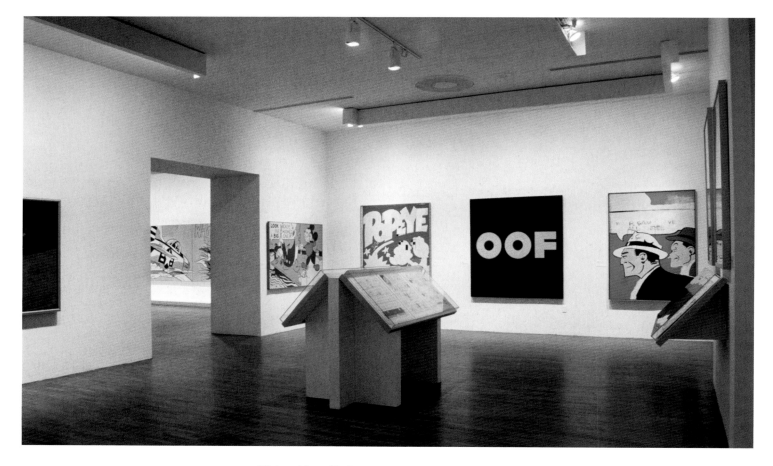

High and Low: Modern Art and Popular Culture, installation views 1990–91

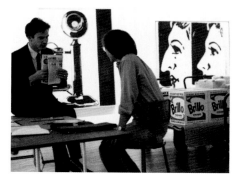

Kirk Varnedoe, Director of Painting and Sculpture, and Adam Gopnik preparing the exhibition *High and Low: Modern Art and Popular Culture*, 1990

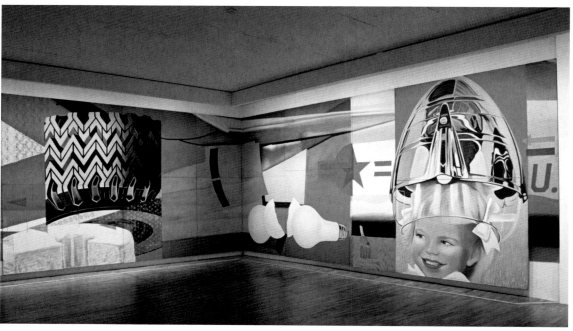

1991

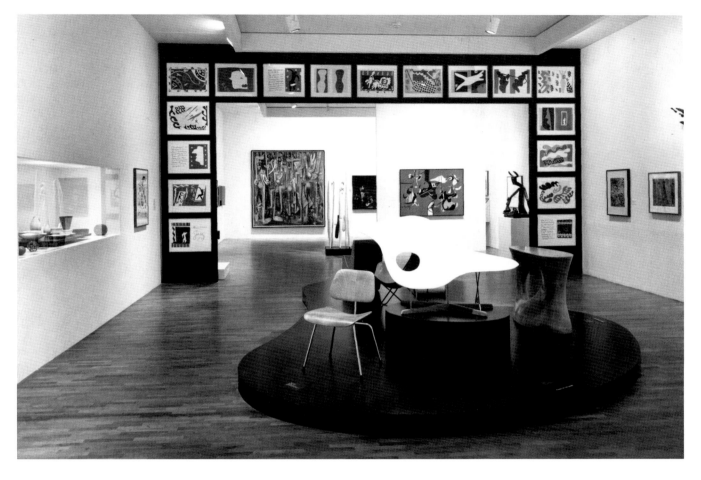

Art of the Forties,
installation views
1991

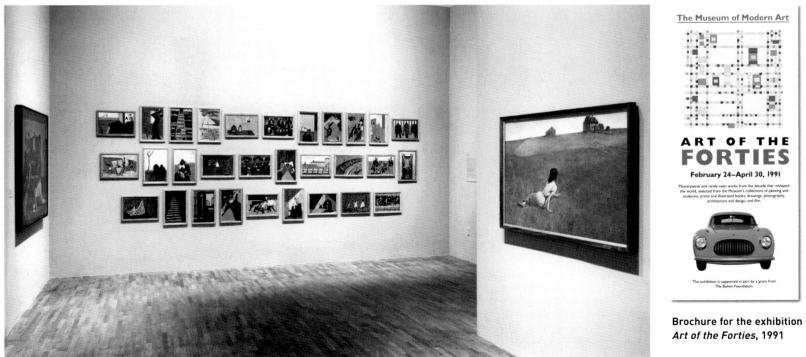

The Museum of Modern Art

ART OF THE FORTIES

February 24–April 30, 1991

Masterpieces and rarely seen works from the decade that reshaped
the world, selected from the Museum's collections of painting and
sculpture, prints and illustrated books, drawings, photography,
architecture and design, and film.

The exhibition is supported in part by a grant from
The Bohen Foundation.

Brochure for the exhibition
Art of the Forties, **1991**

▰ JOHN SZARKOWSKI RETIRES

An art museum is measured finally by the meaning of the art works that it acquires and preserves, for a while, so that their virtues and lessons can be understood and absorbed into the tradition. Those of us who serve art museums are in a sense indentured to the works themselves, a fact which would seem to condemn us to lives of unrequited devotion; we may love the works of art, but the works are clearly not interested in us; we can select them with exquisite discrimination, or support their perpetual care and feeding, or study them like monks, or praise them like poets, but the works will not care; they will not in fact even know. But we can talk to each other, and in this way we keep up our courage, and maintain the hope that our work is in some measure true.

John Szarkowski

John Szarkowski retires as Director of Photography and is named Director Emeritus, 1991.

▰ TERENCE RILEY

Terence Riley is named Curator of Architecture and Design in 1991. Upon the resignation of Stuart Wrede as Director of the department in 1992, Mr. Riley becomes Director of the Department of Architecture and Design.

▰ PETER GALASSI

Peter Galassi, Curator of Photography, is named Director of the Department of Photography, 1991 (photograph 1992).

AGNES GUND NAMED PRESIDENT

Upon the retirement of Donald B. Marron as President, Agnes Gund is elected President of the Museum at the June 12, 1991, meeting of the Board of Trustees.

STUDIES IN MODERN ART INAUGURATED

In founding *Studies in Modern Art*, it was our aim that each volume should have a unifying theme; this would help to focus research within the Museum and would result in a useful work of reference on that subject, and specifically on the Museum's response to it. . . . The first issue of our publication is devoted to American art of the 1960s. It addresses a very broad range of topics in this area, from a neglected film and a surprising exhibition to a renowned series of prints and a most influential painter. . . . Comprehensiveness is not the aim of our publication. Its aim, rather, is to present original research and insightful writing . . . on illuminating topics.
John Elderfield

Seven volumes of the Museum's scholarly journal *Studies in Modern Art*, edited by John Elderfield

1992

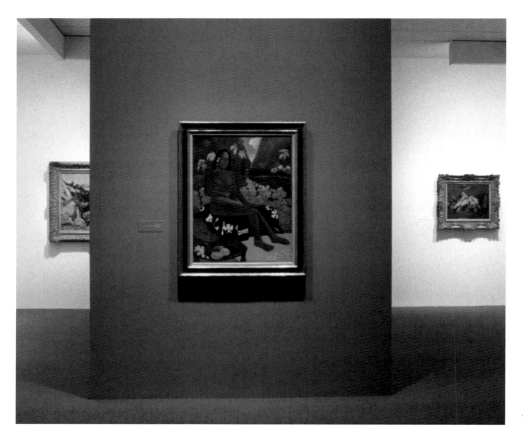

The William S. Paley Collection, installation view, 1992

■ JEAN-LUC GODARD: SON + IMAGE 1974–1991

Jean-Luc Godard is widely recognized as one of the filmmakers who has most influenced the modern art and language of the medium. . . . Like Picasso, Godard reveals to us throughout his work his world as source and subject; the artist's studio, the objects of his daily life, the references to and repetitions of his own works, the layering of words and images, the women he has loved, the horrors of war. But it is in the aspect of his work as collages, the filmmaker's montages of suggestive textures, themes, and images, his play with "found objects" of art, television, and film, that he evokes the sly wit, eroticism, and provocative disjunctions of other surrealist collagists. . . . In setting image against image, image against sound, sound against sound, he creates discontinuities of text and art that disturb us to new discoveries, new perceptions.
Mary Lea Bandy

Catalogue for the film program *Jean-Luc Godard: Son + Image 1974–1991*, edited by Raymond Bellour with Mary Lea Bandy, 1992

Brochure for the exhibition *Allegories of Modernism: Contemporary Drawing*, 1992

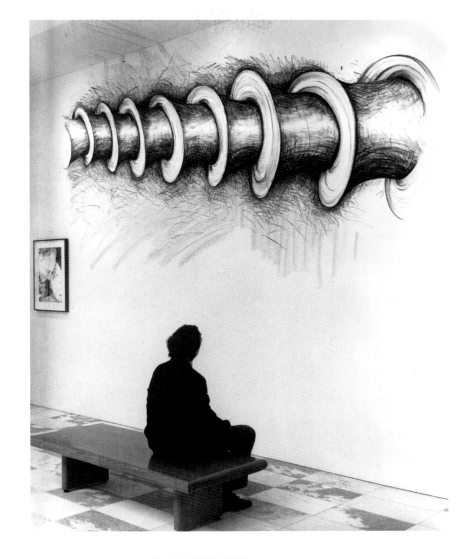

Allegories of Modernism: Contemporary Drawing, installation view, 1992

Vice President Ronald S. Lauder; Jo Carole Lauder; Bernice Rose, Senior Curator of Drawings and director of the exhibition; and Director Richard E. Oldenburg at the opening of the exhibition *Allegories of Modernism: Contemporary Drawing*, February 12, 1992

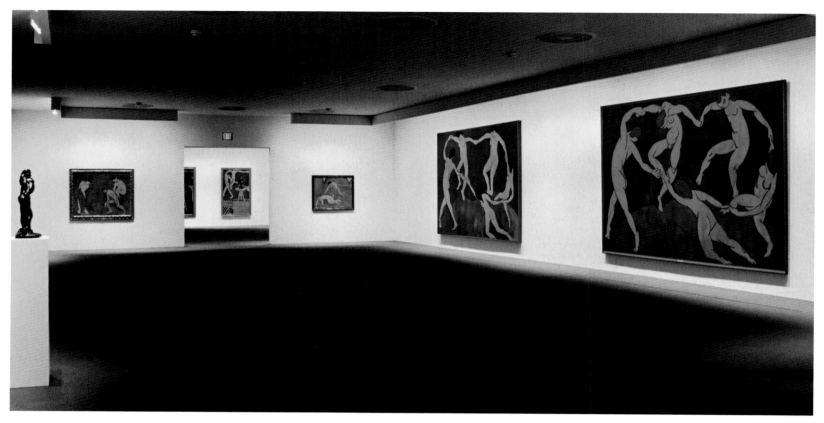

Henri Matisse: A Retrospective, installation view, 1992–93

Invitation to the exhibition *Henri Matisse: A Retrospective*, 1992. The design was adapted from Matisse's design for the brochure of the 1951 exhibition *Henri Matisse.*

John Elderfield, Director of Drawings, Curator of Painting and Sculpture, and director of the exhibition, and Beatrice Kernan, Associate Curator of Drawings, at the opening of *Henri Matisse: A Retrospective*, September 16, 1992

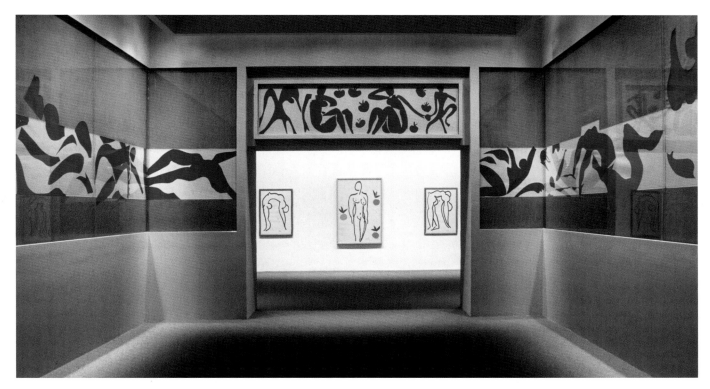

Henri Matisse: A Retrospective, installation view, 1992–93

1993 ■ LATIN AMERICAN ARTISTS OF THE TWENTIETH CENTURY

Invitation to the exhibition
*Latin American Artists of
the Twentieth Century*,
1993

*Latin American Artists
of the Twentieth Century*,
installation view, 1993

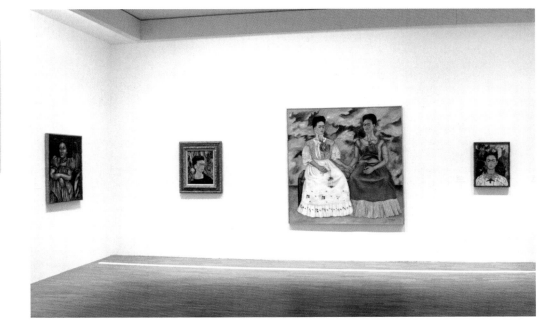

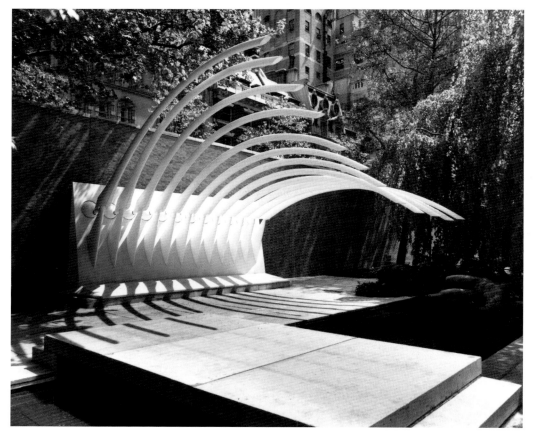

Left to right: Assistant Curator of Architecture and Design and director of the exhibition Matilda McQuaid, the architect Santiago Calatrava, and Director of Architecture and Design Terence Riley at the opening of the exhibition *Santiago Calatrava: Structure and Expression*, March 15, 1993

Santiago Calatrava: Structure and Expression, installation view in the Sculpture Garden, 1993

≡ DESIGNED FOR SPEED

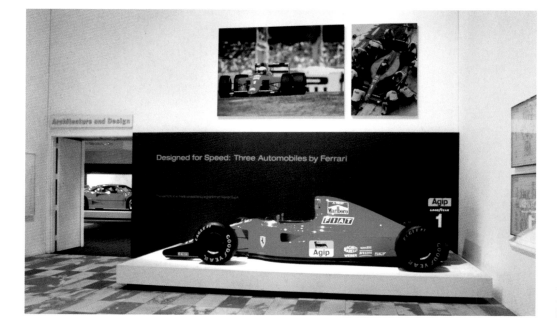

Designed for Speed: 3 Automobiles by Ferrari, installation view, 1993–94

JOAN MIRÓ

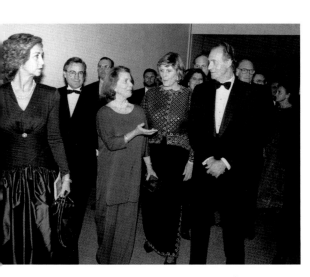

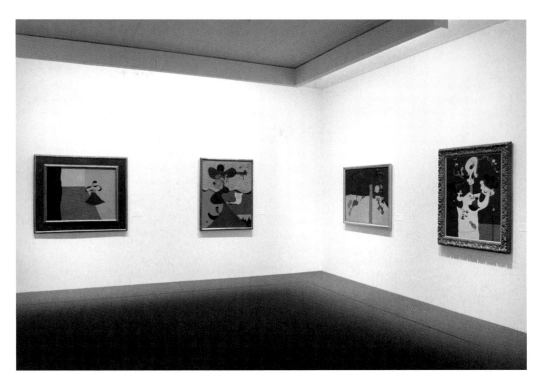

Opening of the exhibition *Joan Miró*, October 13, 1993. Foreground, left to right: Her Majesty Queen Sofia of Spain; Francisco Luzón; Carolyn Lanchner, Curator of Painting and Sculpture and director of the exhibition; Chairman Agnes Gund; and His Majesty Juan Carlos I of Spain

Joan Miró, installation view, 1993–94

ROBERT RYMAN

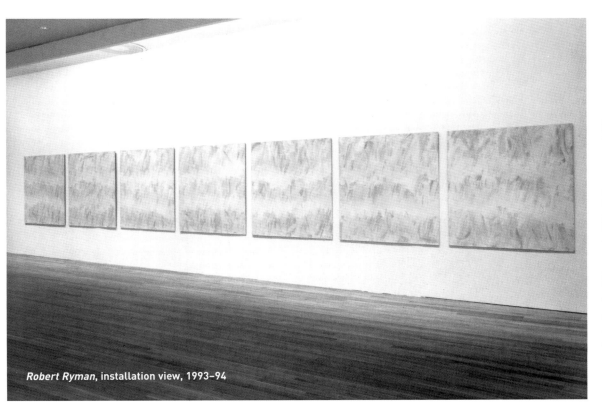

Robert Ryman, installation view, 1993–94

The artist Robert Ryman and Robert Storr, Curator of Painting and Sculpture and director of the exhibition, at the opening of *Robert Ryman*, September 22, 1993

Program for *An Evening with Clint Eastwood* at the Museum, 1993

Staff members in the Department of Film at *An Evening with Clint Eastwood*, October 25, 1993. Front row, left to right: Laurence Kardish, Curator and Coordinator of Film Exhibitions; Andrew Haas, Film Expediter; Mary Lea Bandy, Director of the Department of Film; Edward D'Inzilio, Projectionist. Back row: Gregory Singer, Projectionist; Anthony Tavolacci, Projectionist; Clint Eastwood; and Charles Kalinowski, Head Projectionist

■ CHANGE IN LEADERSHIP

David Rockefeller, seen with Trustee Patricia Phelps de Cisneros, steps down as Chairman of the Board and is named Chairman Emeritus in June 1993 (photograph 2004). President Agnes Gund is named Chairman of the Board.

Opening of *Masterpieces from the David and Peggy Rockefeller Collection: Manet to Picasso* and The Party in the Garden in honor of David and Peggy Rockefeller, June 5, 1994. Left to right: Jo Carole Lauder, President of The International Council; Kirk Varnedoe, Chief Curator of Painting and Sculpture; Peggy Rockefeller; David Rockefeller, Chairman Emeritus; Trustee Mrs. Donald B. Straus; Agnes Gund, Chairman; and Richard E. Oldenburg, Director

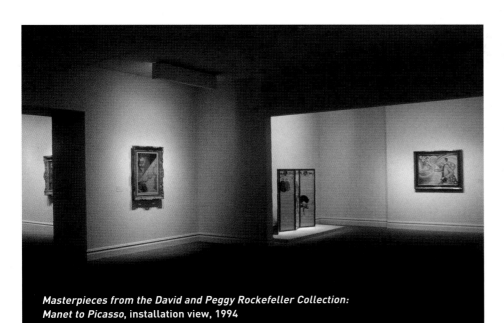

Masterpieces from the David and Peggy Rockefeller Collection: Manet to Picasso, installation view, 1994

RICHARD E. OLDENBURG RETIRES

As we approach a new century, the Museum must look ahead to meeting major challenges which include an ambitious capital campaign and the need to expand the Museum's facilities. . . . I have reflected on these and other long-term goals [and] have concluded that this is a most appropriate time for the direction of the Museum to be entrusted to new leadership which can both initiate these important plans and see them through to completion. It has been a privilege to guide this institution for twenty-one years, longer than any of its previous directors. I am deeply grateful for the support I have received throughout these years from the Museum's Trustees and from the truly incomparable staff of the Museum. I think I can best repay the confidence expressed in me when I was appointed Director before my fortieth birthday by helping now to accomplish the transition to a new generation of leadership.

Richard E. Oldenburg

Richard E. Oldenburg retires as Director of the Museum and is named Director Emeritus and an Honorary Trustee.

1995–2004: MODERN CONTEMPORARY

—1995

Museum of Modern Art Ends Troubled Search for a Chief

By **MICHAEL KIMMELMAN**

The Museum of Modern Art announced yesterday that it had finally found a new director, after a sometimes messy 14-month search. He is Glenn D. Lowry, the 40-year-old director of the Art Gallery of Ontario in Toronto and a specialist in Islamic art. He takes over on July 1, 1995.

Mr. Lowry is a surprise choice to succeed Richard E. Oldenburg, who announced in September 1993 that he planned to retire. Since then, several candidates had turned down offers from the museum, and the names of many others had been bandied about. Mr. Lowry's was not one of them.

The Modern's troubled search for its sixth director came to symbolize the difficulties museums across the country have had in finding people suited to the shifting requirements of the job, in which economic and managerial skills have increasingly come to outweigh the traditional visual and scholarly ones.

At the Modern, the world's preeminent museum of 20th-century art, the situation was more complex: on the cusp of a possible major expansion, it needed a fund-raiser and administrator, and, ideally, a scholar, but not one who would impose his, or her, tastes on the unusually independent group of curators. A new generation of curators, including Kirk Varnedoe, Peter Galassi, Margit Rowell and Terry Riley, had already begun to reshape the Modern, and to debate whether, and how, to redefine it for the next century.

The costly and time-consuming search that ultimately turned up Mr. Lowry actually began months before Mr. Oldenburg's announcement that he would retire, when the Modern's board said it would create the position of paid president, responsible for administrative and fund-raising duties, to share leadership with the director. The idea for such a president was scrapped with Mr. Oldenburg's decision to quit.

Several months of seeking for his successor among prominent directors, including Anne d'Harnoncourt of the Philadelphia Museum of Art, James Wood of the Art Institute of Chicago and Peter Marzio of the Museum of Fine Arts in Houston,

Suzanne DeChillo/The New York Times

Glenn D. Lowry, who has been chosen to be the sixth director of the Museum of Modern Art.

turned up no one, and made the Modern's problems increasingly the subject of uneasy speculation in the art world about trustee conflicts and the desirability of the job there. Mr. Oldenburg agreed to extend his stay to the end of 1994, but his deadline was fast approaching and the search seemed stalled until Mr. Lowry's name surfaced.

Matters changed only in September when the Modern hired a new search firm, which quietly began to focus on young candidates who wanted the job, not solely on those people with long careers at other big institutions. Attention began to center on Mr. Lowry just a month ago, and even high-ranking staff members did not hear about him until this week.

Mr. Lowry brings to the post a background as a scholar and curator, but clearly not one whose area of expertise conflicts with that of anyone at the Modern. He has also had several years of directorial experience raising money and overseeing the construction of new buildings. That included a deeply acrimonious battle he waged with the Ontario provincial government, stemming from a $58 million project to expand the Art Gallery of Ontario.

Glenn D. Lowry, Director of the Art Gallery of Ontario, Toronto, becomes Director of The Museum of Modern Art, 1995 (photograph 1996).

Detail of article by Michael Kimmelman, *The New York Times*, November 17, 1994

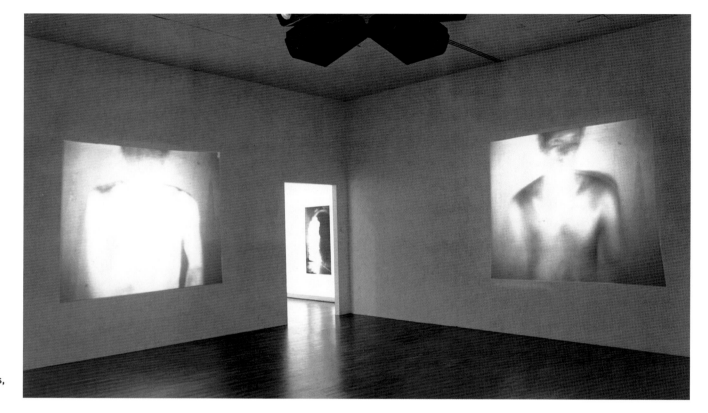

Bruce Nauman, installation views, 1995

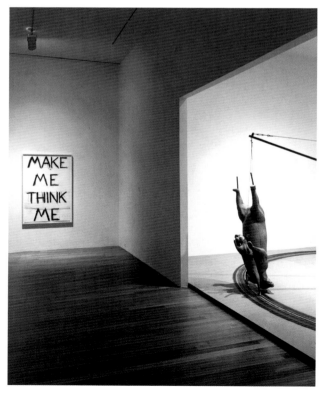

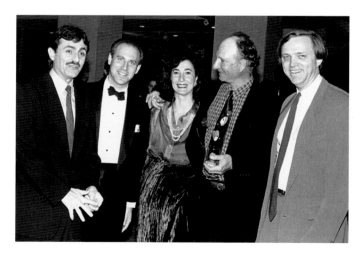

Left to right: Chief Curator of the Hirshhorn Museum and Sculpture Garden Neal Benezra, Director Glenn D. Lowry, Director of the Walker Art Center Kathy Halbreich, the artist Bruce Nauman, and Curator of Painting and Sculpture Robert Storr at the opening of the exhibition *Bruce Nauman*, March 1, 1995

■ MASTERWORKS FROM THE LOUISE REINHARDT SMITH COLLECTION

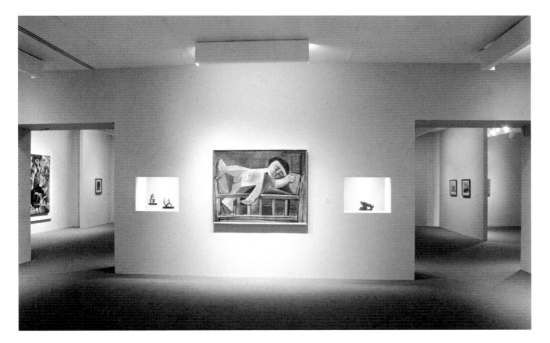

Masterworks from the Louise Reinhardt Smith Collection, installation view, 1995

Louise Reinhardt Smith, center, with fellow Trustee Lewis B. Cullman and Dorothy Cullman at the opening of *Masterworks from the Louise Reinhardt Smith Collection*, **April 3, 1995**

I never had any formal education in art, so my friendships with René [d'Harnoncourt], Alfred [Barr], and Jim [Soby] were a godsend. I already knew how to look, but they taught me how to see. . . . Whenever I was fortunate enough to discover a painting I really loved, I had the wit to ask that it be sent to my home so I could live with it a few days until I was sure that I belonged with the painting and the painting belonged with me. . . . I invariably asked Alfred and Jim to come for a drink and look at the painting I had fallen in love with. The only thing I asked of them was to tell me if the picture I wanted was something that The Museum of Modern Art would welcome as a promised gift.

Louise Reinhardt Smith

■ CHANGE IN LEADERSHIP

Left to right: Chairman Agnes Gund is named President of the Museum for the second time; Vice Chairman Ronald S. Lauder is named Chairman of the Board; Jo Carole Lauder has been the President of The International Council since 1993.

≡ VIDEO SPACES: EIGHT INSTALLATIONS

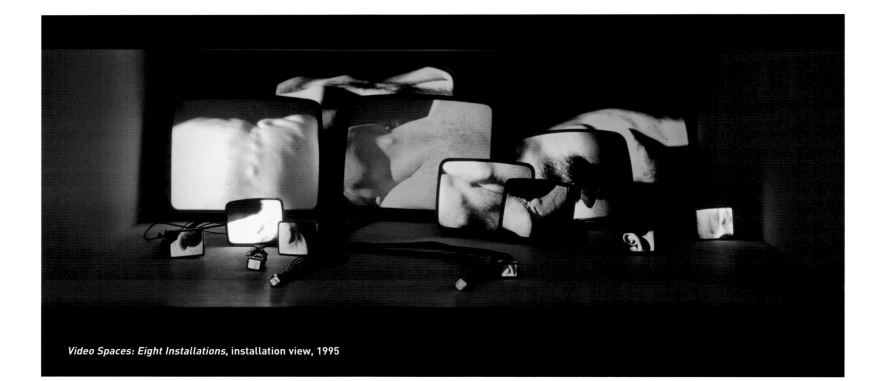

Video Spaces: Eight Installations, installation view, 1995

≡ RIVA CASTLEMAN RETIRES

Riva Castleman retires as Chief Curator of the Department of Prints and Illustrated Books, and is named Chief Curator Emeritus, 1995. Ms. Castleman also served as the first Deputy Director for Curatorial Affairs from 1986 to 1995.

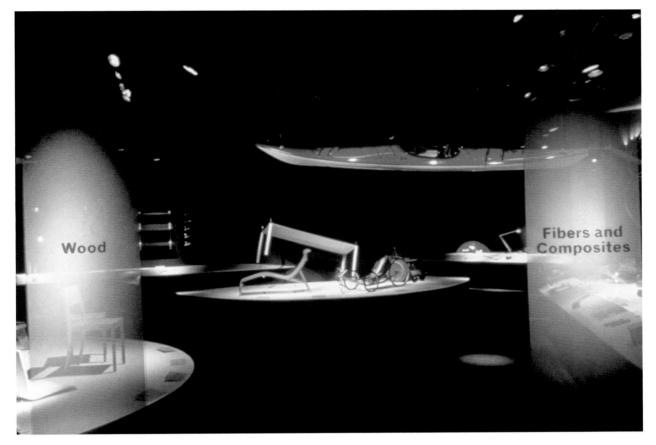

Left to right: Terence Riley, Chief Curator of Architecture and Design, Trustee Lily Auchincloss, and Paola Antonelli, Curator of Architecture and Design and director of the exhibition *Mutant Materials in Contemporary Design*, April 24, 1995

Mutant Materials in Contemporary Design, installation view, 1995

≡ NEW APPOINTMENTS

Michael Margitich, left, pictured with Chairman Emeritus David Rockefeller, is named Deputy Director for Development in 1995 (photograph 2001). Jennifer Russell is named Deputy Director for Exhibitions and Collection support in 1996; in the same year Patterson Sims is appointed Deputy Director for Education and Research Support, and Jay Levenson is named Director of the International Program. After the resignation of Mr. Sims in 2001, Deborah Schwartz is named Deputy Director for Education, in 2002.

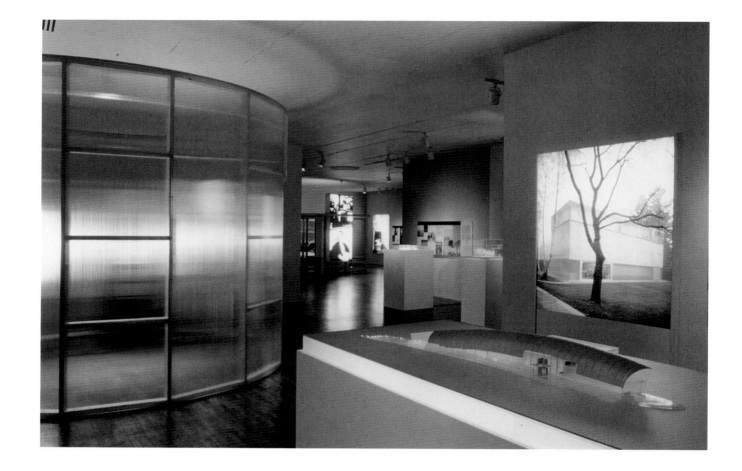

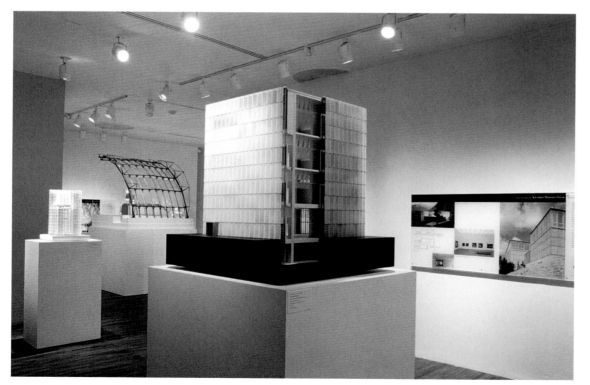

Light Construction,
installation views,
1995–96

■ CELESTE BARTOS FILM PRESERVATION CENTER OPENS

1996

The Celeste Bartos Film Preservation Center opens in Hamlin, Pennsylvania, 1996. Designed by Davis, Brody & Associates, New York. Exterior view

Interior view of vault for film preservation at The Celeste Bartos Film Preservation Center

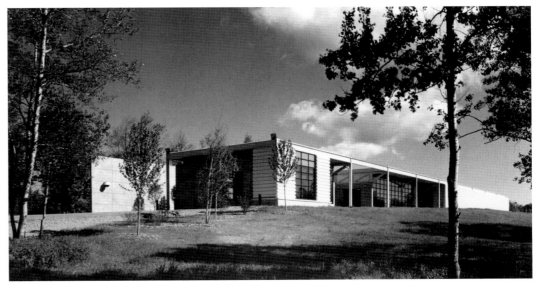

The [Celeste Bartos Film Preservation] Center . . . sets a new standard for film preservation and storage, as well as for the cataloguing and accessibility of the Museum's collection of more than 13,000 films. State-of-the-art environmental controls provide optimum conditions for one of the finest museum collections of international film art in the world, with ample room for acquisitions in the decades to come. . . . Says Mary Lea Bandy, Chief Curator of the Department of Film and Video, "MoMA is . . . a research institution for the study of the entire twentieth century [and thus] the film collection is one of the Museum's most valuable assets."
Museum Press Release

■ DORSET HOTEL PURCHASED

The Dorset Hotel, on West Fifty-fourth Street, is purchased by the Museum as a site for expansion, 1996.

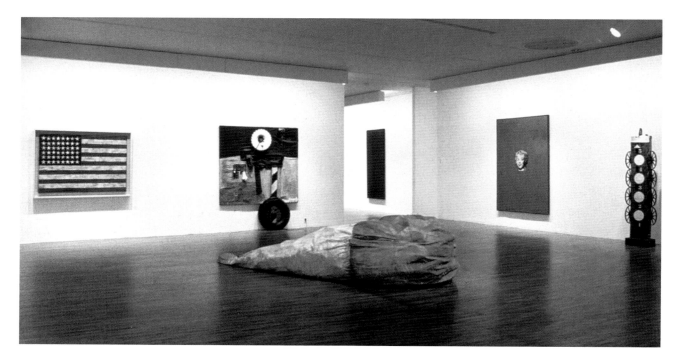

From Bauhaus to Pop: Masterworks Given by Philip Johnson, installation view, 1996

Philip Johnson: Architecture and Design Gifts, installation view, 1996

Left to right: Deputy Director for Exhibitions and Collection Support Jennifer Russell; Trustee, architect, and donor to the collection Philip Johnson; and President Agnes Gund at The Party in the Garden in honor of Philip Johnson, June 5, 1996. Cardboard versions of Mr. Johnson's signature eyeglasses were provided for guests.

Graphic for the exhibition *Thinking Print: Books to Billboards 1980–95*. Design by Barbara Kruger

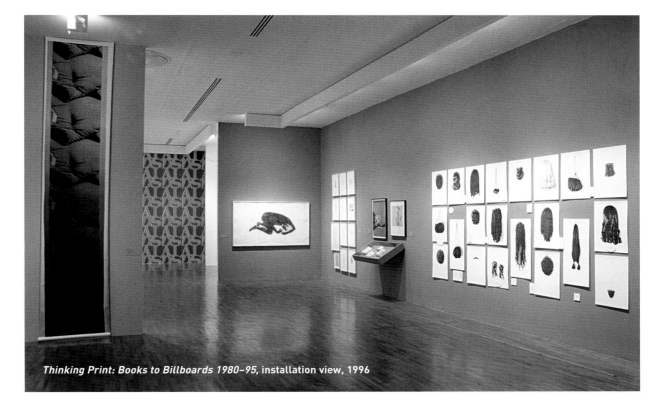

Thinking Print: Books to Billboards 1980–95, installation view, 1996

≡ DEBORAH WYE ≡ DEPUTY DIRECTOR FOR CURATORIAL AFFAIRS NAMED

Deborah Wye, Curator of Prints and Illustrated Books, is named Chief Curator of the Department of Prints and Illustrated Books, 1996 (photograph 1998).

John Elderfield, Chief Curator at Large, is named Deputy Director for Curatorial Affairs, retaining both titles, 1996 (photograph 1992). The position, previously held by Riva Castleman, is redefined to emulate an academic chairmanship with responsibility for coordinating curatorial activities.

The Museum of Modern Art Mission Statement, issued in 1996

mission statement

FOUNDED IN 1929 AS AN EDUCATIONAL INSTITUTION, THE MUSEUM OF MODERN ART is dedicated to being the foremost modern art museum in the world.

Through the leadership of its Trustees and staff, The Museum of Modern Art manifests this commitment by establishing, preserving, and documenting a permanent collection of the highest order that reflects the vitality, complexity, and unfolding patterns of modern and contemporary art; by presenting exhibitions and educational programs of unparalleled significance; by sustaining a library, archives, and conservation laboratory that are recognized as international centers of research; and by supporting scholarship and publications of preeminent intellectual merit.

Central to The Museum of Modern Art's mission is the encouragement of an ever deeper understanding and enjoyment of modern and contemporary art by the diverse local, national, and international audiences that it serves.

To achieve its goals, The Museum of Modern Art recognizes:

- That modern and contemporary art originated in the exploration of the ideals and interests generated in the new artistic traditions that began in the late nineteenth century and continue today.
- That modern and contemporary art transcend national boundaries and involve all forms of visual expression, including painting and sculpture, drawings, prints and illustrated books, photography, architecture and design, and film and video, as well as new forms yet to be developed or understood, that reflect and explore the artistic issues of the era.
- That these forms of visual expression are an open-ended series of arguments and counter arguments that can be explored through exhibitions and installations and are reflected in the Museum's varied collection.
- That it is essential to affirm the importance of contemporary art and artists if the Museum is to honor the ideals with which it was founded and to remain vital and engaged with the present.
- That this commitment to contemporary art enlivens and informs our evolving understanding of the traditions of modern art.
- That to remain at the forefront of its field, the Museum must have an outstanding professional staff and must periodically reevaluate itself, responding to new ideas and initiatives with insight, imagination, and intelligence. The process of reevaluation is mandated by the Museum's tradition, which encourages openness and a willingness to evolve and change.

In sum, The Museum of Modern Art seeks to create a dialogue between the established and the experimental, the past and the present, in an environment that is responsive to the issues of modern and contemporary art, while being accessible to a public that ranges from scholars to young children.

3

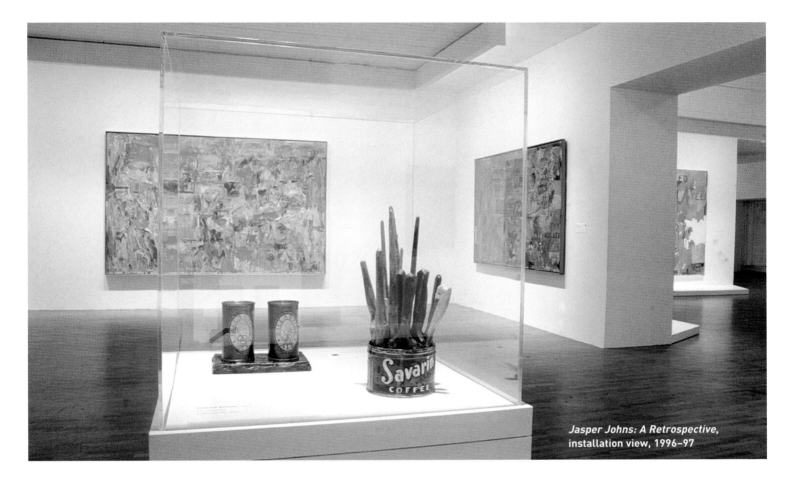

Jasper Johns: A Retrospective, installation view, 1996–97

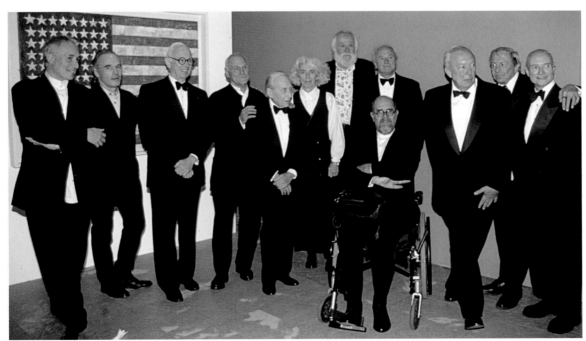

Artists at a party for the exhibition *Jasper Johns: A Retrospective*, October 15, 1996. Left to right: Terry Winters, Brice Marden, Ellsworth Kelly, Richard Serra, art dealer Leo Castelli, Elizabeth Murray, John Baldessari, James Rosenquist, Chuck Close (seated), Jasper Johns, Robert Rauschenberg, and Roy Lichtenstein

Jasper Johns changed the course of art in his time. He is often seen as the "father" of Pop, Minimalism, and Conceptual art. But beyond the well-recognized, immediate impact of the early paintings and sculptures as a generative source for the art of the early 1960s, Johns has provided ongoing inspiration for generations of peers and younger artists of widely differing aesthetic persuasions.
Kirk Varnedoe

■ MANUEL ALVAREZ BRAVO

1997

Catalogue for the exhibition *Manuel Alvarez Bravo*, by Susan Kismaric, 1997

The photographer Manuel Alvarez Bravo and Susan Kismaric, Curator of Photography and director of the exhibition *Manuel Alvarez Bravo*, at the opening of the exhibition, February 19, 1997

■ TOWARD THE NEW MUSEUM OF MODERN ART: SKETCHBOOKS BY TEN ARCHITECTS

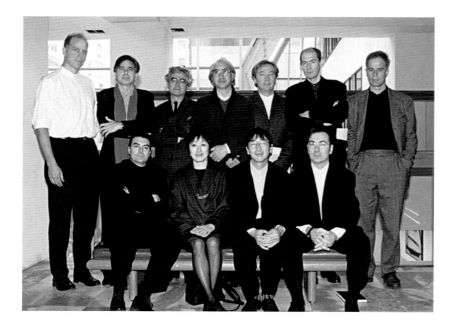

Toward the New Museum of Modern Art: Sketchbooks by Ten Architects, installation view, 1997

Ten architectural firms are invited to submit proposals for the new Museum of Modern Art. Seated, left to right: Dominique Perrault, Billie Tsien, Toyo Ito, Jacques Herzog. Standing: Tod Williams, Bernard Tschumi, Rafael Viñoly, Yoshio Taniguchi, Steven Holl, Rem Koolhaas, and Pierre de Meuron (not pictured: Wiel Arets)

■ CINDY SHERMAN: THE COMPLETE UNTITLED FILM STILLS

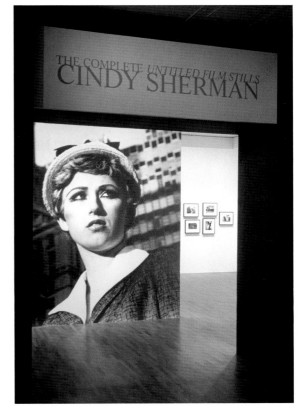

Cindy Sherman: The Complete Untitled Film Stills, installation view, 1997

Left to right: Peter Galassi, Chief Curator of Photography and director of the exhibition, the artist Cindy Sherman, and Director Glenn D. Lowry at the opening of *Cindy Sherman: The Complete Untitled Film Stills*, June 24, 1997

■ ON THE EDGE: CONTEMPORARY ART FROM THE WERNER AND ELAINE DANNHEISSER COLLECTION

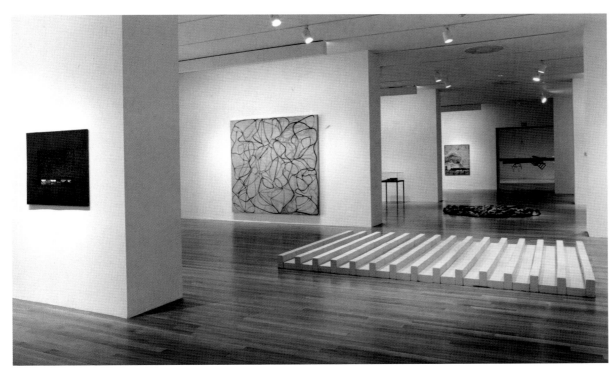

One of the largest and most significant gifts of art in The Museum of Modern Art's history, a group of 85 major contemporary works by . . . European and American artists . . . comprises paintings, sculptures, prints, photographs, and video installations given to the Museum by Elaine Dannheisser. . . . The Dannheisser Collection provides a detailed and discerning overview of some of the best and most provocative work produced in our day.

Museum Press Release

On the Edge: Contemporary Art from the Werner and Elaine Dannheisser Collection, installation view, 1997

■ FERNAND LÉGER

1998

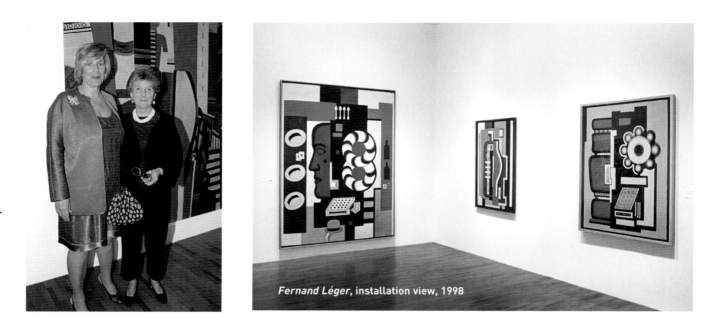

Carolyn Lanchner, right, Curator of Painting and Sculpture and director of the exhibition with President Agnes Gund at the opening of *Fernand Léger*, February 11, 1998

Fernand Léger, installation view, 1998

■ STRUCTURE AND SURFACE: CONTEMPORARY JAPANESE TEXTILES

Left to right: The architect Toshiko Mori, designer of the installation, with exhibition codirectors Cara McCarty, Chief Curator for Design at the Saint Louis Art Museum, and Matilda McQuaid, Associate Curator of Architecture and Design, at the opening of *Structure and Surface: Contemporary Japanese Textiles*, November 11, 1998

Structure and Surface: Contemporary Japanese Textiles, installation view, 1998

ALVAR AALTO: BETWEEN HUMANISM AND MATERIALISM

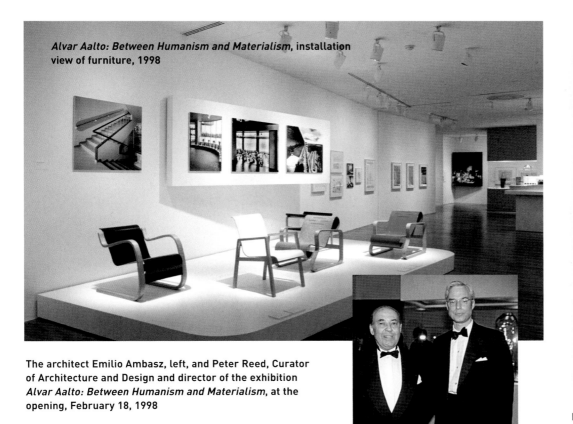

Alvar Aalto: Between Humanism and Materialism, installation view of furniture, 1998

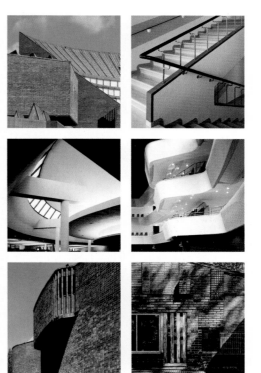

The architect Emilio Ambasz, left, and Peter Reed, Curator of Architecture and Design and director of the exhibition *Alvar Aalto: Between Humanism and Materialism*, at the opening, February 18, 1998

Invitation to the exhibition *Alvar Aalto: Between Humanism and Materialism*, showing details of six buildings by the architect, 1998

INTERNATIONAL COUNCIL PRESIDENTS

Place card for The Party in the Garden honoring former Presidents of The International Council of The Museum of Modern Art, June 10, 1998. Left to right: Beth Straus, Joanne Stern, Joann Phillips, Jeanne Thayer, and Eliza Cobb.

Rethinking the Modern: Three Proposals for the New Museum of Modern Art, **installation view, 1998**

The three finalists in the competition for the Museum's new building. Left to right: Bernard Tschumi, Jacques Herzog, and Yoshio Taniguchi (not pictured: Pierre de Meuron)

Members of the 1998 Architect Selection Committee. Seated, left to right: Chairman Ronald S. Lauder, President Agnes Gund, Chairman Emeritus David Rockefeller. Standing: Director Glenn D. Lowry, Trustee Marshall S. Cogan, and Vice Chairmen Jerry I. Speyer and Sid R. Bass

Sid R. Bass, Chairman of the Architect Selection Committee . . . announced today that Jacques Herzog and Pierre de Meuron (Basel), Yoshio Taniguchi (Tokyo), and Bernard Tschumi (New York) will participate in the next phase to determine an architect for the Museum's expansion and renovation project. These architects were chosen from a field of ten who were invited to take part in a month-long charrette, or problem-solving design exercise. . . . The three finalists will now engage in a competition leading to preliminary architectural designs for the new Museum.

Museum Press Release

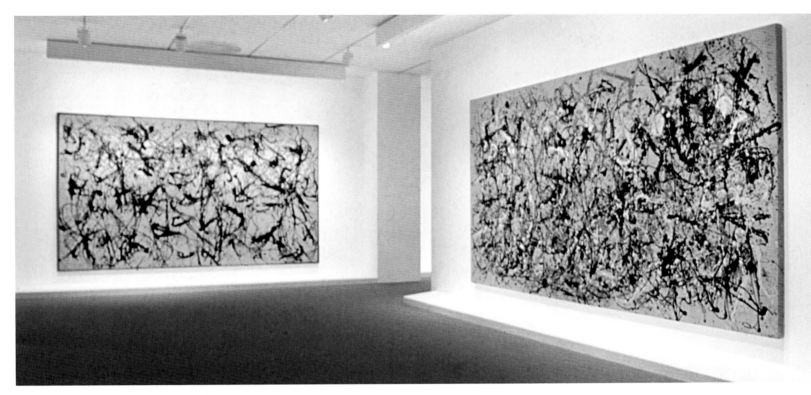

Jackson Pollock, installation view, 1998

Left to right: Chief Curator of Painting and Sculpture Kirk Varnedoe; his wife Elyn Zimmerman; Ed Harris, director and star of the film *Pollock* (2000); Mr. Harris's wife Amy Madigan, who plays Peggy Guggenheim in the same film; Adjunct Assistant Curator Pepe Karmel; and Carey Adina Karmel, at the opening of *Jackson Pollock*, October 28, 1998. The exhibition was directed by Mr. Varnedoe and Mr. Karmel.

Program for lectures and symposia in conjunction with the exhibition *Jackson Pollock*, 1998

1999

The use of the museum as a subject for art has accelerated during the twentieth century in response both to developments within art and to the altered social role of the museum. Like two superpowers that mutually respect each other, even mutually depend on each other, artists and museums nevertheless watch each other vigilantly—as if practicing for the field on which they are engaged together, the miraculous field of visual art.

Kynaston McShine

The Museum as Muse: Artists Reflect, installation view, 1999

■ DEPUTY DIRECTOR FOR CURATORIAL AFFAIRS

Upon the expiration of John Elderfield's term as Deputy Director for Curatorial Affairs, Mary Lea Bandy, Chief Curator of the Department of Film and Video, is named to succeed him, retaining both titles, 1999.

▣ MoMA 2000

MoMA 2000 is a seventeen-month-long, three-cycle reconsideration of modern art as it has evolved over the past century. For this occasion, curators have been invited to collaborate with colleagues from other departments and to delve into material outside their fields of specialization, so that the works in The Museum of Modern Art's collection may be viewed from fresh vantage points and presented to the public in new combinations and formats. It is a multifaceted experiment in the cross-pollination of ideas and the reintegration of artistic disciplines.
Glenn D. Lowry

Catalogue for the exhibition cycle *MoMA 2000: Modern Starts*, edited by John Elderfield, Peter Reed, Mary Chan, and Maria del Carmen González, 1999

▣ MoMA 2000: MODERN STARTS

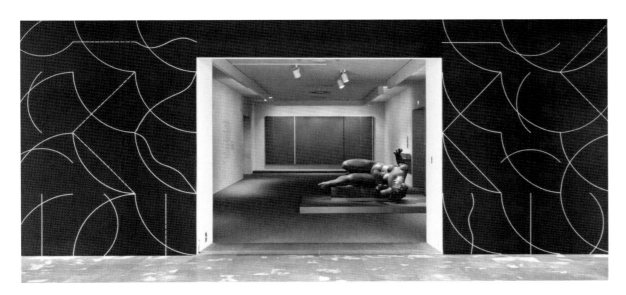

***People*, part of *MoMA 2000: Modern Starts*, installation views, 1999–2000**

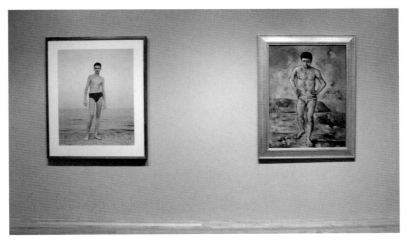

2000

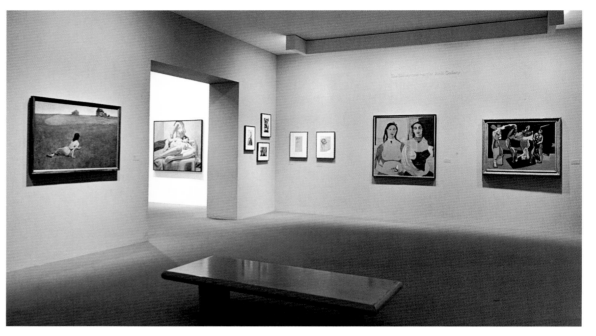

Catalogue for the exhibition *Walker Evans & Company*, by Peter Galassi, part of the second exhibition cycle *MoMA 2000: Making Choices*, 2000

Modern Art despite Modernism, part of *MoMA 2000: Making Choices*, installation view, 2000

Architectural installation in the Museum Sculpture Garden by Shigeru Ban, part of *MoMA 2000: Making Choices*, 2000

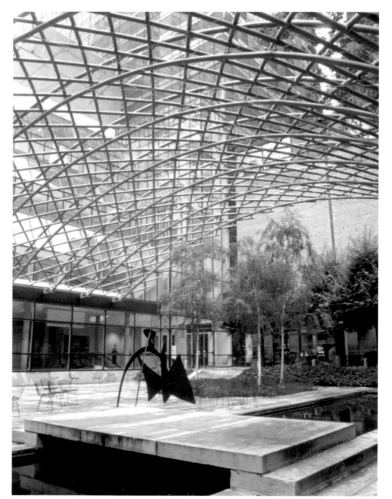

■ MoMA 2000: OPEN ENDS

The collection catalogue *Modern Contemporary*, edited by Kirk Varnedoe, Paola Antonelli, and Joshua Siegel, accompanying the third exhibition cycle *MoMA 2000: Open Ends*, 2000–2001

MODERN CONTEMPORARY

MODERN
CONTEM
PORARY

ART AT MoMA SINCE 1980

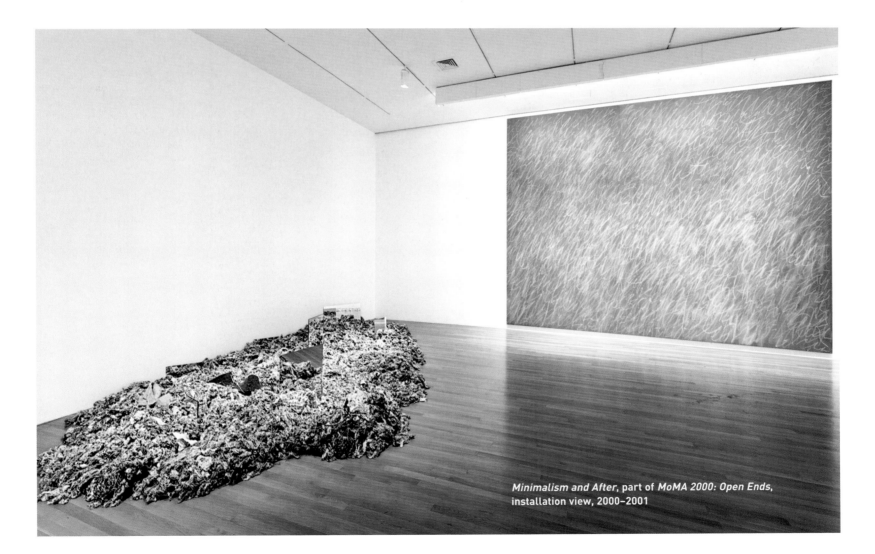

Minimalism and After, part of *MoMA 2000: Open Ends*, installation view, 2000–2001

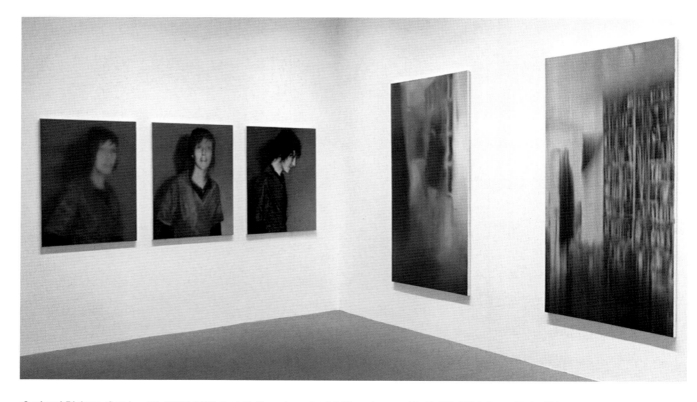

Gerhard Richter: October 18, 1977, 1988, installation view of exhibition shown with *MoMA 2000: Open Ends*, 2000–2001. The fifteen paintings that constitute this work were acquired by the Museum in 1995.

■ GARY GARRELS

■ CHIEF OPERATING OFFICER

Upon the resignation of Margit Rowell as Chief Curator of Drawings, Gary Garrels, Chief Curator at the San Francisco Museum of Modern Art, is named Chief Curator of the Department of Drawings, and Curator of Painting and Sculpture, 2000.

James Gara, left, Chief Financial Officer, is named Chief Operating Officer of the Museum, 2000. Mr. Gara is pictured with Trustee Joan Tisch and Preston Robert Tisch at the opening of *Alberto Giacometti*, October 10, 2001.

▬ P.S. 1 PARTNERSHIP WITH MoMA

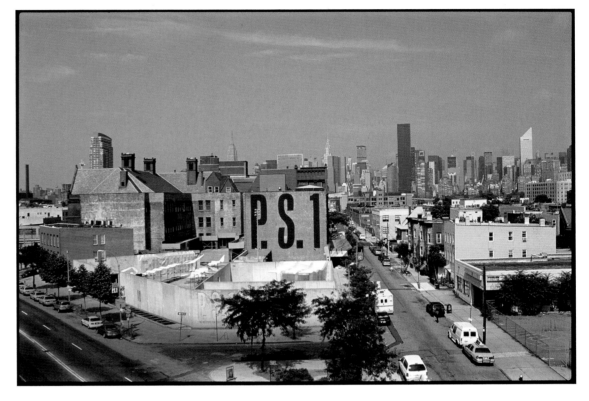

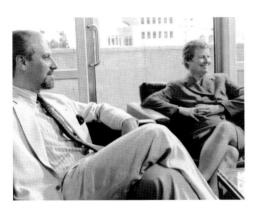

Director Glenn D. Lowry with Alanna Heiss, Founder and Director of P.S. 1 Contemporary Art Center, Long Island City, Queens (photograph 1999). In January 2000 the Museum formally merged with P.S. 1.

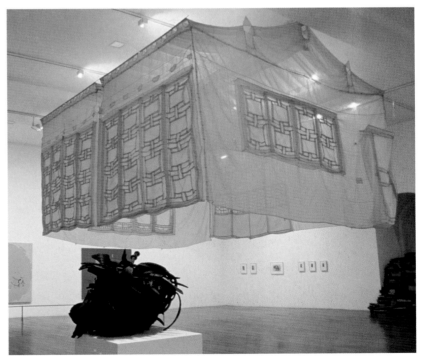

Greater New York, installation views of exhibition at P.S. 1 Contemporary Art Center, 2000. This exhibition, which marked the first significant collaboration between the two institutions, showcased the diverse and dynamic work of more than 140 emerging New York–area artists.

▉ ANDREAS GURSKY

— **2001**

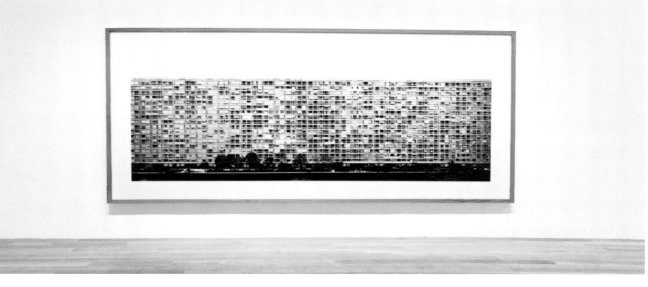

Andreas Gursky, installation view, 2001

Andreas Gursky's best pictures of the past decade knock your socks off, and they're meant to. They're big, bold, full of color, and full of surprise. As each delivers its punch, the viewer is already wondering where it came from—and will continue to enjoy the seduction of surprise long after scrutinizing the picture in detail.
Peter Galassi

Peter Galassi, center, Chief Curator of Photography and director of the exhibition, with the photographer Andreas Gursky and Nina Pohl, at the opening of the exhibition *Andreas Gursky*, **February 28, 2001**

▉ KIRK VARNEDOE RESIGNS

Kirk Varnedoe resigns as Chief Curator of Painting and Sculpture, 2001.

Nearly everyone who met Kirk Varnedoe felt his volubility, the sometimes astonishing flow of words and ideas at his command. There . . . was the feeling that a newly begun sentence could wind up going almost anywhere, crossing the plains into an unknown country or doubling back on a settlement that suddenly looked different than it did the first time we passed it. . . . There was a fine, dark gravel on the streambed of Kirk Varnedoe's voice. Occasionally, a Southern note from his childhood would float to the surface like a perfectly formed bubble. He was a conveyer of knowledge, not a hoarder. No idea, no fact, became quite real to him unless he had passed it along to someone else first. . . . I was always struck by the tangibility of the words he used, whether he was talking about college football, which he had played and coached, or modernism, which he had spent most of his life studying. It was as if he were laying down words on the table one by one as he used them, like brushes in an artist's studio.
Verlyn Klinkenborg, The New York Times, August 16, 2003

2002

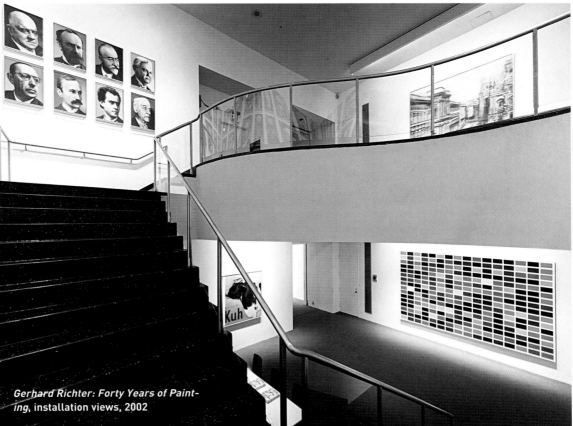

Robert Storr, left, Curator of Painting and Sculpture and director of the exhibition, with Trustee Marie-Josée Kravis and Henry Kravis, at the opening of *Gerhard Richter: Forty Years of Painting*, February 13, 2002

Gerhard Richter: Forty Years of Painting, installation views, 2002

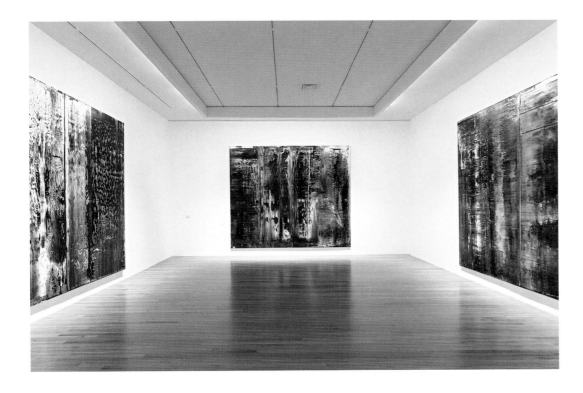

Richter has assumed a skeptical distance from vanguardists and conservatives alike regarding what painting should be, choosing instead to test the limits of what he as an artist could create out of the formal conventions and contradictory ideological legacy of the medium. The result, paradoxically, has been the most thorough "deconstruction" of those conventions and at the same time one of the most convincing demonstrations of painting's renewed vitality to be found in late 20th- and early 21st-century art.

Museum Press Release

Press-kit cover for the exhibition
The Russian Avant-Garde Book 1910–1934, 2002

The Russian Avant-Garde Book . . . is prompted by an extraordinary gift to MoMA of over 1,000 Russian avant-garde illustrated books from The Judith Rothschild Foundation, New York. The gift is the largest to the Department of Prints and Illustrated Books since Abby Aldrich Rockefeller established the collection in the 1940s with her donation of 1,600 prints. . . . The Rothschild gift represents all the significant artistic developments of the period. . . . This comprehensive resource has been characterized by experts in the field as among the most significant collections of its kind worldwide.

Museum Press Release

Left to right: Margit Rowell, codirector of the exhibition, President Agnes Gund, and Deborah Wye, Chief Curator of Prints and Illustrated Books and codirector of the exhibition, at the opening of the exhibition *The Russian Avant-Garde Book 1910–1934*, **March 1, 2002**

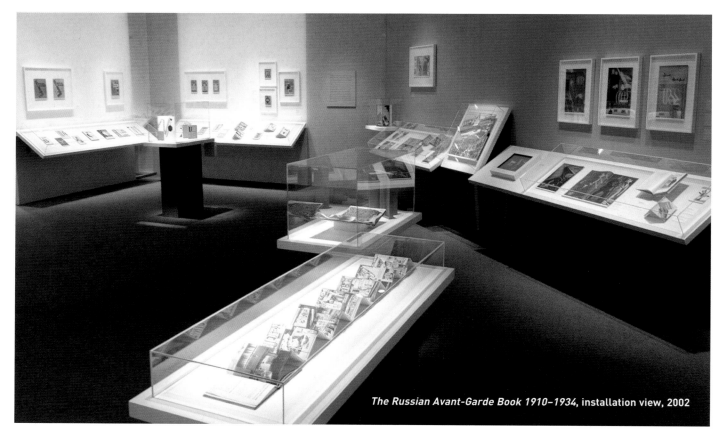

The Russian Avant-Garde Book 1910–1934, installation view, 2002

MoMA QNS facility in Long Island City, Queens, 2002. Main entrance

MoMA QNS. Admissions desk and entry ramp from balcony level, 2002

Enhancing the vibrant cultural scene in the Queens community, MoMA QNS (pronounced Q-N-S) will open this summer in Long Island City, joining a growing list of cutting-edge cultural destinations, galleries, and artists discovering the post-industrial loft space and sweeping views of Manhattan that characterize the area. The new space, designed by Cooper, Robertson & Partners, and Michael Maltzan Architecture will offer a full spectrum of exhibitions that appeals to both members and new audiences.

Museum Press Release

■ TO BE LOOKED AT

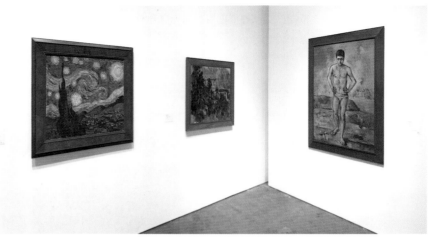

To Be Looked At, installation views of works from the collection of painting and sculpture at MoMA QNS, 2002

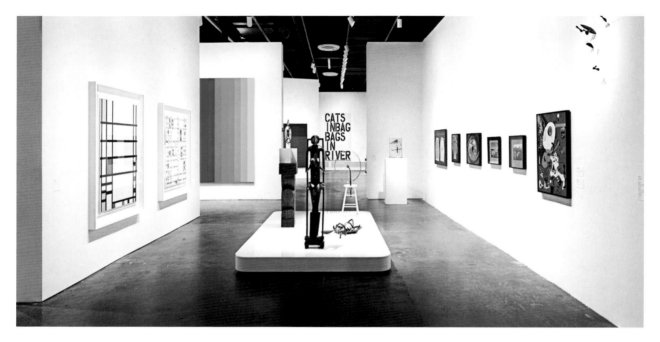

■ CHANGE IN LEADERSHIP

Upon the retirement of Agnes Gund as President, Trustee Robert B. Menschel is named President of the Museum, 2002 (photograph 1990). Ms. Gund is named President Emerita.

2003

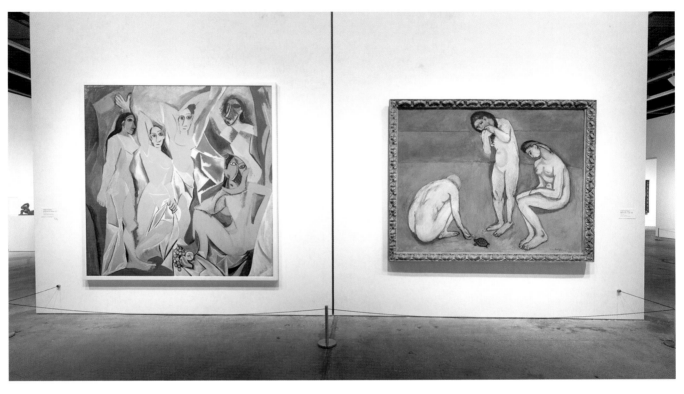

Matisse Picasso, installation views at MoMA QNS, 2003

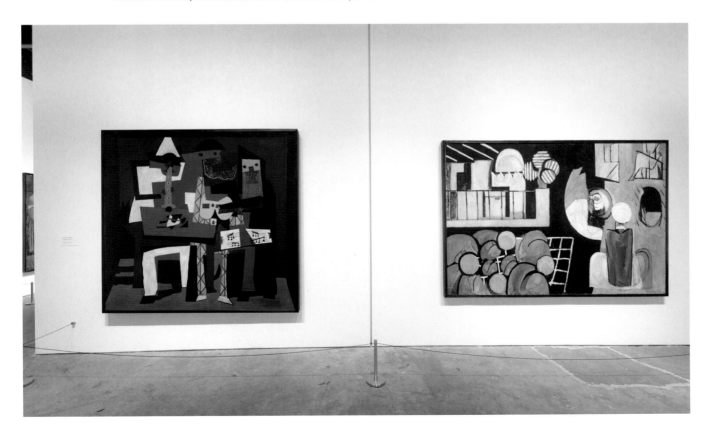

▤ KYNASTON MCSHINE NAMED CHIEF CURATOR AT LARGE

▤ JOHN ELDERFIELD NAMED CHIEF CURATOR OF PAINTING AND SCULPTURE

Kynaston McShine, who served as Acting Chief Curator of the Department of Painting and Sculpture upon the resignation of Kirk Varnedoe as Chief Curator of Painting and Sculpture in 2001, is named Chief Curator at Large in 2003 (photograph 1988).

John Elderfield, Chief Curator at Large, is named Chief Curator of the Department of Painting and Sculpture in 2003.

▤ ARTIST'S CHOICE: MONA HATOUM

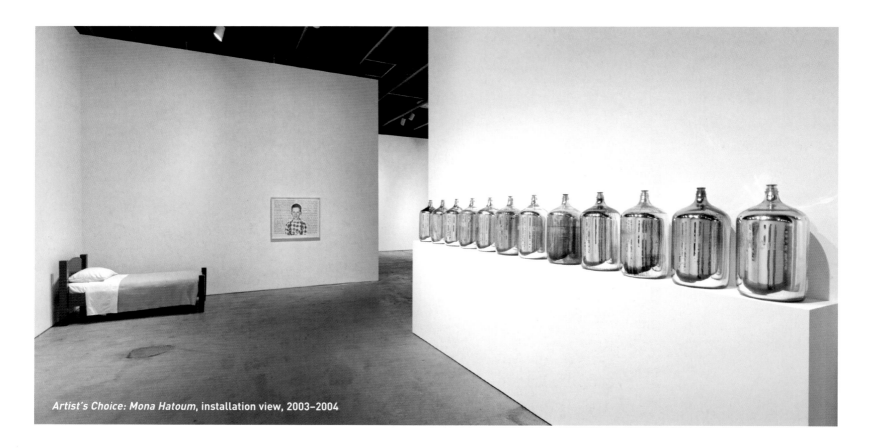

Artist's Choice: Mona Hatoum, installation view, 2003–2004

■ DIETER ROTH

— 2004

Dieter Roth, installation views at simultaneous venues, 2004. Left: P.S. 1 Contemporary Art Center; right: MoMA QNS

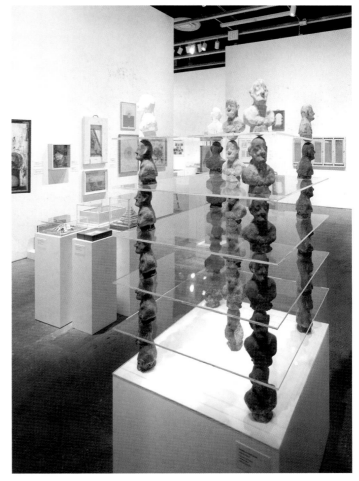

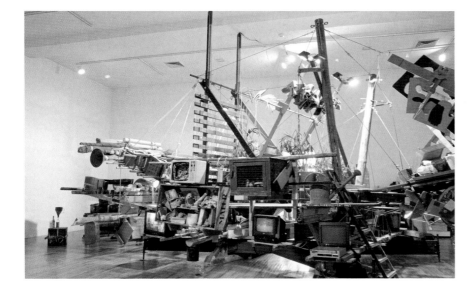

■ TALL BUILDINGS

Catalogue for the exhibition *Tall Buildings*, by Terence Riley and Guy Nordenson, 2003–2004

■ MoMA IN BERLIN

Catalogue for the exhibition *Das MoMA in Berlin*, edited by John Elderfield, one of a number of exhibitions of works from the Museum's collection that traveled during the construction of the Museum's new building, 2003–2004. Over 1 million people visited the exhibition in Berlin.

Groundbreaking ceremony for the new Museum building, May 10, 2001. Left to right: President Agnes Gund, architect Yoshio Taniguchi, Chairman Ronald S. Lauder, Vice Chairman Donald B. Marron, Vice Chairman Jerry I. Speyer, Mayor Rudolph Giuliani, Chairman Emeritus David Rockefeller, and Director Glenn D. Lowry

Director Glenn D. Lowry, left, and Yoshio Taniguchi, the architect selected for the new Museum building, June 9, 2004

Construction photograph of the new Museum building, 2003

Axonometric showing north elevation, 54th Street
(computer generated image)

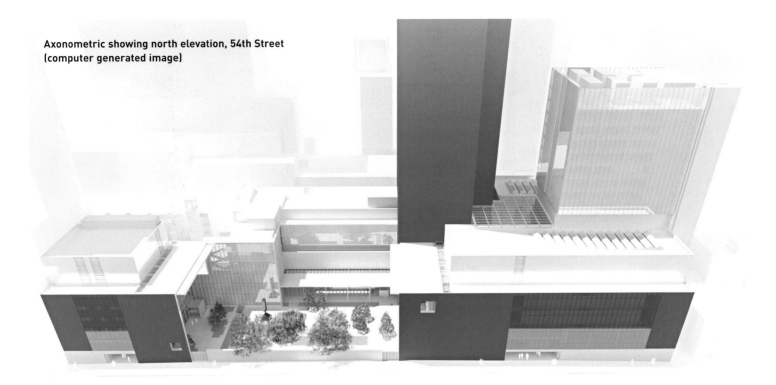

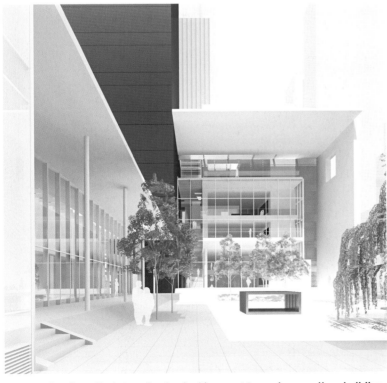

Exterior view from Sculpture Garden looking west toward new gallery building,
2004 (computer generated image)

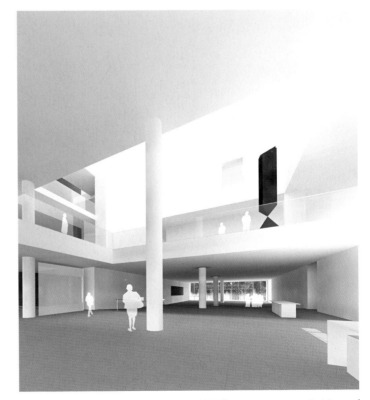

Interior view looking toward atrium, 2004 (computer generated image)

Taniguchi's design is a brilliant response to both the Museum's urban context and its programmatic requirements. . . . The project comprises five parts: a new gallery complex with a ten-floor tower above it, named in honor of David and Peggy Rockefeller, on the site's west side, where the Dorset Hotel and several brownstones used to be; the renovated Goodwin and Stone building of 1939 and Johnson building of 1964, now named in honor of Ronald and Jo Carole Lauder; the Abby Aldrich Rockefeller Sculpture Garden; and the Education and Research Building on the northeast corner of the site, housing a theater, classrooms, curatorial offices, study centers, and the Library and Archives, and named in honor of Lewis and Dorothy Cullman. Rising through the middle of the complex is Pelli's fifty-four-story residential tower (part of the Museum's 1984 expansion), the lower seven floors of which are incorporated into the project.

Taniguchi . . . recognized the simultaneously commercial and residential nature of the area by developing two different facades. To the south . . .

he preserved the Johnson, Goodwin and Stone, and Pelli facades while adding one for the new gallery complex to their west, thereby articulating the Museum's historical development. . . . To the north . . . he created a single, unified facade of . . . black granite, dark gray glass, glass finely fritted in alternately clear and white lines, and aluminum . . . defining the Museum as a single, fully integrated complex. [He also] took advantage of [Cesar Pelli's residential tower] by . . . making it a central axis point for the complex . . . a kind of pivot point between the historical and the new, the interior and the exterior, and several of the principal circulation systems which rise along the side of the tower's core. Finally Taniguchi decided to emphasize the Abby Aldrich Rockefeller Sculpture Garden as the heart of the entire complex. His means was to make the garden larger: while retaining its existing layout, he expanded it by recovering its south terrace. . . . He also extended its east and west terraces and framed them with two giant porticoes.

Glenn D. Lowry

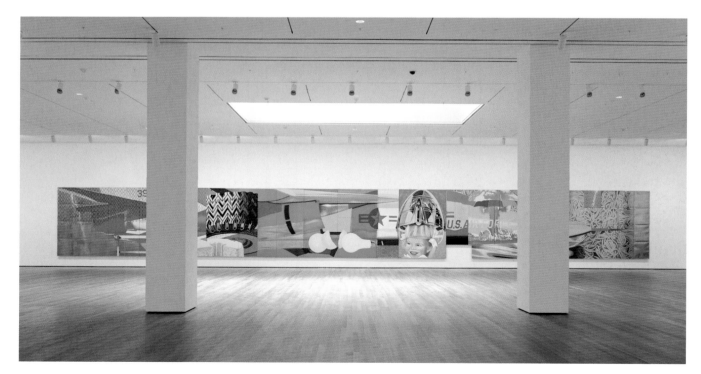

View inside the new contemporary galleries with James Rosenquist's eighty-six-foot-long painting *F-111*, 1964–65, installed, August 2004

The Fifty-third Street facade of the Museum's new building, August 2004

The Museum's new gallery building and office tower from Fifty-fourth Street, August 2004

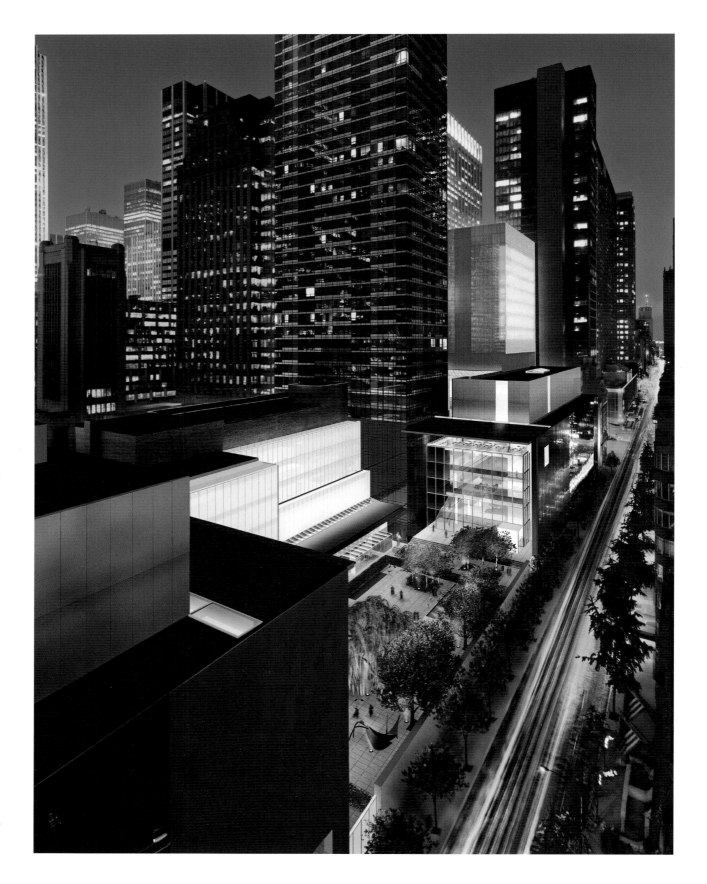

The completed building
from Fifty-fourth Street,
2004 (digital photocom-
position)

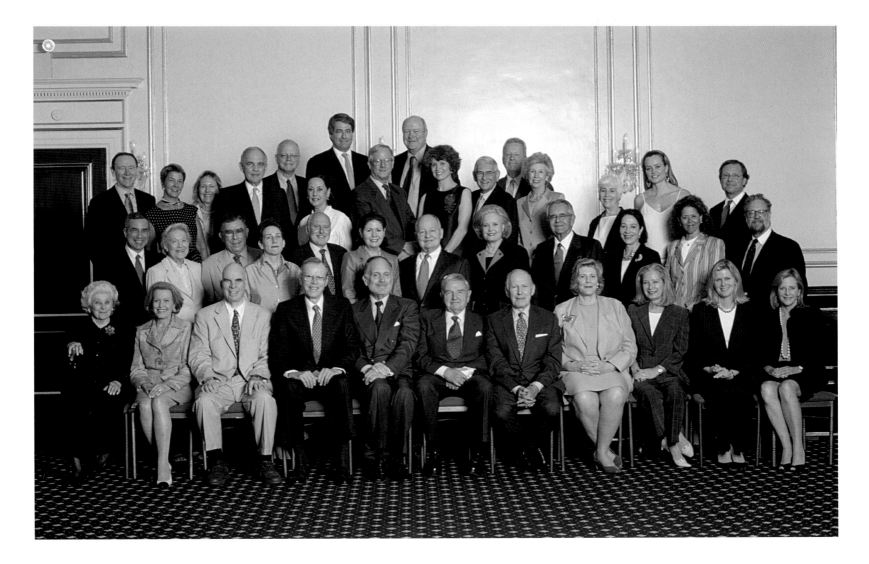

A gathering of Trustees and *ex officio* members of the Board of Trustees of The Museum of Modern Art, June 9, 2004. Front row, left to right: Mrs. Donald B. Straus, Emily Spiegel, Treasurer John Parkinson III, Vice Chairman Donald B. Marron, Chairman Ronald S. Lauder, Chairman Emeritus David Rockefeller, President Robert B. Menschel, President Emerita Agnes Gund, Vice Chairman Mimi Haas, Vice Chairman Kathleen Fuld, Patricia Phelps de Cisneros. Center row: Philip Aarons, Mrs. Jan Cowles, Werner H. Kramarsky, Maja Oeri, Michael Lynne, International Council President Jo Carole Lauder, Douglas S. Cramer, Sharon Percy Rockefeller, Peter G. Peterson, Marlene Hess, Anna Deveare Smith, David Rockefeller, Jr. Back row: Richard Anderman, Leith ter Muelen, Anne Coffin, Donald L. Bryant, Jr., David M. Childs, Barbara Jakobson, Leon D. Black, Peter Norton, James G. Niven, Alexandra A. Herzan, Eli Broad, Paul F. Walter, Anna Marie Shapiro, Emily Rauh Pulitzer, Clarissa Alcock Bronfman, and Michael S. Ovitz (not pictured: Edward Larrabee Barnes, Celeste Bartos, Sid R. Bass, Mrs. Patti Cadby Birch, Thomas S. Carroll, Lewis B. Cullman, H.R.H. Duke Franz of Bavaria, Gianluigi Gabetti, Maurice R. Greenberg, Vartan Gregorian, Mrs. Melville Wakeman Hall, Kitty Carlisle Hart, Philip Johnson, Marie-Josée Kravis, June Noble Larkin, Thomas H. Lee, Harvey S. Shipley Miller, J. Irwin Miller, Mrs. Akio Morita, Daniel M. Neidich, Philip S. Niarchos, Richard E. Oldenburg , Richard D. Parsons, Mrs. Milton Petrie, Gifford Phillips, Lord Rogers of Riverside, Richard E. Salomon, Ileana Sonnabend, Jerry I. Speyer, Joanne M. Stern, Yoshio Taniguchi, Eugene V. Thaw, Jeanne C. Thayer, Joan Tisch, Thomas W. Weisel, Gary Winnick, Richard S. Zeisler)

Source notes for quotations, documents, and photographs are listed below by page number. Each entry refers to an object on the particular page cited and gives the source of the material quoted or shown, as well as any applicable copyright notice. Citations are listed in the order of their subject's appearance on the page, top left and right preceding bottom left and right. In addition to the source notes and photograph credits, occasionally additional information on the subject matter has been added to flesh out the record as to acquisitions, titles, dates, programs, and sequences of events for which all pertinent information could not be featured on the pages of the chronicle itself. Furthermore, it should be noted that the chronicle's events are listed in chronological order wherever possible within each year, but not strictly so, owing to the need to conserve space within the work as a whole. Continuing series of events or programs are for the most part listed one time to indicate recurrent programming over a period of years.

All source images and original objects, such as posters, books, other documents, and installation photographs have been scanned and are courtesy, 2004, the Digital Imaging Studio of The Museum of Modern Art, unless otherwise indicated. Every effort has been made to make clear rights for the written and visual material contained in this work. For certain materials reproduced herein, the editors have been unable to trace the copyright holders, and would appreciate notification of such information for acknowledgment in future editions of the book. Writings and photographs that include works of art reproduced in this volume are protected by the following copyright citations. The following credits appear at the request of the artists or the artists' representatives and/or the owners of the work: Burckhardt, Chamberlain, LeWitt, Marden, Nauman, Stella: © 2004 Artists Rights Society (ARS), New York; Arp, Grosz, Gursky, Pechstein: © 2004 Artists Rights Society (ARS), New York/ADAGP, Paris; Bourgeois: © 2004 Louise Bourgeois; Calder: © 2004 Estate of Alexander Calder/Artists Rights Society (ARS), New York; Christo: © 2004 Christo; Clemente: © 2004 Francesco Clemente; Close: © 2004 Chuck Close; Dalí: © 2004 Salvador Dalí, Gala-Salvador Dalí Foundation/Artists Rights Society (ARS), New York; de Chirico: © 2004 Artists Rights Society (ARS), New York/SIAE, Rome; de Kooning: © 2004 The Willem de Kooning Foundation/Artists Rights Society (ARS), New

York; Duchamp: © 2004 Artists Rights Society (ARS), New York/ADAGP, Paris/Estate of Marcel Duchamp; Hill: © 2004 Gary Hill; Indiana: © 2004 Morgan Art Foundation Ltd./Artists Rights Society (ARS), New York; Johns: © 2004 Jasper Johns/Licenced by VAGA; Kelly: © 2004 Ellsworth Kelly; Lawrence: © 2004 The Jacob and Gwendolyn Lawrence Foundation; Lichtenstein: © 2004 Estate of Roy Lichtenstein; Matisse: © 2004 Succession H. Matisse, Paris/Artists Rights Society (ARS), New York; Miró: © 2004 Successió Miró/Artists Rights Society (ARS), New York/ADAGP, Paris; Newman: © 2004 Barnett Newman Foundation/Artists Rights Society (ARS), New York; Oldenburg: © 2004 Claes Oldenburg; Picasso: © 2004 Estate of Pablo Picasso/Artists Rights Society (ARS), New York; Pollock: © 2004 Pollock-Krasner Foundation/Artists Rights Society (ARS), New York; Reinhardt: © 2004 Estate of Ad Reinhardt/Artists Rights Society (ARS), New York; Richter: © 2004 Gerhard Richter; Roth: © 2004 Estate of Dieter Roth; Rothko: © 2004 Kate Rothko Prizel & Christopher Rothko/Artists Rights Society (ARS), New York; Ruscha: © 2004 Ed Ruscha; Ryman: © 2004 Robert Ryman; Smith: © 2004 Kiki Smith; Twombly: © 2004 Cy Twombly; Viola: © 2004 Bill Viola; Warhol: © 2004 Andy Warhol Foundation for the Visual Arts/Artists Rights Society (ARS), New York; Wright: © 2004 Frank Lloyd Wright Foundation/Artists Rights Society (ARS), New York.

In these notes, the following abbreviations have been used:
MoMA Library
The Museum of Modern Art Library, New York
MoMA Archives
The Museum of Modern Art Archives, New York
Collections within the MoMA Archives:

PA	Photographic Archive
AAR	Abby Aldrich Rockefeller Scrapbooks
ACG	A. Conger Goodyear Scrapbooks
AHB	Alfred H. Barr, Jr., Papers
DCM	Dorothy C. Miller Papers
EMH	Early Museum History: Administrative Records
Graphics	Department of Graphics Records
ICE	International Council/Program Exhibition Records
JTS	James Thrall Soby Papers
MSB	Margaret Scolari Barr Papers
PI	Department of Public Information Records
PI Event Photos	Department of Public Information Event Photos
R&P	Reports and Pamphlets
RDH	René d'Harnoncourt Papers

■ PAGE 16
Poster for Armory Show: "International Exhibition of Modern Art. Association of American Painters and Sculptors. 69th Inf't'y Regt Armory, New York City. February 15th to March 15th 1913. American & Foreign Art." 1913. MoMA Library.

Postcard for Armory Show: "View of Foreign Exhibit: International Exhibition, New York, 1913." Armory Show Collection, scrapbook compiled by Charles A. Smith (gift of Nelson A. Rockefeller). MoMA Archives.

In a sense, the epoch-making Armory Show: Alfred H. Barr, Jr., in "Minutes of the Junior Council of The Museum of Modern Art, Second Meeting, March 8, 1949," Junior Council Records. MoMA Archives.

■ PAGE 17
Inscription to Lillie P. Bliss: Louis C. Tiffany, inscription on notepaper, dated February 24, 1916, pasted into a copy of Louis C. Tiffany and Charles Allen, *The Art Work of Louis C. Tiffany* (New York: Doubleday & Sons, 1916). MoMA Library. The inscription reads: "To my dear friend Lilly Bliss & although she does not agree with me about art—I love her still.— 'The modernists, as they are called for want of a better term (I mean the Cubists etc.)— wander after curiosities of technique, vaguely hoping they may light on some invention which will make them famous. They do not belong to art, they are not artists, they are inventors of processes of the arts.'—Louis C. Tiffany, Feb. 24 '16."

We are not so far apart: Lillie P. Bliss, "From a Letter to a National Academician [Tiffany]," in *The Lillie P. Bliss Collection 1934* (New York: The Museum of Modern Art, 1934): 3.

■ PAGE 19
Abby Aldrich Rockefeller and son: Detail of family photograph taken at the Eyrie. 1921. Digital image courtesy Rockefeller Archive Center.

Frequently at the house: Oral History Project, Interview with David Rockefeller, 1991: 19–24. MoMA Archives. Mr. Rockefeller refers to his mother Abby Aldrich Rockefeller, Miss Bliss, and Mrs. Sullivan, the three ladies who initiated the idea of forming a modern museum.

■ PAGE 20
Lillie P. Bliss: Bliss Family Papers, New York. Courtesy Rona Roob.

She was an advocate: Eleanor Robson Belmont, in *Memorial Exhibition: The Collection of the Late Miss Lizzie P. Bliss, Vice-President of the Museum* (New York: The Museum of Modern Art, 1931): 7–8. Born Lizzie Plummer Bliss, Miss Bliss used "Lizzie" only on formal occasions or on legal documents.

Through her friendship with the American painter Arthur B. Davies, Miss Bliss became a backer of the Armory Show of 1913. For more complete information about Miss Bliss, see Rona Roob, "A Noble Legacy," *Art in America* 91, no. 11 (November 2003): 73–83.

Bliss collection in apartment: Lillie P. Bliss Scrapbook. MoMA Archives.

■ PAGE 21
Mrs. Rockefeller seated at desk: Photograph by H. T. Koshiba. Digital image courtesy Rockefeller Archive Center.

During the spring a small group of New York people: Abby Aldrich Rockefeller, Letter to Eustache de Lorey, August 29, 1929, quoted in Bernice Kert, *Abby Aldrich Rockefeller: The Woman in the Family* (New York: Random House, 1993): 262.

Rockefeller collection in home: Photograph by Samuel Gottscho. Digital image courtesy Rockefeller Archive Center.

■ PAGE 22
Guest book: Detail of Museum guest book, 1929–44. MoMA Archives.

It was the perfect combination: Nelson A. Rockefeller, quoted in *The Museum of Modern Art, New York: The History and the Collection* (New York: The Museum of Modern Art and Harry N. Abrams, 1984): 10. Nelson A. Rockefeller was the third child and second son of Abby Aldrich Rockefeller and her husband John D. Rockefeller, Jr. His involvement with the Museum began when he became a member of the Junior Advisory Committee in 1930. He was elected a Trustee in 1932, and he served as president of the Museum in 1939–41 and 1946–53, and chairman in 1956–58.

Abby had met Mary Sullivan: Kert, *Abby Aldrich Rockefeller: The Woman in the Family:* 268.

Mrs. Sullivan: PA. Museum Archives.

■ PAGE 23
In the latter part of May: A. Conger Goodyear, *The Museum of Modern Art: The First Ten Years* (New York, 1943): 14. The ladies asked Goodyear partly because they had heard of his falling out with the Albright Gallery in Buffalo over a Rose Period Picasso, *La Toilette*, which he had purchased for that museum to the distress of his fellow trustees.

A. Conger Goodyear: PA. Museum Archives.

Frank Crowninshield: Photograph by Nickolas Muray, © Nickolas Muray Photo Archives, LCC. Digital image courtesy George Eastman House.

■ PAGE 24
Josephine Boardman Crane: Digital image courtesy Adele Bildersee, the Dalton School, New York.

[Paul J. Sachs] was in the family: Oral History Project, Interview with David Rockefeller, 1991: 21. MoMA Archives.

Paul J. Sachs: Digital image courtesy Fogg Art Museum, Harvard University Art Museums.

■ PAGE 25
Alfred H. Barr, Jr.: MSB, box 35. MoMA Archives.

Business card: 1929. AAR, 1. MoMA Archives.

Alfred Barr was not a convivial type: Philip Johnson, in *Alfred H. Barr, Jr.: A Memorial Tribute, October 21, 1981* (New York: The Museum of Modern Art, 1981): n.p.

■ PAGE 26
Charter: Museum Charter, box 1. MoMA Archives. Photograph by Kate Keller. PA. MoMA Archives.

It is perfectly located: Alfred H. Barr, Jr., quoted in "The Making of a Museum," *ARTnews, The Museum of Modern Art at 50* (October 1979): 62.

Postcard: "Plaza Hotel and Heckscher Bldg Fifth Avenue. New York," 1923. MoMA Archives.

■ PAGE 27
Membership solicitation: "The Museum of Modern Art: A New Institution for New York." ACG, 1. MoMA Archives.

■ PAGES 28–29
Brochure: AHB, 9a.1a. MoMA Archives. The first annotation reads as follows: "Summer [crossed out] 1929 Contains 2 indirect references to 'multidepartmental plan'—all that I could get away with at that time." The second: "This is second edition and may be as late as Nov. '29. First edition is on buff paper. AHB." Two sections are numbered to indicate the indirect references to the multidepartmental plan. At number 2, Barr had proposed the text shown on page 29.

In preparing a draft: Alfred H. Barr, Jr., "Chronicle of the Collection of Painting and Sculpture," in his *Painting and Sculpture in The Museum of Modern Art 1929–1967* (New York: The Museum of Modern Art, 1977): 620. Quotations by Barr from this work are dated 1967, the year it was written, rather than the date of publication (1977).

■ PAGE 30
Catalogue: Alfred H. Barr, Jr., *The Museum of Modern Art First Loan Exhibition, New York, November 1929: Cézanne, Gauguin, Seurat, van Gogh* (New York: The Museum of Modern Art, 1929).

The youngest: Lloyd Goodrich, "A Museum of Modern Art," *The Nation* 129, no. 3361 (December 4, 1929): 664–665.

Cézanne, Gauguin, Seurat, van Gogh: November 7–December 7, 1929. PA. MoMA Archives. The second exhibition, *Paintings by Nineteen Living Americans,* was shown December 13, 1929–January 13, 1930.

■ PAGE 31
The walls are faced with monk's cloth: Margaret Scolari Barr, "Our Campaigns," *The New Criterion* (Special Issue 1987): 23.

Attendance ledger: Early Museum Ledger Books, Attendance Ledger, November 1929–April 1936. MoMA Archives.

Max Pechstein, *Dialogue (Zwiesprache).* 1920. Woodcut, plate: 15⁹⁄₁₆ x 12⁹⁄₁₆" (40.2 x 31.9 cm). The Museum of Modern Art, New York. Gift of Paul J. Sachs.

George Grosz, *Anna Peter,* 1926–27, Pencil on paper, 27⅛ x 21¼" (68.9 x 54 cm). The Museum of Modern Art, New York. Gift of Paul J. Sachs.

■ PAGE 32
Dear Mr. Goodyear: Stephen C. Clark, Letter to A. Conger Goodyear, January 20, 1930. ACG, 31. MoMA Archives.

Bulletin page: The Bulletin of The Museum of Modern Art 8, no. 1 (November 1940). Edward Hopper. *House by the Railroad.* 1925. Oil on canvas, 24 x 29" (61 x 73.7 cm). Given anonymously.

Elizabeth Bliss: n.d. PA. MoMA Archives.

Lincoln Kirstein: n.d. PA. MoMA Archives.

Nelson A. Rockefeller: c. 1939. Photograph by Harris and Ewing, Washington D.C. PA. MoMA Archives.

The matter of Junior Trustees: From the "Minutes of the Fourteenth Meeting of the Trustees of The Museum of Modern Art," April 18, 1930. Trustee Minutes. MoMA Archives.

The Junior Advisory Committee: Barr, "Chronicle of the Collection of Painting and Sculpture": 621. The Committee disbanded in 1945.

■ PAGE 33
March 12: Miss Lillie P. Bliss: Barr, "Chronicle of the Collection of Painting and Sculpture": 621.

Memorial Exhibition: The Collection of the late Lillie P. Bliss: May 17–October 6, 1931. Photograph by Peter A. Juley. PA. MoMA Archives.

Letter to Cornelius N. Bliss: April 20, 1931. Lillie P. Bliss Scrapbook. MoMA Archives. The letter reads:

"Dear Mr. Bliss: I would like very much if I might sometime tell you how deeply impressed and touched I am by your sister's gift to the Museum of Modern Art. It is so in line with the generous way in which she did all things that it will make her memory a very living inspiration to us all. It makes me more eager than ever to see the Museum worthily succeed. I should love to talk it all over with you if you could find time to stop in here either in the morning on your way downtown or in the afternoon—whichever is more convenient for you. With renewed expressions of sympathy, I am Sincerely Abby A. Rockefeller."

PAGE 34

Henri Matisse: November 3–December 6, 1931. PA. MoMA Archives. This was Matisse's first important museum exhibition in the United States.

Letter to Alfred H. Barr, Jr.: December 14, 1931. AHB, II.v.2.a. MoMA Archives. Translation by Jillian Slonim, 2004.

PAGE 35

Henri Matisse: PA. MoMA Archives.

Copy of catalogue: Alfred H. Barr, Jr., *Henri Matisse Retrospective Exhibition* (New York: The Museum of Modern Art, 1931). AHB, II.v.2.a. MoMA Archives. The inscription reads: "In memory of an ensemble, the harmony of which was born of a common understanding."

PAGE 36

International Exhibition: Department of Circulating Exhibitions Records, album A1(1). MoMA Archives.

Henry-Russell Hitchcock: Detail of photograph of opening of the Bauhaus exhibition. MSB, box 35. MoMA Archives.

In 1931: Henry-Russell Hitchcock, "Foreword to the 1966 Edition," *The International Style* (New York: W. W. Norton, 1966): vii, xiii.

PAGE 37

A[lfred] and Philip talk fervently: Barr, "Our Campaigns": 25.

Cortona, Italy: MSB. MoMA Archives.

The Department of Architecture: Alfred H. Barr, Jr., "Notes on departmental expansion of the Museum." AHB, 9a.5A. MoMA Archives. This was the first department devoted to architecture in an art museum.

PAGE 38

The Museum moved: Report to the Corporation, Annual Reports 1931–40. MoMA Archives. Essentially, the move grew out of a need for more space. In addition, the management of the Heckscher Building began to post notices requesting cooperation of Museum visitors who were clogging eleva-

tors and impeding other tenants of the building.

Townhouse: Photograph by Soichi Sunami. PA. MoMA Archives. This townhouse was leased from John D. Rockefeller, Jr.

Murals: May 3–31, 1932. PA. MoMA Archives.

PAGE 39

"Torpedo" Diagram: AHB, 9a.7A. MoMA Archives.

Theory and Contents: Alfred H. Barr, Jr., "A Report on the Permanent Collection," 1933, typescript. AHB, 9a.7A. MoMA Archives.

Alfred H. Barr, Jr.: PA. MoMA Archives.

PAGE 40

The circulation of exhibitions: The *Bulletin of The Museum of Modern Art* 21, nos. 3–4 (summer 1954): 4–5. One of the earliest programs of its kind, the circulating exhibitions program was important in spreading modernism in the United States, and also provided a model for museums worldwide.

Elodie Courter: June 1941. Photograph by Albert Fenn. PA. MoMA Archives.

Bliss Bequest: PA. MoMA Archives.

PAGE 41

Philip Johnson: Photograph by Paul Parker. PA. MoMA Archives.

Machine Art: March 5–April 29, 1934. PA. MoMA Archives.

Catalogue: Philip Johnson and Henry-Russell Hitchcock, *Machine Art.* Foreword by Alfred H. Barr, Jr. (New York: The Museum of Modern Art, 1934).

Johnson surprised: Paola Antonelli, "Objects of Design," in *Objects of Design from The Museum of Modern Art* (New York: The Museum of Modern Art, 2003): 11.

Cartoon: © The New Yorker Collection 1934 Alan Dunn. Digital image from cartoonbank.com. All rights reserved.

PAGE 42

She directed many important exhibitions: Richard E. Oldenburg, "Dorothy Miller," Skowhegan Awards Dinner brochure, 1983.

Dorothy Miller: Photograph by Soichi Sunami. PA. MoMA Archives.

Abby Aldrich Rockefeller, acting anonymously: Barr, "Chronicle of the Collection of Painting and Sculpture": 625.

Letter to Abby Aldrich Rockefeller: July 20, 1935. AHB, 10.A.64.a. MoMA Archives. The inscription reads: "Affectionately A Barr. Will write

from The Hague. P.S. England is just now starting a film library!"

PAGE 43

John Hay Whitney: n.d. PA. MoMA Archives.

Iris Barry and John E. Abbott: PI, II.C.17. MoMA Archives.

Article: Museum of Modern Art Film Library Press Clippings, no. 1, April–November 1935. Film Study Center.

This report embodies a project: John E. Abbott and Iris Barry, "An Outline of a Project for Founding the Film Library of the Museum of Modern Art," April 17, 1935. EMH, I.12. MoMA Archives. The Film Library was given working space by William S. Paley in the CBS Building at 485 Madison Avenue, at Fifty-first Street. Public screenings were held at the Museum of Natural History and the Dalton School, and film programs were distributed to numerous outside borrowers. The Museum was the first art museum to recognize the motion picture as an art form and the first to create an international archive of films.

PAGE 44

Foreign loans: Photograph by Beaumont Newhall. PA. MoMA Archives.

In assembling the current exhibition: Thomas Dabney Mabry, "The Government Defines Art," *The Bulletin of The Museum of Modern Art* 3, no. 5 (April 1936): 2.

Cubism and Abstract Art: March 2–April 19, 1936. Photographs by Beaumont Newhall. PA. MoMA Archives. This landmark exhibition and its companion show, *Fantastic Art, Dada and Surrealism*, were the first comprehensive surveys in the United States of works by twentieth-century artists, and the first to give historical perspective to European innovators and to the principal movements of modern art.

PAGE 45

Dust jacket: Alfred H. Barr, Jr., *Cubism and Abstract Art* (New York: The Museum of Modern Art, 1936). AHB, 3.C.4. MoMA Archives.

Hand-drawn diagram: AHB, 10.A.34. MoMA Archives.

Cubism and Abstract Art: Robert Rosenblum, Foreword to the 1986 edition of Alfred H. Barr, Jr., *Cubism and Abstract Art* (New York: The Museum of Modern Art, 1986): 2–3.

PAGE 46

Fantastic Art, Dada and Surrealism: December 7, 1936–January 17, 1937. Photograph by Soichi Sunami. PA. MoMA Archives.

Fantastic Art, Dada and Surrealism is the second in the series: Alfred H. Barr, Jr., "Preface," *Fantastic Art,*

Dada and Surrealism (New York: The Museum of Modern Art, 1936): 7–8.

Title page of the catalogue: Barr, *Fantastic Art, Dada and Surrealism:* 3.

PAGE 47

Photography 1839–1937: March 17–April 18, 1937. Photograph by Soichi Sunami. PA. MoMA Archives. The catalogue for this exhibition was later published as *The History of Photography,* by Beaumont Newhall, in many subsequent revised and enlarged editions.

Beaumont Newhall: n.d. PA. MoMA Archives.

Victor D'Amico: PI, II.C.54. MoMA Archives. The Museum's first educational program was founded with ten New York City high schools, and sponsored classes in modern art and art appreciation for high-school students.

Young People's Gallery: Photograph by Soichi Sunami. PA. MoMA Archives.

PAGE 48

The Staff of the Museum: Photograph by Soichi Sunami. PA. MoMA Archives.

Press release: Museum Press Release, no. 19, June 1937.

Entrance to the temporary quarters: 14 West Forty-ninth Street. Photograph by Soichi Sunami. PA. MoMA Archives.

PAGE 49

Bauhaus: 1919–1928: December 7, 1938–January 30, 1939. Photograph by Soichi Sunami. PA. MoMA Archives.

Invitation: ACG, 50. MoMA Archives.

After the great Bauhaus exhibition: Alfred H. Barr, Jr., "Preface," in *Bauhaus 1919–1928* (New York: The Museum of Modern Art, 1938): 5–6. Barr had first visited the Bauhaus in 1927; it is one of several models for his idea of a multidepartmental museum.

PAGE 50

Girl Before a Mirror: Photograph by Nancy Newhall. PA. MoMA Archives. Pablo Picasso. *Girl Before a Mirror.* 1932, March 14. Oil on canvas, 64 x 51¼" (163.2 x 130.2 cm). Gift of Mrs. Simon Guggenheim.

Mrs. Simon Guggenheim: Detail of a photograph of Trustees at the exhibition *XXVth Anniversary Exhibition: Paintings,* October 19, 1954. PA. MoMA Archives.

Late in 1937: Barr, "Chronicle of the Collection of Painting and Sculpture": 625. Mrs. Simon Guggenheim made over fifty gifts of works of art to the Museum. Among the best-known of these are Peter Blume's *The Eternal City,* Umberto

Boccioni's *The City Rises,* Alexander Calder's *Black Widow,* Marc Chagall's *I and the Village,* Jean Dubuffet's *Joë Bousquet in Bed,* Paul Gauguin's *Still Life with Three Puppies,* Roger de La Fresnaye's *The Conquest of the Air,* Gaston Lachaise's *Standing Woman,* Fernand Léger's *Three Women,* Henri Matisse's *Piano Lesson* and *The Red Studio,* Claude Monet's *Water Lilies* triptych, Pablo Picasso's *Three Musicians, Night Fishing at Antibes,* and *She-Goat,* Auguste Rodin's *St. John the Baptist Preaching,* Henri Rousseau's *The Sleeping Gypsy,* Yves Tanguy's *Multiplication of the Arcs,* and Thomas Wilfred's *Lumia Suite, Op. 158.*

Useful Household Objects: September 28–October 28, 1938. Photograph by Soichi Sunami. PA. MoMA Archives.

PAGE 51

Evans's book: Peter Galassi, *Walker Evans & Company* (New York: The Museum of Modern Art, 2000): 19–21.

Walker Evans: American Photographs. Afterword by Lincoln Kirstein (New York: The Museum of Modern Art, 1938).

Catalogue: Trois Siècles d'Art aux Etats-Unis. Exposition organisée en collaboration avec le Museum of Modern Art, N.Y. Musée du Jeu de Paume. (Paris: Editions des Musées Nationaux, 1938). ACG, 49. MoMA Archives.

Trois siècles d'art aux Etats-Unis: May 24–July 31, 1938. Archive Photographique d'Art et d'Histoire. PA. MoMA Archives.

PAGE 52

Picasso's Les Demoiselles d'Avignon: ACG, 52. MoMA Archives. Pablo Picasso. *Les Demoiselles d'Avignon.* 1907. Oil on canvas, 8' x 7' 8" (243.9 x 233.7 cm). Acquired through the Lillie P. Bliss Bequest.

Through a somewhat complicated transaction: Goodyear, *The First Ten Years:* 87.

PAGE 53

Demolition of townhouses: PI Event Photos. MoMA Archives.

Model for The Museum of Modern Art: Photograph by Soichi Sunami. PA. MoMA Archives.

Edward D. Stone and Philip L. Goodwin: PA. MoMA Archives. Barr had wanted Ludwig Mies van der Rohe to serve as co-architect of the Museum building. See Rona Roob, "The Museum Selects an Architect: Excerpts from the Barr Papers of The Museum of Modern Art," *Archives of American Art Journal* 23, no. 1 (1983).

PAGE 54

Construction photographs: PI Event Photos. MoMA Archives.

The architects were: Paul Goldberger, "Townhouse to Tower," *ARTnews, The Museum of Modern Art at 50* (October 1979): 180–181.

PAGE 55

View through Penthouse roof: Photograph by Wurts Brothers. PA. MoMA Archives.

Museum facade: PA. MoMA Archives.

Aerial view of Museum: PA. MoMA Archives. Photograph by Andreas Feininger.

PAGE 56

Museum entrance: During the exhibition, *Art in Progress: 15th Annniversary Exhibition.* May 24–October 22, 1944. Photograph: Newspictures. PA. MoMA Archives.

Museum lobby: Photograph by Robert A. Damora. PA. MoMA Archives.

Staircase: Photograph by Robert A. Damora. PA. MoMA Archives.

PAGE 57

Members Penthouse: Photograph by Robert A. Damora. PA. MoMA Archives.

Staff office: Photograph by Robert A. Damora. PA. MoMA Archives.

Auditorium: Photograph by Robert A. Damora. PA. MoMA Archives.

Library: Photograph by Robert A. Damora. PA. MoMA Archives.

PAGE 58

Sculpture Garden: Photograph by Wurts Brothers. PA. MoMA Archives.

John McAndrew: n.d. PA. MoMA Archives.

The first garden: Elizabeth Kassler, "The Sculpture Garden," *MoMA: A Publication for Members of The Museum of Modern Art* (summer 1975): n.p.

PAGE 59

Sculpture Garden: Photographs by Wurts Brothers. PA. MoMA Archives.

PAGE 60

Guests: PA. MoMA Archives.

In the tenth year: A. Conger Goodyear, "Preface" in *Art in Our Time* (New York: The Museum of Modern Art, 1939): 11–12.

PAGE 61

Press release for President: Museum Press Release, April 27, 1939.

The mission of this museum is plain: Monroe Wheeler Papers. MoMA Archives. In addition to President Roosevelt's broadcast from the White House, the radio program included such other speakers as Nelson A. Rockefeller, Lowell Thomas, Edward Bruce, John Hay Whitney, Walt Disney, and Dean Robert Hutchins.

■ **PAGE 62**

Cover of the exhibition catalogue: Alfred H. Barr, Jr., *Art in Our Time* (New York: The Museum of Modern Art, 1939).

"Art in Our Time" is the first exhibition in the Museum's new building: Barr, *Art in Our Time:* 13.

Art in Our Time: 10th Anniversary Exhibition: May 10–September 30, 1939. Photograph by Soichi Sunami. PA. MoMA Archives.

■ **PAGE 63**

Art in Our Time: 10th Anniversary Exhibition: Photograph by Soichi Sunami. PA. MoMA Archives.

Visitors during the exhibition Art in Our Time: PA. MoMA Archives.

Lobster Trap and Fish Tail: Photograph by Soichi Sunami. PA. MoMA Archives. Alexander Calder. *Lobster Trap and Fish Tail.* 1939. Hanging mobile: painted steel wire and sheet aluminum, about 8' 6" h. x 9' 6" diam. (260 x 290 cm). Commissioned by the Advisory Committee for the stairwell of the Museum.

■ **PAGE 64**

Nelson Rockefeller: Monroe Wheeler, "I Remember MOMA," *ARTnews: The Museum of Modern Art at 50* (October 1979): 128.

Nelson A. Rockefeller and Stephen C. Clark: PA. MoMA Archives. Presidents of the Museum have been: A. Conger Goodyear, 1929–39; Nelson A. Rockefeller, 1939–41; John Hay Whitney, 1941–46; Nelson A. Rockefeller, 1946–53; William A. M. Burden, 1953–59; Mrs. John D. Rockefeller 3rd, 1959–62; William A. M. Burden, 1963–65; Mrs. Bliss Parkinson, 1965–67; John Hay Whitney, 1967–69; William S. Paley, 1969–72; Mrs. John D. Rockefeller 3rd, 1972–85; Donald B. Marron, 1985–91; Agnes Gund, 1991–93; 1995–2002; Robert B. Menschel, 2002–present. Chairmen of the Board have been: Stephen C. Clark, 1939–46; John Hay Whitney, 1946–56; Nelson A. Rockefeller, 1956–58; David Rockefeller (pro tem.), 1958–59; Mrs. John D. Rockefeller 3rd, 1959; Dr. Henry Allen Moe, 1959–61; William A. M. Burden, 1961–62; David Rockefeller, 1962–72 ; William S. Paley, 1972–85; Mrs. John D. Rockefeller 3rd, 1985–87; David Rockefeller, 1987–93; Agnes Gund, 1993–95; Ronald S. Lauder, 1995–present.

Stephen Clark: Wheeler, "I Remember MOMA": 127.

Brochure, Books: AAR, 5. MoMA Archives.

Museum publications: P. K. Thomajan, "New York's Museum of Modern Art and Its Books that Set Precedent in Creative Publishing,"

Direct Advertising 46, no. 3 (first quarter, 1961): 25–26.

Monroe Wheeler: Photograph by George Platt Lynes. PA. MoMA Archives.

■ **PAGE 65**

Poster: AAR, 8. MoMA Archives.

Picasso: Forty Years of His Art: November 15, 1939–January 7, 1940. Photographs by Soichi Sunami. PA. MoMA Archives.

■ **PAGE 67**

Diagram, Average Day at the Museum: The Year's Work: Annual Report to the Board of Trustees and Corporation Members of the Museum of Modern Art for the Year June 30, 1939–July 1,1940. Annual reports 1931–40. MoMA Archives.

■ **PAGE 68**

Unpacking works: PA. MoMA Archives.

Visitors to Italian Masters: January 26–April 7, 1940. Photograph by Eliot Elisofon. PA. MoMA Archives.

Botticelli's Birth of Venus: Alfred H. Barr, Jr., "Preface," in *Italian Masters* (New York: The Museum of Modern Art, 1940): 6. Italian officials were eager to send these treasures to the United States for safety during the war in Europe. The exhibition had been turned down by The Metropolitan Museum of Art before it was accepted by The Museum of Modern Art.

■ **PAGE 69**

Bulletin announcing Department of Photography: The Bulletin of The Museum of Modern Art 8, no. 2 (December 1940–January 1941). This was the first department devoted to photography in an art museum.

Living photographs are: Beaumont Newhall, in "The New Department of Photography," *The Bulletin of The Museum of Modern Art* 8, no. 2 (December 1940–January 1941): 4–5.

Margareta Akermark: Photograph by Lida Moser. MoMA Archives.

Eliot Noyes PA. MoMA Archives. This was the first department devoted solely to industrial design in an art museum. In 1948 this department merged with that of architecture to form the Department of Architecture and Design.

■ **PAGE 70**

Telegram to Frances Perkins: November 28, 1939. MSB, box 14. MoMA Archives.

Artists in Exile: Taken at Pierre Matisse Gallery, New York. Photograph by George Platt Lynes. PA. MoMA Archives.

Shortly after the fall of Paris: Margaret Scolari Barr, "Rescuing Artists in W. W. II," typescript,

dated January 7, 1980. MoMA Archives.

■ **PAGE 71**

Marquee sign for Twenty Centuries of Mexican Art: May 15–September 30, 1940. PA. MoMA Archives.

Checking objects for Twenty Centuries of Mexican Art: Photograph by Eliot Elisofon. PA. MoMA Archives.

José Clemente Orozco painted fresco: Photographs by Eliot Elisofon. PA. MoMA Archives. José Clemente Orozco. *Dive Bomber and Tank.* 1940. Fresco, 9 x 18' (275 x 91.4 cm). The Museum of Modern Art, New York. Commissioned through the Abby Aldrich Rockefeller Fund.

■ **PAGE 72**

D. W. Griffith: Iris Barry, *D. W. Griffith: American Film Master* (New York: The Museum of Modern Art, 1965).

As first curator of The Museum of Modern Art Film Library: Richard Griffith, "Foreword," in Barry, *D. W. Griffith:* 6.

Poster: AAR, 8. MoMA Archives.

■ **PAGE 73**

Bulletin pages: The Bulletin of The Museum of Modern Art 9, no. 2 (November 1941): 2–3. Vincent van Gogh. *The Starry Night.* 1889. Oil on canvas, 29 x 36¼" (73.7 x 92.1 cm). Acquired through the Lillie P. Bliss Bequest. *The Starry Night* is purchased by Alfred H. Barr, Jr., from Paul Rosenberg, after the Frick Collection turns it down.

Organic Design in Home Furnishings: September 24–November 9, 1941. PA. MoMA Archives.

Jury members: Photograph by Albert Fenn. PA. MoMA Archives. The exhibition *Organic Design in Home Furnishings,* was based on a competition of the previous year open to North and South American designers, and was won by Charles Eames and Eero Saarinen for their molded plywood chair, which led to later Eames innovations in twentieth-century furniture design.

■ **PAGE 74**

Poster: January 22–April 27, 1941. Reproduced from the collections of the Library of Congress. PA. MoMA Archives.

Totem pole: PA. MoMA Archives.

■ **PAGE 75**

Fred Kabotie with Eleanor Roosevelt: PA. MoMA Archives.

Navaho artists executing sand painting: March 26, 1941. PA. MoMA Archives.

■ **PAGE 76**

Bulletin: "The Museum and the War," *The Bulletin of The Museum of Modern Art* 10, no. 1 (October–November 1942).

During the war years: Waldo Rasmussen, "The Museum of Modern Art: A Half Century," typescript, c. 1978, The Museum of Modern Art, New York: 18. Prepared for translation into Spanish and French for the circulating exhibition *American Art from The Museum of Modern Art.*

Poster: EMH, I.3.0. MoMA Archives.

■ **PAGE 77**

Karl Koehler and Private Victor Ancona: PA. MoMA Archives.

Servicemen's canteen: Photograph by Larry Gordon. PA. MoMA Archives.

Bulletin page: "The Museum Collection." *The Bulletin of the Museum of Modern Art* 10, no. 1 (October–November 1942): n.p.

James Thrall Soby and serviceman: JTS, V.65. MoMA Archives.

■ **PAGE 78**

Publicity photograph for Road to Victory: May 21–October 4, 1942. PA. MoMA Archives.

Catalogue, Americans 1942: Dorothy C. Miller, *Americans 1942: 18 Artists from 9 States* (New York: The Museum of Modern Art, 1942). In the *Americans* exhibitions, each artist was given a single room, making each exhibition like a series of one-person shows.

In 1942 the Inter-American Fund: Photograph by Soichi Sunami. PA. MoMA Archives. At this time, Lincoln Kirstein was appointed a consultant for Latin American art, and with Alfred H. Barr, Jr., and Edgar Kaufmann, Jr., acquired hundreds of works through the Inter-American fund.

■ **PAGE 79**

Oskar Schlemmer's Bauhaus Stairway: Seen in the exhibition *The Museum Collection of Painting and Sculpture,* June 20, 1945–February 13, 1946. PA. MoMA Archives. Oskar Schlemmer. *Bauhaus Stairway.* 1932. Oil on canvas, 63⅞ x 45" (162.3 x 114.3 cm). Gift of Philip Johnson.

March [1933]: Barr, "Our Campaigns": 31–32, 34.

Joe Milone with his Shoeshine Stand: December 22, 1942–January 10, 1943. Photograph by Soichi Sunami. PA. MoMA Archives. This object was brought to Alfred H. Barr, Jr.'s attention by the sculptor Louise Nevelson, and was exhibited during the Christmas season for its festive appearance. Many Trustees were outraged and began to reconsider Mr. Barr's position as director.

■ **PAGE 80**

Space had been allocated: Beaumont Newhall, *Focus: Memoirs of a Life in Photography* (Boston: Bulfinch Press, 1993): 102. This photography center existed for only eight

months, from November 1943 to June 1944.

Photography Center: 9 West Fifty-fourth Street, 2nd floor. PA. MoMA Archives.

What Is Modern Painting?: Alfred H. Barr, Jr., *What Is Modern Painting?* (New York: The Museum of Modern Art, 1943).

This booklet is written for people: Barr, "Preface and Introduction," in his *What Is Modern Painting?*

His brief survey: Barr, "Our Campaigns": 68.

■ **PAGE 81**

Dear Alfred: For some time past: Stephen C. Clark, Letter to Alfred Barr, October 15, 1943. MSB, box 14. MoMA Archives. This letter was mailed to Mr. Barr. For additional information, see Barr, "Our Campaigns."

Letter to Alfred H. Barr, Jr.: November 3, 1943. MSB, box 14. MoMA Archives.

Dear Alfo and Marga: Philip Johnson, Letter to Alfred Barr, 1943. MSB, box 14. MoMA Archives.

■ **PAGE 82**

James Thrall Soby loved the museum: Wheeler, "I Remember MOMA": 130.

James Thrall Soby: JTS, V.62.1. MoMA Archives.

Bulletin pages: The Bulletin of the Museum of Modern Art 12, no. 1 (November 1944): 14–15. Piet Mondrian. *Broadway Boogie Woogie.* 1942–43. Oil on canvas, 50 x 50" (127 x 127 cm). Given anonymously.

■ **PAGE 83**

The Museum's Purpose: Alfred H. Barr, Jr. "The Museum Collections: A Brief Report," January 15, 1944. AHB, 9a.27. MoMA Archives.

James Johnson Sweeney: PA. MoMA Archives.

■ **PAGE 84**

René d'Harnoncourt installing: January 29–May 19, 1946. PA. MoMA Archives. In 1944 Mr. d'Harnoncourt joined the staff as Vice President for Foreign Activities and Director of the Department of Manual Industry.

■ **PAGE 85**

Hand-drawn floor plan: RDH, IX.A.31. MoMA Archives.

Hand-drawn installation plan: RDH, IX.A.6. MoMA Archives.

Arts of the South Seas: RDH, IX.A.40. MoMA Archives.

■ **PAGE 86**

John Hay Whitney: n.d. PA. MoMA Archives.

Nelson A. Rockefeller: Detail of photograph for the International Furniture Competition, sponsored by The Museum of Modern Art and Museum Design Project, Inc., January 18, 1949. Photograph by Homer Page. PA. MoMA Archives.

Picasso: Fifty Years of His Art: Alfred H. Barr, Jr., *Picasso: Fifty Years of His Art* (New York: The Museum of Modern Art, 1946). Mr. Barr received his Ph.D. from Harvard University upon completion of this book.

Inscription and drawing: Dated September 5, 1952. AHB, 12.Add.1. MoMA Archives.

■ **PAGE 87**

Brochure, Modern Art 5,000 Years Ago: R&P, 1940s. MoMA Archives.

Expansion committee: Photograph by Tampone. PA. MoMA Archives.

■ **PAGE 88**

René d'Harnoncourt: n.d. Photograph by Paul Berg. PA. MoMA Archives.

I think René: Nelson A. Rockefeller, quoted in Geoffrey T. Hellman, "Profiles: Imperturbable Noble," *The New Yorker* (May 1, 1960): 52.

René . . . loved and recognized genius: Philip Johnson, in *Alfred H. Barr, Jr.: A Memorial Tribute.*

Alfred H. Barr, Jr., Dorothy C. Miller: n.d. PA. MoMA Archives.

■ **PAGE 89**

Nelson A. Rockefeller, President of the Museum: Museum Press Release, December 1945.

Edward Steichen: n. d. Photograph by Homer Page. PA. MoMA Archives. Beaumont Newhall soon left his post as Curator of Photography. For additional information, see Newhall, *Focus: Memoirs of a Life in Photography.*

Bernard Karpel: PA. MoMA Archives.

■ **PAGE 90**

Press release on Inter-Museum Agreement: September 15, 1947. R&P, 1940s. MoMA Archives.

■ **PAGE 91**

Philip Johnson and Ludwig Mies van der Rohe: PA. MoMA Archives.

Mies van der Rohe: September 16, 1947–January 25, 1948. PA. MoMA Archives.

■ **PAGE 92**

Memo on death of Mrs. John D. Rockefeller, Jr.: April 28, 1948. William S. Lieberman Papers, III.13.46. MoMA Archives.

Dear Nelson: Alfred H. Barr, Jr., Letter to Nelson A. Rockefeller, April 17, 1948. AHB, 10.A.64.a. MoMA Archives.

■ **PAGE 93**

Master Prints from the Museum Collection: May 10–July 10, 1949. Photograph by Soichi Sunami. PA. MoMA Archives.

René d'Harnoncourt: PI, II.C.85. MoMA Archives. The Directors of the Museum have been: Alfred H. Barr, Jr., 1929–43; Executive Committee, 1943–49; René d'Harnoncourt, 1949–68; Bates Lowry, 1968–69; Operating Committee, 1969–70; John B. Hightower, 1970–72; Richard E. Oldenburg, 1972–94; Glenn D. Lowry, 1995–present.

René had inexhaustible patience: Arthur Drexler, from a tribute delivered at the René d'Harnoncourt Memorial Service, October 8, 1968, Museum Garden, as reprinted in *The Museum of Modern Art Biennial Report 1967–69* (New York: The Museum of Modern Art, 1969): 5.

■ **PAGE 94**

Construction of the Marcel Breuer house: Photograph by Soichi Sunami. PA. MoMA Archives.

The House in the Museum Garden (Marcel Breuer): April 12–October 30, 1949. Photograph by Ezra Stoller © Esto. PA. MoMA Archives.

Andrew Carnduff Ritchie: May 1954. Photograph courtesy Worcester Art Museum, Worcester, Massachusetts. PA. MoMA Archives.

■ **PAGE 95**

Minutes of Junior Council: February 8, 1949. Junior Council Records. MoMA Archives. In 1981 The Junior Council changed its name to The Associate Council, and in 1986 to The Contemporary Arts Council.

The Junior Council was formed: Oral History Project, Interview with Barbara Jakobson, 1997: 16–19. MoMA Archives.

Art Lending Service: 1950–60. PA. MoMA Archives.

■ **PAGE 96**

Good Design: November 27, 1951–January 27, 1952. Photograph by Soichi Sunami. PA. MoMA Archives.

Good Design: November 21, 1950–January 28, 1951. Photograph by Soichi Sunami. PA. MoMA Archives.

Edgar Kaufmann, Jr.: PA. MoMA Archives.

■ **PAGE 97**

Trustees of the Grace Rainey Rogers Trust Fund: n.d. Photograph by Leo Trachtenberg. PA. MoMA Archives.

Although the Museum: Peter Reed, "The Space and the Frame: Philip Johnson as the Museum's Architect," in *Philip Johnson and The Museum of Modern Art*, Studies in Modern Art 6 (New York: The Museum of Modern Art, 1998): 76.

Grace Rainey Rogers Annex: Photograph by Alexandre Georges. PA. MoMA Archives.

■ **PAGE 98**

Cover of Matisse: His Art and His Public: AHB, 11.V.1.a. MoMA Archives. Alfred H. Barr, Jr., *Matisse: His Art and His Public* (New York: The Museum of Modern Art, 1951).

Matisse: His Art and His Public, the recently published: René Gaffé, in "Book Reviews," *Magazine of Art* (May 1952): 236.

Eight Automobiles: August 28–November 11, 1951. PA. MoMA Archives.

Arthur Drexler: PI, II.C.68. MoMA Archives.

Automobiles are hollow: Arthur Drexler, *8 Automobiles* (New York: The Museum of Modern Art, 1951): n.p.

■ **PAGE 99**

Photocopy of letter to Dorothy C. Miller: DCM, I.6.b. MoMA Archives. The letter reads: "Dear Dorothy, I want you to know what a wonderful job I think you did in hanging my room at the Museum. There was probably extra work for you (or was there?) in my staying away. At any rate I think it was wise of me. I wish I could give No. 7 a coat of glue sizing—it would take some of the wrinkles out of it. Perhaps when I'm in next time I can do it after Museum hours. It wouldn't take more than ten minutes. The invitation for you and Eddy still stands, we would love to have you—give us a call when you are free to come. Sincerely Jackson."

Dorothy C. Miller handwritten notes: DCM, I.6.b. MoMA Archives.

15 Americans: April 9–July 27, 1952. Photographs by Soichi Sunami. PA. MoMA Archives.

■ **PAGE 100**

Porter McCray: Source Photograph Lufthansa Photo. PA. MoMA Archives.

International Program map: Photograph by Soichi Sunami. PA. MoMA Archives. Founded with a grant from the Rockefeller Brothers Fund, the International Program was designed to foster understanding of modern art internationally through exchange exhibitions.

René d'Harnoncourt with crates: PA. MoMA Archives.

U.S. Pavilion at the Venice Biennale: ICE-F-23-54: box 20.5. MoMA Archives.

■ **PAGE 101**

There were very few: Elizabeth Bliss Parkinson Cobb, in *The International Council of The Museum of Modern Art:*

The First Forty Years (New York: The Museum of Modern Art, 1993): 19.

Mrs. Rockefeller and Mrs. Parkinson: International Council Records, records management box 2793. MoMA Archives.

Ambassador and Mrs. John Kenneth Galbraith: PA. MoMA Archives.

The trustees of the Museum: Mrs. John D. Rockefeller 3rd, "Draft of Letter for Prospective Members of International Council of Museum of Modern Art," July 31, 1953. EMH, I.20. MoMA Archives. The International Council formed as an organization of art patrons and community leaders from 18 states and 6 foreign countries, devoted to promoting international good will through exchange in the arts. The Council sponsors the Museum's activities abroad. The Presidents of The International Council have been: Mrs. John D. Rockefeller 3rd, 1953–57; Elizabeth Bliss Parkinson, 1957–66; Mrs. Donald B. Straus, 1966–71; Joanne M. Stern, 1971–86; Mrs. Gifford Phillips, 1986–91; Jeanne C. Thayer, 1991–93; Jo Carole Lauder, 1993–present. The Chairmen have been: Mrs. John D. Rockefeller 3rd, 1953–57; August Heckscher, 1957–63; Walter Dowling, 1963–69; Alfredo Boulton, 1970–74; August Heckscher, 1974–76; H.R.H. Prinz Franz von Bayern, 1976–89; Brian Urquhart, 1989–2002; Agnes Gund, 2002–present.

■ **PAGE 102**

The Abby Aldrich Rockefeller Sculpture Garden: Fall 1953. Photograph by Soichi Sunami. PA. MoMA Archives.

Philip Johnson. The Abby Aldrich Rockefeller Sculpture Garden: Plan. 1950–53. Architecture and Design Study Center, The Museum of Modern Art, New York.

■ **PAGE 103**

The Abby Aldrich Rockefeller Sculpture Garden: Photograph by Soichi Sunami. PA. MoMA Archives.

The Abby Aldrich Rockefeller Sculpture Garden: Photograph by Alexandre Georges. PA. MoMA Archives.

When the Trustees: Kassler, "The Sculpture Garden": n.p. The Abby Aldrich Rockefeller Sculpture Garden (begun in 1951) was 100 x 175 feet. Philip Johnson's design, in collaboration with landscape architect James Fanning, features pools and bridges, gray marble slab pavement, weeping birches, and other plantings.

■ **PAGE 105**

Whitney Museum of American Art: Summer 1954. Photograph by Ezra Stoller © Esto. PA. MoMA Archives.

Garden Restaurant: Photograph by Ezra Stoller © Esto. PA. MoMA Archives.

■ **PAGE 106**

Poster: Leo Lionni. The World of Modern Art: Twenty-fifth Anniversary, The Museum of Modern Art. Poster, 21 x 11", The Museum of Modern Art, New York. Gift of the Publications Department.

The public response: René d'Harnoncourt, in *Twenty-Fifth Anniversary Year: Final Report* (New York: The Museum of Modern Art, 1956): 19.

Opening ceremony: PA. MoMA Archives.

■ **PAGE 107**

XXVth Anniversary Exhibitions: October 19, 1954–February 6, 1955. Photographs by Soichi Sunami. PA. MoMA Archives.

■ **PAGE 108**

Masters of Modern Art: Alfred H. Barr, Jr., ed., *Masters of Modern Art* (New York: The Museum of Modern Art, 1954).

In the autumn of 1929: Barr, "Introduction," *Masters of Modern Art:* 9–10.

Committee on Museum Collections: Photograph by Dan Budnik. PI, II.C.214. MoMA Archives.

■ **PAGE 109**

Japanese Exhibition House: June 16–October 21, 1954 and April 26–October 16, 1955. Photograph by Ezra Stoller © Esto. PA. MoMA Archives.

Visit of Prime Minister: PA. MoMA Archives.

Japanese Exhibition House, interior: Photograph by Ezra Stoller © Esto. PA. MoMA Archives.

The Museum's Japanese Exhibition House: Arthur Drexler, *The Architecture of Japan* (New York: The Museum of Modern Art, 1954): 262.

■ **PAGE 110**

Party around Monument to Balzac: PI Event Photos. MoMA Archives. Auguste Rodin. *Monument to Balzac.* 1897–98 (cast 1954). Bronze, 9' 3" x 48½" x 41" (282 x 122.5 x 104.2 cm). The Museum of Modern Art, New York. Presented in memory of Curt Valentin by his friends.

Catalogue, The Family of Man: Edward Steichen, *The Family of Man* (New York: The Museum of Modern Art, 1955).

The Family of Man: January 24–May 8, 1955. Photograph by Rolf Petersen. PA. MoMA Archives.

■ **PAGE 111**

Arthur Drexler: PA. MoMA Archives.

Textiles U.S.A: August 29–November 4, 1956. Photographs by George Barrows. PA. MoMA Archives. This exhibition was selected by Greta Daniel, Curator of Design, and the installation designed by Bernard Rudofsky.

■ **PAGE 112**

Pablo Picasso and Alfred H. Barr, Jr.: Photograph by James Thrall Soby. AHB, 12.II.M. MoMA Archives.

At Picasso's home: Photograph by James Thrall Soby. AHB, 12.II.M. MoMA Archives.

Picasso: 75th Anniversary: May 4–September 8, 1957. Photograph by Soichi Sunami. PA. MoMA Archives.

■ **PAGE 113**

Audrey Hepburn at Picasso: 75th Anniversary: May 4–September 8, 1957. AHB. MoMA Archives.

Silkscreened silk tie: AHB, 12.XIII. MoMA Archives.

Alfred H. Barr, Jr.: PA. MoMA Archives.

■ **PAGE 114**

Newspaper photograph of firemen: Digital image courtesy AP/Wide World Photos.

Just before one p.m.: Wheeler, "I Remember MOMA": 131–132.

Cartoon: © The New Yorker Collection 1958 Alan Dunn. Digital image from cartoonbank.com. All rights reserved.

■ **PAGE 115**

William C. Seitz and Peter H. Selz: n.d. PI Event Photos. MoMA Archives.

Rockefeller Guest House: Photographs by Robert A. Damora. PA. MoMA Archives. The house was used by the Museum for entertaining, and was sold in 1964.

■ **PAGE 116**

Parade of Abstraction: Reproduced from *Time* magazine. August 4, 1958. © 1958 TIME Inc. Reprinted by permission. Thomas B. Hess, Willem de Kooning Papers. MoMA Archives. The installation shown is in Milan.

Working its way through Europe: Time (August 4, 1958): 40.

The [International] Council was barely five: The International Council of The Museum of Modern Art: The First Forty Years: 23–24.

The New American Painting: May 28–September 8, 1959. Photograph by Soichi Sunami. PA. MoMA Archives.

■ **PAGE 117**

Installing Claude Monet's Water Lilies: Photograph by Rollie McKenna. PA. MoMA Archives. Claude Monet. *Water Lilies* c. 1920. Oil on canvas: triptych, each section 6' 6" x 14' (200 x 425 cm). Mrs. Simon Guggenheim Fund.

Two works by Monet, a large mural and a small painting, both *Water Lilies*, had been destroyed in the 1958 fire.

Mrs. John D. Rockefeller 3rd and William A. M. Burden: At the 30th Anniversary Dinner, October 2, 1962. PA. MoMA Archives.

■ **PAGES 118–119**

Sixteen Americans: December 16, 1959–February 17, 1960. Photographs by Soichi Sunami. PA. MoMA Archives.

■ **PAGE 120**

Catalogue for Joan Miró: James Thrall Soby, *Joan Miró* (New York: The Museum of Modern Art, 1959).

Joan Miró and James Thrall Soby: PI, II.C.201. MoMA Archives.

Joan Miró: March 19–May 10, 1959. Photograph by George Barrows. PA. MoMA Archives.

There is a decided quality: Soby, *Joan Miró:* 7.

Buckminster Fuller is a philosopher: Arthur Drexler, Exhibition brochure, 1959.

Three Structures by Buckminster Fuller: September 22, 1959–winter 1960. Photograph by Alexandre Georges. PA. MoMA Archives.

■ **PAGE 121**

Conservation Laboratory: September 1960. Photograph by George Barrows. PA. MoMA Archives.

On a dank evening: William C. Seitz, *The Art of Assemblage* (New York: The Museum of Modern Art, 1961): 89.

Homage to New York: March 17, 1960. Photograph by David Gahr. Courtesy David Gahr. PA. MoMA Archives.

Homage to New York: Drawing printed on the brochure, *Homage to New York*, 1960. William C. Seitz Papers, Art of Assemblage, 6. MoMA Archives.

■ **PAGE 122**

Performance at Jazz in the Garden: Photographs by George Barrows. PA. MoMA Archives.

Monroe Wheeler: PA. MoMA Archives.

Museum Publications Retrospective Exhibition. October 5–November 27, 1960. Photograph by George Barrows. PA. MoMA Archives.

■ **PAGE 123**

The Art of Assemblage: October 4–November 12, 1961. Photographs by Soichi Sunami. PA. MoMA Archives.

Assemblage is a new medium: William C. Seitz, *The Art of Assemblage* (New York: The Museum of Modern Art, 1961): 87.

Waldo Rasmussen: n.d. Photograph by Jonathan Wright. PI, II.C.169. MoMA Archives. Mr. Rasmussen retired as Director of the International Program in 1993.

■ **PAGE 124**

My concern is not: John Szarkowski, Typescript for a speech given in Philadelphia, December 1962. PI, II.C.208. MoMA Archives.

Edward Steichen and John Szarkowski: n.d. Photograph by Paul Huf.

John Hay Whitney and David Rockefeller: At René d'Harnoncourt's birthday party, 1961. PI, II.C.231. MoMA Archives.

■ **PAGE 125**

Henri Matisse's Dance: Henri Cartier-Bresson, *The Museum of Modern Art, New York.* 1964. Gelatin silver print, 15¼ x 10¼" (38.7 x 26 cm). The Museum of Modern Art, New York. Gift of the photographer. Henri Matisse. *Dance (First Version).* Paris (March 1909). Oil on canvas, 8' 6½" x 12' 9½" (259.7 x 390.1 cm). Gift of Nelson Rockefeller in honor of Alfred H. Barr, Jr.

Letter to Dorothy C. Miller: June 15, 1963. DCM, I.20.d. MoMA Archives.

Americans 1963: May 22–August 18, 1963. Photograph by Soichi Sunami. PA. MoMA Archives.

■ **PAGE 126**

Jacqueline Kennedy and Indira Gandhi: SP-ICE-28-61: box 174.9. MoMA Archives.

Museum press release: Museum Press Release, February 23, 1962.

Victor d'Amico with the Children's Art Carnival in India: SP-ICE-28-61: box 174.9. MoMA Archives. In 1948 the War Veterans Center became the People's Art Center, offering courses for children and adults, and moved to 21 West 53 Street in 1951, then to the Garden Wing in 1964. In 1960 it was incorporated as the Institute of Modern Art; Summer Art Classes were held in rented space in Amagansett and Southampton, and after 1961, in the Kearsarge Art Center (Barge) of the Institute of Modern Art, in Napeague Harbor, Long Island, New York. Victor D'Amico retired in 1969.

Children's Art Carnival in Harlem: Photograph by Bill Anderson. PI Event Photos, 28. MoMA Archives.

Victor D'Amico, Director of the Department: Museum Press Release, no. 107, October 13, 1963.

■ **PAGE 127**

John Szarkowski: André Kertész. *John Szarkowski.* 1963. Courtesy Estate of André Kertész.

The Photographer's Eye: John Szarkowski, *The Photographer's Eye* (New York: The Museum of Modern Art, 1966).

This book is an investigation: Szarkowski, *The Photographer's Eye:* 6–13.

Reopening of the Museum: Photograph by Erich Hartmann, Magnum Photos, Inc. Courtesy Erich Hartmann, Magnum Photos. PA. MoMA Archives.

■ **PAGE 128**

The East Wing facade: Reed, "The Space and the Frame: Philip Johnson as the Museum's Architect": 89.

Expanded facade: Photograph by Alexandre Georges. PA. MoMA Archives.

Aerial view of Garden Wing: Photograph by Alexandre Georges. PA. MoMA Archives.

Except for certain changes in the planting: Kassler, "The Sculpture Garden": n.p.

■ **PAGE 129**

Philip L. Goodwin Architecture and Design Galleries: Photograph by George Cserna. R&P, 1960s. MoMA Archives.

The Paul J. Sachs Galleries of Drawings and Prints: Photograph by Alexandre Georges. PA. MoMA Archives.

Edward Steichen Photography Study Center: R&P, 1960s. MoMA Archives.

■ **PAGE 131**

Abby Aldrich Rockefeller Print Study Room: Photograph by George Cserna. R&P, 1960s. MoMA Archives.

Eliza Bliss Parkinson Cobb: n.d. Photograph by George Cserna. PA. MoMA Archives.

■ **PAGE 132**

LOVE: Greeting card, printed in color. Junior Council Records, records management box 3905. MoMA Archives.

We [The Junior Council] had committees: Oral History Project, Interview with Barbara Jakobson, 1997: 19. MoMA Archives.

The Responsive Eye: Museum Press Release, no. 14, Tuesday, February 23, 1965.

The Responsive Eye: February 25–April 25, 1965. Photograph by George Cserna. PA. MoMA Archives.

■ **PAGE 133**

To render what the eye: Peter Selz, "Introductory Note," in *Alberto Giacometti* (New York: The Museum of Modern Art, 1965): 8.

Alberto Giacometti: June 9–October 10, 1965. Photograph by Alexandre Georges. PA. MoMA Archives.

Alicia Legg: Photograph by James Mathews. PA. MoMA Archives.

■ **PAGE 134**

Robert Motherwell: October 1–November 28, 1965. Photograph by Rolf Peterson. PA. MoMA Archives.

Robert Motherwell, Frank O'Hara: n.d. PA. MoMA Archives. Frank O'Hara, poet, art critic, and curator, worked at the Museum in 1951–53 and 1955–66. He organized exhibitions for the Department of Circulating Exhibtions and the Department of Painting and Sculpture. He died tragically in an accident on Fire Island on July 25, 1966.

■ **PAGE 135**

The Architecture of Louis I. Kahn: April 26–May 30, 1966. Photograph by George Cserna. PA. MoMA Archives.

Kahn's effort: Arthur Drexler, quoted in Museum Press Release, no. 34, Monday, March 28, 1966.

Willard van Dyke: n.d. Photograph by Martin Harris. PA. MoMA Archives.

William S. Lieberman: 1962. Photograph by Alexander Liberman. Reproduced by permission of the Research Library, The Getty Research Institute, Los Angeles. Alexander Liberman, "Photograph Collection & Archive" (2000. R.19).

■ **PAGE 136**

Alexander Calder wrote a letter: Barr, "Chronicle of the Collection of Painting and Sculpture": 645.

Handwritten notes: December 23, 1966. DCM, I.23.a. MoMA Archives.

Calder, 19 Gifts from the Artist: February 1–September 5, 1967. Photograph by Rolf Peterson. PA. MoMA Archives.

■ **PAGE 137**

Alfred H. Barr, Jr.: n.d. Photograph by Rollie McKenna. PA. MoMA Archives.

Letter to Alfred H. Barr, Jr.: AHB, I.382. MoMA Archives.

Dear Marga and Alfred: Elodie Courter, Letter to Alfred and Marga Barr, June 30, 1967. AHB, I.382. MoMA Archives.

■ **PAGE 138**

Monroe Wheeler: Photograph by Dan Budnik. PI, II.C.225. MoMA Archives.

Monroe Wheeler contributed: David Rockefeller, Remarks at Memorial Service for Monroe Wheeler,

November 3, 1988, typescript, Archives Pamphlet File: Wheeler.

In the past decade: John Szarkowski, in Brochure for *New Documents: Diane Arbus, Lee Friedlander, Garry Winogrand,* 1967.

New Documents: PI Event Photos. MoMA Archives.

■ **PAGE 139**

Sketch of Picasso installation: RDH, IX.A.114. MoMA Archives.

The Sculpture of Picasso: October 11, 1967–January 1, 1968. Photograph by George Cserna. PA. MoMA Archives.

René d'Harnoncourt installing: PA. MoMA Archives.

■ **PAGE 140**

Exhibition brochure: Brochure for *The Sidney and Harriet Janis Collection,* 1967.

Formal announcement: Barr, "Chronicle of the Collection of Painting and Sculpture": 647–648.

Jackson Pollock's One (Number 31, 1950): Photograph by James Mathews. PA. MoMA Archives. Jackson Pollock. *One (Number 31, 1950).* 1950. Oil and enamel on unprimed canvas, 8' 10" x 17' 5⅝" (269.5 x 530.8 cm). Sidney and Harriet Janis Collection Fund (by exchange). The first painting by Jackson Pollock to be acquired by a museum was *The She-Wolf,* 1943, which was purchased by The Museum of Modern Art soon after it was painted, in 1944.

Cartoon: © The New Yorker Collection 1967 Dana Fradon. Digital image from cartoonbank.com. All rights reserved.

■ **PAGE 141**

René d'Harnoncourt: Director of the Museum installing *The Sculpture of Picasso,* 1967. PA. MoMA Archives.

These nineteen years as Director: René d'Harnoncourt, June 13, 1968. Trustee Minutes. MoMA Archives.

René d'Harnoncourt was not a scholar: William S. Lieberman, in *René d'Harnoncourt: A Tribute,* October 8, 1968 (New York: The Museum of Modern Art, 1968): n.p. Several weeks after his retirement, Mr. d'Harnoncourt died tragically when struck by an automobile on Long Island, August 13, 1968.

■ **PAGE 142**

Bates Lowry: n.d. Photograph by Dan Budnik. PA. MoMA Archives.

The Center makes available: Museum Press Release, October 1968. The north wing of the Museum (formerly the Whitney Museum of American Art) is dedicated as The Lillie P. Bliss International Study Center. It was conceived as a

world center for advanced research in art, museology, and the Museum collection, incorporating scholar exchanges, sabbaticals, and an internship program. It also functioned as an umbrella for Museum libraries and study collections, and provided additional space for conservation and storage.

Lillie P. Bliss International Study Center: PI, II.B.631. MoMA Archives.

■ **PAGE 143**

William S. Paley: In the foyer of his home at 820 Fifth Avenue, in front of Pablo Picasso's *Boy Leading a Horse.* n.d.

Ludwig Glaeser: Detail of photograph taken at the opening of *Architecture of Museums.* Photograph by James Tormey. PI Event Photos, 54. MoMA Archives.

Mies van der Rohe, Furniture Sketch: From Ludwig Glaeser, *Ludwig Mies van der Rohe: Furniture and Furniture Drawings from the Design Collection and the Mies van der Rohe Archive,* (New York, The Museum of Modern Art, 1977): 74.

The Mies van der Rohe Archive: Arthur Drexler, "Introduction," *The Mies van der Rohe Archive, Volume One* (New York and London: Garland Publishing, 1986): xi.

■ **PAGE 144**

Dada, Surrealism, and Their Heritage: March 22–May 12, 1968. Photographs by James Mathews. PA. MoMA Archives.

Invitation to Dada, Surrealism, and Their Heritage: Archives Pamphlet File.

Dada, Surrealism, and Their Heritage: Museum Press Release, no. 26, Wednesday, March 27, 1968.

■ **PAGE 145**

The Machine as Seen at the End of the Mechanical Age: November 27, 1968–February 9, 1969. Photograph by James Mathews. PA. MoMA Archives.

Technology today: K. G. Pontus Hultén, Museum Press Release, no. 123, 1968.

Cover of The Machine as Seen at the End of the Mechanical Age: K. G. Pontus Hultén, *The Machine as Seen at the End of the Mechanical Age* (New York: The Museum of Modern Art, 1968).

■ **PAGE 146**

Word and Image: January 25–March 10, 1968. Photograph by George Cserna. PA. MoMA Archives.

Bates Lowry: The Museum of Modern Art New York Biennial Report 1967–69 (New York: The Museum of Modern Art, 1969): 7.

Wilder Green: Photograph by

Marvin P. Lazarus. PI Event Photos. MoMA Archives.

Richard Koch: Photograph by Marvin P. Lazarus. PI Event Photos. MoMA Archives.

Walter Bareiss: Photograph by James Mathews. PI, II.C.8. MoMA Archives.

■ **PAGE 147**

Riva Castleman: Photograph by Daniel Haar. PA. MoMA Archives.

Dorothy C. Miller: n.d. Photograph by Marvin P. Lazarus. PI, II.C.144. MoMA Archives.

Miss Miller's friend and colleague: Robert Rosenblum, "An Appreciation," in *Dorothy C. Miller: With an Eye to American Art* (Northampton, Mass.: Smith College Museum of Art, 1985): n.p.

■ **PAGE 148**

Yayoi Kusama's Grand Orgy to Awaken the Dead at MoMA: © New York Daily News, L.P. reprinted with permission. Archives Pamphlet File: Sculpture Garden.

John B. Hightower and William S. Paley: October 31, 1971. Photograph by Leonardo Le Grand. PI Event Photos, 77. MoMA Archives.

■ **PAGE 149**

Information: July 2–September 20, 1970. Photographs by James Mathews. PA. MoMA Archives.

Rafael Ferrer's MoMA Ice Piece: Photograph by Manny Greenhaus. PI Event Photos, 66. MoMA Archives.

Information is primarily concerned: Kynaston McShine, Memo to Arthur Drexler, February 5, 1970. Registrar Exhibition Files, Exh. #934. MoMA Archives.

■ **PAGE 150**

Frank Stella: Paintings: March 24–June 2, 1970. Photograph by James Mathews. PA. MoMA Archives.

William S. Rubin and Frank Stella: PI, II.C.180. MoMA Archives. Curators frequently use wheelchairs while installing large exhibitions.

■ **PAGE 151**

A Treasury of Modern Drawing: William S. Lieberman, *A Treasury of Modern Drawing: The Joan and Lester Avnet Collection* (New York: The Museum of Modern Art, 1978).

The Joan and Lester Avnet Collection of drawings: Lieberman, *A Treasury of Modern Drawing:* 7, 34.

William S. Lieberman: n.d. Photograph by Pach Brothers. PA. MoMA Archives.

The Artist as Adversary . . . selected by Betsy Jones: Museum Press Release, no. 69, July 1, 1971.

Artist as Adversary: July 1–September 27, 1971. Photograph by James Mathews. PA. MoMA Archives.

■ **PAGE 152**

Pablo Picasso and William S. Rubin: Photograph by Jacqueline Picasso. PI, II.C.180. MoMA Archives. Pablo Picasso. *Guitar.* 1912–13. Sheet metal and wire, 30½ x 13⅛ x 7⅝" (77.5 x 35 x 19.3 cm). Gift of the artist.

Projects: Sam Gilliam: November 9–December 8, 1971. Photograph by James Mathews. PA. MoMA Archives. This exhibition was directed by Kynaston McShine, originator of the series of small exhibitions presented to inform the public about current researches and explorations in the visual arts. The first exhibition in the series was *Projects: Keith Sonnier* in June 1971. For that exhibition, the artist converted two ground-floor galleries into a unified sound and light environment.

Projects: Nancy Graves: December 15, 1971–January 24, 1972. Photograph by James Mathews. PA. MoMA Archives.

In May 1971, The Museum of Modern Art initiated PROJECTS: Museum Press Release, no. 77, August 1978.

■ **PAGE 153**

Frei Otto: June 3–September 30, 1971. Photograph by Ezra Stoller © Esto. PA. MoMA Archives.

Invitation: Special Programming and Events Records, Invitations, 1969–71. MoMA Archives.

Dancers, Summergarden: Photograph by Daniel Haar. PA. MoMA Archives.

■ **PAGE 154**

Richard E. Oldenburg: Photograph by Jonathan Wenk. PA. MoMA Archives.

Visitor at A Classic Car: December 8, 1972–January 29, 1973. Photograph by Leonardo Le Grand. PA. MoMA Archives.

PAGE 155

The emergence of Italy: Emilio Ambasz, "Introduction," *Italy: The New Domestic Landscape* (New York: The Museum of Modern Art, 1972): 19–21.

Italy: The New Domestic Landscape: May 26–September 11, 1972. Department of Architecture and Design Exhibition Files, Exh. #1004. MoMA Archives.

Emilio Ambasz: Photograph by Studio Photomabon, Callao. PA. MoMA Archives.

Italy: The New Domestic Landscape: Department of Architecture and Design Exhibition Files, Exh. #1004. MoMA Archives.

■ **PAGE 157**

Alfred H. Barr, Jr., honored by trustees: March 12, 1973. *Vogue* (1973). Photograph by Harry Benson. Courtesy Harry Benson. PA. MoMA Archives. Mr. Barr passed away on August 15, 1981.

William S. Rubin: PA. MoMA Archives.

■ **PAGE 158**

Staff strike, 1973: PASTA and Protests. MoMA Archives. This was the second of three strikes by the professional and administrative staff association. The first took place in 1971, and the third in 2000.

A seven-week strike against the Museum: Robert Hanley, "Modern Museum's Staff Ends Walkout," *The New York Times* (November 30, 1973): 30.

Looking at Photographs: John Szarkowski, *Looking at Photographs: 100 Pictures from the Collection of The Museum of Modern Art* (New York: The Museum of Modern Art, 1978). PA. MoMA Archives.

■ **PAGE 159**

New Directors/New Films: Museum Press Release, March 1973.

Advertisement and ticket order form: PI, II.B.1037. MoMA Archives.

■ **PAGE 160**

Marcel Duchamp: December 28, 1973–February 24, 1974. Photograph by Kate Keller. PA. MoMA Archives.

Catalogue, Marcel Duchamp: Anne d'Harnoncourt and Kynaston McShine, eds., *Marcel Duchamp* (New York and Philadelphia: The Museum of Modern Art and Philadelphia Museum of Art, 1973).

■ **PAGE 161**

The Architecture of the École des Beaux Arts: October 29, 1975–January 4, 1976. Photograph by Kate Keller. PA. MoMA Archives.

Copy of newspaper clipping: October 26, 1975. © The New York Times Magazine. PI, II.A.686. MoMA Archives.

■ **PAGE 162**

In the fall of 1975: Richard E. Oldenburg, "Report of the Director," *The Museum of Modern Art New York Biennial Report 1974–76* (New York: The Museum of Modern Art, 1976): 9.

Copy of newspaper clipping: September 17, 1976. ©The New York Times. Director's Office Records, records management box 1772. MoMA Archives.

Riva Castleman: Photograph by Anthony Edgeworth. PA. MoMA Archives.

■ **PAGE 163**

Drawing Now: 1955–1975: January 21–March 9, 1976. Photograph by Kate Keller. PA. MoMA Archives.

During the past twenty years: Bernice Rose, *Drawing Now* (New York: The Museum of Modern Art, 1976): 9.

The "Wild Beasts": John Elderfield, *The "Wild Beasts:" Fauvism and Its Affinities* (New York: The Museum of Modern Art, 1976).

■ **PAGE 164**

William Eggleston's Guide: John Szarkowski, *William Eggleston's Guide* (New York: The Museum of Modern Art, 1976).

These pictures are fascinating: Szarkowski, *William Eggleston's Guide:* 5–6, 13–14.

Taxicabs have already: Emilio Ambasz, "The Role of Taxis in Urban Transportation," in Emilio Ambasz, ed., *The Taxi Project: Realistic Solutions for Today* (New York: The Museum of Modern Art, 1976): 107–108.

The Taxi Project: Realistic Solutions for Today: June 16–September 7, 1976. Photograph by George Cserna. PA. MoMA Archives.

■ **PAGE 165**

Robert Rauschenberg: March 25–May 17, 1977. PA. MoMA Archives.

■ **PAGE 166**

Impresario: Ambroise Vollard: Brochure for *Impresario: Ambroise Vollard* (New York: The Museum of Modern Art, 1977).

Ambroise Vollard was an extraordinary merchant: Riva Castleman, in Brochure for *Impresario Ambroise Vollard.*

Cézanne: The Late Work: October 7, 1977–January 3, 1978. Photograph by Kate Keller. PA. MoMA Archives.

■ **PAGE 167**

Everything was done just as it should be: Oral History Project, Interview with Sol LeWitt, 1994: 26–27. MoMA Archives. LeWitt worked at the Museum in various capacities during the 1960s.

Sol LeWitt: February 3–April 4, 1978. Photographs by Kate Keller. PA. MoMA Archives.

■ **PAGE 168**

Video Viewpoints: Archives Pamphlet File: Video Viewpoints.

Memo to the staff: July 31, 1978. Department of Education Records, III.4. MoMA Archives.

Children's panel: n.d. Photograph by Ben Blackwell. © Ben Blackwell. PI Event Photos. MoMA Archives.

■ **PAGE 169**

William S. Paley: Photograph by Daniel Haar. PA. MoMA Archives.

Detail of a Museum press release: Museum Press Release, 1979.

Letter from the White House: MoMA Library.

■ **PAGE 170**

Nelson A. Rockefeller Bequest: Photograph by James Mathews. PA. MoMA Archives.

James Thrall Soby Bequest: March 22–April 20, 1979. Photograph by Kate Keller. PA. MoMA Archives.

■ **PAGE 171**

Magazine clipping: Illustration by Randall Enos. Courtesy *New York Magazine.* PI, II.A.811. MoMA Archives.

Oscar for the Department of Film: Photograph by Long Photography. © Academy of Motion Picture Arts and Sciences. PA. MoMA Archives.

■ **PAGE 172**

Transformations in Modern Architecture: February 21–April 24, 1979. PA. MoMA Archives.

John Elderfield: Photograph by Helaine R. Messer. PA. MoMA Archives. Mr. Elderfield joined the Museum in 1975 as Curator of Painting and Sculpture.

■ **PAGE 173**

Printed Art: A View of Two Decades: February 13–April 1, 1980. Photograph by Kate Keller. PA. MoMA Archives.

The past twenty years: Museum Press Release, no. 11, January 1980.

Mary Lea Bandy: Photograph by Jonathan Wenk. PA. MoMA Archives. Ms. Bandy joined the Museum in 1973 as Associate Editor in the Department of Publications.

■ **PAGE 174**

William Rubin and Alicia Legg: May 22–September 30, 1980. Photograph by Leonardo Le Grand. PI Event Photos, 138. MoMA Archives.

The idea for the present exhibition: William Rubin, "Genesis of an Exhibition," in William Rubin, ed., *Pablo Picasso: A Retrospective* (New York: The Museum of Modern Art, 1980): 11–12.

Richard E. Oldenburg, First Lady Rosalynn Smith Carter: August 1980. Photograph by Leonardo Le Grand. PI Event Photos, 140. MoMA Archives.

■ **PAGE 175**

Pablo Picasso: A Retrospective: PA. MoMA Archives.

Crowds in line to see Pablo Picasso: A Retrospective: summer 1980. Photograph by Leonardo Le Grand. PA. MoMA Archives.

■ **PAGE 176**

Cornell is best known: Museum Press Release, no. 60, 1980.

Catalogue, Joseph Cornell: Kynaston McShine, ed., *Joseph Cornell* (New York: The Museum of Modern Art, 1980).

Joseph Cornell: November 17, 1980–January 20, 1981. Photograph by Kate Keller. PA. MoMA Archives.

■ **PAGE 177**

It is a rare occasion: John Szarkowski, "Department of Photography," *The Museum of Modern Art New York Biennial Report 1967–69* (New York: The Museum of Modern Art, 1969): 19.

The Work of Atget: Vol. 1, 1981; vol. 2, 1982; vol. 3, 1983; vol. 4, 1985. John Szarkowski and Maria Morris Hamburg, *The Work of Atget,* Vols. 1–4 (New York: The Museum of Modern Art, 1981–1985).

■ **PAGE 178**

Museum staff in front of Pablo Picasso's Guernica: September 8, 1981. Photograph by Leonardo Le Grand. PI, II.B.1638. MoMA Archives.

We knew it was going: Oral History Project, Interview with Eloise Ricciardelli, 1994: 51–56. MoMA Archives.

■ **PAGE 179**

Memo to the staff: September 9, 1981. PI, II.B.1639. MoMA Archives.

Guernica is taken down; rolling the canvas: September 8, 1981. Photographs by Mali Olatunji. PI, II.B.1638. MoMA Archives.

■ **PAGE 180**

Four works on canvas: Selections from the Permanent Collection of Painting and Sculpture. July 1, 1993. Photograph by Kate Keller. PA. MoMA Archives. Vasily Kandinsky. *Painting Number 198.* 1914. Oil on canvas, 64 x 36¼" (162.5 x 92.1 cm). The Museum of Modern Art, New York. Mrs. Simon Guggenheim Fund. Vasily Kandinsky. *Painting Number 199.* 1914. Oil on canvas, 64⅛ x 48⅛" (162.6 x 122.7 cm). The Museum of Modern Art, New York. Nelson A. Rockefeller Fund (by exchange). Vasily Kandinsky. *Painting Number 200.* 1914. Oil on canvas, 64 x 31½" (162.5 x 80 cm). The Museum of Modern Art, New York. Mrs. Simon Guggenheim Fund. Vasily Kandinsky. *Painting Number 201.* 1914. Oil on canvas, 64¼ x 48¾" (163 x 123.6 cm). The Museum of Modern Art, New York. Nelson A. Rockefeller Fund (by exchange).

Skyscrapers are machines: Arthur Drexler, *Three New Skyscrapers* (New York: The Museum of Modern Art, 1983): 3.

graph by Leonardo Le Grand. PA. MoMA Archives.

Three New Skyscrapers: January 27–March 29, 1983. Photograph by Kate Keller. PA. MoMA Archives.

■ **PAGE 181**

Richard E. Oldenburg and Cesar Pelli: summer 1983. PA. MoMA Archives.

Representatives of the Expansion Committee: May 7, 1984. Photograph by Helaine Messer. PI Event Photos, 200. MoMA Archives.

Garden Hall: PA. MoMA Archives.

■ **PAGE 182**

Model of front facade: Director's Office Records, records management box 1772. MoMA Archives.

Night view of Garden Hall: PA. MoMA Archives.

Cartoon: © The New Yorker Collection, 1984 Charles Saxon. Digital image from cartoonbank.com. All rights reserved.

■ **PAGE 183**

An International Survey of Recent Painting & Sculpture: May 17–August 19, 1984. PA. MoMA Archives.

Few if any external influences: Museum Press Release, no. 17, August 1984.

"Primitivism" in 20th Century Art: Affinity of the Tribal and the Modern: September 19, 1984–January 15, 1985. Photograph by Kate Keller. PA. MoMA Archives.

■ **PAGE 185**

Donald B. Marron: Photograph by Evelyn Hofer. PA. MoMA Archives.

The presence of King Carl XVI Gustaf: Donald B. Marron and Richard E. Oldenburg, "Report of the President and the Director," *The Museum of Modern Art, New York, Annual Report 1985–86* (New York: The Museum of Modern Art, 1986): 7.

John Szarkowski: Photograph by Helaine Messer. PI Event Photos, 164. MoMA Archives.

■ **PAGE 186**

Mies van der Rohe Centennial Exhibition: February 5–April 15, 1986. Photograph by Kate Keller. PA. MoMA Archives.

His exhibitions, publications, and acquisitions: Museum Press Release, no. 3, January 1987.

Arthur Drexler: PI, II.C.68. MoMA Archives. Mr. Drexler retired early owing to illness. He died of pancreatic cancer on January 16, 1987.

■ **PAGE 187**

Vienna 1900: Art, Architecture, and Design: July 3–October 26, 1986. Photographs by Kate Keller. PA. MoMA Archives.

■ PAGE 188

The Drawings of Roy Lichtenstein: March 15–June 2, 1987. Photograph by Kate Keller. PA. MoMA Archives.

The Edward John Noble Education Center: 1984–2002. Department of Planning/Expansion Records, records management box 2136. MoMA Archives.

■ PAGE 189

William S. Rubin: Photograph by Ken Collins. PI, II.C.180. MoMA Archives.

[William Rubin's] role as curator: Museum Press Release, no. 20, 1988.

Richard E. Oldenburg: Museum Press Release, no. 20, 1988.

Kirk Varnedoe: Photograph by Timothy Greenfield-Sanders. Courtesy Timothy Greenfield-Sanders.

■ PAGE 190

Garry Winogrand: May 15–August 16, 1988. Photograph by Kate Keller. PA. MoMA Archives.

Winogrand is, in my view: John Szarkowski, *Garry Winogrand: Figments from the Real World* (New York: The Museum of Modern Art, 1988): jacket copy.

The Modern Poster installation: Cover of *The Museum of Modern Art New York Annual Report 1987–88* (New York: The Museum of Modern Art, 1988).

Opening of The Modern Poster: Photograph by Mary Hilliard. PI Event Photos, 218. MoMA Archives.

Philip Johnson and Stuart Wrede: Opening of the exhibition, *Mario Botta,* November 19, 1986. Photograph by Star Black. © Star Black. PI Event Photos, 201. MoMA Archives.

■ PAGE 191

Presentation of Robert Rauschenberg's Bed: May 9, 1989. Photograph by Eric Weiss. © Eric Weiss. PI Event Photos, 190. MoMA Archives. Robert Rauschenberg. *Bed.* 1955. Combine painting: oil and pencil on pillow, quilt, and sheet on wood supports, 6′ 3¼″ × 31½″ × 8″ (191.1 x 80 x 20.3 cm). Gift of Leo Castelli in honor of Alfred H. Barr, Jr.

The selections and juxtapositions: Museum Press Release, no. 28, March 1989.

Artist's Choice: Chuck Close (Head-On/The Modern Portrait): January 10–March 19, 1991. Photograph by Kate Keller. PA. MoMA Archives.

■ PAGE 192

Andy Warhol: A Retrospective: February 6–May 2, 1989. PA. MoMA Archives.

Opening of Andy Warhol: Photograph

by Star Black. © Star Black. PI Event Photos, 230. MoMA Archives.

Objects and documents: August 2004. Photograph by Thomas Griesel. PA. MoMA Archives.

■ PAGE 193

Photography Until Now: February 14–May 29, 1990. Photograph by Kate Keller. PA. MoMA Archives.

Exhibition brochure: Graphics. MoMA Archives.

An Evening with Gregory Peck: Photograph by Star Black. © Star Black. PI Event Photos, 253. MoMA Archives.

■ PAGE 194

High and Low: Modern Art and Popular Culture: October 7, 1990–January 15, 1991. PA. MoMA Archives.

Kirk Varnedoe and Adam Gopnik: Photograph by Sara Barrett. © Sara Barrett. PI, II.B. 2577. MoMA Archives.

■ PAGE 195

Art of the Forties: February 20–April 30, 1991. Photographs by Kate Keller. PA. MoMA Archives.

Exhibition brochure: Graphics. MoMA Archives.

■ PAGE 196

John Szarkowski: Opening of *Stieglitz at Lake George,* September 13, 1995. Photograph by Star Black. © Star Black. PI Event Photos, 333. MoMA Archives.

An art museum is measured: John Szarkowski, Memorial for Blanchette Rockefeller, courtesy the author.

Terence Riley: Photograph by Ken Collins. PA. MoMA Archives.

Peter Galassi: Photograph by Timothy Greenfield-Sanders. Courtesy Timothy Greenfield-Sanders. Timothy Greenfield-Sanders "Art World" Collection. MoMA Archives. Mr. Galassi joined the Museum in 1981 as Associate Curator of Photography.

■ PAGE 197

Agnes Gund: Photograph by Timothy Greenfield-Sanders. Courtesy Timothy Greenfield-Sanders. Timothy Greenfield-Sanders "Art World" Collection. MoMA Archives.

In founding Studies in Modern Art: John Elderfield, "Preface," in *American Art of the 1960s. Studies in Modern Art* 1 (New York: The Museum of Modern Art, 1991): 9–11.

Studies in Modern Art: John Elderfield, ed., *Studies in Modern Art.* Vol. 1, 1991; vol. 2, 1992; vol. 3, 1994; vol. 4, 1994; vol. 5, 1995; vol. 6, 1998; vol. 7, 1998 (New York: The Museum of Modern Art, 1991–1998).

■ PAGE 198

The William S. Paley Collection: January 30–April 7, 1992. PA. MoMA Archives. The William S. Paley Collection comprised works donated during Mr. Paley's lifetime as well as those bequeathed upon his death in 1990.

Jean-Luc Godard: Raymond Bellour and Mary Lea Bandy, eds., *Jean-Luc Godard: Son + Image 1974–1991* (New York: The Museum of Modern Art, 1992).

Jean-Luc Godard is widely recognized: Bandy, "Preface," in Bellour and Bandy, *Jean-Luc Godard:* 7–8.

■ PAGE 199

Brochure: Graphics. MoMA Archives.

Allegories of Modernism: February 12–May 12, 1992. Photograph by Geoffrey Clements. PA. MoMA Archives.

Opening of Allegories of Modernism: February 12–May 5, 1992. PI Event Photos, 276. MoMA Archives.

■ PAGE 200

Henri Matisse: A Retrospective: September 24–January 12, 1993. PA. MoMA Archives.

Invitation to Henri Matisse: A Retrospective: Graphics, 887. MoMA Archives.

John Elderfield and Beatrice Kernan: Photograph by Star Black. © Star Black. PI Event Photos, 283. MoMA Archives.

■ PAGE 201

Henri Matisse: A Retrospective: MoMA Photographic Archives.

Invitation to Latin American Artists: Graphics. MoMA Archives.

Latin American Artists of the Twentieth Century: June 2–September 7, 1993. PA. MoMA Archives. In 1999–2002, Paulo Herkenhoff served as the Museum's first Adjunct Curator for Latin American art.

■ PAGE 202

Opening of Santiago Calatrava: Photograph by Star Black. © Star Black. PI Event Photos, 298. MoMA Archives.

Santiago Calatrava: Structure and Expression: March 25–May 18, 1993. Photograph by Kate Keller. PA. MoMA Archives.

Designed for Speed: 3 Automobiles by Ferrari: November 4, 1993–April 5, 1994. PA. MoMA Archives.

■ PAGE 203

Opening of Joan Miró: Photograph by Star Black. © Star Black. PI Event Photos, 305. MoMA Archives.

Joan Miró. October 13, 1993–January 11, 1994. PA. MoMA Archives.

Robert Ryman: September 26, 1993–

January 4, 1994. Photograph by Kate Keller. PA. MoMA Archives.

Robert Ryman and Robert Storr: Photograph by Star Black. © Star Black. PI Event Photos, 304. MoMA Archives

■ PAGE 204

Program for An Evening with Clint Eastwood: Graphics. MoMA Archives.

Staff Members of the Department of Film: Photograph by Star Black. © Star Black. Department of Film. Shortly thereafter, the Department of Film became the Department of Film and Video. In June 2001, the name was changed to Department of Film and Media.

David Rockefeller and Patricia Phelps de Cisneros: Metropolitan Club, New York (June 9, 2004). Photograph by Timothy Greenfield-Sanders. Courtesy Timothy Greenfield-Sanders. PA. MoMA Archives.

■ PAGE 205

Opening of Frank Lloyd Wright Architect: Photograph by Star Black. © Star Black. PI Event Photos, 308. MoMA Archives.

Frank Lloyd Wright: Architect: February 16–May 10, 1994. Photograph by Kate Keller. PA. MoMA Archives.

Invitation: Dedication of The Lily Auchincloss Architecture and Design Center, May 24, 1994. Department of Architecture and Design Exhibition Files. MoMA Archives.

Lily Auchincloss and Alexandra A. Herzan: Photograph by Star Black. © Star Black. PI Event Photos, 192. MoMA Archives.

■ PAGE 206

Margit Rowell: Photograph by Jacques Faujour. PA. MoMA Archives. In 1993 the directors of the curatorial departments were renamed Chief Curators.

Deborah Wye and Louise Bourgeois: Photograph by Star Black. © Star Black. PI Event Photos, 316. MoMA Archives.

A Century of Artists Books: October 19, 1994–January 24, 1995. Photograph by Kate Keller. PA. MoMA Archives.

■ PAGE 207

Masterpieces from the David and Peggy Rockefeller Collection: From Manet to Picasso: May 27–August 2, 1994. PA. MoMA Archives.

Opening of Masterpieces: Photograph by Star Black. © Star Black. PI Event Photos, 301. MoMA Archives.

As we approach a new century: Richard E. Oldenburg, quoted in Museum Press Release, no. 51, 1993.

Richard E. Oldenburg: Photograph by Timothy Greenfield-Sanders. Cour-

tesy Timothy Greenfield-Sanders. PI Event Photos. MoMA Archives.

Robert Ryman and Robert Storr: Photograph by Star Black. © Star Black. PI Event Photos, 304. MoMA Archives

■ PAGE 209

Detail of article: Michael Kimmelman, "Museum of Modern Art Ends Troubled Search for a Chief," *The New York Times* (November 17, 1994). A1. © The New York Times.

Glenn D. Lowry: Photograph by Ben Asen. Courtesy Ben Asen. Department of Communications.

■ PAGE 210

Bruce Nauman: March 1–May 23, 1995. Photographs by Kate Keller. PA. MoMA Archives.

Opening of Bruce Nauman: Photograph by Star Black. © Star Black. PI Event Photos, 324. MoMA Archives.

■ PAGE 211

Masterworks from the Louise Reinhardt Smith Collection: May 3–August 22, 1995. PA. MoMA Archives.

I never had any formal education in art: Louise Reinhardt Smith, "Preface," in *Masterworks from The Louise Reinhardt Smith Collection* (New York: The Museum of Modern Art, 1995): 8–9.

Louise Reinhardt Smith: Photograph by Star Black. © Star Black. PI Event Photos, 327. MoMA Archives.

Chairman Agnes Gund: PA. MoMA Archives.

■ PAGE 212

Video Spaces: Eight Installations: June 21–September 12, 1995. The video work illustrated is Gary Hill's *Inasmuch As It Is Always Already Taking Place,* 1990.

Riva Castleman retires: Photograph by Timothy Greenfield-Sanders, 1990. Digital image courtesy Timothy Greenfield-Sanders. Timothy Greenfield-Sanders "Art World" Collection. MoMA Archives.

Deborah Wye and Louise Bourgeois: Photograph by Star Black. © Star Black. PI Event Photos, 316. MoMA Archives.

■ PAGE 213

Mutant Materials in Contemporary Design: May 24–August 27, 1995. Photograph courtesy Paola Antonelli.

Opening of Mutant Materials in Contemporary Design: Photograph courtesy Paola Antonelli.

Michael Margitich: Farewell party for Kirk Varnedoe, December 13, 2001. PI Event Photos, 455. MoMA Archives.

■ PAGE 214

Light Construction: September 20, 1995–January 2, 1996. Department of Architecture and Design Exhibition Files, Exh. #1726. MoMA Archives.

■ PAGE 215

Interior view of vault: Photograph by Paul Warchol. PA. MoMA Archives.

Exterior view of The Celeste Bartos Film Preservation Center: Photograph by Paul Warchol. PA. MoMA Archives.

The [Celeste Bartos Film Preservation] Center: Museum Press Release, no. 31, 1996.

Dorset Hotel: Digital image courtesy Rebecca Stokes.

■ PAGE 216

From Bauhaus to Pop: June 5–September 3, 1996. PA. MoMA Archives.

Philip Johnson: Architecture and Design Gifts: June 5–September 3, 1996. PA. MoMA Archives.

The Party in the Garden, in honor of Philip Johnson: Spring 1996. Photograph by Patrick McMullan. © Patrick McMullan. Digital image courtesy Patrick McMullan.

■ PAGE 217

Graphic for Thinking Print: Graphics. MoMA Archives.

Thinking Print: June 19–September 10, 1996. PA. MoMA Archives.

Deborah Wye: Photograph by Timothy Greenfield-Sanders. Courtesy Timothy Greenfield-Sanders. Timothy Greenfield-Sanders "Art World" Collection. MoMA Archives. Ms. Wye joined the Museum in 1979 as Assistant Curator of Prints and Illustrated Books.

John Elderfield: Photograph by Timothy Greenfield-Sanders. Digital image courtesy Timothy Greenfield-Sanders.

■ PAGE 218

The Museum of Modern Art Mission Statement: 1996. This statement was printed in both the 1996–97 and the 1997–98 Annual Reports. The format reproduced here is from *The Museum of Modern Art Annual Report 1997–1998:* 3.

■ PAGE 219

Jasper Johns: A Retrospective: October 15, 1996–January 21, 1997. PA. MoMA Archives.

Artists at a party: Photograph by Patrick McMullan. © Patrick McMullan. PI Events Photos, 350. MoMA Archives.

Jasper Johns changed the course: Museum Press Release, no. 46, 1996.

■ PAGE 220

Catalogue, Manuel Alvarez Bravo: Susan Kismaric, *Manuel Alvarez Bravo* (New York: The Museum of Modern Art, 1997).

Manual Alvarez Bravo and Susan Kismaric: Detail, opening of *Manuel*

Alvarez Bravo. PI Event Photos. MoMA Archives.

Architects included in Toward the New Museum of Modern Art: PI Event Photos. MoMA Archives.

Toward the New Museum of Modern Art: Sketchbooks by Ten Architects: May 1–October 7, 1997. Photograph by Kate Keller. PA. MoMA Archives.

■ **PAGE 221**
Opening of Cindy Sherman: The Complete Untitled Film Stills: PI Event Photos. MoMA Archives.

Cindy Sherman: The Complete Untitled Film Stills: June 24–September 2, 1997. PA. MoMA Archives.

On the Edge: Contemporary Art from the Werner and Elaine Dannheisser Collection: September 29, 1997–January 4, 1998. Photograph by Kate Keller. PA. MoMA Archives.

One of the largest: Museum Press Release, no. 45, August 1997.

■ **PAGE 222**
Opening of Fernand Léger: Photograph by Patrick McMullan. © Patrick McMullan. PI Event Photos, 364. MoMA Archives.

Fernand Léger: February 11–May 12, 1998. PA. MoMA Archives.

Opening of Structure and Surface: Photograph by Star Black. © Star Black. Courtesy Department of Architecture and Design.

Structure and Surface: Contemporary Japanese Textiles: November 11, 1998–January 26, 1999. Department of Architecture and Design Exhibition Files, Exh. #1820. MoMA Archives.

■ **PAGE 223**
Alvar Aalto: Between Humanism and Materialism: February 18–May 19, 1998. PA. MoMA Archives.

Invitation to Alvar Aalto: Between Humanism and Materialism. Graphics. MoMA Archives.

Opening of Alvar Aalto: Photograph by Patrick McMullan. © Patrick McMullan. PI Event Photos, 365. MoMA Archives.

Place Card: Courtesy Department of Special Programming and Events. Note: Eliza Cobb is Elizabeth Bliss Parkinson Cobb.

■ **PAGE 224**
Rethinking the Modern: Three Proposals for the New Museum of Modern Art: March 3–April 28, 1998. Photograph by Kate Keller. PA. MoMA Archives.

The three finalists: March 3, 1998. Photograph by Eric Weiss. © Eric Weiss. Digital image courtesy Eric Weiss.

Architect Selection Committee: Photograph by Timothy Greenfield-Sanders, 1998. Courtesy Timothy Greenfield-Sanders. Timothy Greenfield-Sanders "Art World" Collection. MoMA Archives.

Sid R. Bass: Museum Press Release, no. 26, April 10, 1997.

■ **PAGE 225**
Jackson Pollock: October 28, 1998–February 2, 1999. PA. MoMA Archives.

Opening of Jackson Pollock: Photograph by Patrick McMullan. © Patrick McMullan. PI Event Photos. MoMA Archives.

Program for lectures and symposia: Program, "Public Programs Fall 1998: Jackson Pollock." Graphics. MoMA Archives.

■ **PAGE 226**
The Museum as Muse: Artists Reflect: March 10–June 1, 1999. PA. MoMA Archives.

The use of the museum as a subject: Kynaston McShine, "Introduction," in his *The Museum as Muse: Artists Reflect* (New York: The Museum of Modern Art, 1999): 11.

Mary Lea Bandy: Photograph by Timothy Greenfield-Sanders, 1998. Courtesy Timothy Greenfield-Sanders.

■ **PAGE 227**
MoMA 2000 is a seventeen-month-long: Glenn D. Lowry, "Foreword," in Robert Storr, *Modern Art despite Modernism* (New York: The Museum of Modern Art, 2000): 20.

Catalogue for the exhibition cycle MoMA 2000: Modern Starts: John Elderfield, Peter Reed, Mary Chan, and Maria del Carmen González, eds., *Modern Starts* (New York: The Museum of Modern Art, 1999).

Modern Starts: People: Actors, Dancers, Bathers: October 6, 1999–February 1, 2000. PA. MoMA Archives.

■ **PAGE 228**
Exhibition catalogue, Walker Evans & Company: Peter Galassi. *Walker Evans & Company* (New York: The Museum of Modern Art, 2000).

Modern Art despite Modernism: March 15–August 22, 2000. PA. MoMA Archives.

Shigeru Ban: A Paper Arch: April 26–August 1, 2000. PA. MoMA Archives.

■ **PAGE 229**
Collection catalogue, Modern Contemporary: Kirk Varnedoe, Paola Antonelli, and Joshua Siegel, eds., *Modern Contemporary* (New York: The Museum of Modern Art, 2000).

Minimalism and After: November 1–January 30, 2001. PA. MoMA

Archives. Still image extraction from virtual-reality tour.

■ **PAGE 230**
Gerhard Richter: October 18, 1977: PA. MoMA Archives. Still image extraction from virtual-reality tour.

Gary Garrels: Photograph by Timothy Greenfield-Sanders, 2004. Courtesy Timothy Greenfield-Sanders.

James Gara and Joan and Preston Robert Tisch: Photograph by Patrick McMullan © Patrick McMullan. PI Event Photos. MoMA Archives. Mr. Gara joined the Museum in 1982 as Manager of Financial Planning and Analysis.

■ **PAGE 231**
Glenn D. Lowry and Alanna Heiss: Photograph by Mark Morosse. PI Event Photos. MoMA Archives.

P.S. 1 Contemporary Art Center: Photograph by John Harris. Courtesy John Harris. PA. MoMA Archives.

Greater New York installation: Rob Pruitt, *Power of the Panda*, 2000, P.S. 1 Contemporary Art Center. February 27–May 2000. Photograph courtesy P.S. 1.

Greater New York installation: Do-Ho Suh, *Seoul Home/LA Home/NY Home*, 1999; Michelle Lopez, *Boy*, 1999; and Chakaia Booker, *Nomadic Warrior*, P.S. 1 Contemporary Art Center. Photograph by Eileen Costa. Courtesy P.S. 1.

■ **PAGE 232**
Andreas Gursky: February 28–May 15, 2001. PA. MoMA Archives. Still image extraction from virtual-reality tour.

Andreas Gursky's best pictures: Peter Galassi, "Gursky's World," in his *Andreas Gursky* (New York: The Museum of Modern Art, 2001): 9.

Opening of Andreas Gursky: Photograph by Patrick McMullan. © Patrick McMullan. PI Event Photos. MoMA Archives.

Kirk Varnedoe resigns: Speaking at his farewell party, December 13, 2001. Photograph by Star Black. © Star Black. PI Event Photos, 455. MoMA Archives. Mr. Varnedoe resigned owing to illness. He joined the faculty of the Institute for Advanced Studies at Princeton University where he completed the Mellon Lectures in the spring of 2003. He died of cancer on August 14, 2003.

Nearly everyone who met Kirk Varnedoe: Verlyn Klinkenborg, *The New York Times* (August 16, 2003): Section A, 24.

■ **PAGE 233**
Opening of Gerhard Richter: Forty Years of Painting: Photograph by Patrick McMullan. © Patrick

McMullan. PI Event Photos. MoMA Archives.

Gerhard Richter: Forty Years of Painting: February 13–May 21, 2002. PA. MoMA Archives. Still image extractions from virtual-reality tour.

Richter has assumed a skeptical distance: Museum Press Release, February 2002.

■ **PAGE 234**
Press kit for The Russian Avant-Garde Book: MoMA Archives.

The Russian Avant-Garde Book: Museum Press Release, October 2001.

Opening of The Russian Avant-Garde Book: Photograph by Mary Hilliard. PI Event Photos. MoMA Archives.

The Russian Avant-Garde Book 1910–1934: March 28–May 21, 2002. PA. MoMA Archives. Still image extraction from virtual-reality tour.

■ **PAGE 235**
MoMA QNS facility in Long Island City: Michael Maltzan Architecture, Los Angeles, and Cooper, Robertson and Partners, New York. Digital image courtesy Rebecca Stokes.

MoMA QNS, interior view of admissions: Digital image courtesy Rebecca Stokes.

Enhancing the vibrant cultural scene in the Queens community: Museum Press Release, no. 81, October 2001.

■ **PAGE 236**
To Be Looked At: June 29, 2002–September 6, 2004. PA. MoMA Archives. Still image extractions from virtual-reality tour. This ongoing installation by Kynaston McShine, Chief Curator at Large, rotated works from the collection.

Robert B. Menschel: 1990. Photograph by Timothy Greenfield-Sanders. Courtesy Timothy Greenfield-Sanders. Timothy Greenfield-Sanders "Art World" Collection. MoMA Archives.

■ **PAGE 237**
Matisse Picasso, installation views: February 13–May 19, 2003. PA. MoMA Archives. Still image extractions from virtual-reality tour.

■ **PAGE 238**
Kynaston McShine: Photograph by Robert Mapplethorpe. © Robert Mapplethorpe Foundation. Used with permission.

John Elderfield: Photograph by Timothy Greenfield Sanders. Courtesy Timothy Greenfield-Sanders.

Artist's Choice: Mona Hatoum: November 7, 2003–February 2, 2004. PA. MoMA Archives. Still image extraction from virtual-reality tour.

■ **PAGE 239**
Roth Time: A Dieter Roth Retrospective: March 12–June 7, 2004. Photographs courtesy P.S. 1 and PA. MoMA Archives.

Catalogue for Tall Buildings: Terence Riley and Guy Nordenson, *Tall Buildings* (New York: The Museum of Modern Art, 2003).

Catalogue for Das MoMA in Berlin: John Elderfield, ed., *Das MoMA in Berlin: Meisterwerke aus dem Museum of Modern Art, New York* (New York: The Museum of Modern Art, 2004). Among the other exhibitions shown outside the Museum during the construction period were two in New York City: *Sculpture from The Museum of Modern Art at the New York Botanical Garden*, April 26, 2002–August 31, 2003; and *MoMA at El Museo: Latin American and Caribbean Art from the Collection of The Museum of Modern Art*, March 4–July 25, 2004, El Museo Del Barrio, New York.

■ **PAGE 240**
Groundbreaking Ceremony: Photograph by Eric Weiss. © Eric Weiss. Courtesy Department of Communications.

The Museum under construction: Digital image courtesy Rebecca Stokes.

Glenn D. Lowry and Yoshio Taniguchi: Photograph by Timothy Hursley. Digital image courtesy Timothy Hursley.

■ **PAGE 241**
Axonometric showing north elevation: Rendering courtesy Taniguchi and Associates/Masanori Kasahara. Digital image courtesy Department of Architecture and Design.

Exterior view from Sculpture Garden: Rendering courtesy Taniguchi and Associates/Masanori Kasahara. Digital image courtesy Department of Architecture and Design.

Interior view toward atrium: Rendering courtesy Taniguchi and Associates/ Masanori Kasahara. Digital image courtesy Department of Architecture and Design.

■ **PAGE 242**
Taniguchi's design is a brilliant: Glenn D. Lowry, *Designing the New Museum of Modern Art* (New York: The Museum of Modern Art, 2004): 24–28.

View inside the new contemporary galleries: Photograph by Timothy Hursley. Digital image courtesy Timothy Hursley.

■ **PAGE 243**
The Museum's new gallery building: Photograph by Timothy Hursley. Digital image courtesy Timothy Hursley.

View of the Fifty-third Street facade: Photograph by Timothy Hursley.

Digital image courtesy Timothy Hursley.

■ **PAGE 244**
Digital photocomposition of completed building: Photograph by Elizabeth Felicella, architectural rendering by Kohn Pedersen Fox Associates, digital composite by Robert Bowen, 2003.

■ **PAGE 245**
Board of Trustees: Metropolitan Club, New York, June 9, 2004. Photograph by Timothy Greenfield-Sanders. Courtesy Timothy Greenfield-Sanders. PA. MoMA Archives.

ACKNOWLEDGMENTS

This publication would not have been possible without The Museum of Modern Art Archives, which organizes, preserves, and makes accessible written and visual materials critical to the Museum's history, and which was founded in 1989 by Rona Roob. We owe her a special debt of gratitude for having led the way and taught us so much of this history.

There are many individuals we wish to thank for supporting this project and for helping to compile the chronicle within a relatively brief period of time. First among these is Amanda González Moreno, who joined us as an intern and remained as an indispensable assistant until the book went to press. Her enthusiasm, intelligence, cooperation, and engaging personality were crucial to the successful completion of the book, and we thank her fondly for her excellent work.

For the rapid cataloguing and scanning of the images we are greatly indebted to Thomas Grischkowsky, Archives Specialist, and Erik Landsberg, Head of Collections Imaging. We thank Thomas Griesel, Collections Photographer; Paige Knight, Collections Photographer; Jonathan Muzikar, Collections Archiving Specialist; Roberto Rivera, Production Assistant; Rosa Smith, Senior Archiving Technician; John Wronn, Collections Photographer; and Margaret Raimondi, Coordinator, Deputy Director for Curatorial Affairs, for their splendid work. Their extraordinary professionalism yielded scans for hundreds of illustrations in record time.

In the Department of Publications, we especially thank Christina Grillo, Production Manager, for the intelligent, painstaking care and dedication to excellence with which she coordinated all the complicated aspects of the production for this book; we owe her the lion's share of gratitude on the entire project. Warm thanks are also due David Frankel, the Museum's Managing Editor, for his expert editorial oversight of the volume. We also thank Lawrence Allen, Publications Manager, for his strong commitment to the project and for crafting the financial plan for its execution. We acknowledge the critical participation of the Museum's Publisher, Michael Maegraith. Steven Schoenfelder provided the superb design for this handsome volume with his usual thoughtfulness, ingenuity, and expertise.

The idea for this book would not have become a reality without the dedicated support of Mary Lea Bandy, the Museum's indispensable Deputy Director for Curatorial Affairs and Chief Curator of the Department of Film and Media, who fully understood and championed the project from the start, and supervised its completion with the professionalism of one who began her life at the Museum as an editor in the Department of Publications. We are equally grateful for the crucial backing of the Museum's Director, Glenn D. Lowry, and that of the Deputy Director for External Affairs, Michael Margitich, whose early enthusiasm for the book guaranteed its success. Both Ms. Bandy and Kynaston McShine, the Museum's Chief Curator at Large, read the manuscript as it developed and provided essential guidance as to the contents and the balance of the whole. It was a privilege to have the benefit of Mr. McShine's generous involvement; his knowledge of the Museum's history and collection, as well as his high standards, are unequaled, and we thank him wholeheartedly.

We are most grateful for the support of the Museum Archives staff. Special mention is due Michelle Harvey, Associate Archivist, whose unwavering dedication to the Archives is a model to us all. We also thank Miriam Gianni, Records Manager; Kathleen Tunney, Assistant to Museum Archives and Library; Eve Lambert, Dedalus Fellow; and Kwaku Sarpong, Intern. A special acknowledgment is due Milan Hughston, Chief of Library and Museum Archives, for his informed and enthusiastic support of the book.

In addition, many other people throughout the institution provided assistance of various kinds. We acknowledge and thank John Elderfield, Chief Curator of Painting and Sculpture; Peter Galassi, Chief Curator of Photography; Deborah Wye, Chief Curator of Prints and Illustrated Books; Terence Riley, Chief Curator of Architecture and Design; in Film and Media: Laurance Kardish, Senior Curator of Programming, Ron Magliozzi, Assistant Curator, Research and Collections, and Jenny He, Research Assistant; in Architecture and Design: Peter Reed, Curator, and Tina di Carlo, Assistant Curator; Rebecca Stokes, Director, Campaign and Development Communication; in Special Programming and Events: the late Ethel Shein, Director, and Kara Moore, Associate Director; in Communications: Kim Mitchell, Director, and Kim Donica, Research Assistant; Mikki Carpenter, former Director of Imaging Services; Jenny Tobias, Librarian, Collection Development; in the office of the General Counsel: Stephen Clark, Associate, Nancy Adelson, Assistant, and Jane Panetta, Department Manager; Todd Bishop, Director, Exhibition Funding; Catherine McGovern, Director of Human Resources; John Szarkowski, Director Emeritus of Photography; and Rachel Dorsey of the P.S. 1 Contemporary Art Center. In addition, we thank Marni Pillsbury, Peter Johnson, and Claire Eastman of the office of David Rockefeller; Jamie Bennett of the office of Agnes Gund; Elizabeth Pozen of the office of Ronald S. Lauder; Marianne Sammarco of the office of Robert B. Menschel; and Diana Pulling and Jocelynn Hyde of the office of Glenn D. Lowry.

We also thank the photographers and their assistants who provided photographs, and permissions for their use, for this project. They are all listed in the Source Notes and Photograph Credits, but we particularly acknowledge here those who helped locate items and who provided photographs without charge: Academy of Motion Picture Arts and Sciences, Ben Asen, Sara Barrett, Harry and Gigi Benson, Adele Bildersee of the Dalton School, David Gahr, Star Black, Ben Blackwell, Timothy Greenfield-Sanders, John Harris, Mary Hilliard, Robert Gurbo of the Estate of André Kertész, Joree Adilman of the Robert Mapplethorpe Foundation, Jason Crantz and Patrick McMullan, Mimi and Nikolas Muray, Randall Enos, Amy Boshnack of New York Magazine, Jeanne Russo and Homer Page, Michele Hiltzig of Rockefeller Archive Center, Rona Roob, Smithsonian American Art Museum, James Tormey, Leo Trachtenberg, Paul Warchol, Eric Weiss, and the Worcester Art Museum.

We are deeply grateful for the continued support of the Trustee Committee on Museum Archives, Library and Research, and in particular the committee's Chair, Barbara Jakobson, and founding Chair, Agnes Gund. Committee member Philip Aarons's personal commitment to this volume is also greatly appreciated. Additionally, we would like to express our thanks to the Blanchette Hooker Rockefeller Fund, which generously provided support for this publication. Special thanks are owed the four Trustees who provided gracious and inspiring statements for the opening of this book: Chairman Emeritus David Rockefeller, President Emerita Agnes Gund, Chairman Ronald S. Lauder, and President Robert B. Menschel.

And last, we would like to acknowledge the immense gratitude we owe our distinguished forebears in this incomparable institution. It should be evident in the pages of the book.

HARRIET S. BEE
FORMER EDITORIAL DIRECTOR,
DEPARTMENT OF PUBLICATIONS

MICHELLE ELLIGOTT
MUSEUM ARCHIVIST, MUSEUM ARCHIVES

TRUSTEES OF THE MUSEUM OF MODERN ART

David Rockefeller*
Chairman Emeritus

Agnes Gund
President Emerita

Ronald S. Lauder
Chairman

Robert B. Menschel
President

Sid R. Bass
Kathleen Fuld
Mimi Haas
Marie-Josée Kravis
Donald B. Marron
Richard E. Salomon
Jerry I. Speyer
Vice Chairmen

John Parkinson III
Treasurer

Glenn D. Lowry
Director

Patty Lipshutz
Secretary

James Gara
Assistant Treasurer

Celeste Bartos*
H.R.H. Duke Franz of
 Bavaria**
Mrs. Patti Cadby Birch**
Leon D. Black
Eli Broad
Clarissa Alcock Bronfman
Donald L. Bryant, Jr.
Thomas S. Carroll*
David M. Childs
Patricia Phelps de Cisneros
Mrs. Jan Cowles**
Douglas S. Cramer
Lewis B. Cullman**
Gianluigi Gabetti*
Maurice R. Greenberg**
Vartan Gregorian
Mrs. Melville Wakeman Hall*
Kitty Carlisle Hart**
Alexandra A. Herzan
Marlene Hess
Barbara Jakobson
Philip Johnson*
Werner H. Kramarsky*
June Noble Larkin*
Thomas H. Lee
Michael Lynne
Harvey S. Shipley Miller
Mrs. Akio Morita

Daniel M. Neidich
Philip S. Niarchos
James G. Niven
Peter Norton
Maja Oeri
Richard E. Oldenburg**
Michael S. Ovitz
Richard D. Parsons
Peter G. Peterson*
Mrs. Milton Petrie**
Gifford Phillips*
Emily Rauh Pulitzer
David Rockefeller, Jr.
Sharon Percy Rockefeller
Lord Rogers of Riverside**
Anna Marie Shapiro
Anna Deavere Smith
Ileana Sonnabend**
Emily Spiegel**
Joanne M. Stern*
Mrs. Donald B. Straus*
Yoshio Taniguchi**
Eugene V. Thaw**
Jeanne C. Thayer*
Joan Tisch*
Paul F. Walter
Thomas W. Weisel
Gary Winnick
Richard S. Zeisler*

Ex Officio

Peter Norton
*Chairman of the Board
of P.S. 1*

Michael R. Bloomberg
Mayor of the City of New York

William C. Thompson, Jr.
*Comptroller of the City of
New York*

Gifford Miller
*Speaker of the City Council
of the City of New York*

Jo Carole Lauder
*President of The International
Council*

Richard Anderman and
Anne Coffin
*Co-Chairmen of The
Contemporary Arts Council*

*Life Trustee
**Honorary Trustee

Maxwell Simpson - 109 Broad St. Elizabeth. N.J.
Douglas L. Fox, 55 Morton St. New York.

Carl Van Vechten

Julien Levy - 602 Madison Ave. N.Y.C.

Cipriano Efisio Oppo

Le Sidaner
Guillaume Apollinaire Paris —
Diego Rivera . Mexico 13 Nov. '31
Jan Juta Paris — 5/26/32

Mr. & Mrs. G.D. Sondhi. Lahore India. 24/8/
C. Y. Wang Chinese National Art Museum

George Gershwin Sept. 8, 1932.

Arch Bishop Tikhon Oct. 23ᵈ 1932
536 30th Washington Ave
N. York
Haroutune Hazarian 140. W 27 N.Y.C.

Antonio Taylor Taos N.M.